FILMING EVEREST

MALI 2004

STEPH DAVIS

EVEREST SKI 2006

180 SOUTH 2008

MERU 2008

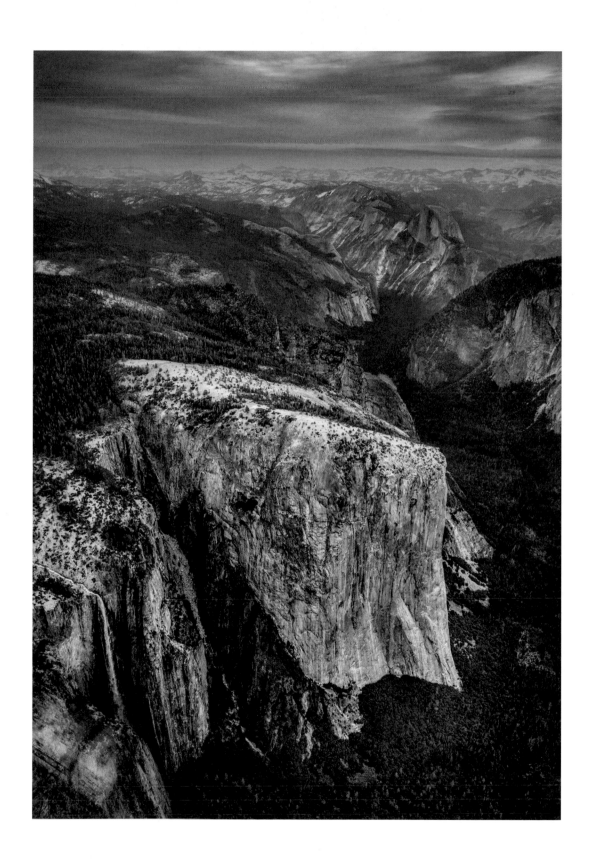

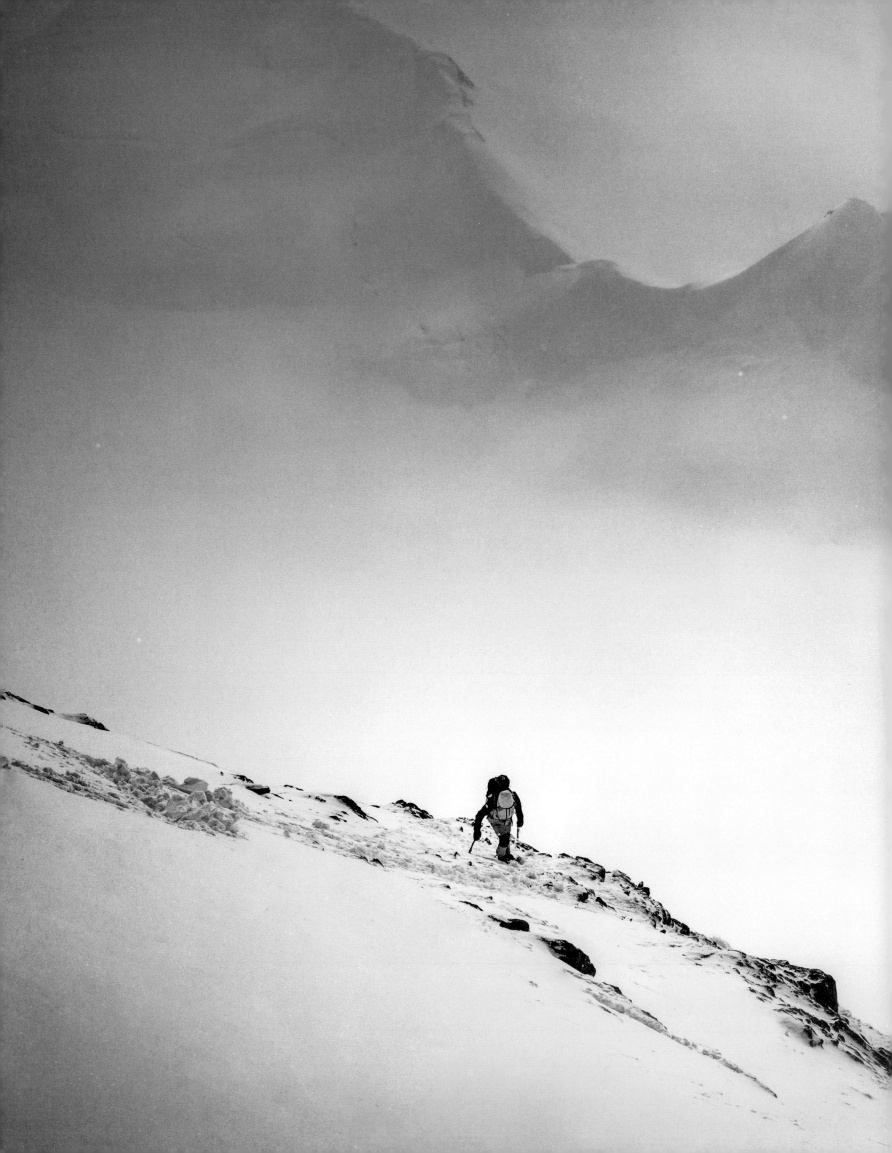

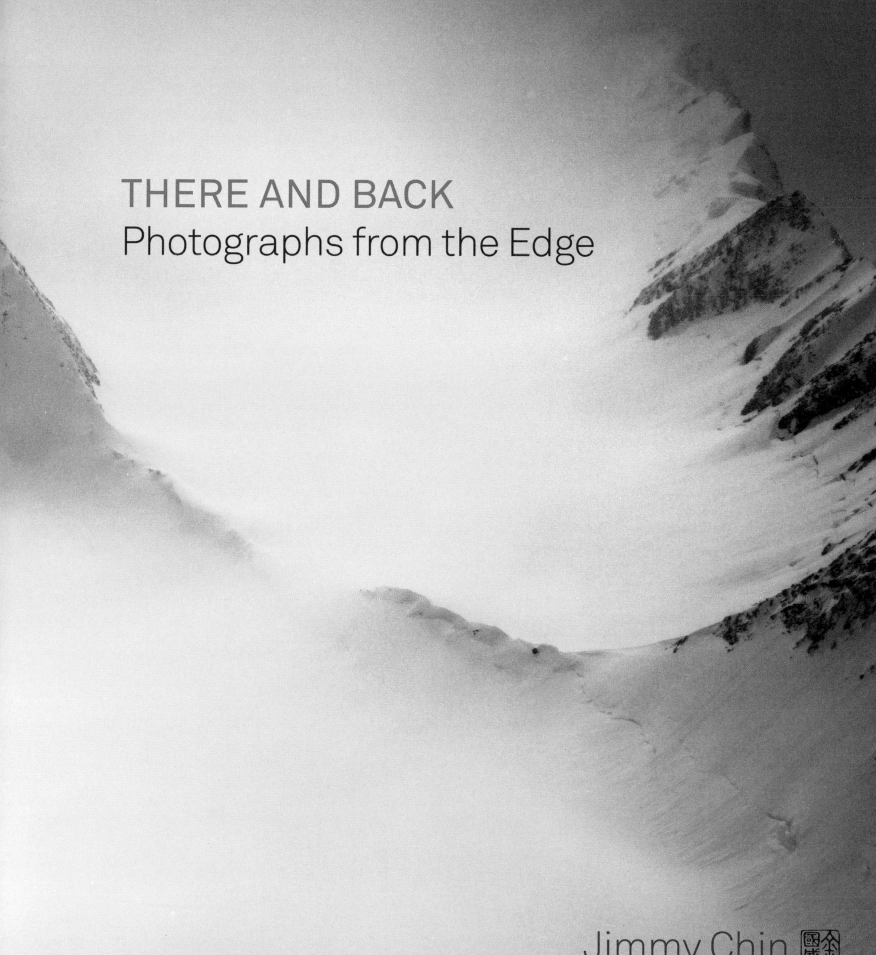

# THERE AND BACK
## Photographs from the Edge

Jimmy Chin

TEN SPEED PRESS
California | New York

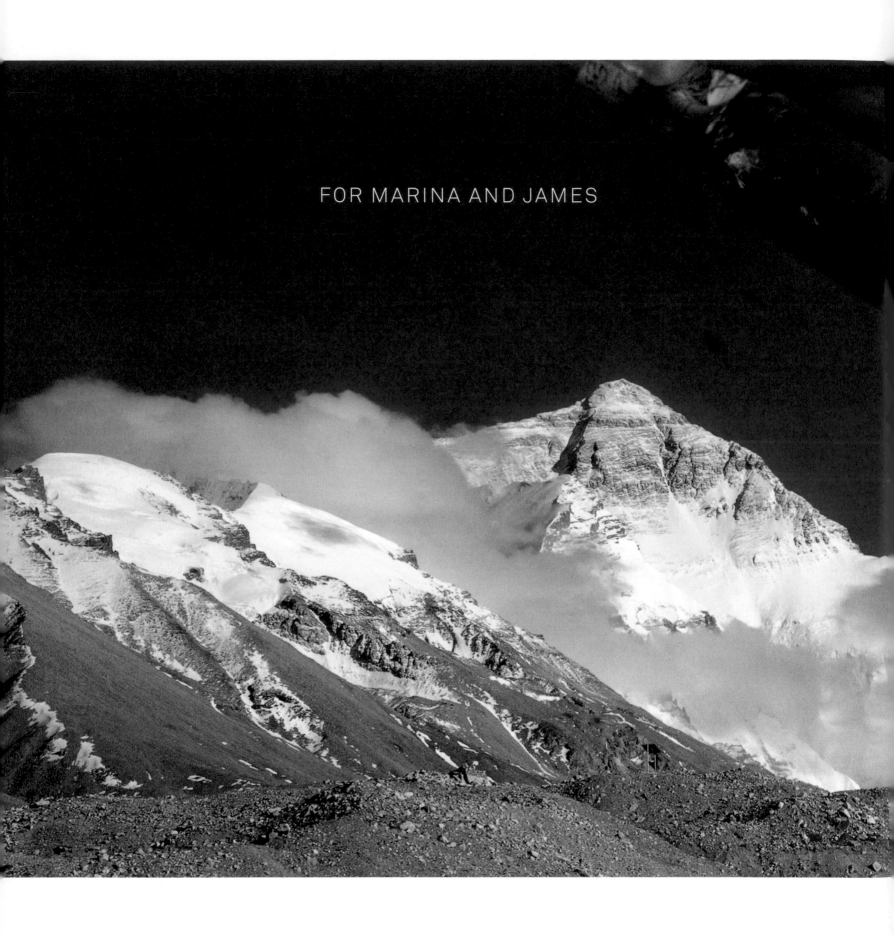

FOR MARINA AND JAMES

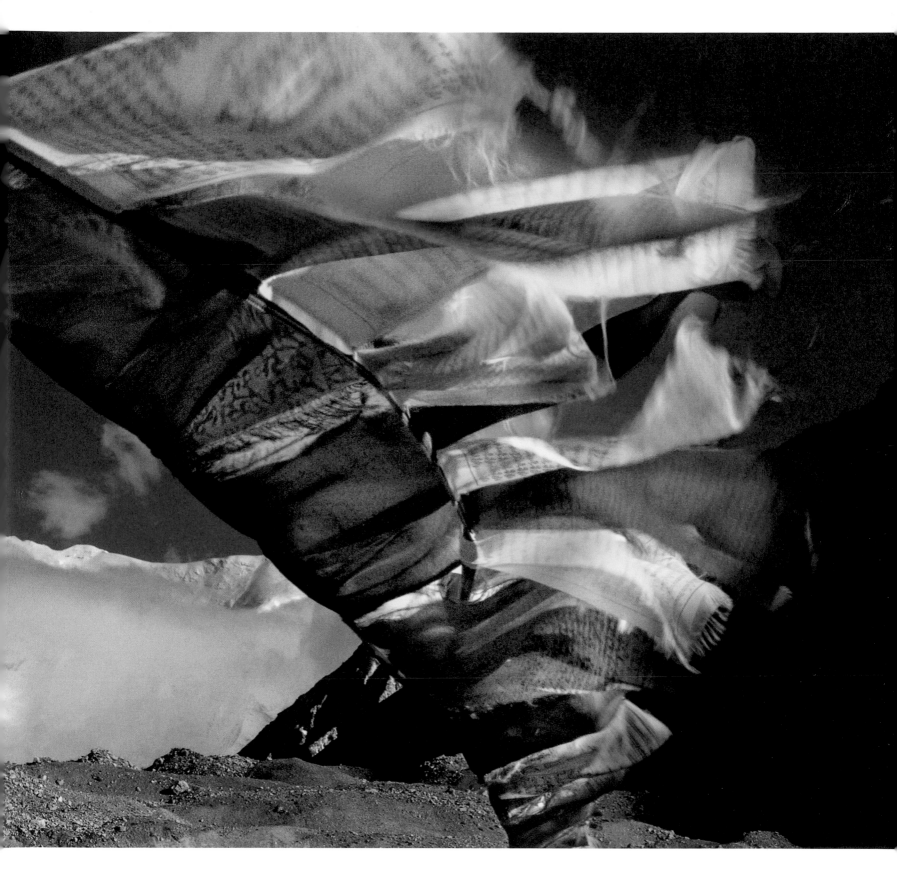

PAGE i  Yosemite Valley, California.

PREVIOUS  Conrad Anker climbing the Grand Couloir
on Mount Tyree. Sentinel Range, Antarctica.

ABOVE  Three ravens and Tibetan prayer flags
fly over the north face of Mount Everest.
Chomolungma, Tibet.

FOLLOWING  Kit DesLauriers crossing the glacier on
Sermersooq Island to climb and ski Taqqartortuusaq
peak. Western Greenland.

# CONTENTS

# Foreword

Nature is the wellspring of human existence. From the beginning of civilization, we have spent the better part of our lives taming the wild world. But while the grand edifices we have created reflect our self-importance, wilderness and extreme environments possess an elemental force that affirms life. These incredible places—remnants of an Earth before history—rejuvenate our souls, bringing us closer to the essence of living.

We can't live in these wild places permanently. But, from time to time, we can venture into the cold, barren, and exposed landscape and test ourselves against nature's forces. Our adventures, fueled by remote bivouacs and a lack of food, are life-defining endeavors. When we return, we understand the power of nature and how it can affect our daily lives. We hope to have gained a sliver of self-knowledge on our journey.

Photos can take us anywhere the photographer wants at a glance. A fraction of a second after the artist releases the shutter, a two-dimensional image becomes a time stamp of that exact moment. How the photographer, using the same tools available to all of us, creates art is the difference between the exceptional and the mundane. Our imaginations are left to wander, be it through ravages of war or celebrations of life. We wonder, What was the moment like when the photographer created the image? We also ask ourselves, How do our own lived experiences shape what we see in the image? The best photography can capture emotion or transport us to a place that opens our minds, creating a flywheel for creativity and a deep sense of calm.

Jimmy Chin's photography takes us to places where we are guests. Held tight by the cold, buffeted by wind, anchored by gravity and a foundation of self-reliance, Jimmy helps us experience the mystique of being in the wild. It's not easy. Add on the difficulties of working with camera gear, even in the best circumstances, and it is truly rare that a person can create art in these conditions with landscape, light, and people.

Jimmy, to our benefit, has been able to combine photography and mountaineering in one discipline. I remember seeing this on our first expedition to the Charakusa Valley, a ring of granite peaks in Pakistan. The route we attempted offered a steep wall that would require multiple days of effort. We ascended despite inclement weather, only to be beset by a storm. The weather continued unabated, pinning us to the side of the mountain. Throughout the ordeal, Jimmy kept his camera ready, capturing the odd moments that give a climb character. After four stormbound nights, we realized it was time to descend. Even though success eluded us, we stayed safe and became closer friends.

Twenty years later, Jimmy is still out there, pushing the limits of reason and endurance, creating images that can transport us to wild places. His photographs might fuel the creative drive for your own journey, provide you with an appreciation of these wild places, or challenge your perception of what's possible. May your own connection to these images be as deep as mine is with Jimmy. Thank you, Jimmy, for taking us there and back.

– Conrad Anker

**OPPOSITE** Conrad Anker traversing near the summit of Mount Owen, Grand Teton National Park, Wyoming. The north face of the Grand Teton is in the background.

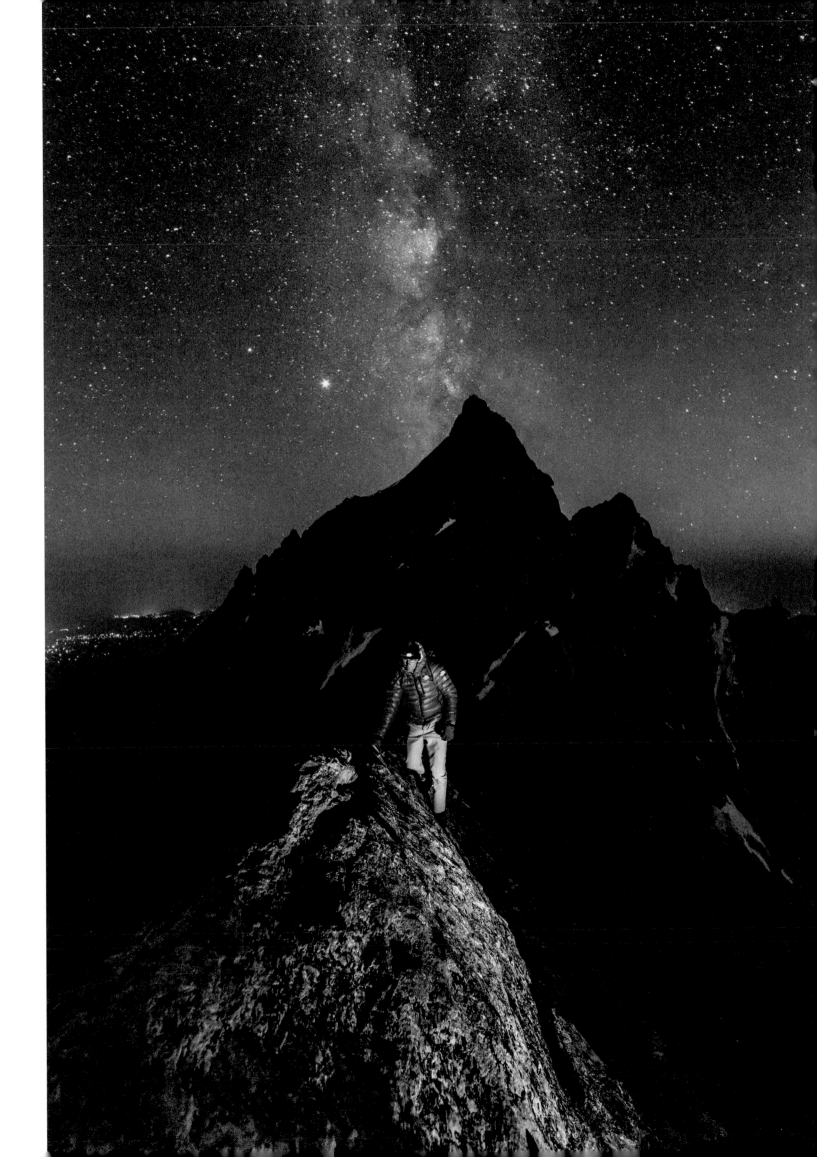

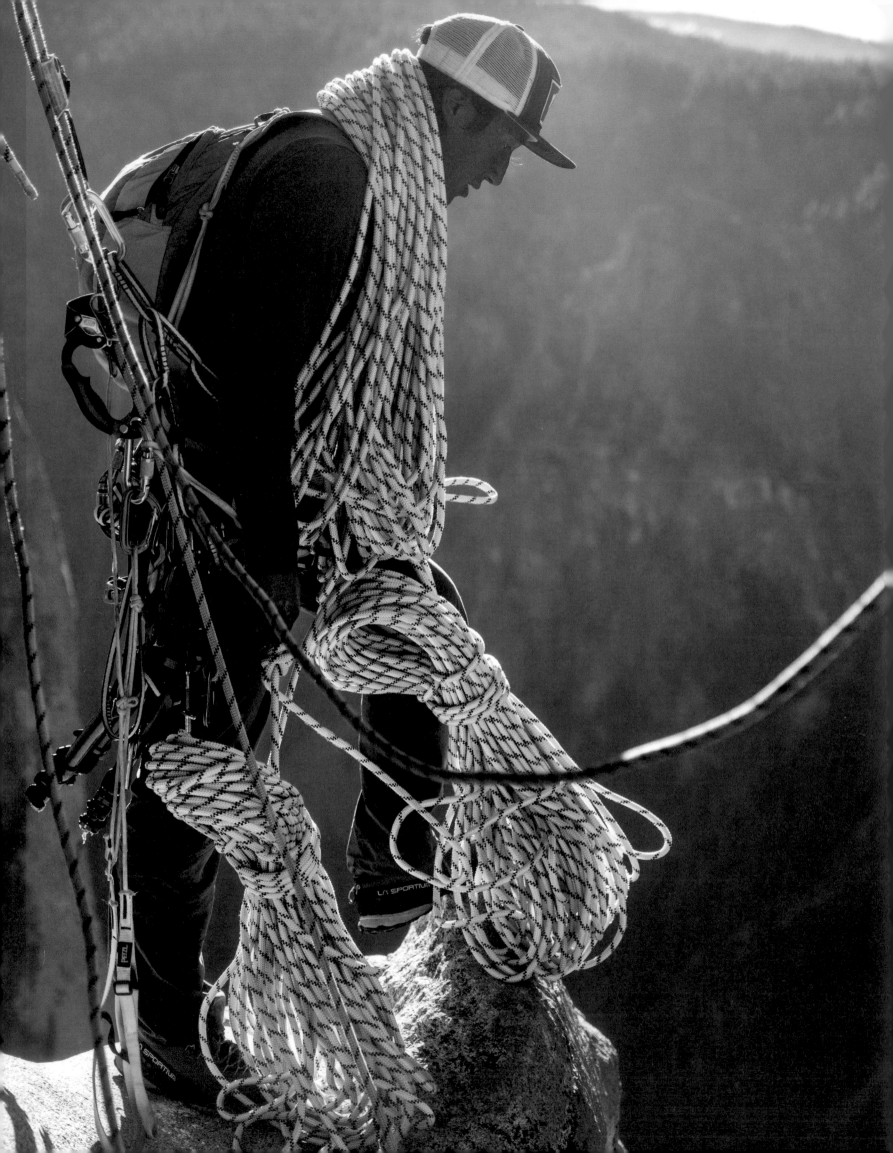

# Introduction

*My parents used to say, "Of course we're worried. There's no word in Chinese for what you do."*

As the kid of Chinese immigrants, I was told there were only three careers: doctor, lawyer, or professor. Climbing bum was not on that list. When I finished college, I was sure these traditional expectations didn't fit me, and I decided to make up my own way through the world.

I would spend my twenties drifting between climbing destinations and living out of a stubborn 1989 Subaru Loyale. It was not the graduate program my mom and dad had hoped for me.

Despite their strict view of careers, my parents, both librarians, had unwittingly set me on this path by introducing me to an endless supply of books. The great adventures I read about spurred my curiosity about the world beyond my Mankato, Minnesota, backyard. Thankfully, my parents also instilled in me the work ethic and confidence to strive for a life I didn't even know I wanted—the life I discovered on sweeping granite walls, desert towers, and knife-edge ridges.

These places stirred a sense of awe and self-reliance in me. I found the best version of myself where the world fell away below me and the rules of life were simple—commit and embrace the struggle. While climbing in Yosemite, I picked up a camera and began capturing the places that I fell in love with and the sublime moments that I experienced. Taking photographs became a way to examine these places and share these moments.

I believe photography can expand our perception of the natural world, and of what humans can achieve in it. Over time, I hoped that sharing the beauty of our planet and our place within it would foster a sense of responsibility to protect and preserve these places, both for future generations to enjoy and for their intrinsic value.

Along the way, I found a second family in the adventurers who seek out the world's wildest places and devote their lives to accomplishing what others have never dared. The members of this tribe became my most cherished friends, partners, and mentors. I've been astonished, again and again, at what these individuals are capable of doing with vision and clarity of purpose, from Kit DesLauriers skiing from the summit of Everest to Alex Honnold free soloing El Capitan and beyond.

Being a witness to grand successes and epic failures, I discovered my own purpose: to share the stories of the people I found so inspiring. Every person I've photographed has helped shape me into who I am today. For that I will be forever grateful. This book is a record of our shared adventures spanning twenty years, and a celebration of the places that brought us together.

1

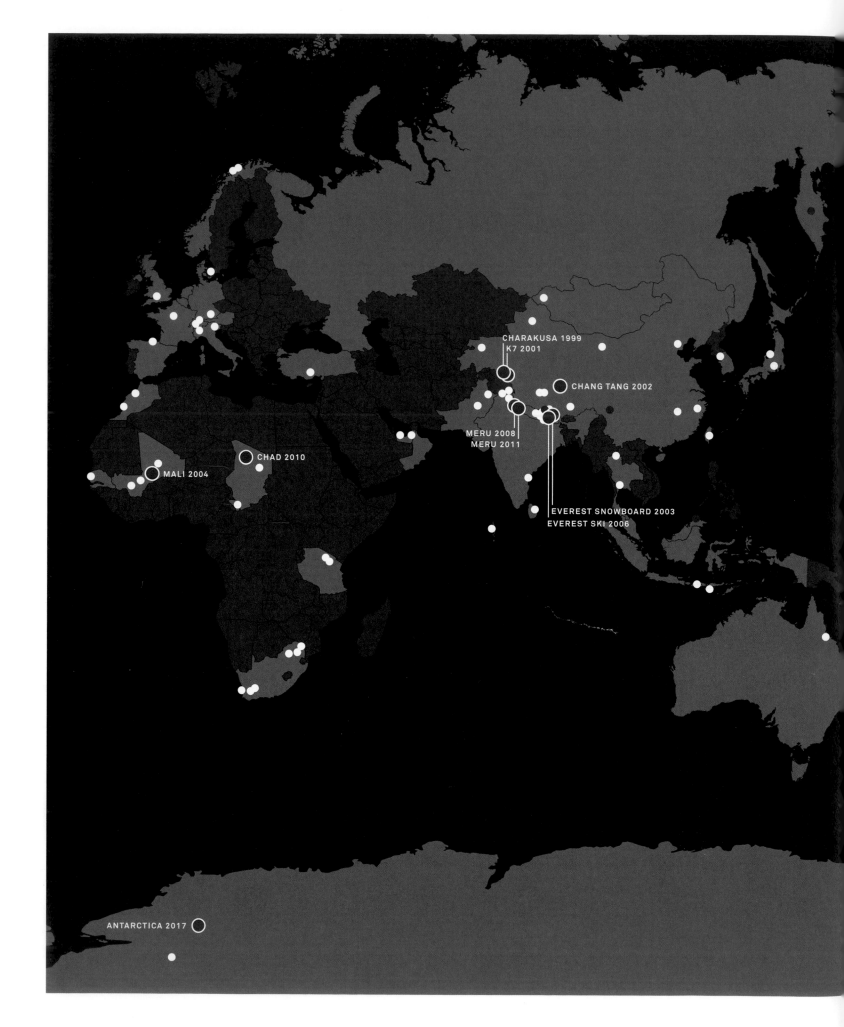

CHARAKUSA 1999
K7 2001

CHANG TANG 2002

MERU 2008
MERU 2011

EVEREST SNOWBOARD 2003
EVEREST SKI 2006

CHAD 2010

MALI 2004

ANTARCTICA 2017

2

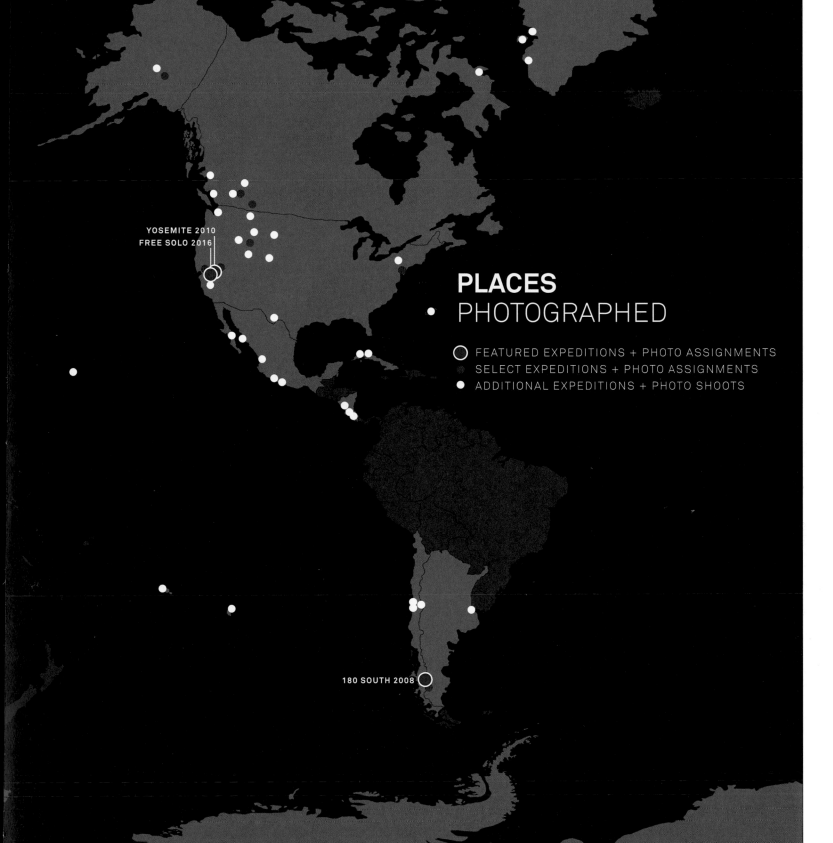

YOSEMITE 2010
FREE SOLO 2016

# PLACES
## PHOTOGRAPHED

○ FEATURED EXPEDITIONS + PHOTO ASSIGNMENTS
   SELECT EXPEDITIONS + PHOTO ASSIGNMENTS
● ADDITIONAL EXPEDITIONS + PHOTO SHOOTS

180 SOUTH 2008 ○

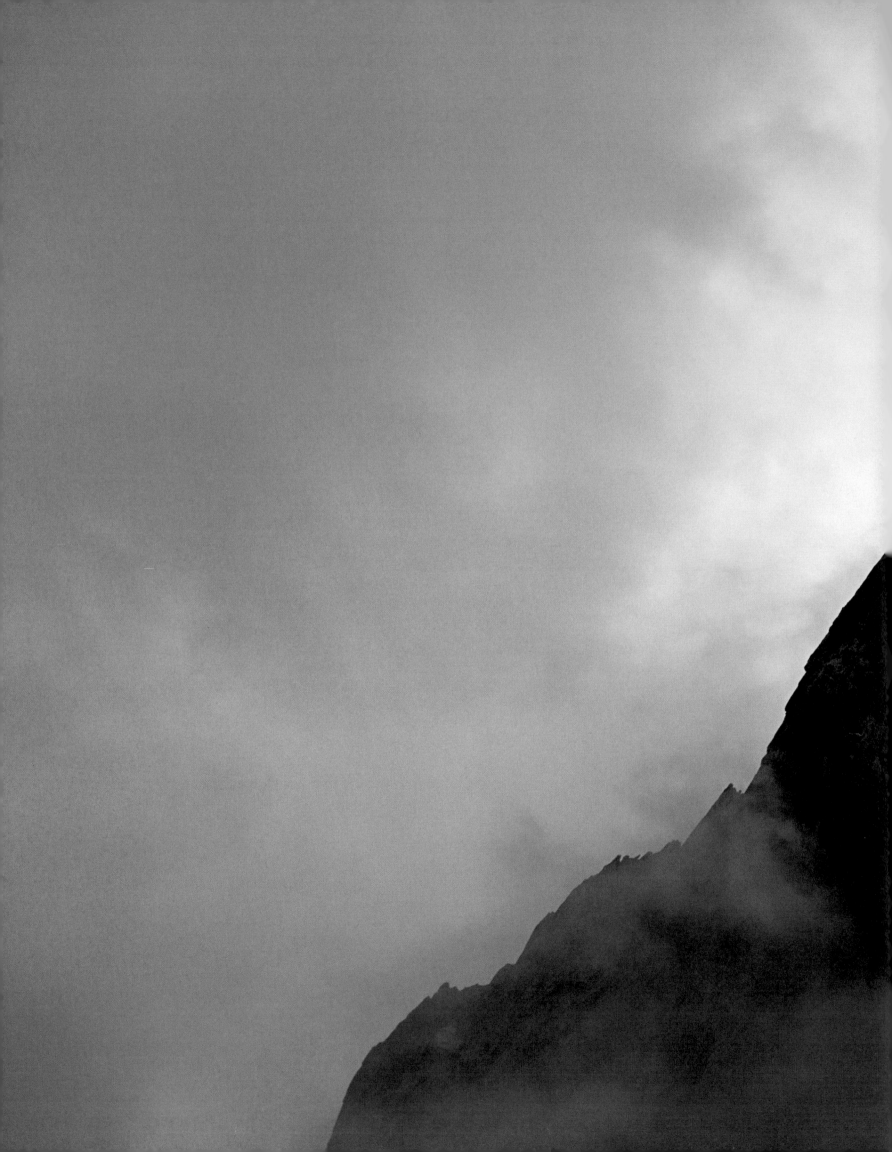

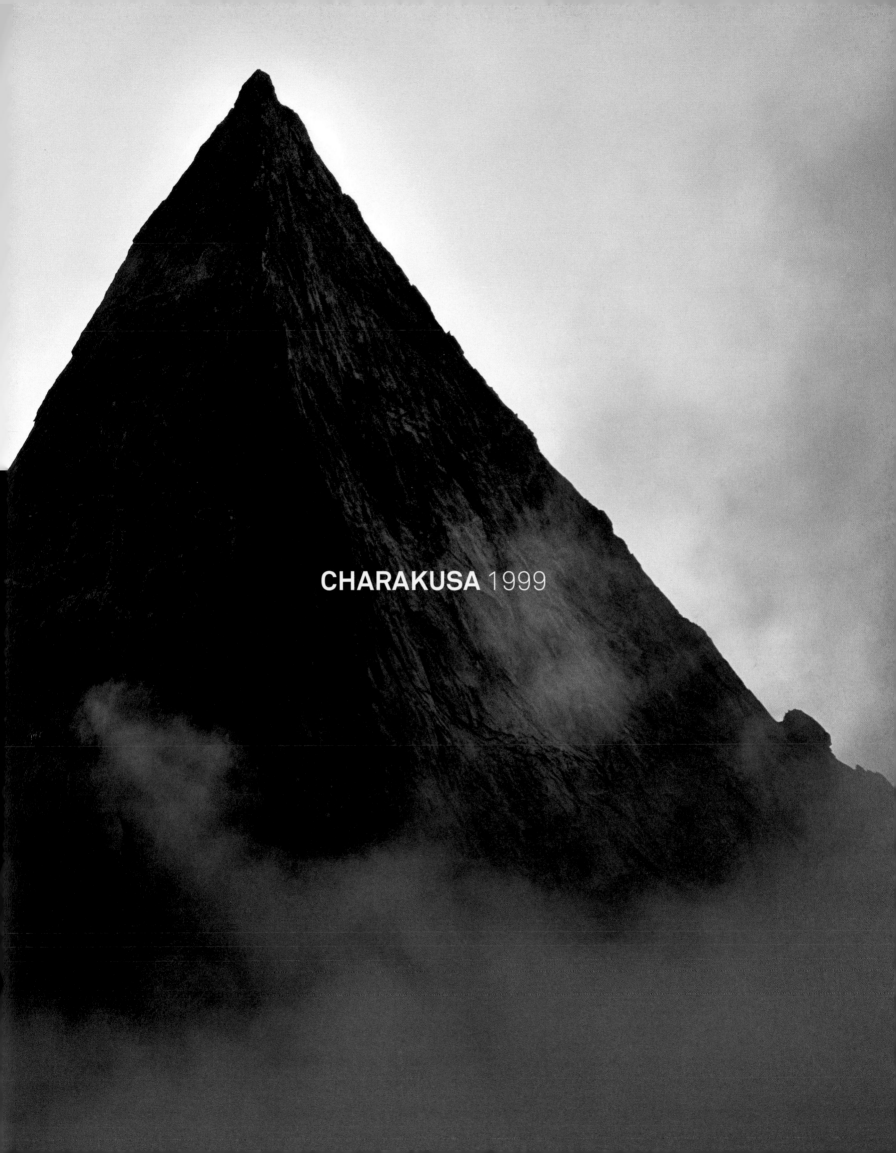

CHARAKUSA 1999

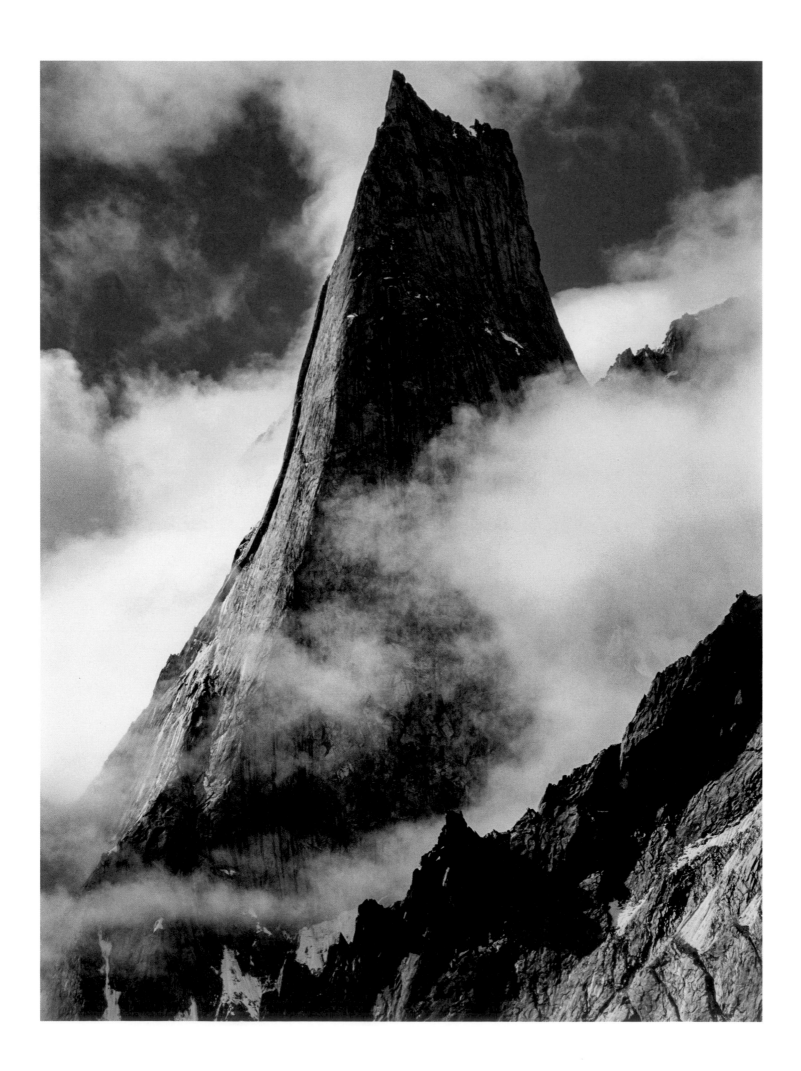

# You only get to experience your first expedition once.

The unknowns seem greater. The stakes feel higher. The dread, more acute, and the awe, more profound. Traveling to the Charakusa Valley of Pakistan in the summer of 1999 was a turning point for me. It led me away from pursuing any sensible career and toward a life spent scaling big mountains instead.

I'd first seen photos of the Charakusa Valley in a climbing magazine. Legendary climber and photographer Galen Rowell had captured stunning images of revered climbers Conrad Anker and Peter Croft making first ascents in the Karakoram range. The images made up my mind; real climbers climbed in the Karakoram Mountains. And I wanted to be a real climber.

I didn't know the first thing about organizing an expedition to Pakistan, so I steered my car—my residence at the time—toward Berkeley, California, to ask Galen myself. After a night sleeping in the parking lot, I walked into the office of the Mountain Light Gallery, looking and smelling like the dirtbag climber I was, and asked a skeptical receptionist if I could see Galen. I was told that he was busy, but that I could wait in the lobby. For five days in a row, I sat patiently until the gallery closed each evening. Galen finally emerged late on a Friday afternoon and said, "You must be Jimmy . . ."

He ushered me into his office, and for two hours, he shared images and stories from his trip to the Charakusa Valley, explained the logistics of getting there, and gave me his main contact in Pakistan. He then walked me through a room full of prints laid out on tables for him to sign. In between signatures, he explained how he'd gotten each shot. Before I left, he handed me a slide, still precious to me, that showed two giant granite towers. "There's your objectives," he said. "Make sure you bring a camera."

As I walked into the Charakusa Valley months later, I was struck dumb by the sight of Fathi Tower and Parhat Tower, two granite sentries standing guard. Imagining climbing either filled me with fear. I took out my newly bought camera and snapped a photo.

My climbing partner Brady Robinson and I threw ourselves at Fathi Tower, but were thwarted twice by its size, steepness, and complexity. Waking at 2 a.m. for our third attempt, Brady muttered, "This is the last thing I want to do in the entire world." I felt the same. I doubted this was how real climbers were supposed to feel.

We tried one more time, drawing from skills learned on previous ascents in Yosemite and the High Sierra, and sometimes resorting to techniques we'd only read about in climbing magazines. As we passed our previous high points, we gained momentum, climbing pitch after pitch. This time, we prevailed. The peak was so sharp we had to take turns perching on the summit for pictures.

Our friends Jed and Doug Workman and Evan Howe joined us later in the trip and we climbed two more new routes in the valley. Wandering up oceans of rock previously untouched by humans changed us forever. We left the valley feeling like real climbers. I didn't know it at the time, but I would devote the next two decades to traveling the world in pursuit of the same sense of fear and awe that gripped me when I first stepped foot in that spectacular valley.

**PREVIOUS**  Naysar Peak, Charakusa Valley, Pakistan.

**OPPOSITE**  Fathi Tower. Our new route followed the dihedral on the left skyline.

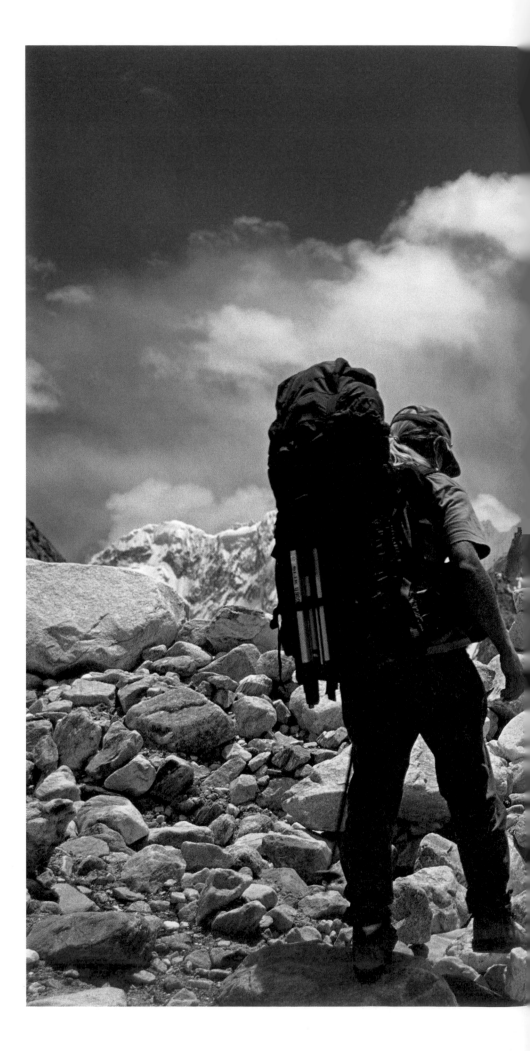

**RIGHT** Brady Robinson and our sirdar, Ibrahim, entering the Charakusa Valley.

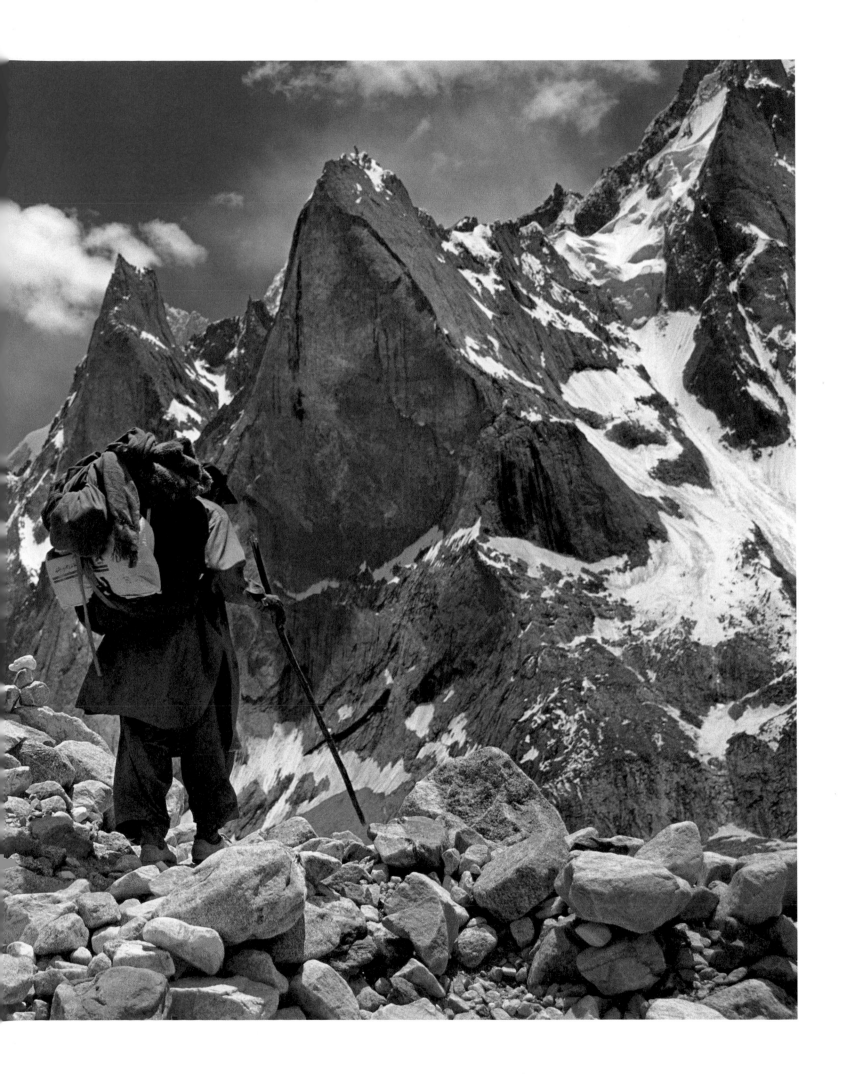

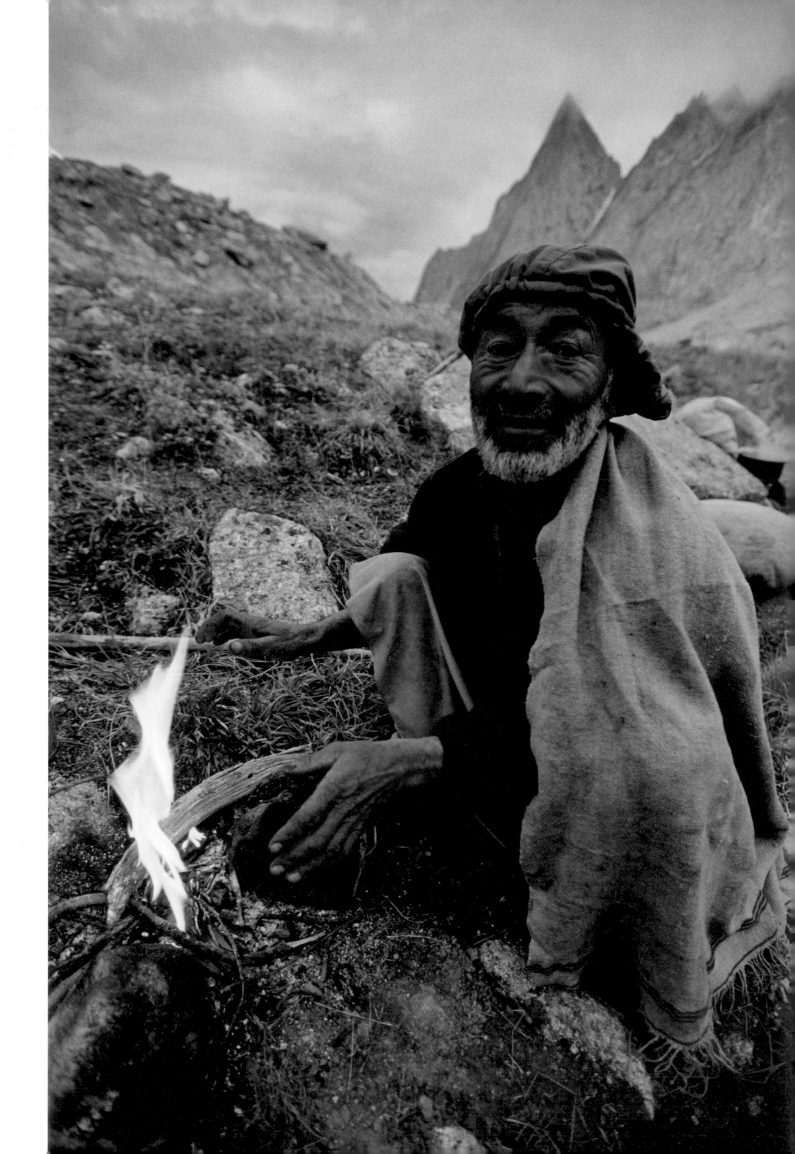

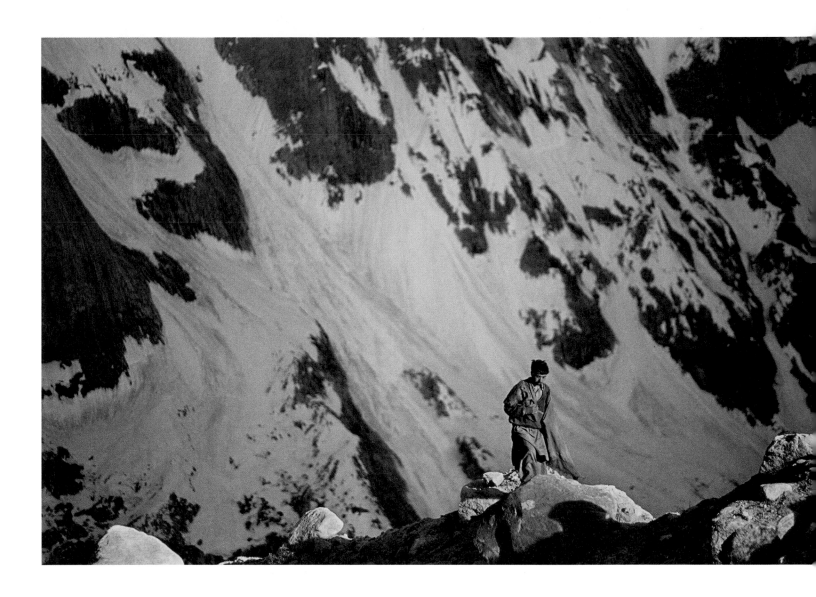

**OPPOSITE** A Balti porter brewing tea in the morning during our approach into the Charakusa Valley.

**ABOVE** A Balti porter returning to camp at sunset.

**FOLLOWING** Our base camp in the Charakusa Valley. My first attempt at night photography.

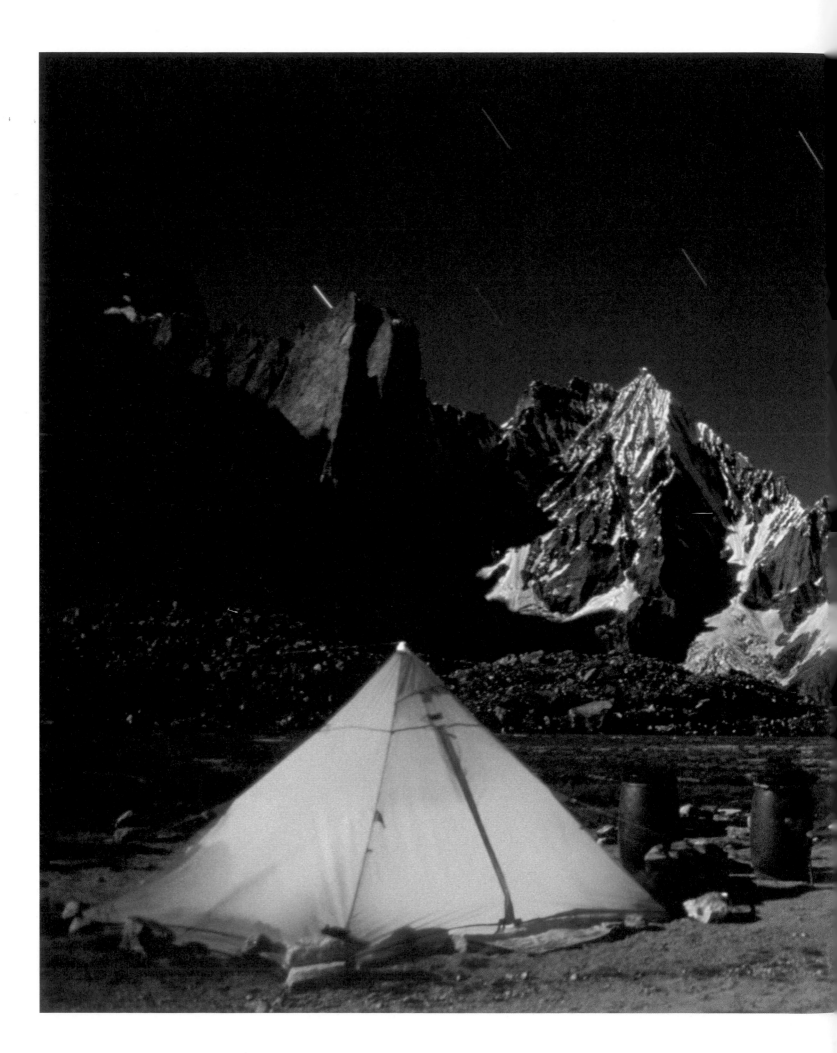

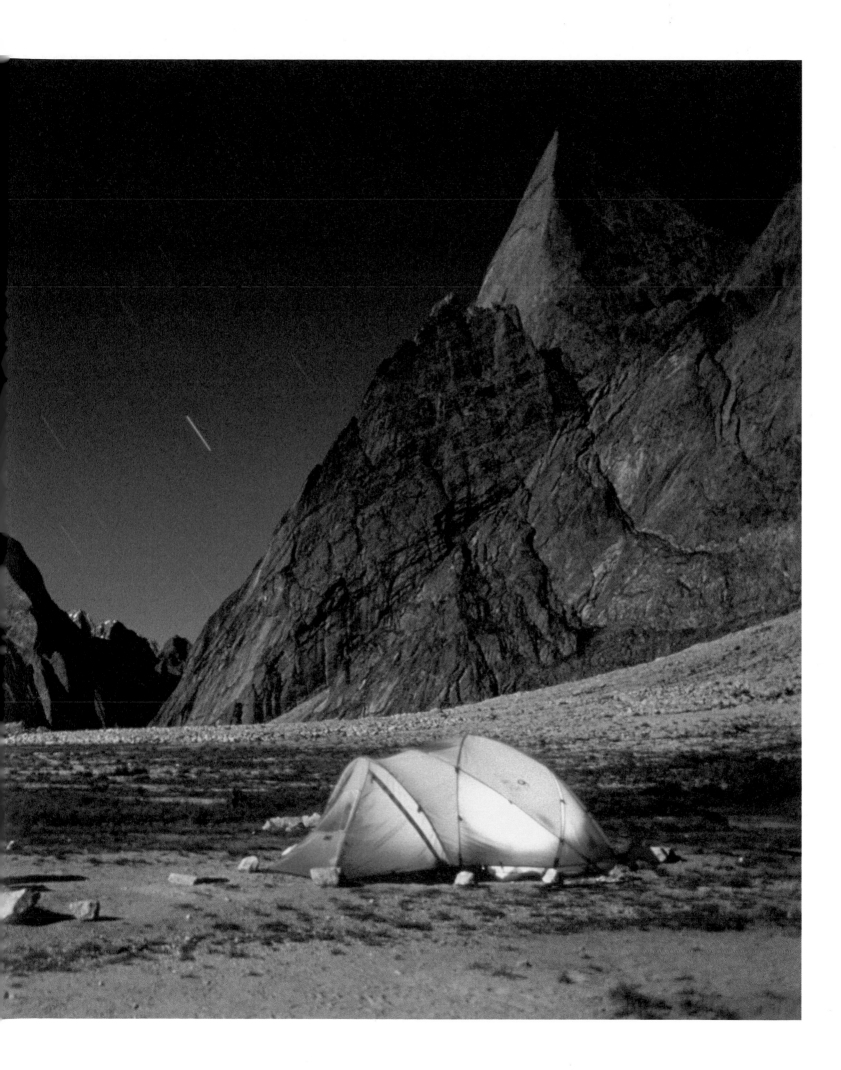

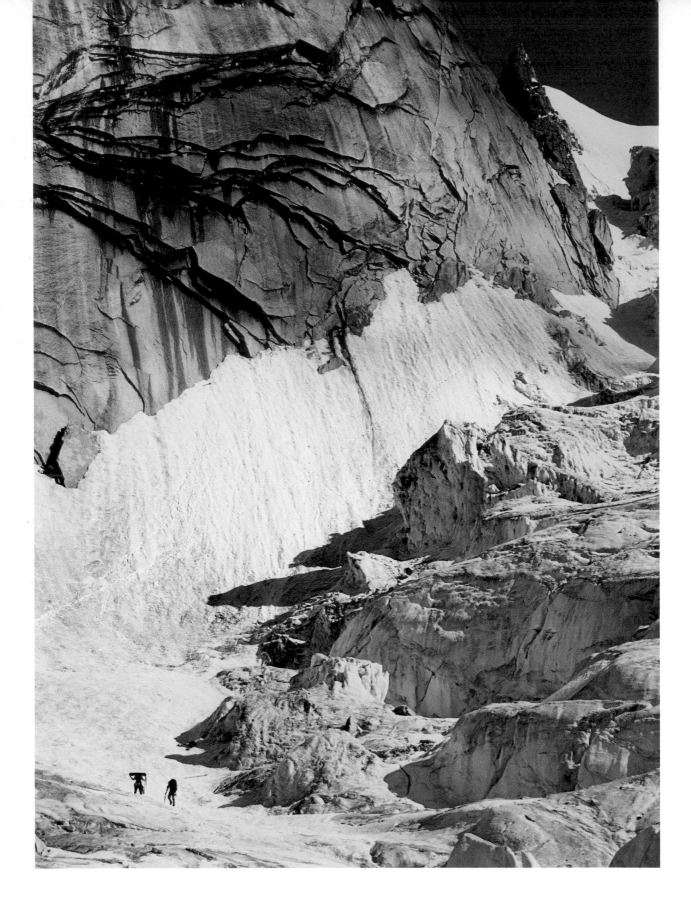

**ABOVE** Evan Howe and Doug Workman navigating the icefall while carrying loads to the base of Beatrice Tower.

**OPPOSITE** Evan ascending fixed lines above our portaledge camp. Beatrice Tower.

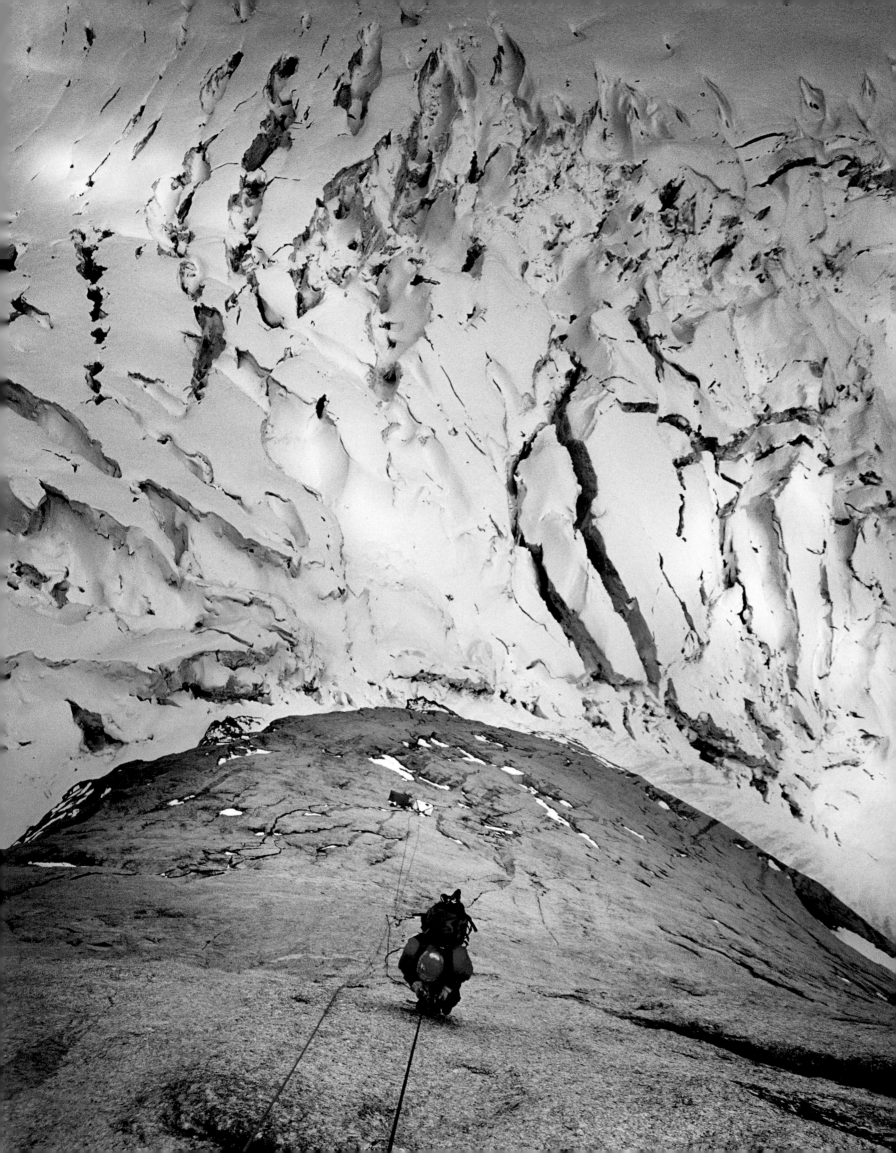

16

**RIGHT**  Doug Workman peering out of our portaledge camp on Beatrice Tower. A storm had trapped us on the wall the night before. With the warming of the day, sheets of ice and snow that the storm had pasted on the wall above began crashing down on us. The impacts bounced us around inside our hanging tents. With nowhere to escape, we sat with our backs against the wall hoping the falling debris wouldn't floss us off the face.

**FOLLOWING**  Fathi Tower (left) and Parhat Tower (right) were our main climbing objectives for the expedition. Charakusa Valley, Karakoram, Pakistan.

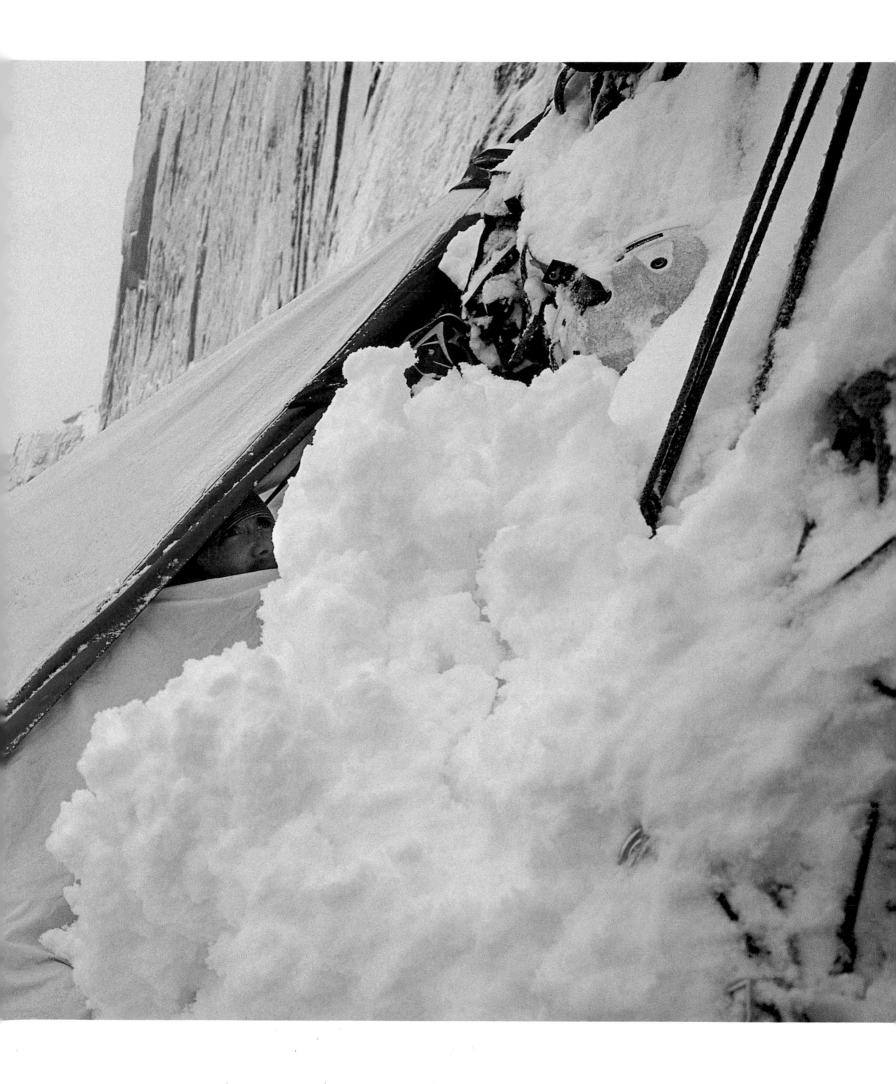

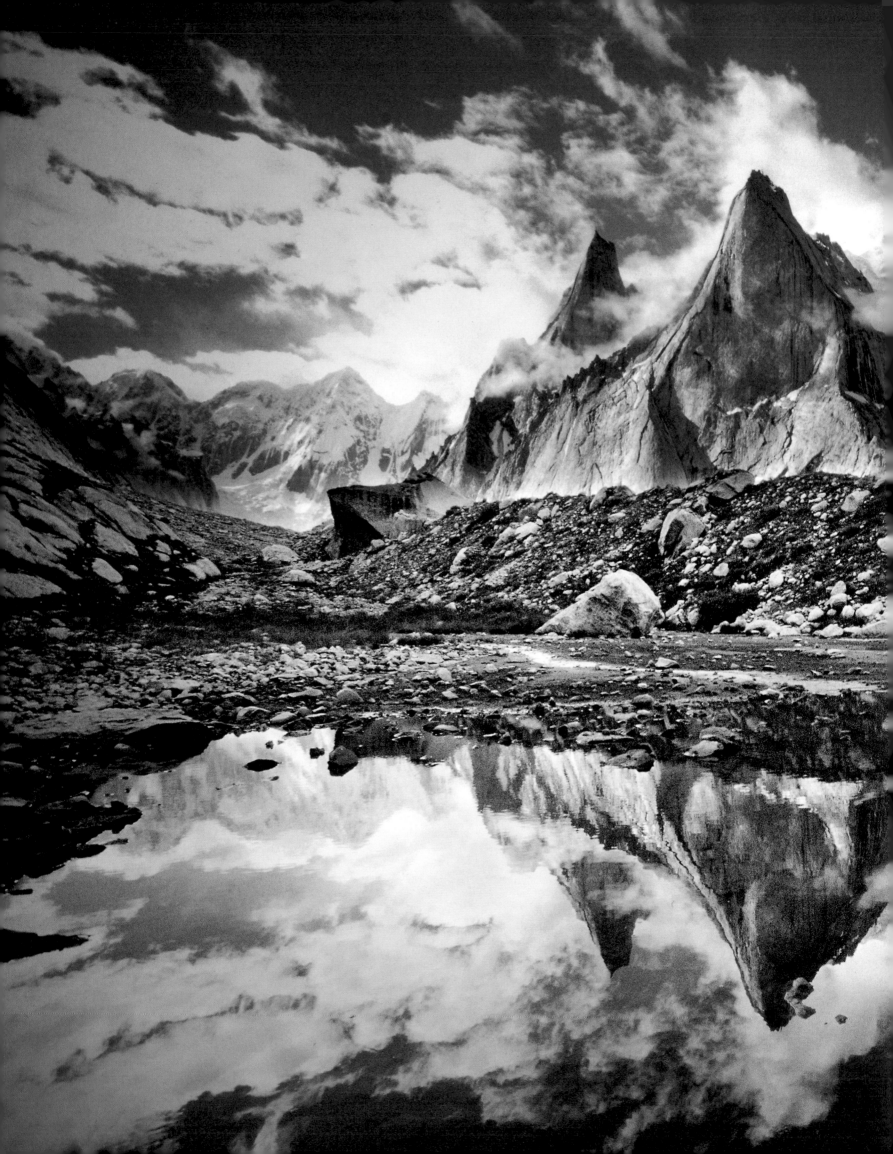

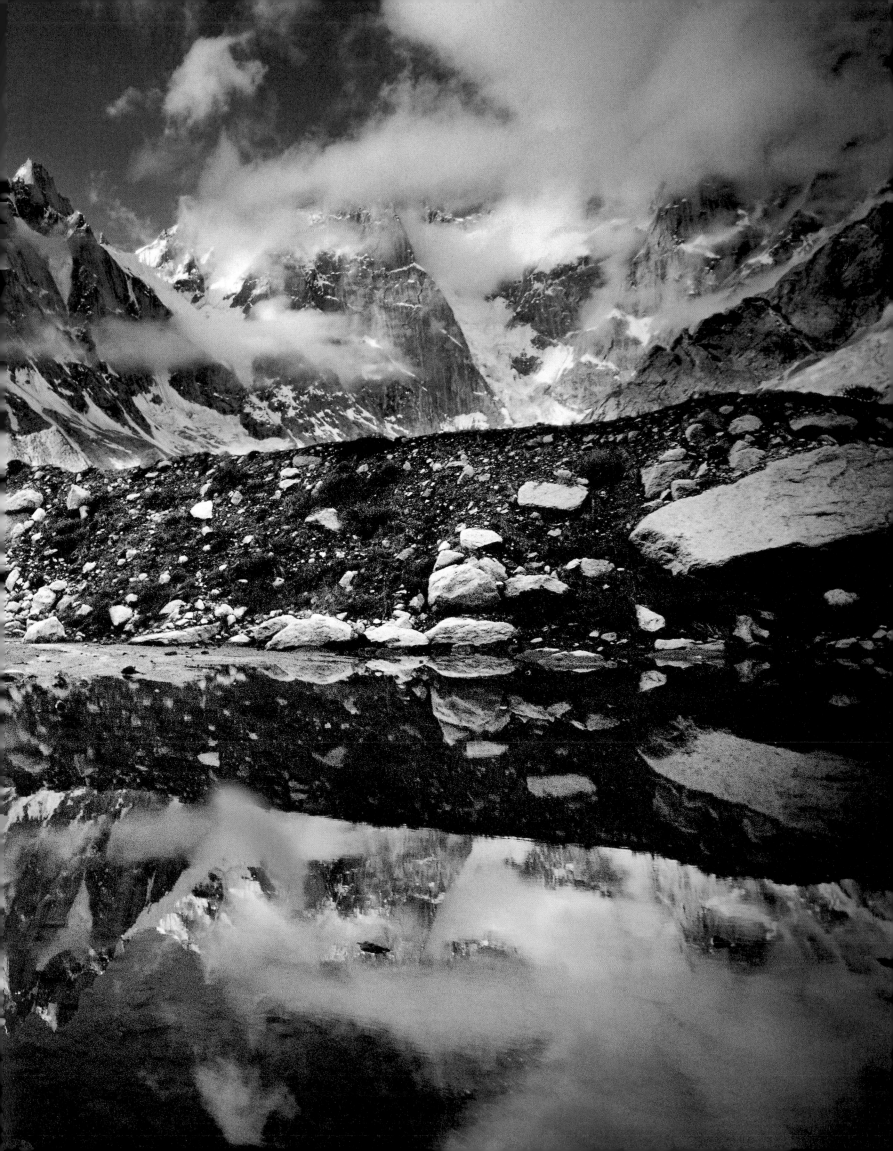

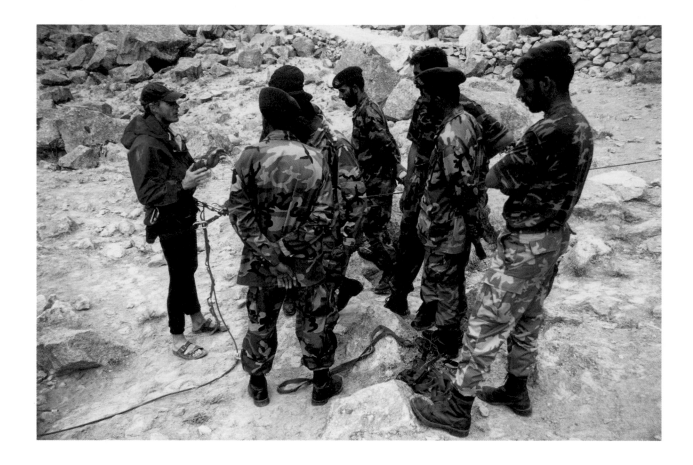

## FORBIDDEN TOWERS EXPEDITION

Upon returning from my first trip to Pakistan, I began poring over a map of the Karakoram and wondered what lay in the Kondus Valley. Little was known about the valley, except that it was part of the militarized buffer zone adjacent to the disputed Kashmir region. Home to the highest active war in the world, it had been closed to foreigners for almost twenty years.

I had only been able to find one photo of the valley. It showed a dense array of granite towers. I applied for a special permit to climb there, and in April 2000, the Pakistani government did the unexpected and granted me permission. In June, without much information about the area, except that nothing in the valley had been climbed, Brady Robinson, Dave Anderson, Steph Davis, and I started up the Karakoram Highway toward the mountains.

On our way, we learned our permit would be useless in the militarized zone. Our friend and fixer Nazir Sabir contacted his friend Brigadier General Muhammad Tahir of the Northern Pakistani Army. General Tahir not only granted us permission to continue to the Kondus, but he secured us a special forces team to escort us there.

Our objective became clear when we arrived: a three-thousand-foot unclimbed granite spike that towered over the entrance of the valley. Before we started climbing, we spent a few days getting to know our special forces team, sharing high-angle rescue skills with them while they showed us how to shoot their AK-47s. We eventually established a thirty-five-pitch route after sixteen days of climbing and topped out on a summit the size of two pool tables. We called the route "All Quiet on the Eastern Front" for the thumping of artillery we heard every night from our portaledge camp. We named the tower "Tahir Tower" after our new friend, General Tahir.

**ABOVE**  Brady Robinson teaching high-angle rescue techniques to our Pakistani Special Forces escorts.

**OPPOSITE**  Steph Davis leading the crux free-climbing pitch on Tahir Tower, Karakoram, Pakistan.

**FOLLOWING**  Brady taking in the view on the summit of Tahir Tower, Karakoram, Pakistan.

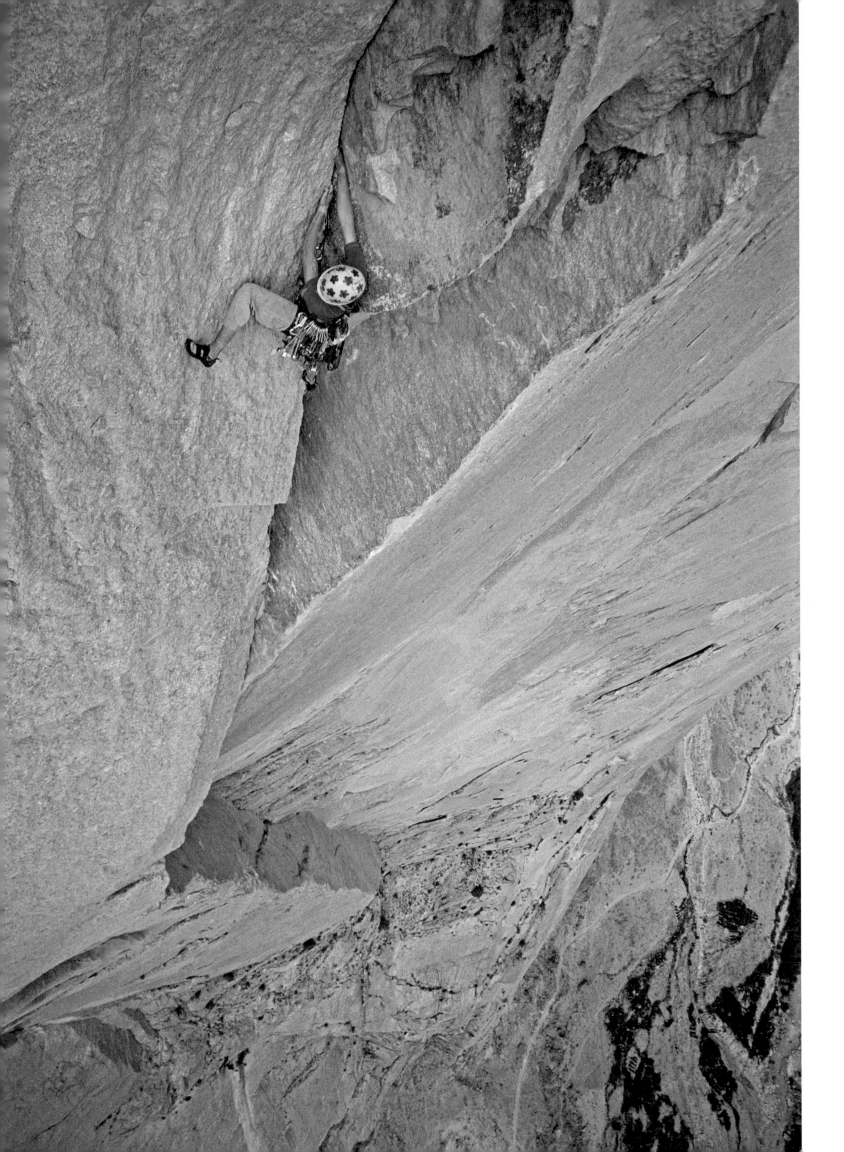

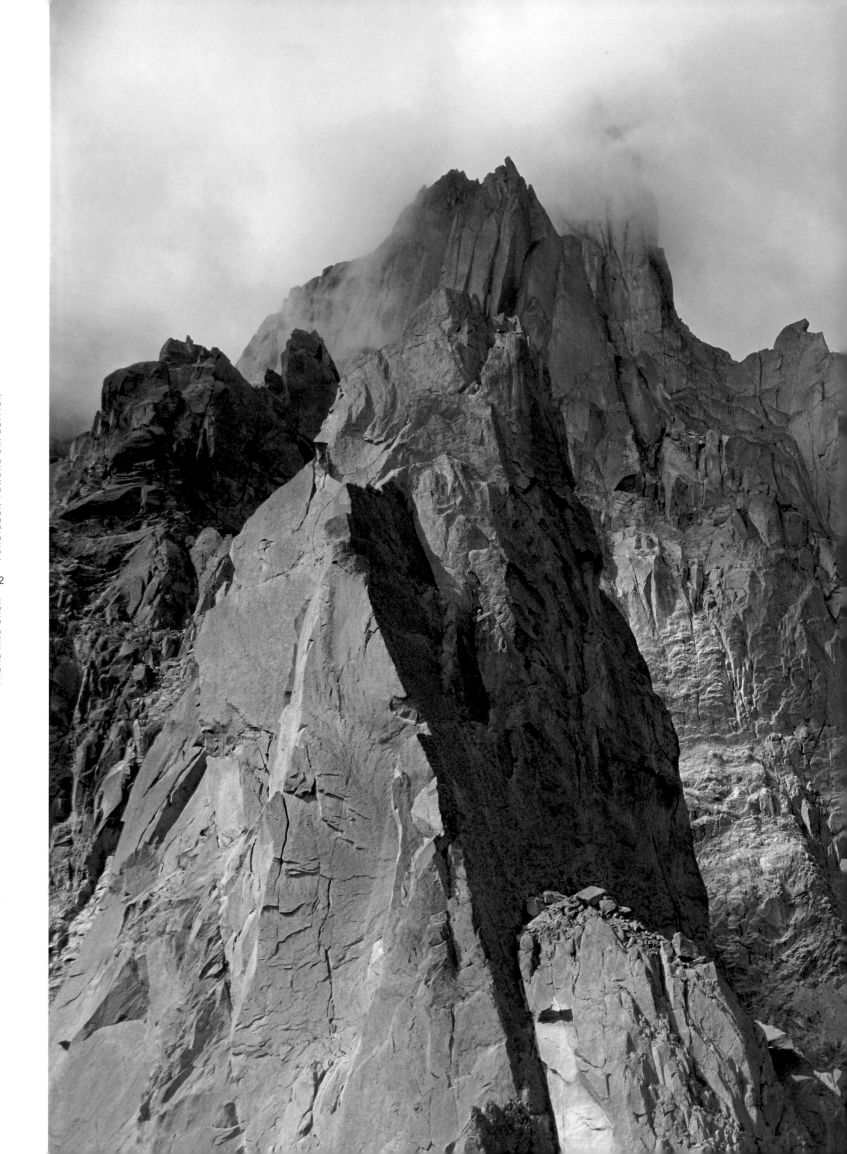

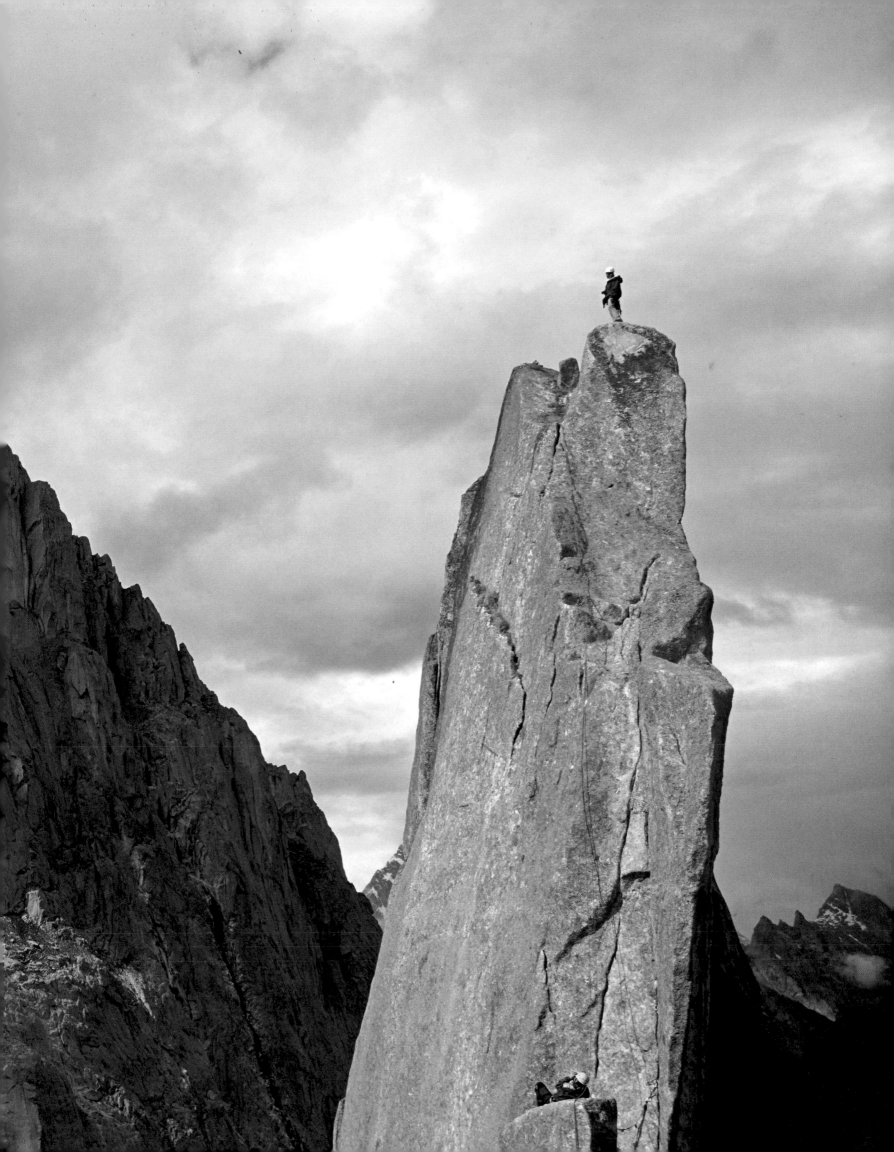

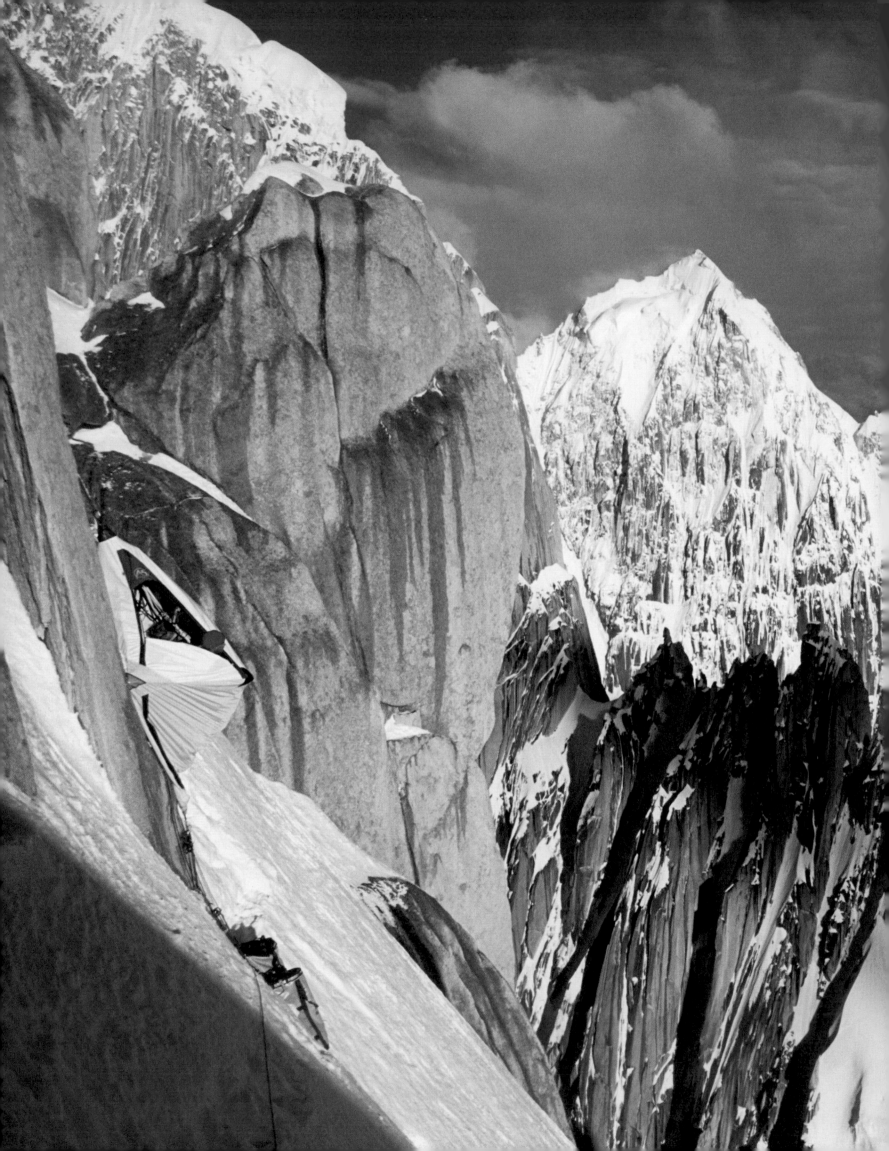

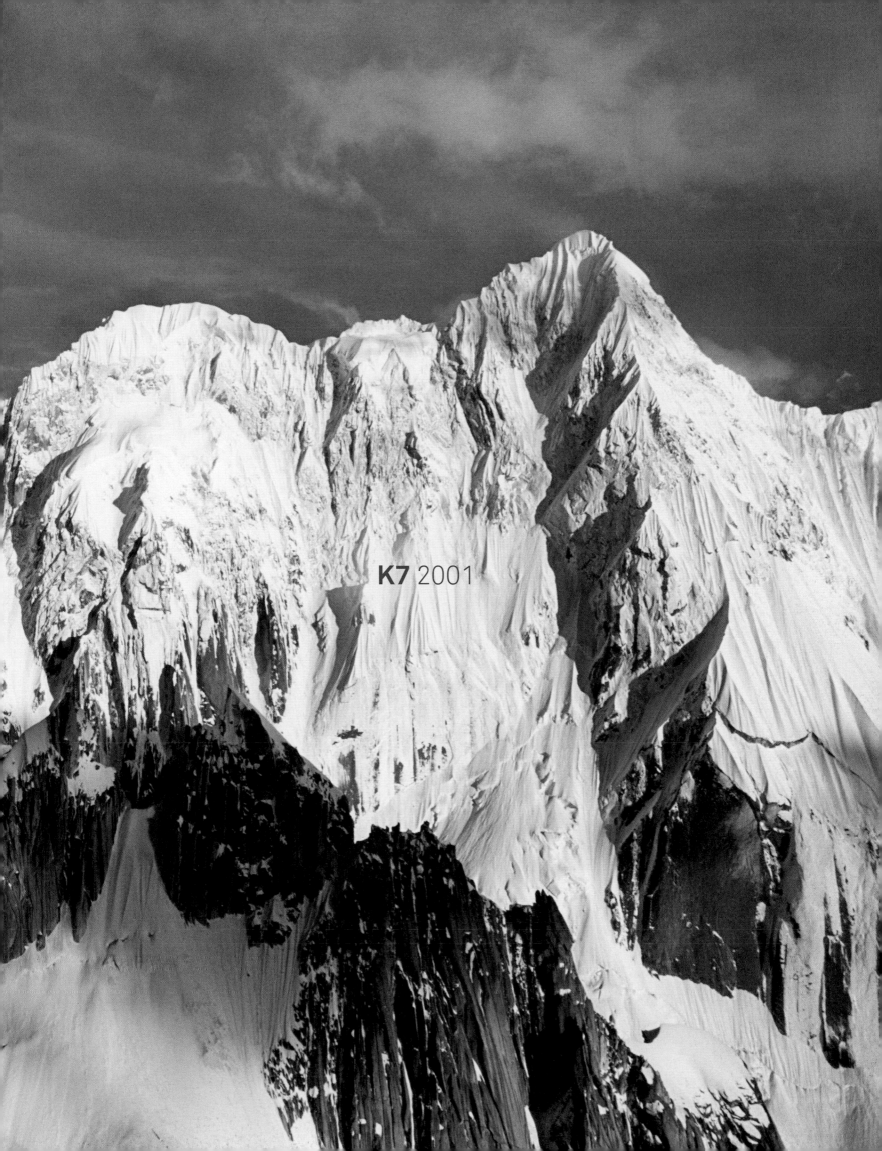

K7 2001

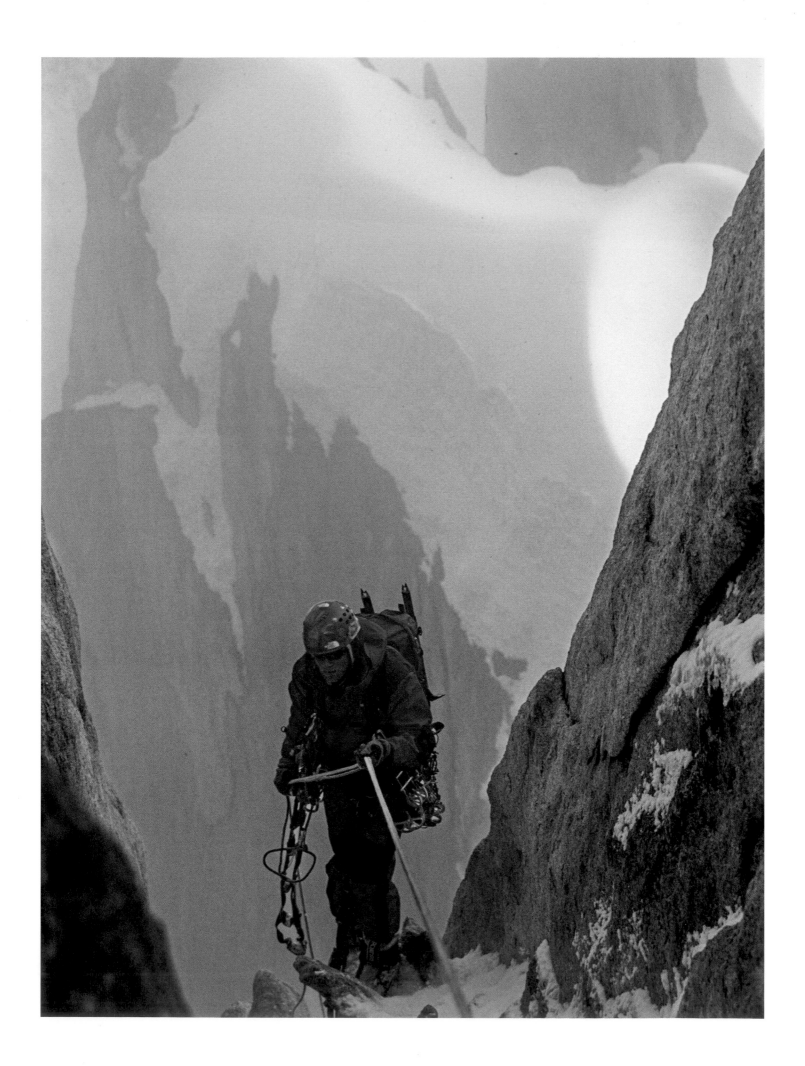

# Most people have never heard of K7, but it's a magnificent mountain.

Rising to 22,749ft, it brings to mind an alpine fortress. Seeing K7 during our first expedition to the Charakusa Valley in 1999, Brady Robinson and I vowed to come back to climb it. In July of 2001, we returned to the Karakoram with Conrad Anker to attempt the southeast face.

I first met Conrad in the summer of 2000. I'd already read plenty about him—he was a celebrated climber at the pinnacle of his career: he had made significant first ascents around the world, graced the cover of *National Geographic*, and recently found the body of George Mallory on Mount Everest. To me, he was superhuman, so I was surprised when he asked to join Brady and me on K7. I worried whether I could meet his expectations.

During our first week in base camp, Brady and I noticed that Conrad always got up before us. We didn't want to seem lazy, so we started getting up earlier and earlier every morning. But each day, Conrad was making coffee or organizing gear by the time we were out of our tents.

The night before attempting K7, the three of us agreed to wake up at 3 a.m. Brady and I secretly decided to wake up at 2 a.m. to get ready before Conrad. That morning, Brady and I woke early, quietly gathered our gear, and exited our tent in the dark. As we rushed to load our packs, a headlamp clicked on nearby. I looked over to see Conrad leaning casually against a rock with his pack shouldered and ready to go. I shook my head in awe and disbelief.

We started up K7 on June 10. It was a pleasure to watch Conrad practice his craft. He climbed boldly and steadily in difficult terrain, anticipating problems before they arose. Drawing on decades of refinement, he was decisive about how we should approach the climb, what gear to bring, which risks we should and shouldn't take. He gave Brady and me confidence, and we tried hard to impress him.

On our third day on the wall, a storm hit. We burrowed into our small portaledge for five days. Retreat was impossible due to the large amount of new snow and the resulting avalanches that swept down around us. Our situation felt dire. But Conrad seemed unperturbed, as if this were exactly where he wanted to be—removed from the small distractions of everyday life and focused only on the simple task of survival.

When the storm cleared, we continued the climb for two more days, struggling up snow- and ice-covered rock. Our rations were dangerously low. When another storm arrived, we finally decided to retreat, only to be trapped again by more avalanches. After a harrowing five-day descent to the glacier, we dragged our giant haul bags back toward base camp. Brady and I collapsed in exhaustion more than once while Conrad stomped ahead, unfazed.

By the time we got back to our base camp, we had been on the mountain for sixteen days. Because we'd only taken enough food for ten, I weighed fifteen pounds less than when I started the climb. This was the first time I would nearly starve on one of Conrad's expeditions. But it wasn't the last.

**PREVIOUS** Conrad Anker and Brady Robinson enjoying the sun from our portaledge high camp after a five-day storm on K7. Charakusa Valley, Pakistan.

**OPPOSITE** Conrad retreating off K7 after the second storm.

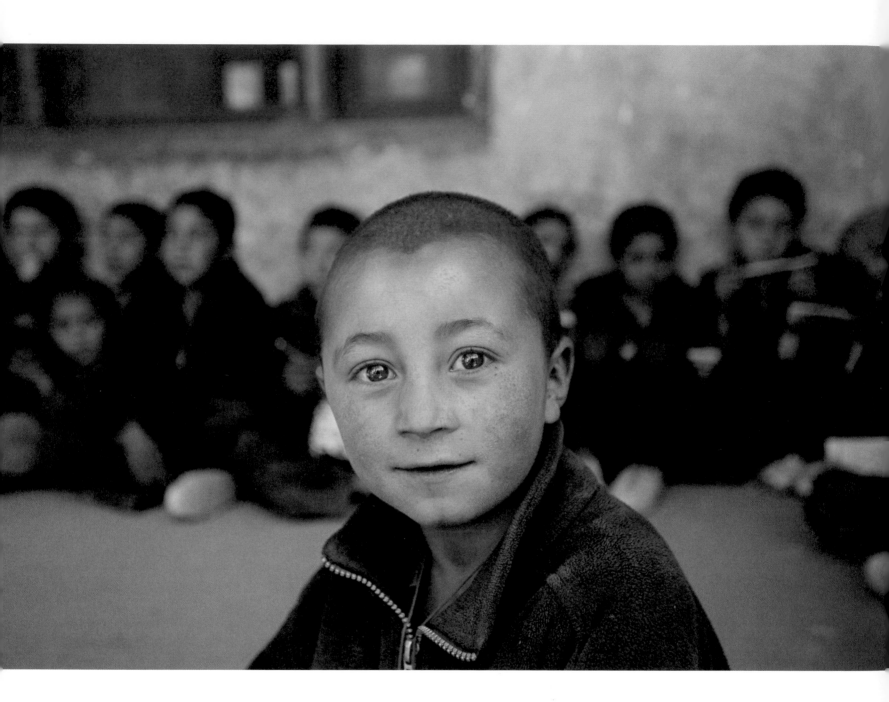

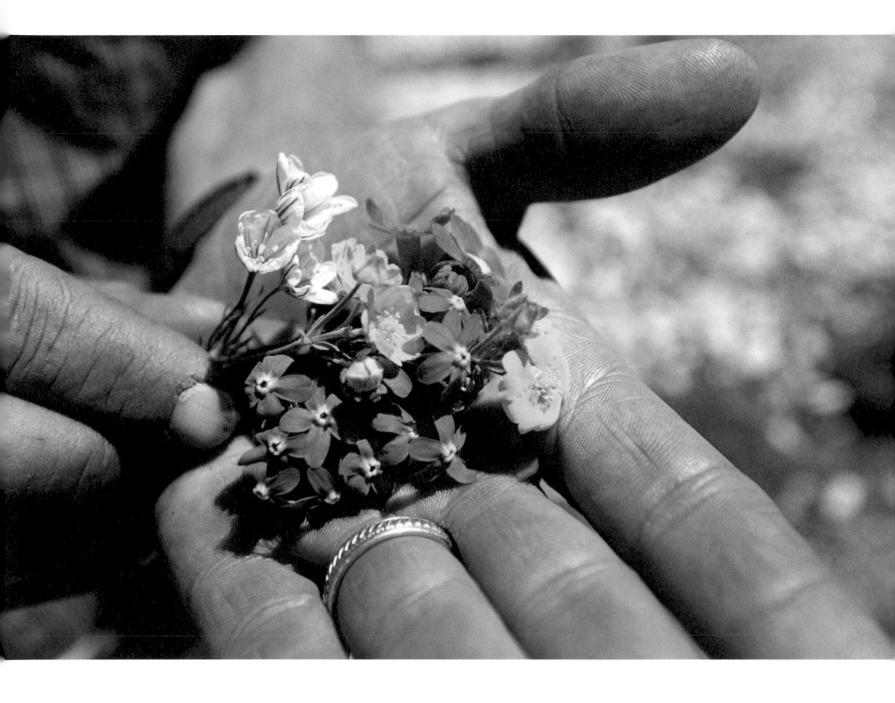

**OPPOSITE** Balti schoolboy. Hushe Valley, Karakoram, Pakistan.

**ABOVE** Conrad Anker's new wedding band and flowers he'd picked to press and bring home to Jenni Lowe-Anker.

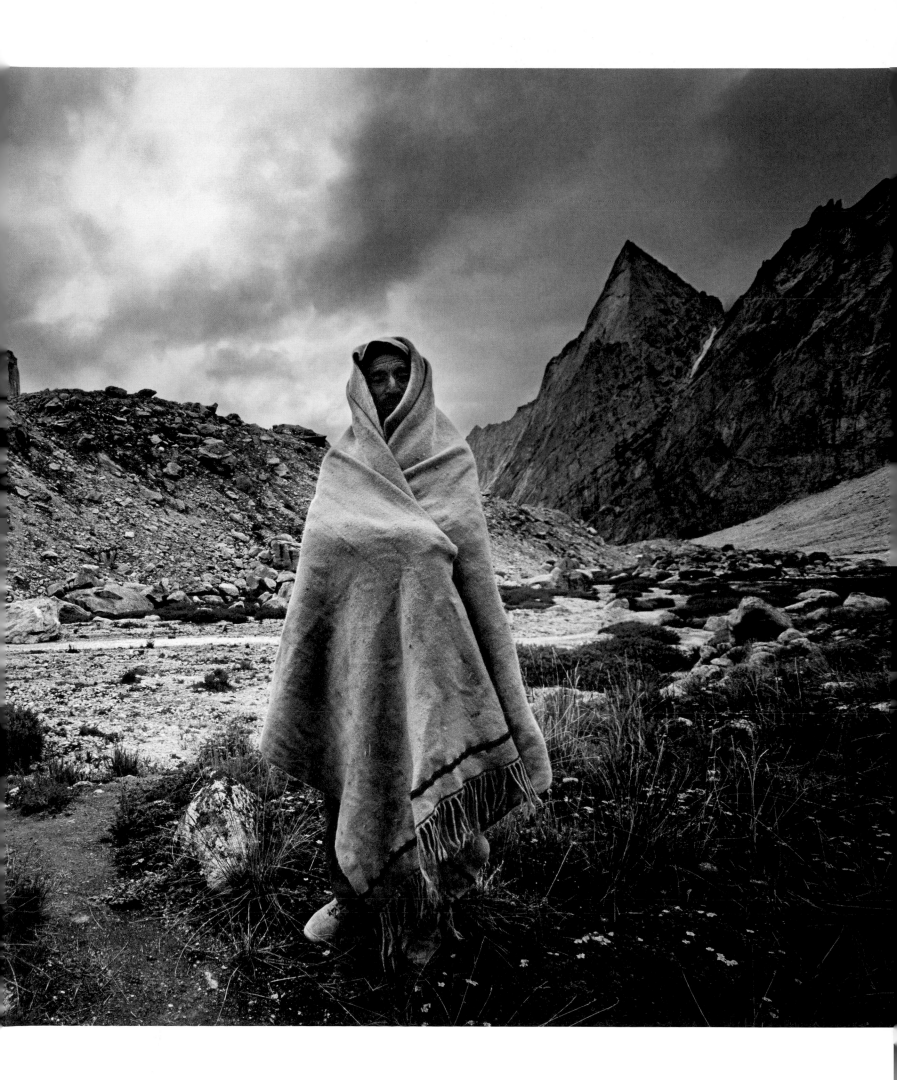

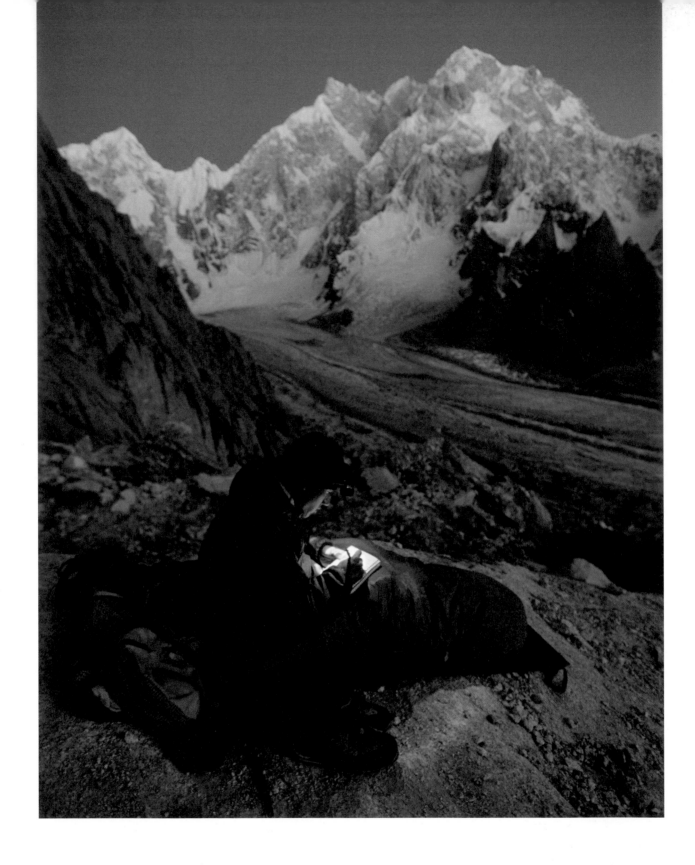

**ABOVE** Self-portrait at a small bivy ledge with the north face of K6 in the background.

**OPPOSITE** Conrad Anker climbing with a 70lb haul bag.

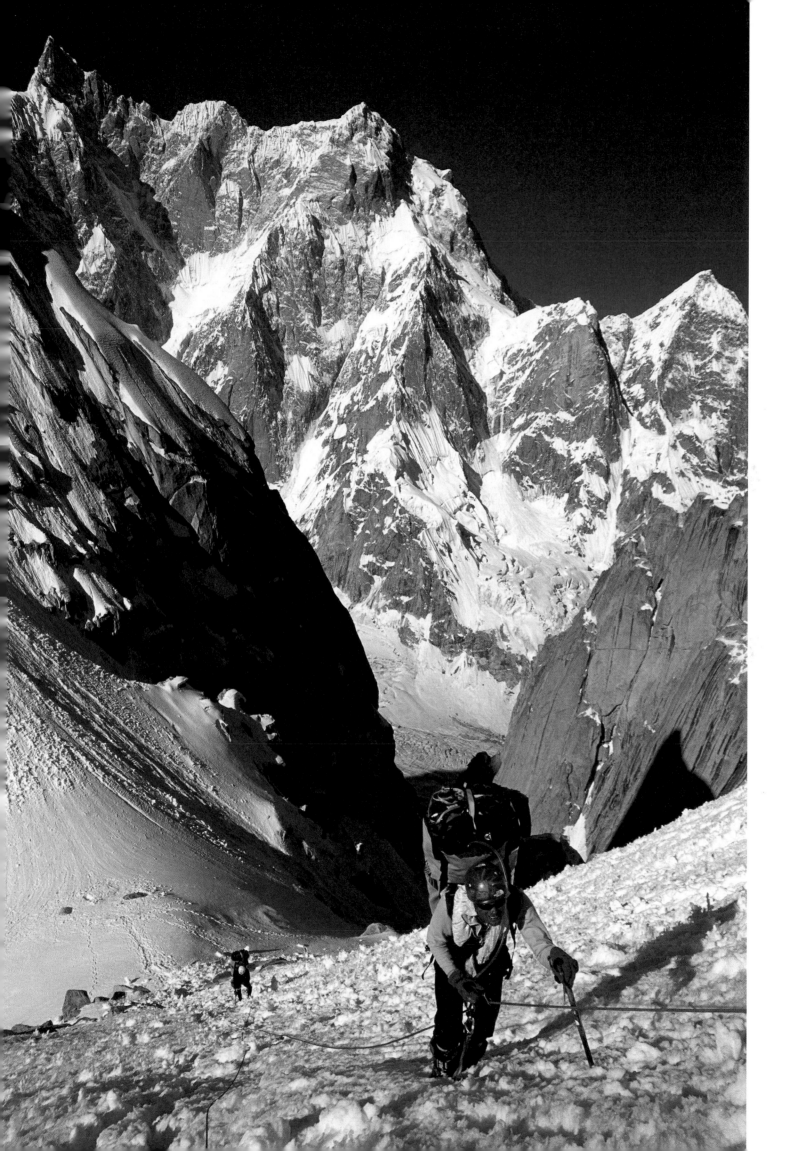

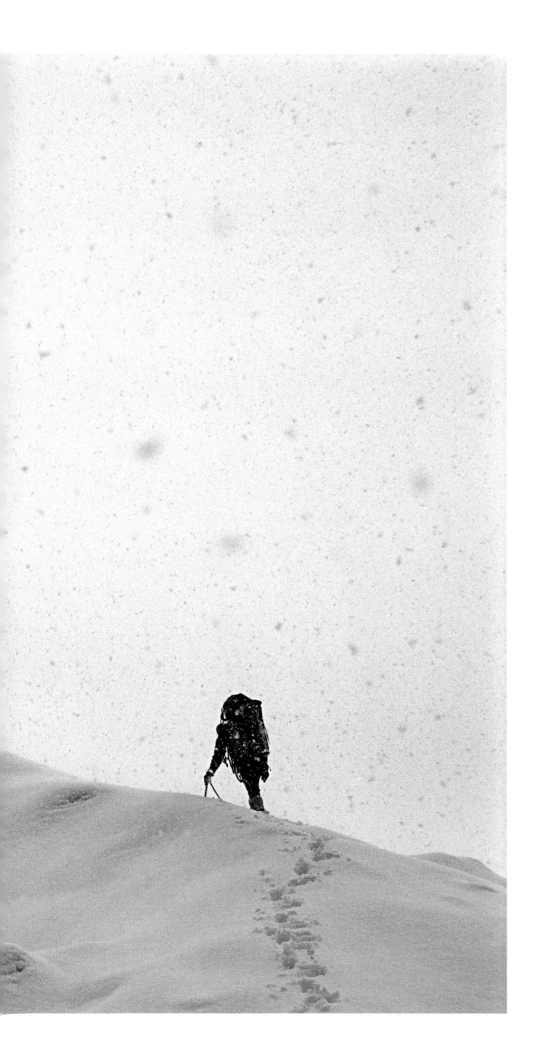

**LEFT** Conrad Anker carrying loads through the icefall toward our first camp on K7.

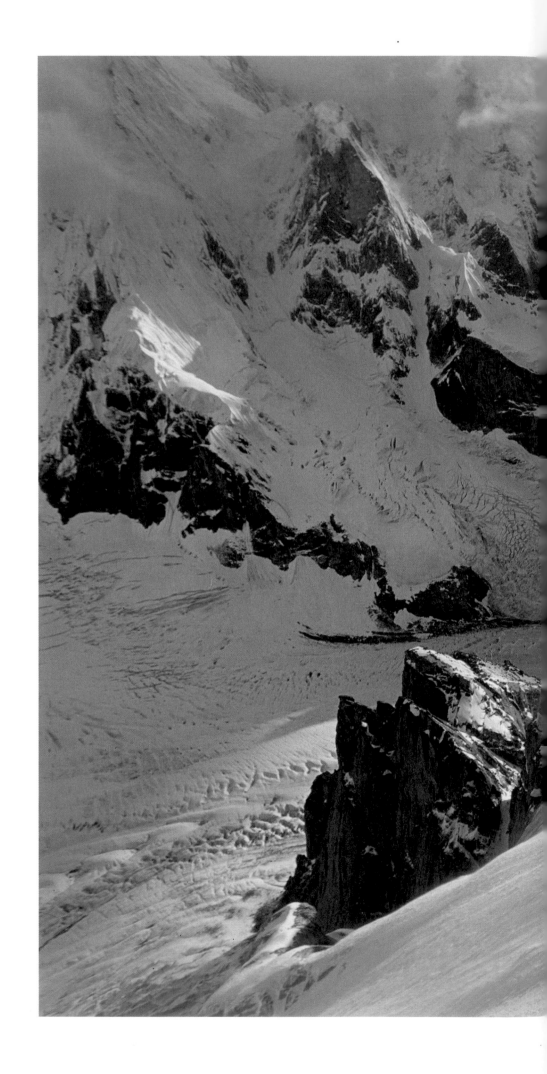

**RIGHT** Conrad Anker moves into our highest portaledge camp on K7. A storm would pin us there for the next five days.

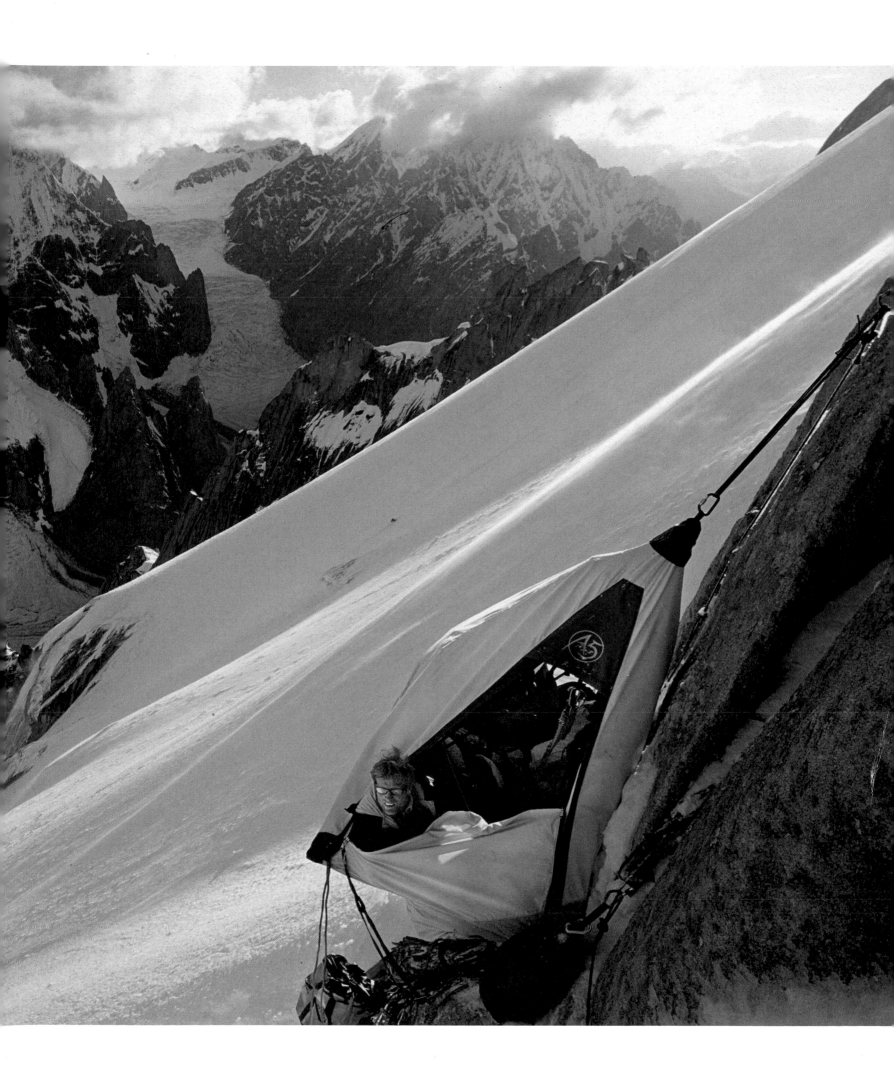

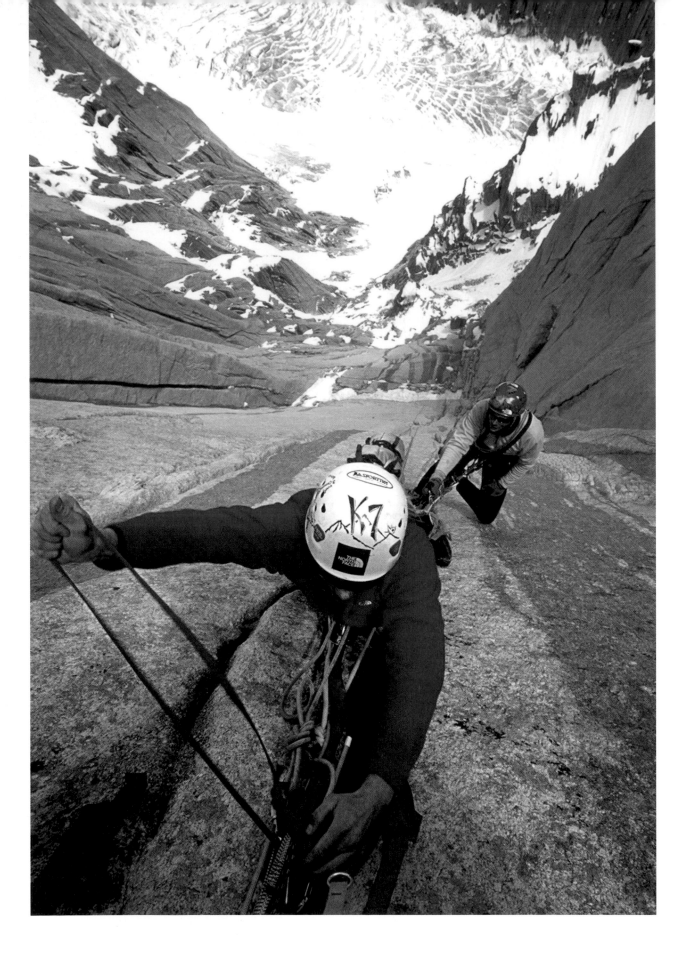

**ABOVE** Brady Robinson and Conrad Anker hauling gear and food on the lower wall of K7. Charakusa Valley, Karakoram, Pakistan.

**OPPOSITE** Conrad eyes the route ahead while Brady ascends the rope to our high point.

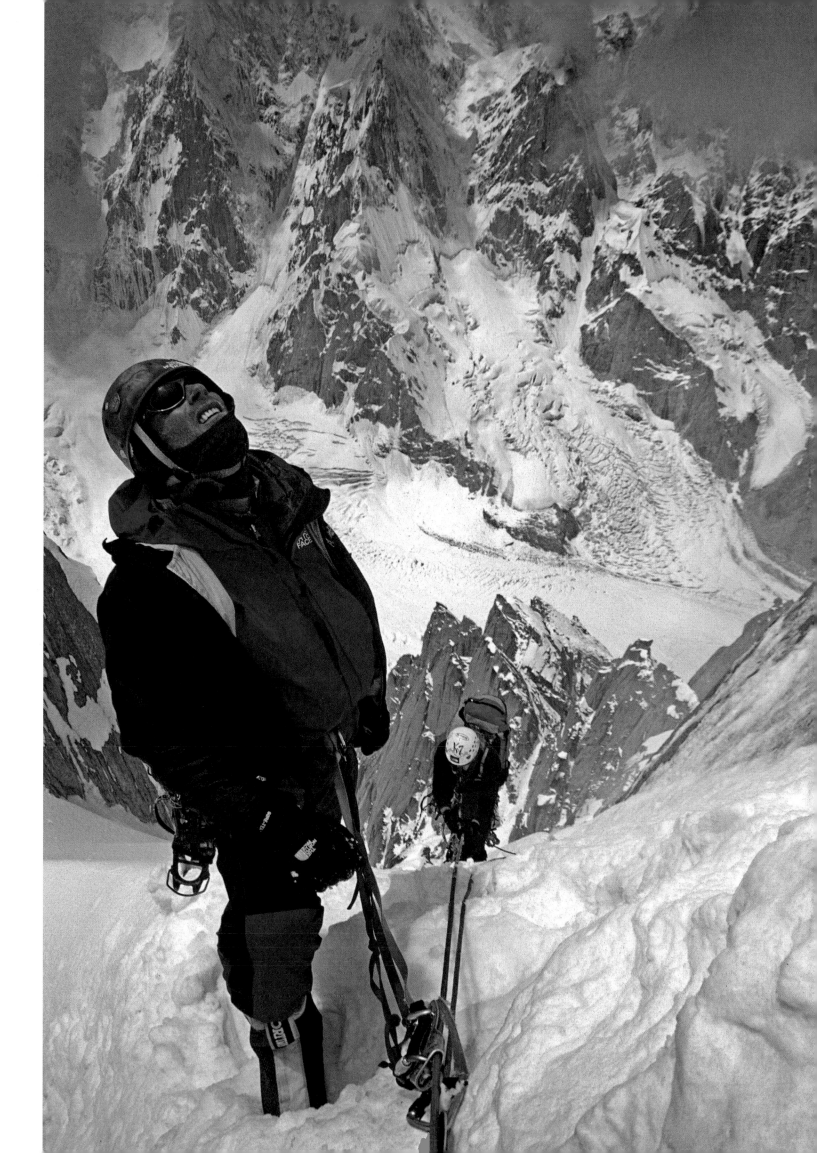

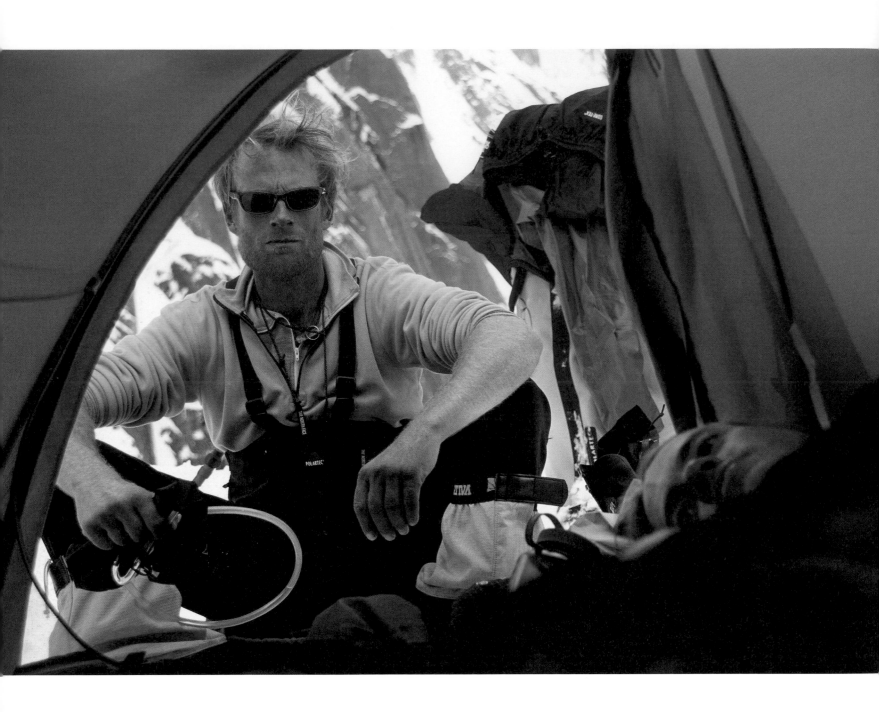

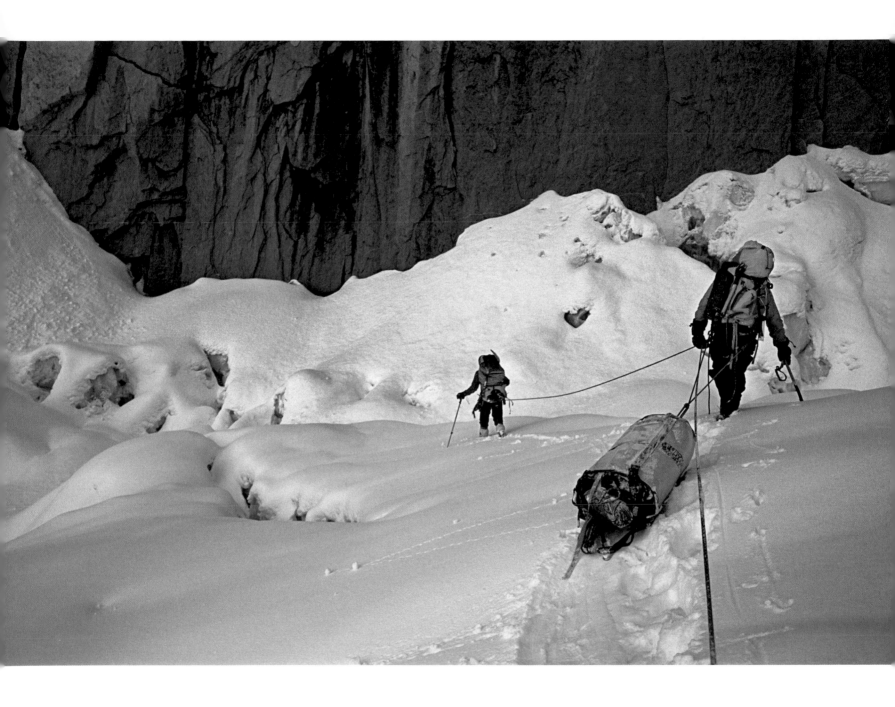

**OPPOSITE** Conrad Anker and Brady Robinson waiting to descend from Camp 1 after retreating off the wall. Avalanches from above had closed off any safe options for descent. Patience was our only plan.

**ABOVE** Conrad and Brady dragging our haul bags across the crevassed glacier back to base camp.

**FOLLOWING** Brady making a swinging traverse on K7.

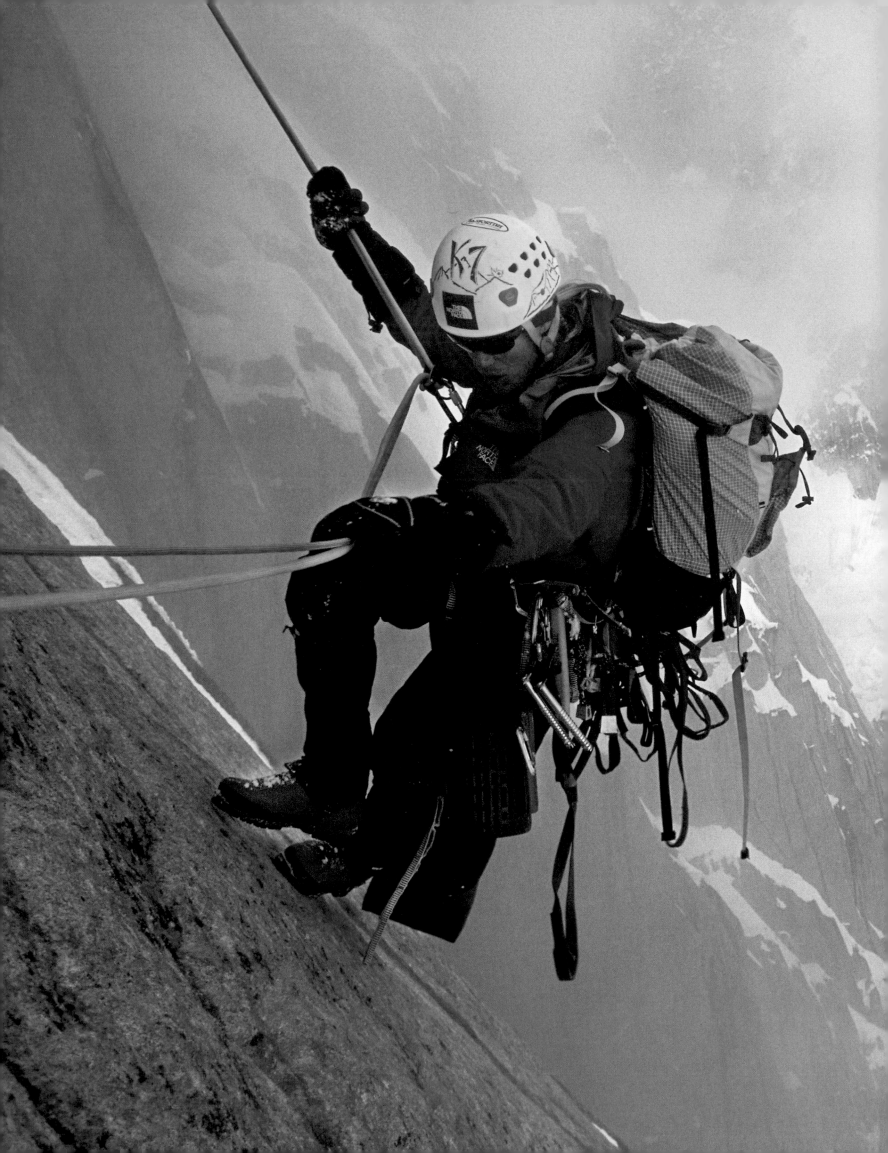

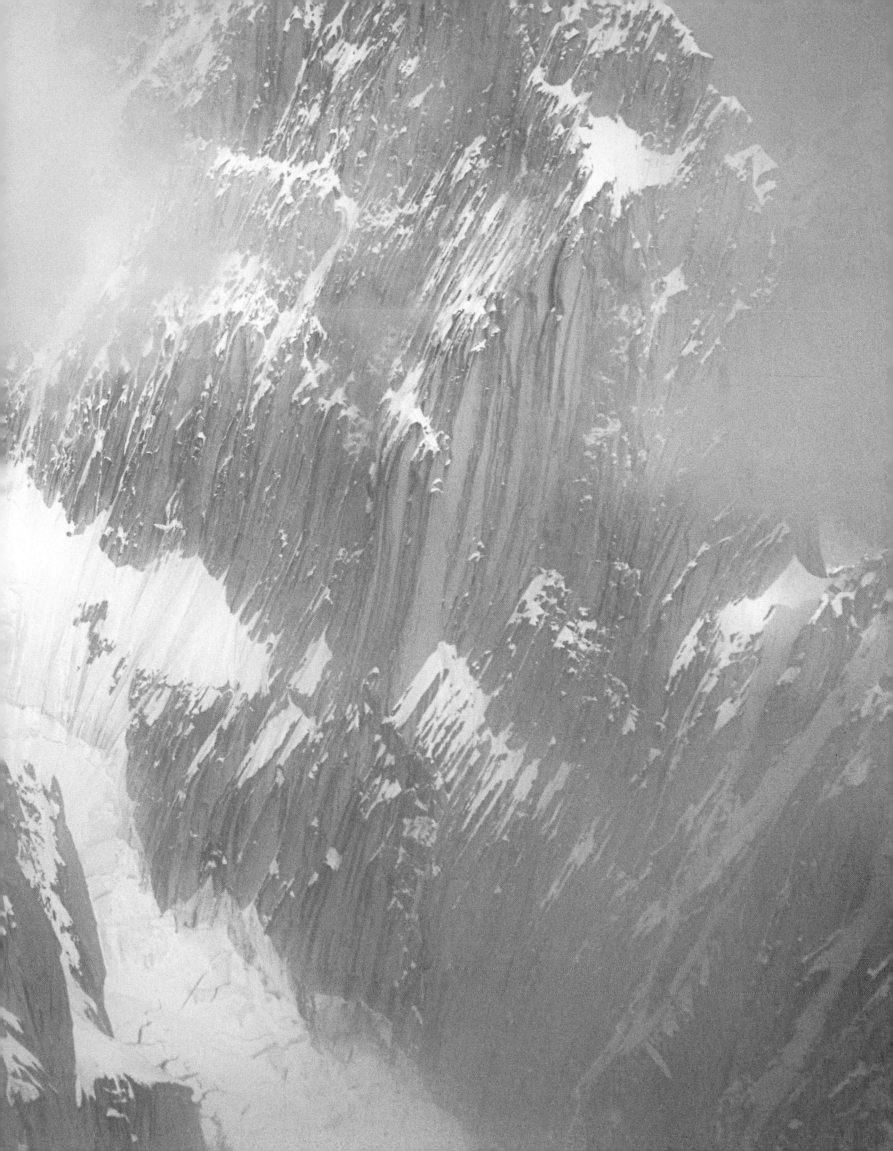

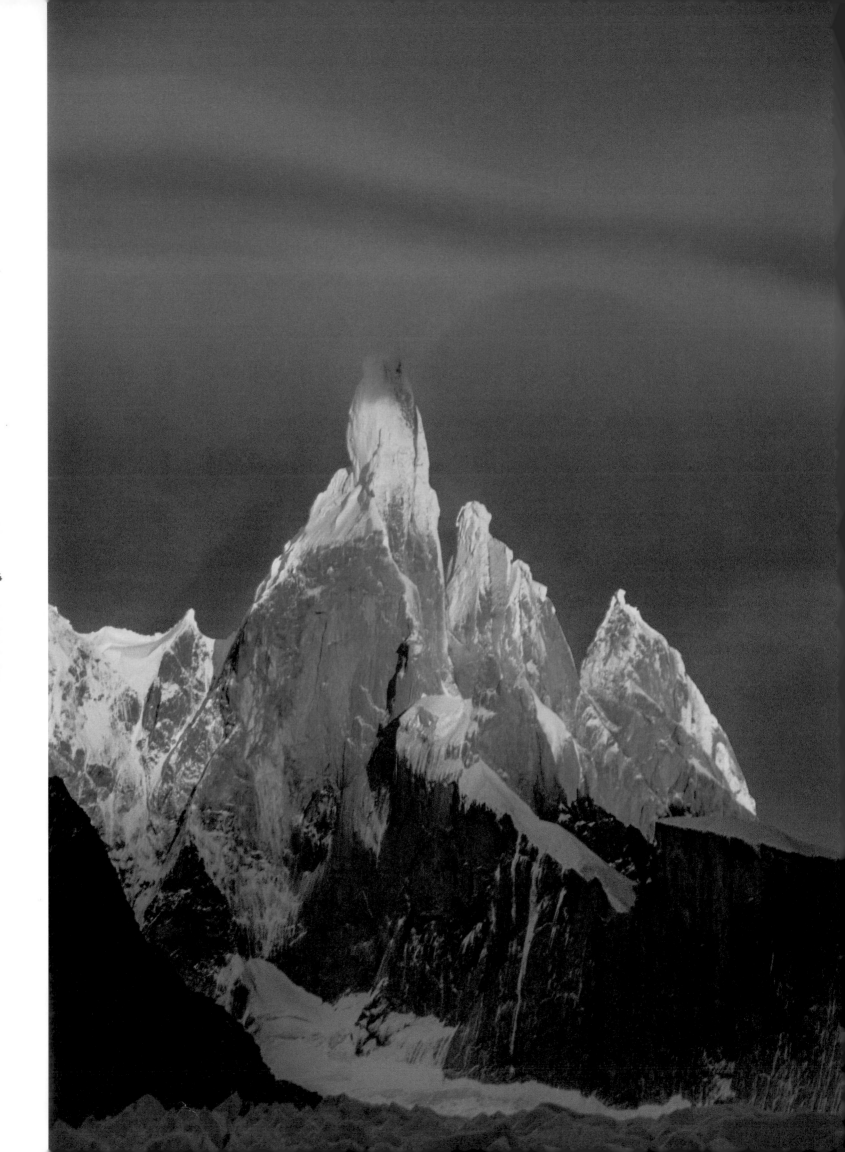

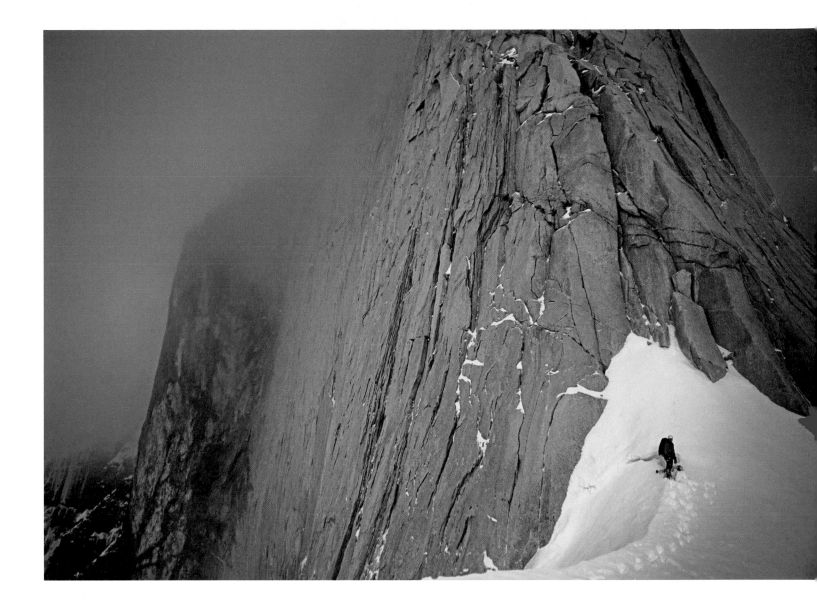

## PATAGONIA

In December 2001, Brady Robinson and I traveled to Patagonia to attempt the Compressor Route on Cerro Torre. The weather and winds in Patagonia are notoriously bad. Storms rolling off the Patagonian Ice cap continually batter the Fitzroy and Torre massifs. We waited four wet weeks for one day of climbable weather. After a long day of treacherous climbing over snow- and ice-covered rock, we arrived at the shoulder below the main headwall. The winds and impending storm made the decision to retreat simple.

But nothing is simple about climbing in Patagonia. After spending a night shivering in an icy cave, we tried to rappel down to the glacier below. When we tossed our ropes over the ledge for our first rappel, the winds shot our ropes straight up into the air and they got caught up in the rocks far above us. After we climbed up to retrieve our stuck ropes, we rappelled with the ropes coiled in slings attached to our harnesses. Instead of going down, the winds blew us sideways across the wall. When the wind changed directions, we would swing wildly down the face.

It was an interesting descent and a typical Patagonian whipping. We didn't get to climb Cerro Torre, but we did witness some beautiful sunrises and sunsets.

**OPPOSITE** The Torre Group—Cerro Torre, Torre Egger, and Cerro Standhardt—at sunrise.

**ABOVE** Brady Robinson digging into our snow cave below the headwall on the Compressor Route. Patagonia, Argentina.

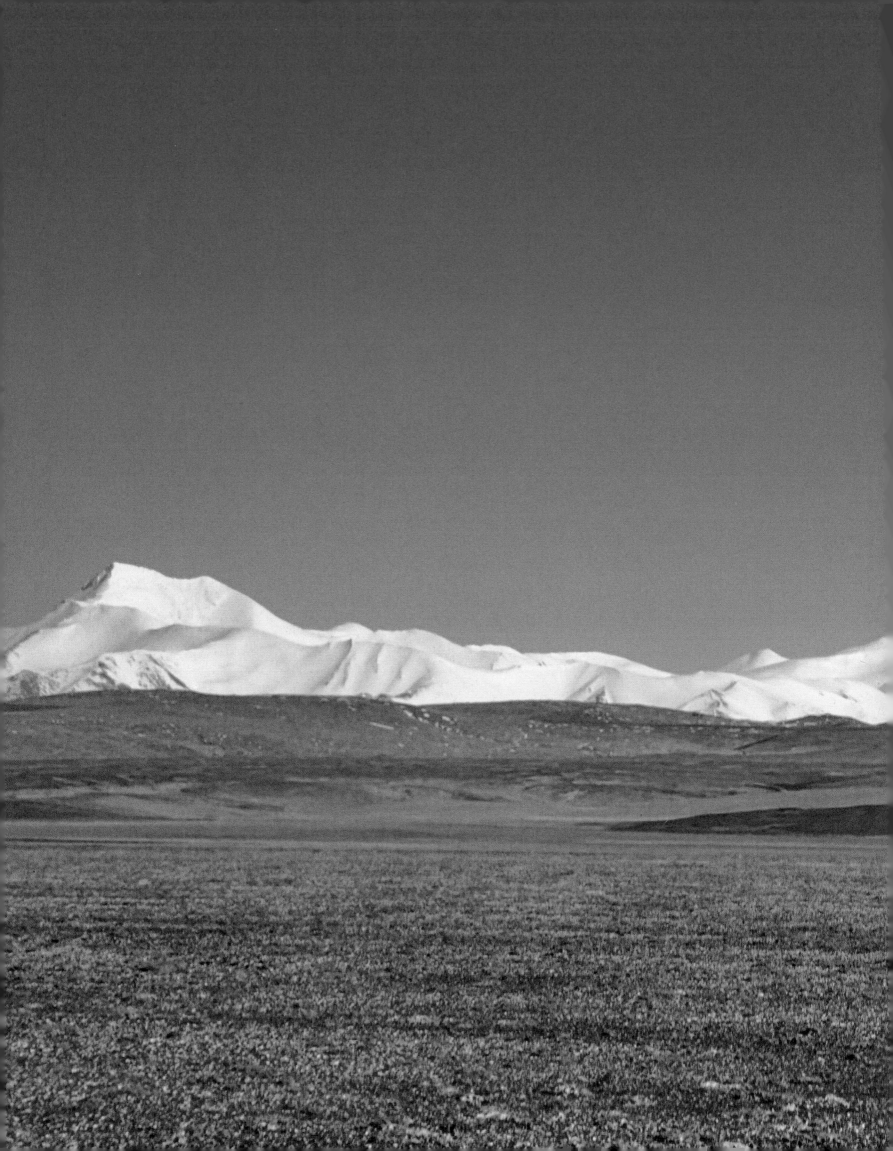

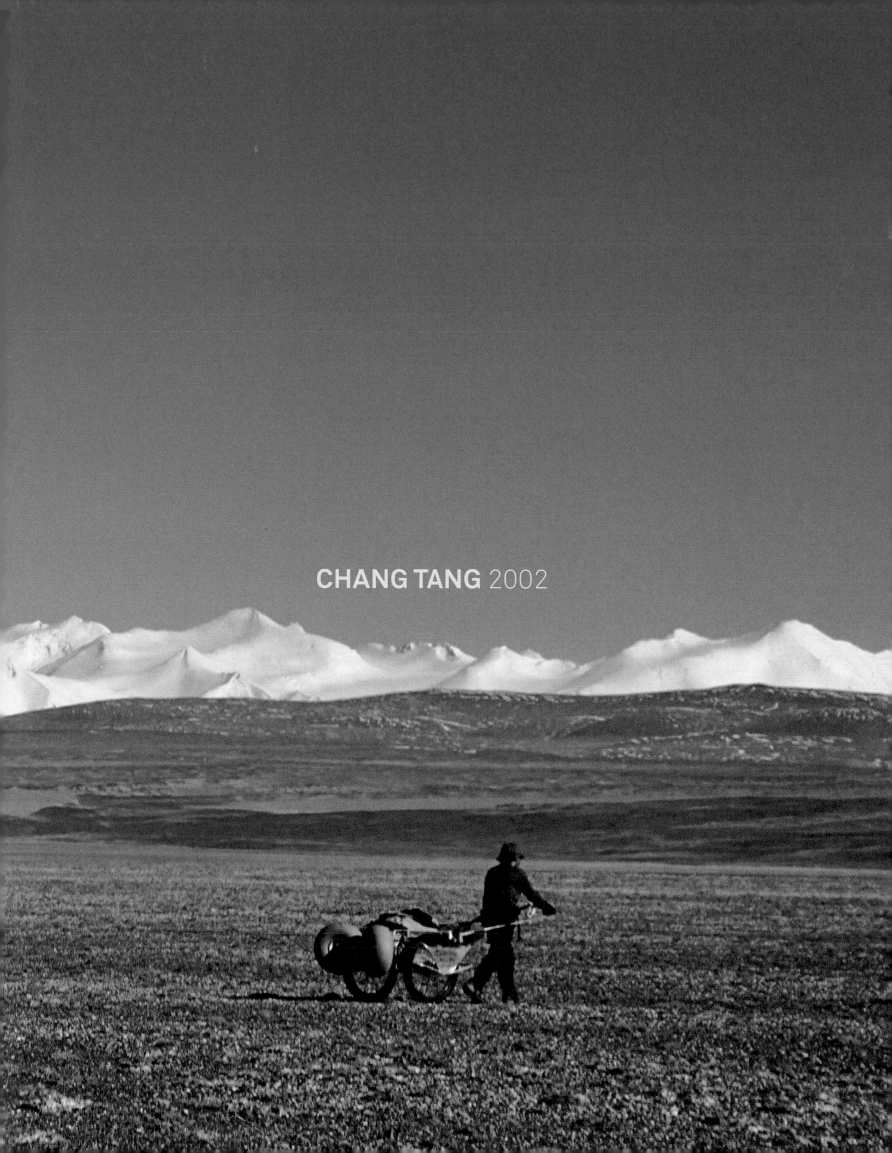

CHANG TANG 2002

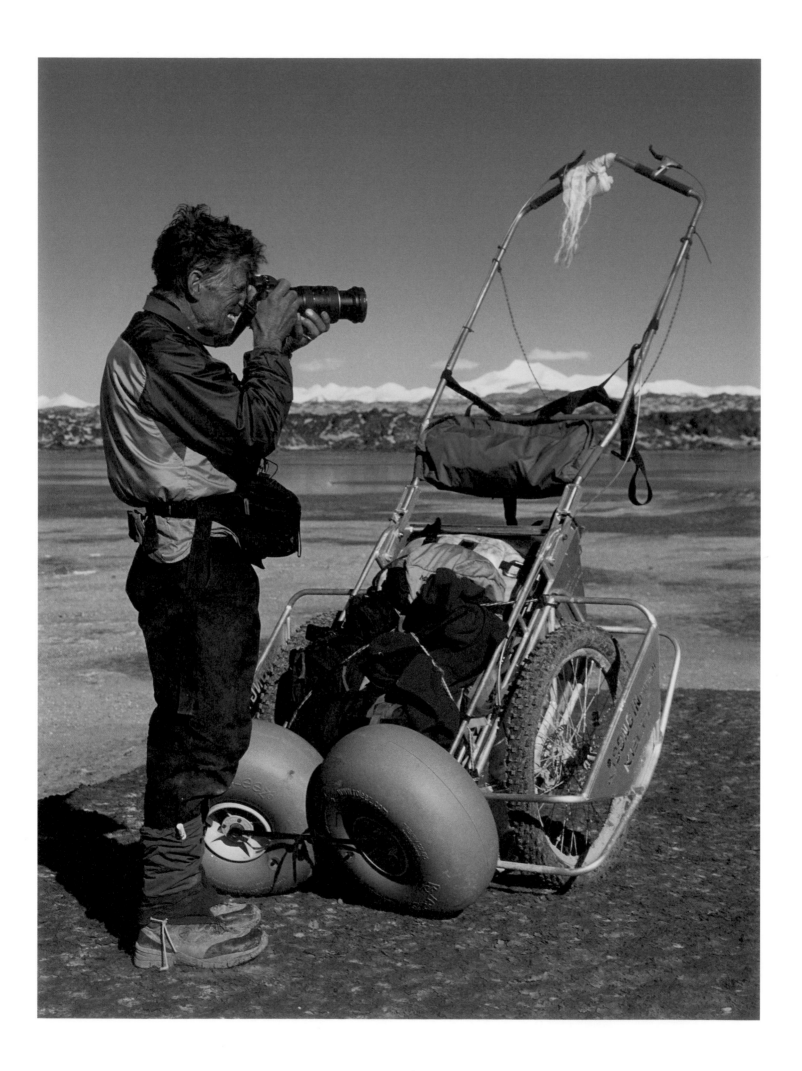

# Few understand elective suffering. Fewer enjoy it.

In 2002, I stood next to three masters of the craft, taking in the bleak landscape in front of me. We were embarking on a 275-mile unsupported traverse across the Chang Tang Plateau in northwestern Tibet—the highest, most remote desert plateau on earth.

Back in the winter of 2001, Rick Ridgeway called me to discuss the expedition. High demand for Shahtoosh shawls, a rare cashmere, had driven the population of the endemic Tibetan antelope, or chiru, from millions to the brink of extinction. Rick, Conrad Anker, Galen Rowell, and David Breashears wanted to follow the elusive chiru migration in search of their hidden birthing grounds. By documenting it for *National Geographic*, they hoped the area could be protected as a wildlife preserve. David planned to film, but he had to drop out. "We need a fourth," Rick said. I wanted to go, but I'd never filmed before. I didn't feel confident I could replace the director of the IMAX mega-hit, *Everest*.

"Commit," Rick told me, "And figure it out."

Because we had to carry everything we needed—food, clothing, climbing and camping gear, cameras, film—Rick devised aluminum rickshaws to haul our individual 200lb loads. Besides surviving the traverse, the success of the expedition was dependent on timing our intersection with the migration perfectly in order to find the birthing grounds just before the chiru birthed their young. If we moved too slowly, we might fail to intersect with the migration altogether. If we arrived to the birthing grounds too early, we wouldn't have enough food to wait for the chiru to start birthing. Water would be scarce; alternate food options were nonexistent, and rescue was impossible.

I thought the plan was absurd but I knew there were no better mentors than Rick, Conrad, and Galen. They had over a hundred expeditions between them. Though Rick was preoccupied scribbling notes for the article he'd been assigned to write, he still took the time to teach me how to film. I studied every decision Galen made, every picture he took, and the astonishing lengths he went to meet the exacting standards of *National Geographic*. Conrad always hauled more than his share of weight.

After twenty-five days of trudging, we found the chiru the day before they began giving birth. The next day we filmed and photographed the first newborn chiru being birthed. The trip was a success but we still had over a hundred miles and very little food to get to our pickup point. On the way out, Rick, Galen, and Conrad stopped to glass an unclimbed peak, the highest in the Kunlun Range. "We brought these ice axes and crampons, we might as well use them," Galen said. I thought, "Are you kidding me? We're going to climb a mountain we're clearly not going to live to tell about?" But a day later, we'd climbed it. As we neared the top, I took a photo of Galen reaching the summit.

A year later, Galen and his wife, Barbara, died in a plane crash. The Chang Tang trip would be his last expedition. In tribute, *National Geographic* published my photo of Galen on the summit ridge. It was his final gift to me: my first spread in the pages of the iconic yellow-border magazine that would launch my own career as a *National Geographic* photographer.

**PREVIOUS** Rick Ridgeway hauling his rickshaw at 17,000ft, across the Chang Tang Plateau.

**OPPOSITE** Galen Rowell shooting on assignment for *National Geographic* magazine.

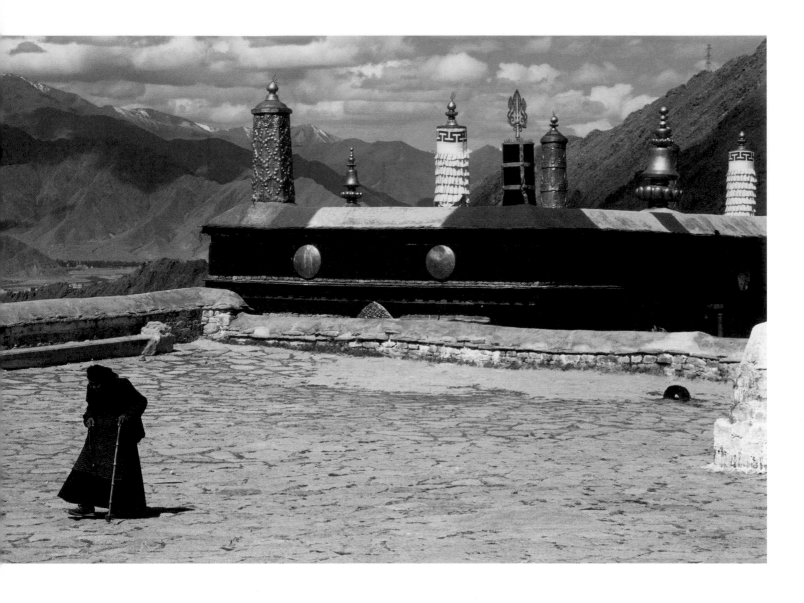

**ABOVE** A Tibetan nun walks in front of a gompa. Ngari Prefecture, Tibet.

**OPPOSITE** We arrived in Lhasa during the Saga Dawa, one of the holiest days in the Tibetan calendar. Rick Ridgeway walks with Tibetan pilgrims toward the circumambulation of the Potala Palace.

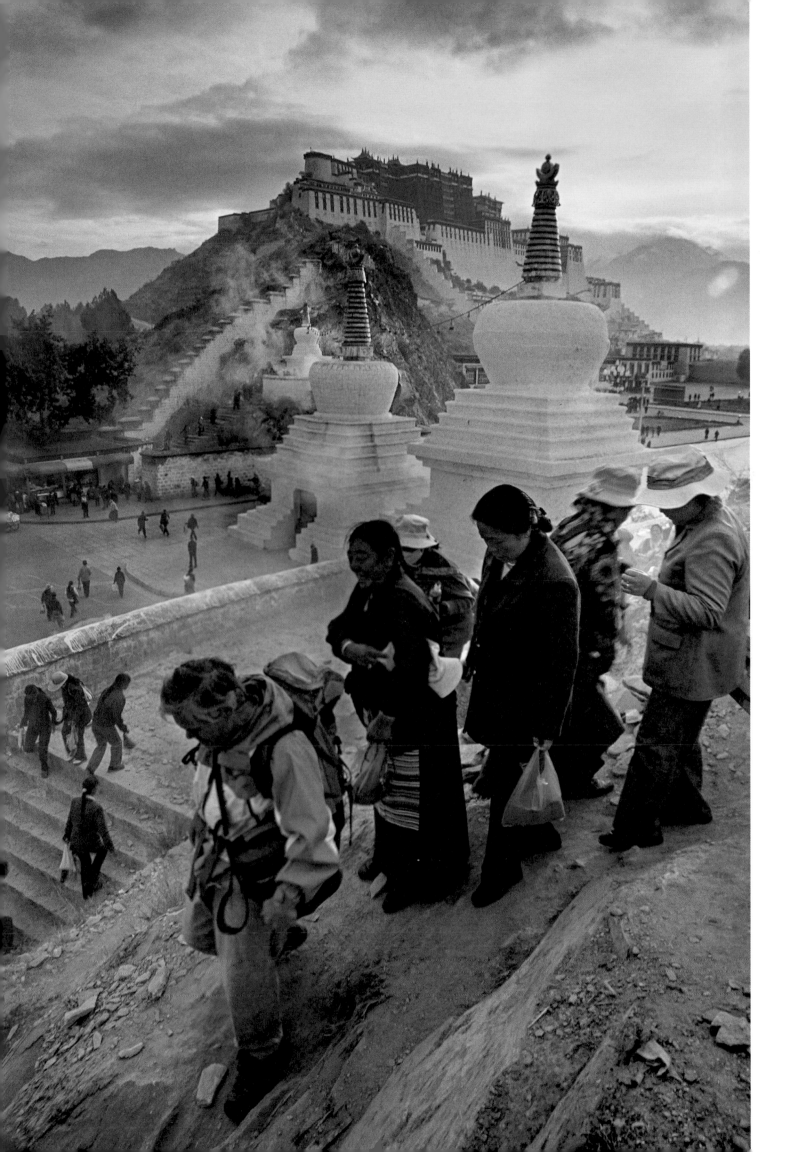

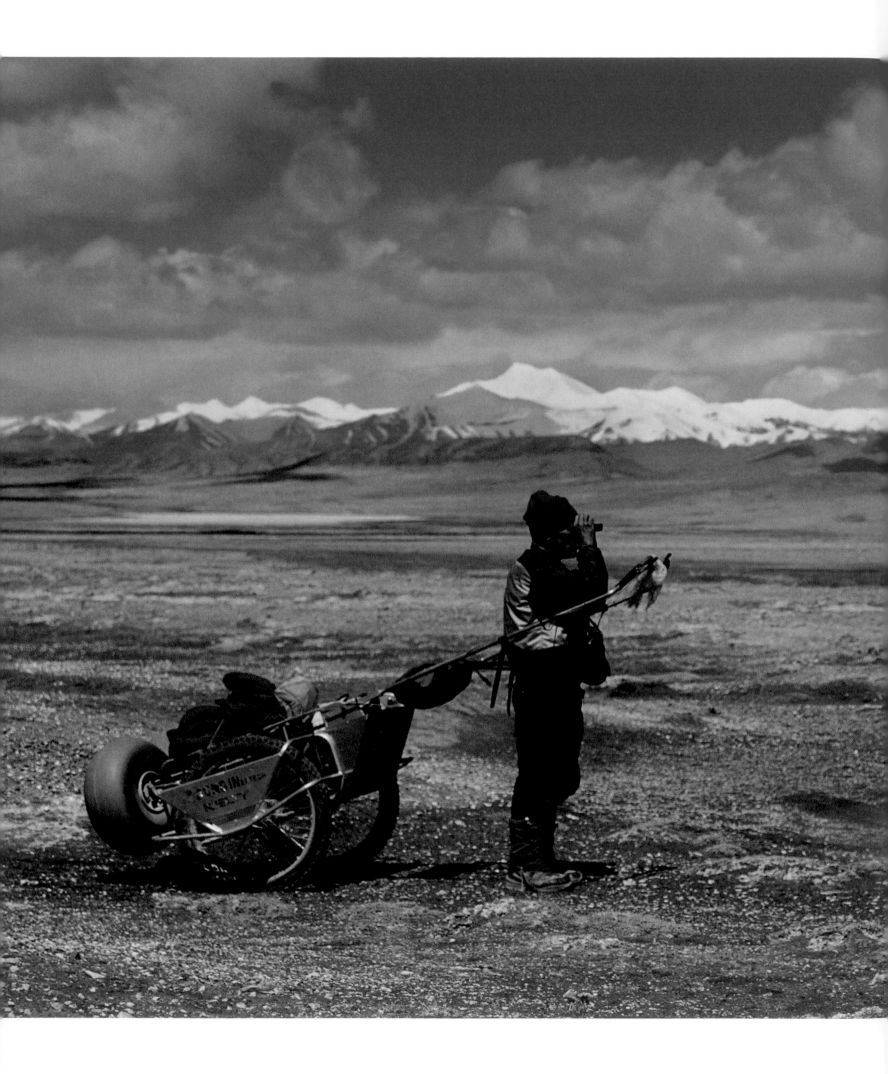

**LEFT**  Galen Rowell scanning the horizon for chiru (Tibetan antelope).

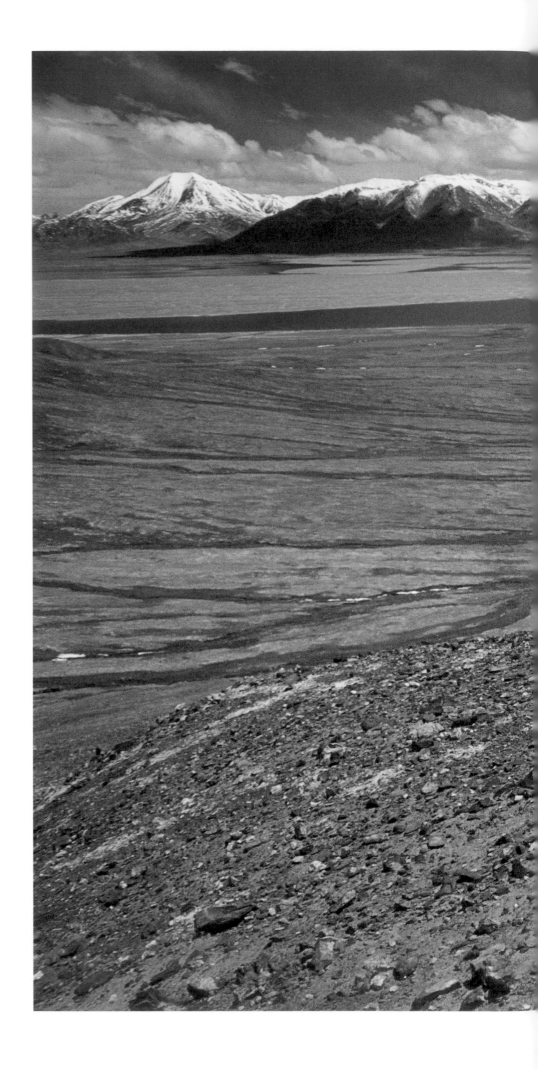

**RIGHT** Galen Rowell repacking his camera gear near Hei Shi Bei Hu Lake on our seventh day of the traverse.

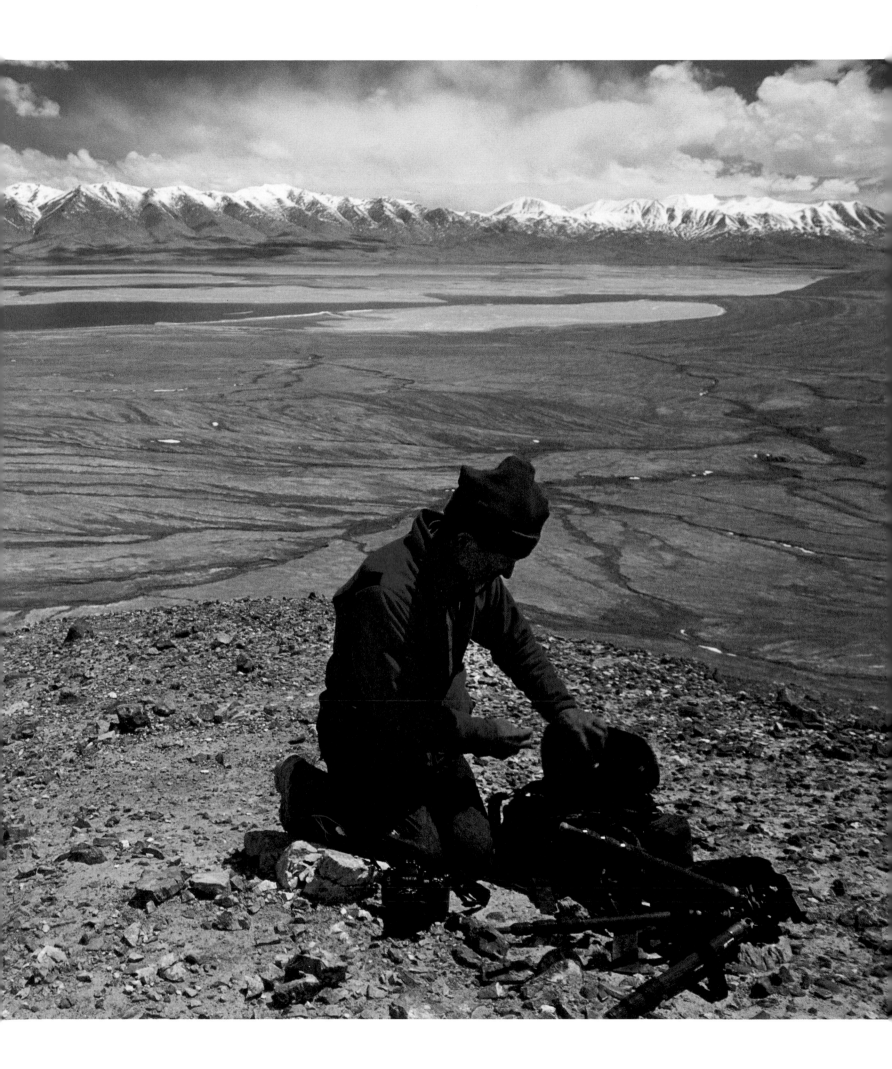

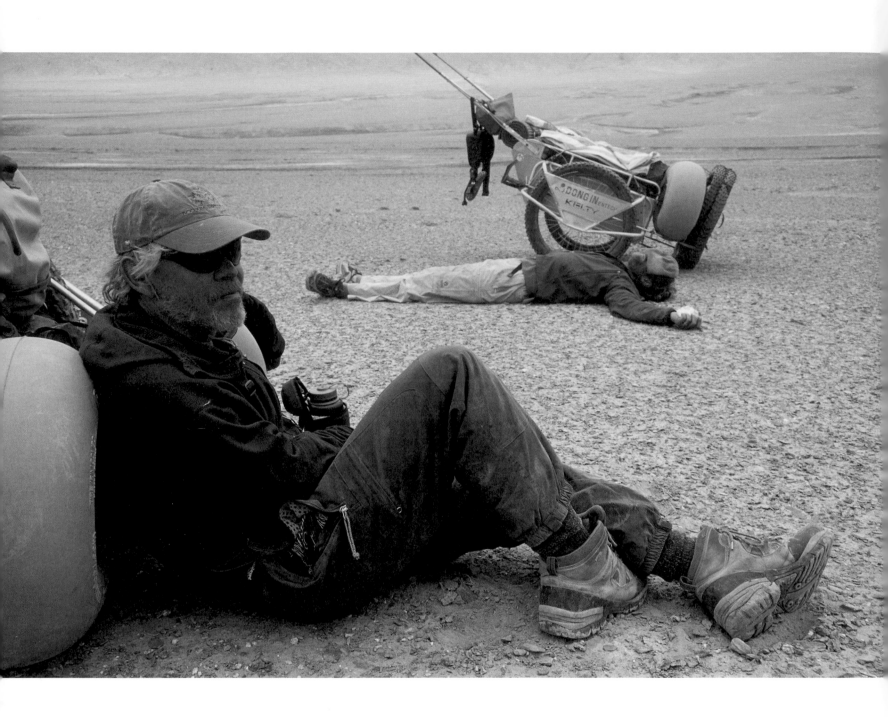

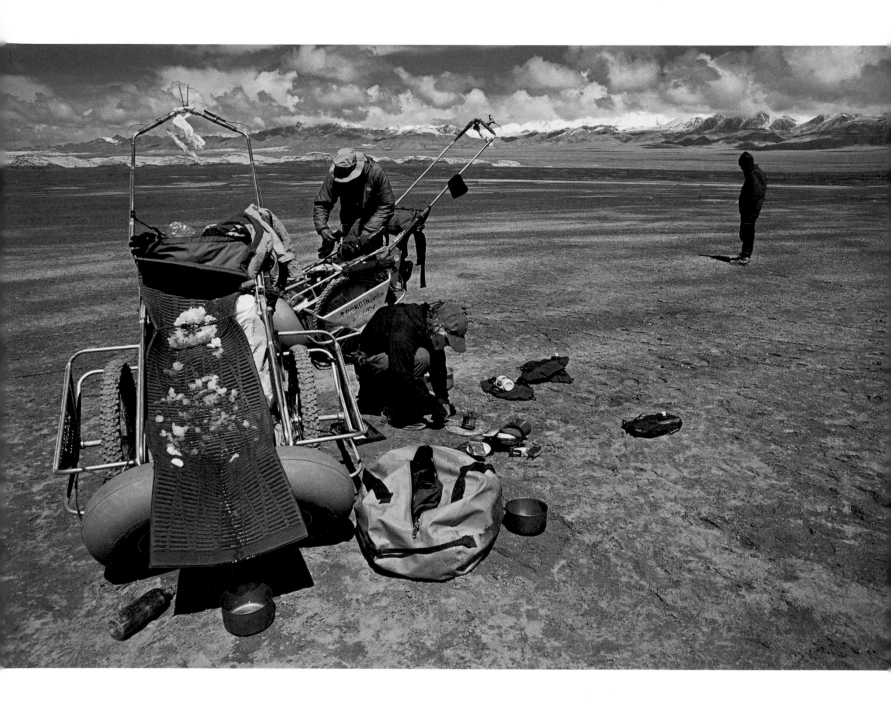

**OPPOSITE** Exhaustion and caloric deprivation set in twenty-five days into the traverse. With another hundred miles to go and little food left, Rick Ridgeway and Conrad Anker stretch out after a twenty-mile day of pulling their rickshaws.

**ABOVE** Our days were often spent trying to find water. Occasionally, we were able to gather a little overnight snowfall before it dried up in the morning sun. Using a sleeping pad as a solar snow-melting device, we not only saved fuel for melting water but also washed the foul debris from our dank sleeping pads straight into our drinking water.

**FOLLOWING** Galen Rowell climbing toward the summit of Chiru Peak. The first ascent of this 21,000ft peak would be his last climb.

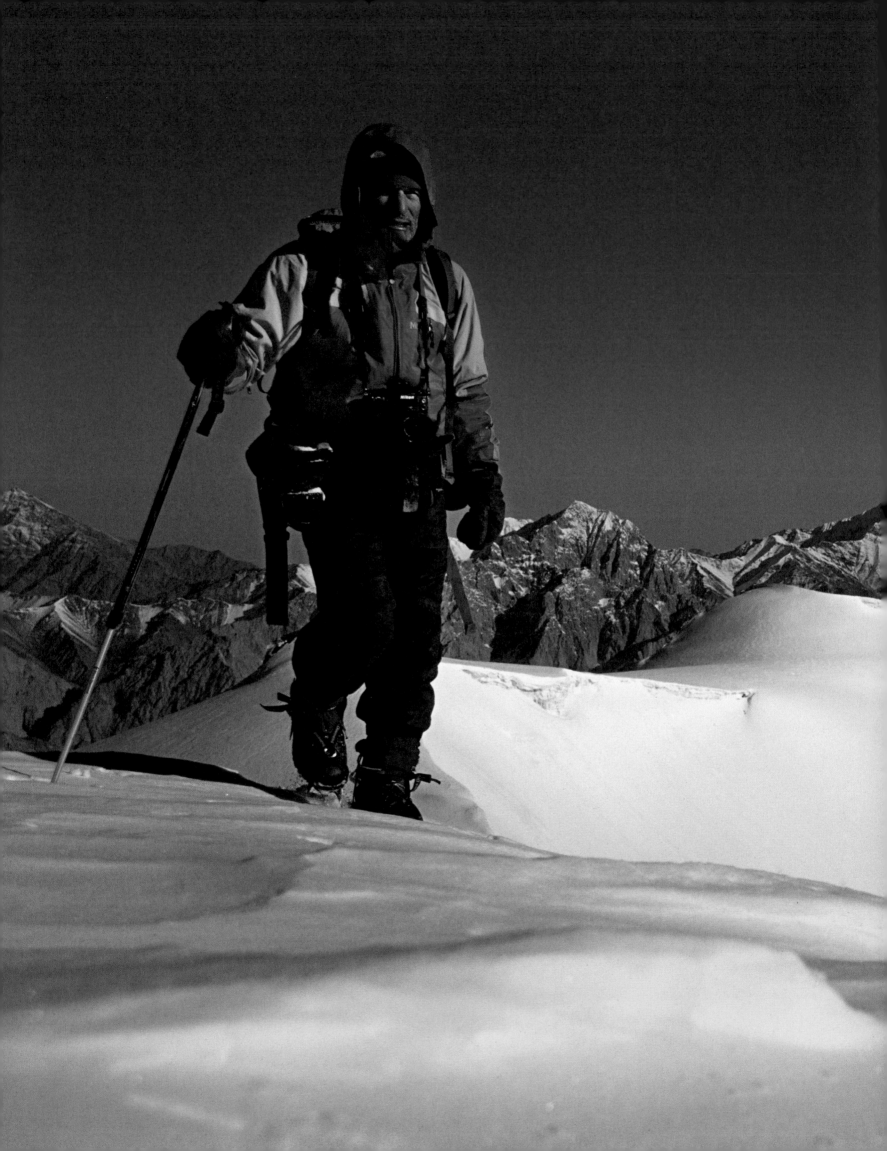

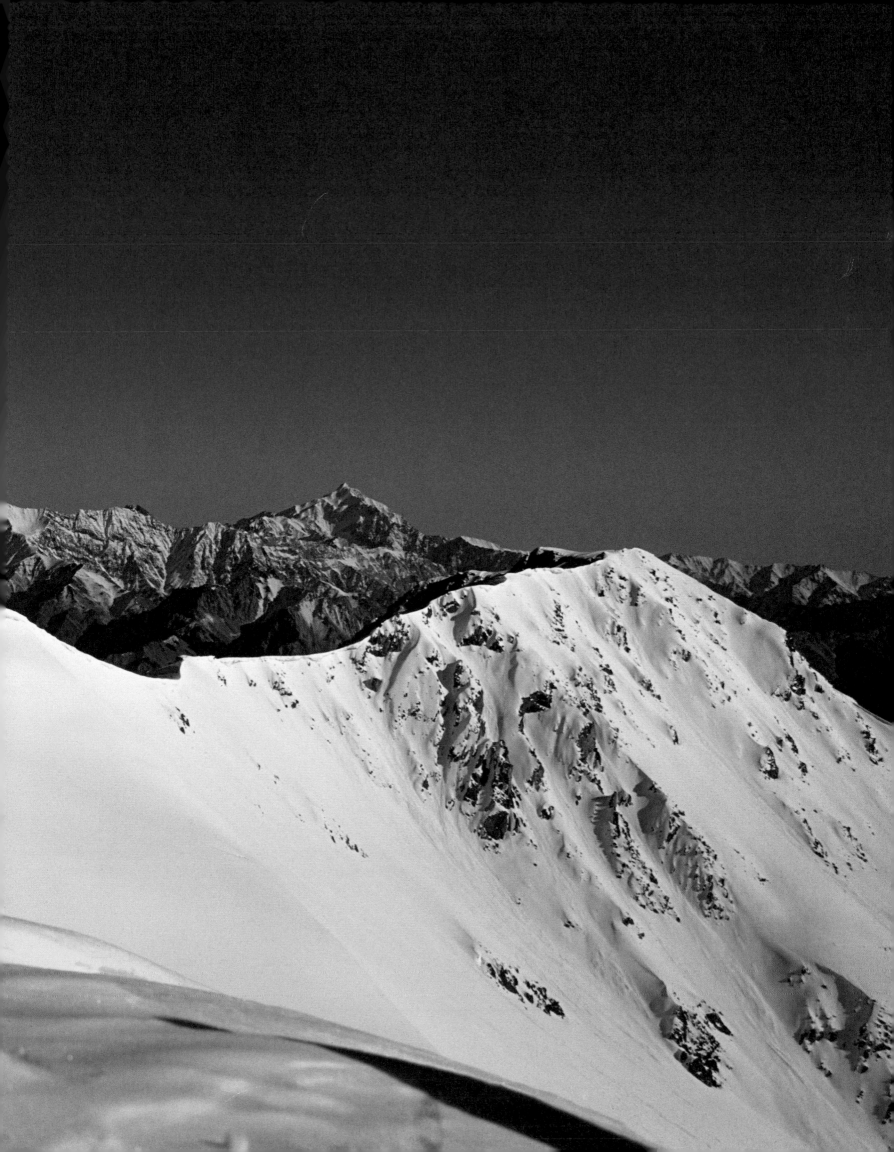

# TETONS

I first arrived in the Tetons when I was eighteen. At the time, climbing the Grand Teton seemed like an impossible undertaking. I hadn't even imagined the Grand was skiable. I returned year after year to climb and ski in these beautiful mountains and eventually decided to move here in the late nineties.

The iconic skyline of the Tetons holds a legacy of bold alpine feats and ski mountaineering descents. The combination of accessibility and big relief has made the Tetons a perfect alpine training ground for almost a century. Climbing legends like Barry Corbett, Yvon Chouinard, and Royal Robbins, and world-class ski and snowboard mountaineers like Kit DesLauriers and Stephen Koch, all cut their teeth in the Tetons before taking their skills to the greater ranges of the world.

The Tetons became my training ground as well. While preparing for expeditions to the Himalaya, Antarctica, and Alaska, I eventually climbed and skied from the summits of all the principal peaks and made more than twenty-five ski descents of the Grand. But as with all mountains, the Tetons demand respect—several friends have died while adventuring in these mountains, and an avalanche in this range nearly took my life.

I've called the Tetons my home for over twenty years. With seven thousand feet of vertical relief, the high alpine peaks provide great technical climbing terrain. Long, cold winters, deep snowpack, and mountains stacked with steep faces and couloirs deliver skiers epic powder as well as serious ski mountaineering lines.

But in the end, I've stayed here because of the incredible community. People live here because they are passionate about being in the mountains and have a deep appreciation for the landscape we live in. It's more likely than not that your bartender or teenager's high school teacher shreds harder than you. In the Tetons, keeping up with your neighbor has a completely different meaning. And that's the way I like it.

OPPOSITE  Griffin Post trenching neck deep in the Teton cold smoke.

FOLLOWING  Mark Synnott climbing the Chevy Couloir on the Grand Teton. Skiing the Grand is a rite of passage in the Tetons.

PAGES 64-65  Winter sunset in the Tetons.

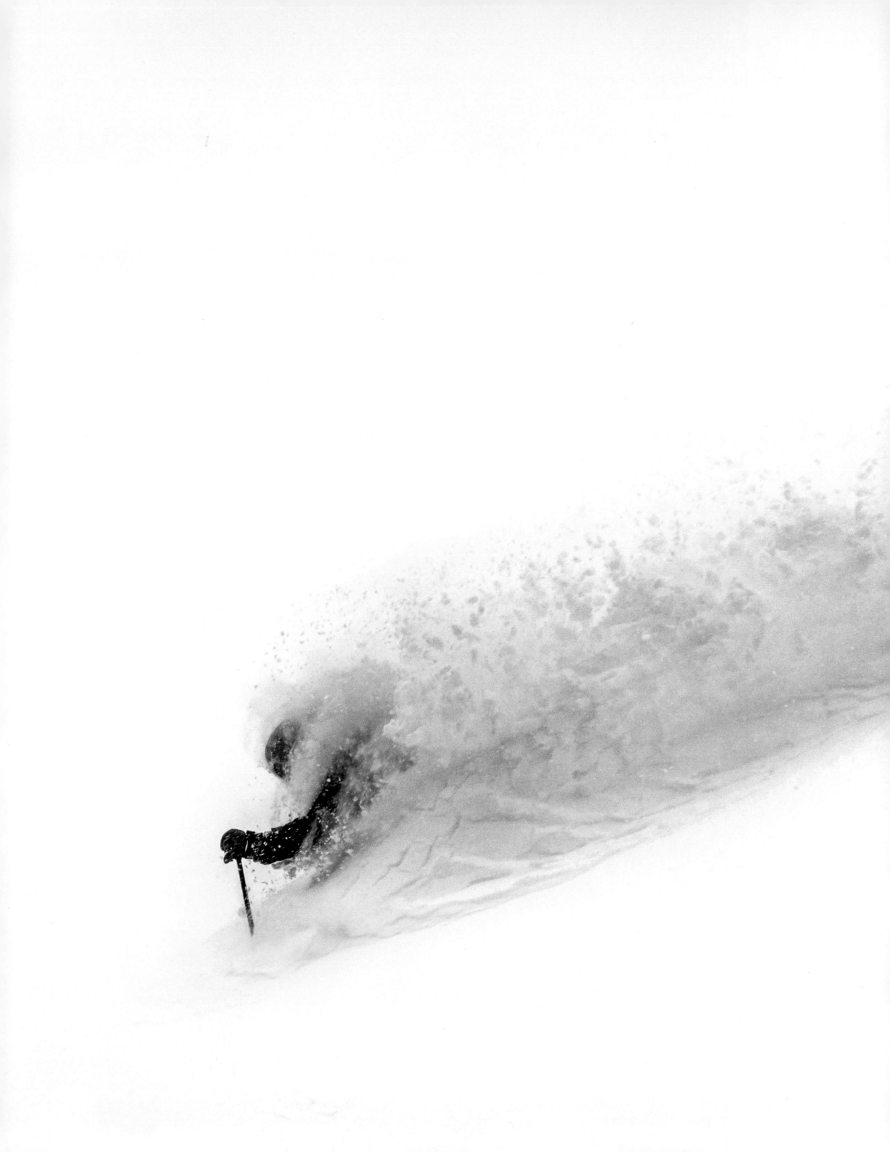

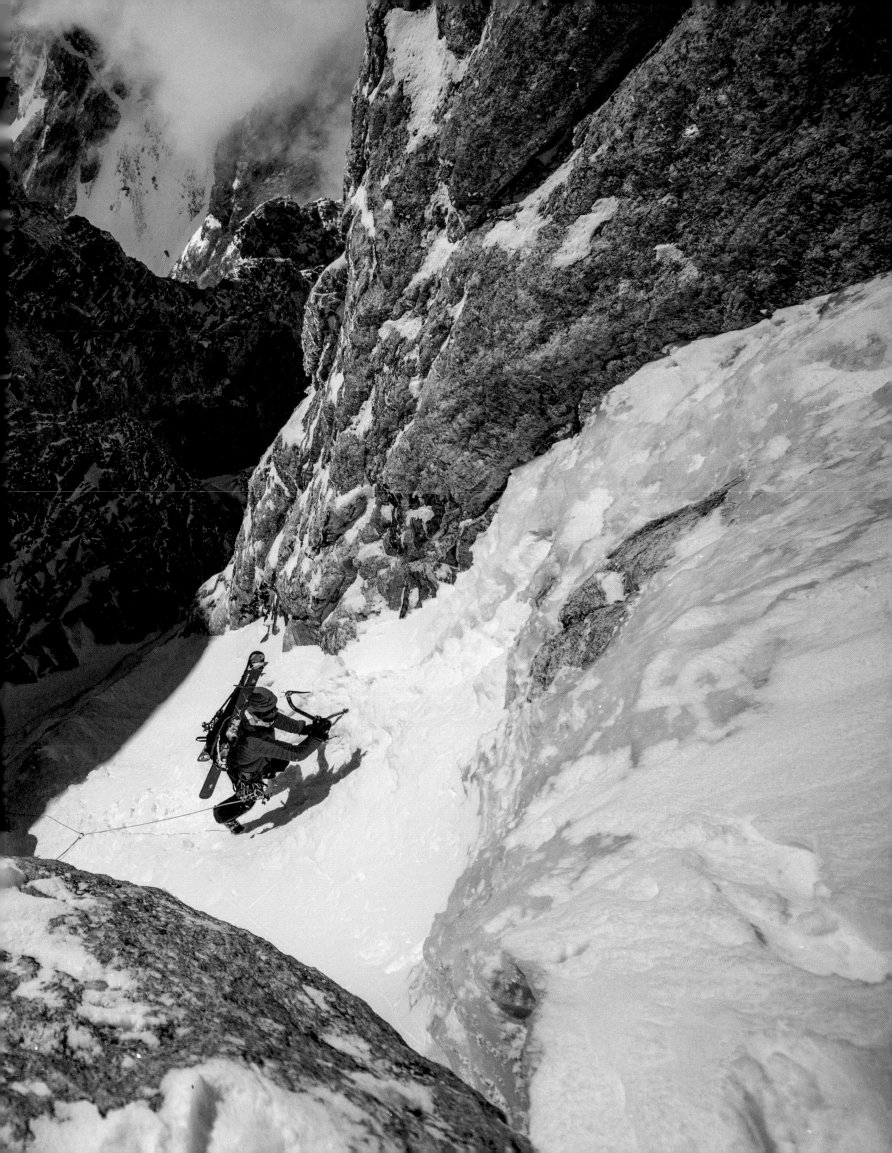

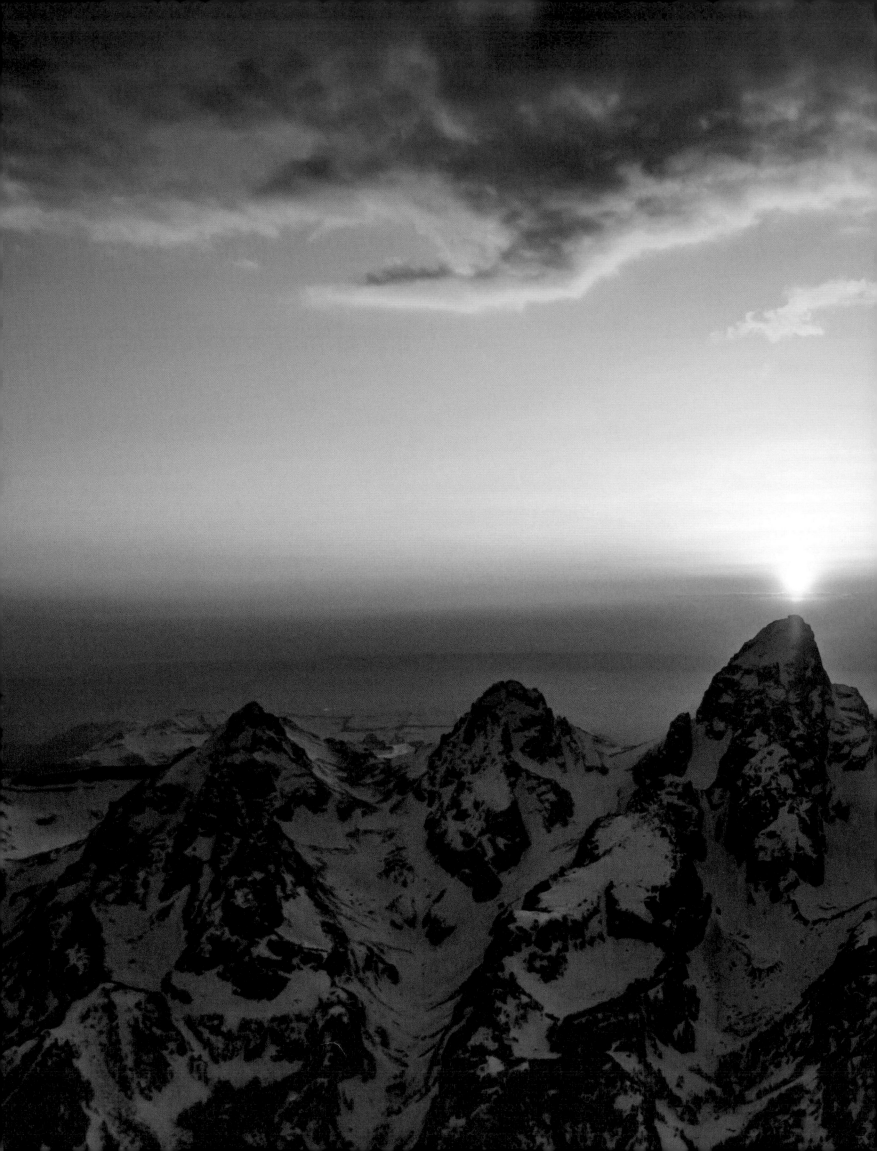

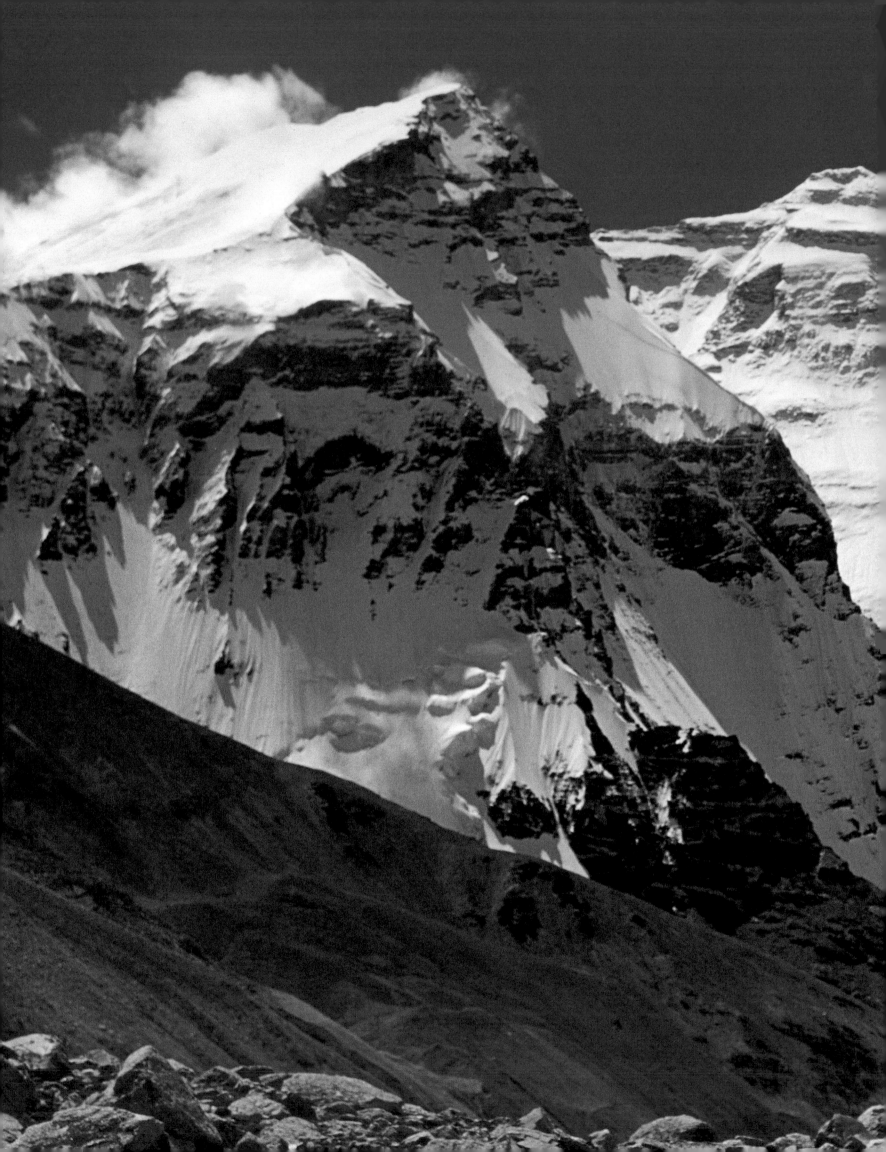

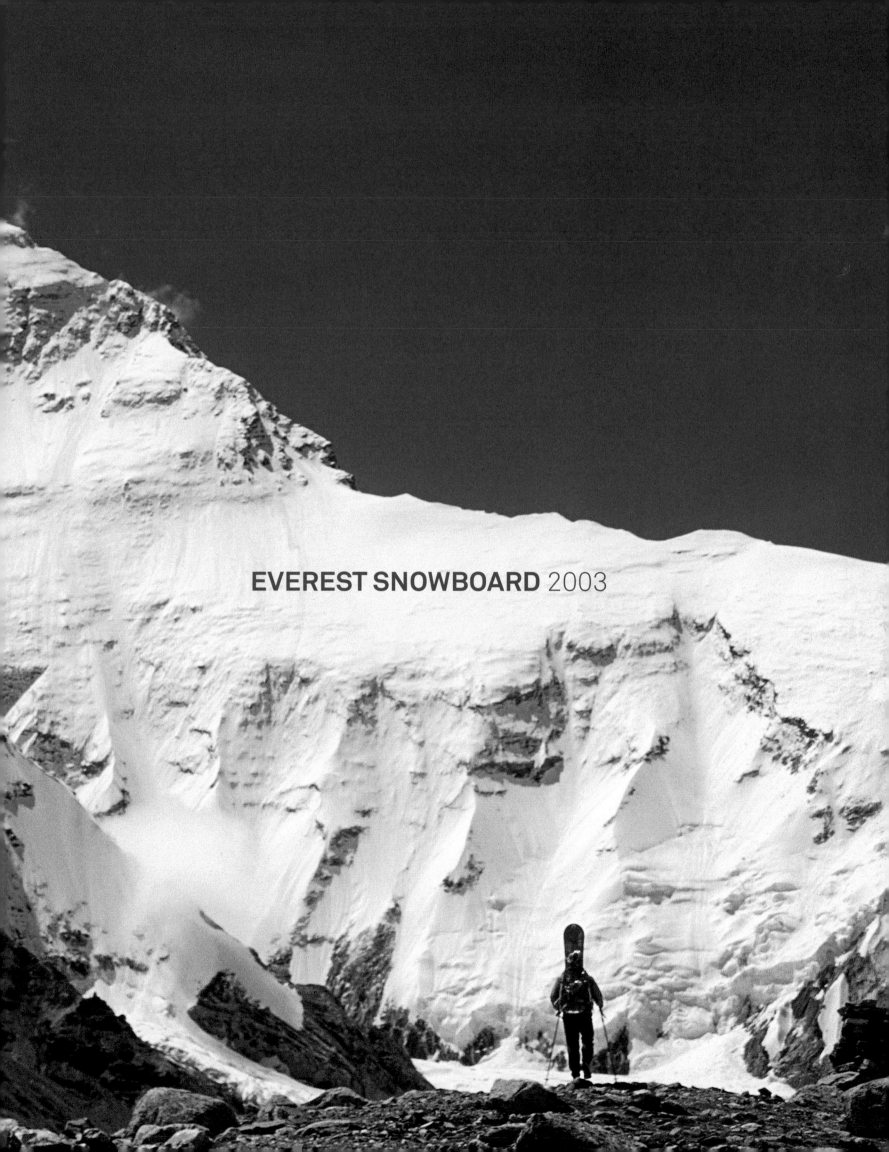
EVEREST SNOWBOARD 2003

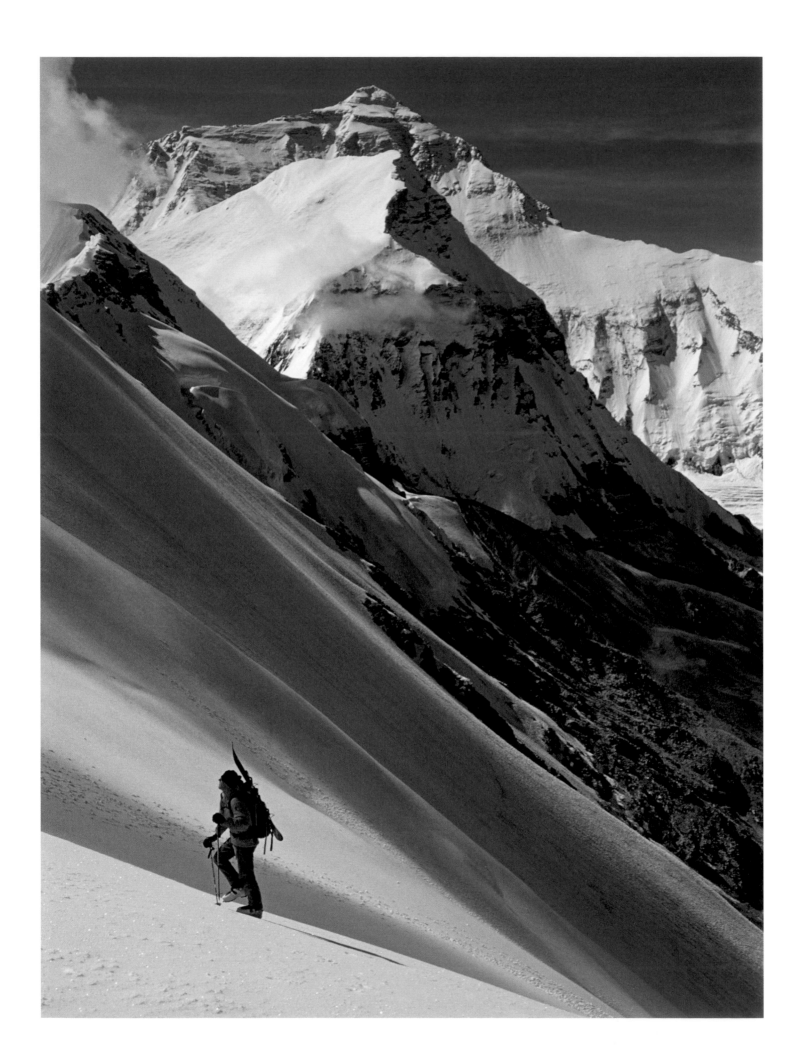

# Stephen Koch had one summit left in his quest to snowboard the Seven Summits.

An early pioneer of snowboard mountaineering, Stephen conceived a bold plan to snowboard Mount Everest: He'd climb and descend the direct north face, connecting the Japanese Couloir to the Hornbein Couloir. This nine-thousand-foot line bisects one of the biggest faces on the tallest mountain on Earth. It was an audacious goal, but Stephen wanted to make it even more challenging by climbing it alpine style—in a single push, without the use of supplemental oxygen, fixed ropes, or preestablished camps.

I'd met Stephen in Jackson, Wyoming, where Stephen was a fixture in the Tetons. When he asked me to join him on his expedition, I, naively, said yes. At twenty-eight, I'd had just enough expedition experience—and ambition—to get myself in over my head.

In August 2003, we recruited Kami Sherpa and Lakpa Sherpa to join us and our friend Eric Henderson to manage base camp. We were the only team on Everest. Borrowing the strategy of Jean Troillet and Erhard Loretan, who had scaled the north face alpine style in 1986, Stephen and I intended to hyperacclimate to 23,000ft, and then go for it in the small window between the monsoon and post-monsoon seasons, when the face would be caked with snow and the jet stream winds would be manageable.

After studying the weather and avalanche conditions on the face for more than a month, we made our first attempt. We roped up in the dark to navigate the giant crevasse fields below the face. At 1 a.m., we stopped for food and water. I heard a tiny "crack" in the distance followed by slight rumbling, which grew in intensity until the earth shook. Stephen dropped to his chest and jammed his axe into the ice, hoping to survive the massive avalanche that was rushing down from the darkness above. I stood facing the oncoming explosion of snow with my arms outstretched, preparing to die.

The air blast blew me off my feet, but Stephen's ice axe somehow held. The rope between us pulled taut as I flapped in the air like a kite. When the avalanche ended, I fell to the ground on my face. Miraculously, Stephen and I were both okay. Refrigerator-sized avalanche debris had stopped just short of us. We staggered back to our camp to gather our wits.

A week later, we returned. I'll never forget the feeling I had as I climbed over the bergschrund and gazed up at the north face. It looked like Valhalla, shining in the moonlight. We climbed for twelve hours, kicking steps in knee-deep snow. As the midday sun baked us and the avalanche conditions grew dangerous, we needed to make a decision. We weren't moving fast enough to get to a spot safe from avalanches. Reluctantly, we turned around and descended. The next day, we woke to find that an avalanche had erased our tracks in the Japanese Couloir. If we hadn't retreated, it would have erased us too.

We abandoned Everest and headed for home. Although our two months of anticipation culminated in failure, the expedition was revelatory nonetheless. This attempt at Everest's direct north face made every other mountain I've visited since feel a little less daunting. It also taught me an important lesson: If you turn around and come home alive, you made the right decision. The goal is to make it there and back.

PREVIOUS Stephen Koch approaching the north face of Everest. Central Rongbuk Glacier, Tibet.

OPPOSITE Stephen acclimatizing on Chang Zheng peak near Everest.

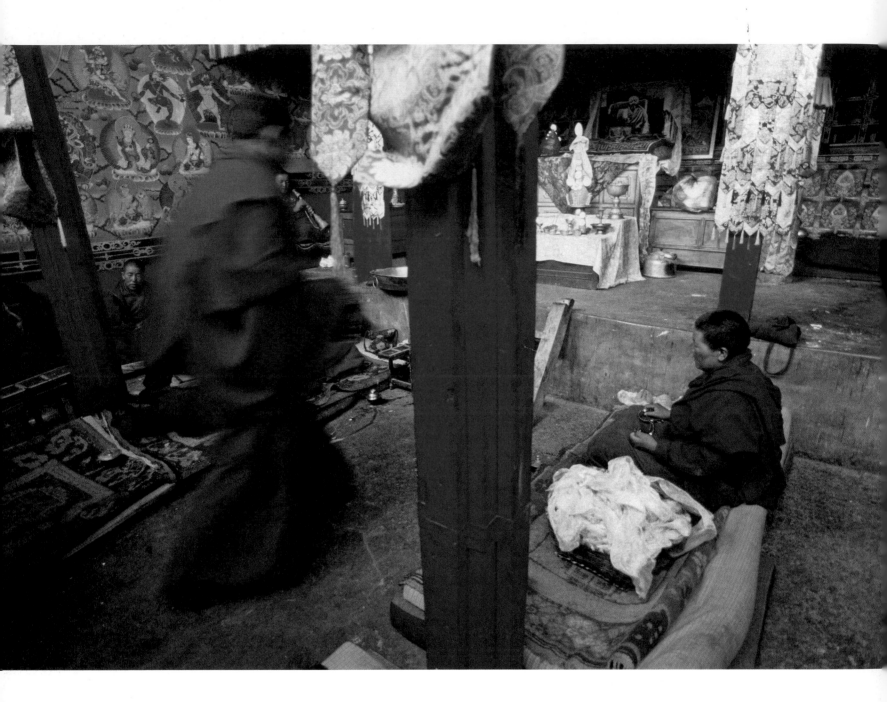

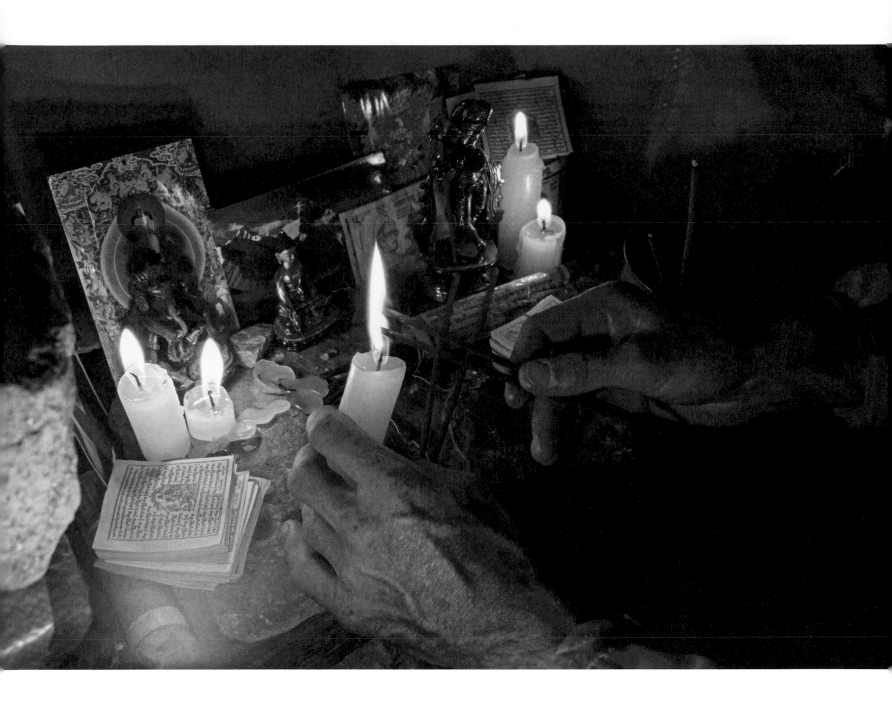

OPPOSITE Tibetan nuns preparing for daily prayer. The Rongbuk Monastery, situated at over 16,000ft, is one of the highest-elevation Buddhist monasteries in the world.

ABOVE Stephen Koch lighting candles at our makeshift altar. Neither of us was a practicing Buddhist, but when you spend two months staring up at the nine-thousand-foot north face of Everest, praying for safe passage doesn't seem unreasonable.

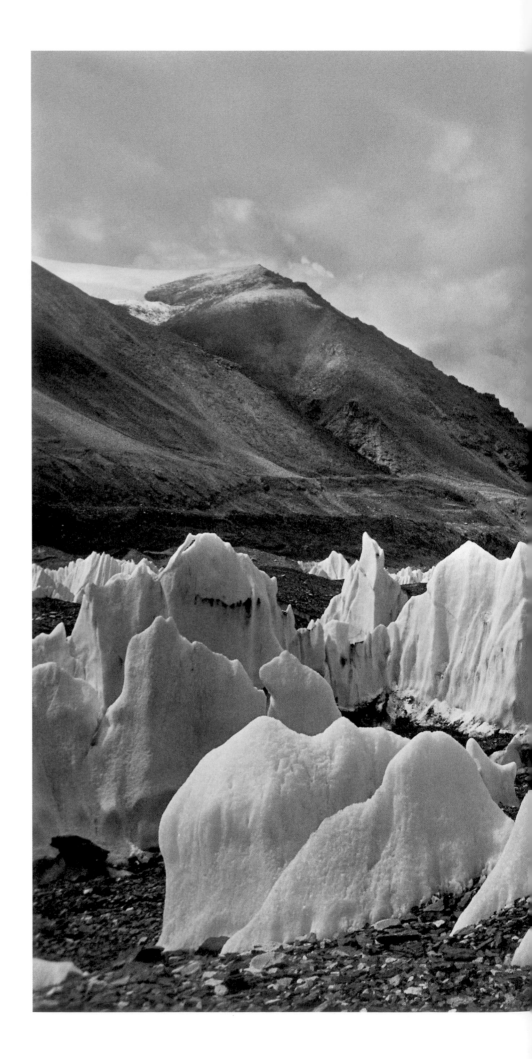

**RIGHT** Stephen Koch climbing one of the ice towers near our advanced base camp. Central Rongbuk Glacier, Tibet.

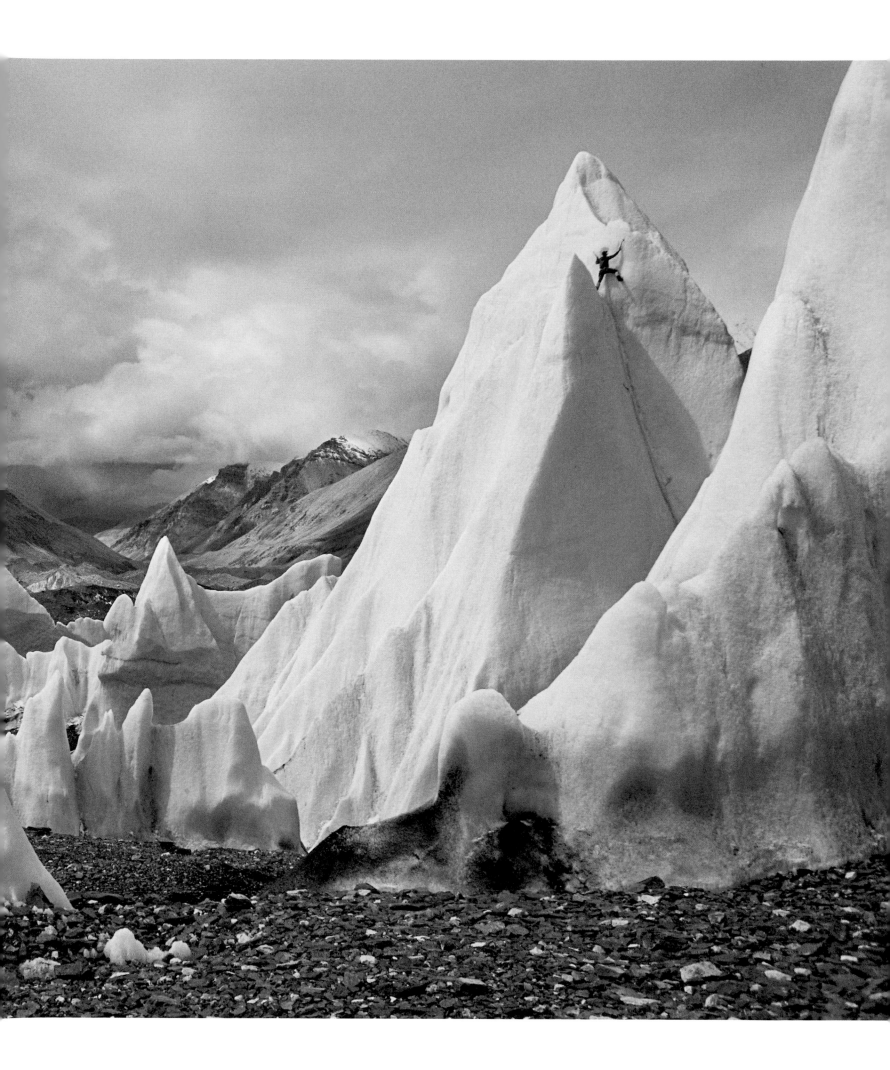

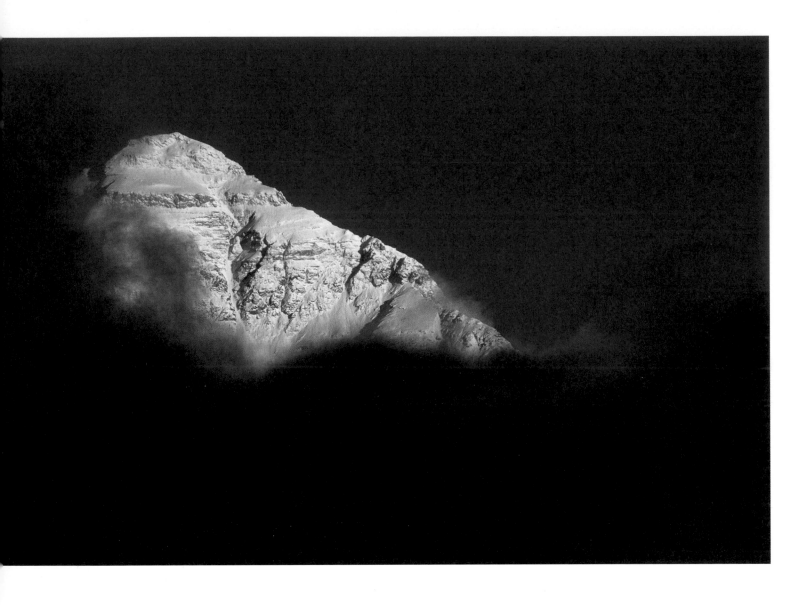

**ABOVE** Sunset on Mount Everest.

**OPPOSITE** Lenticular cloud over Everest.
Central Rongbuk Glacier, Tibet.

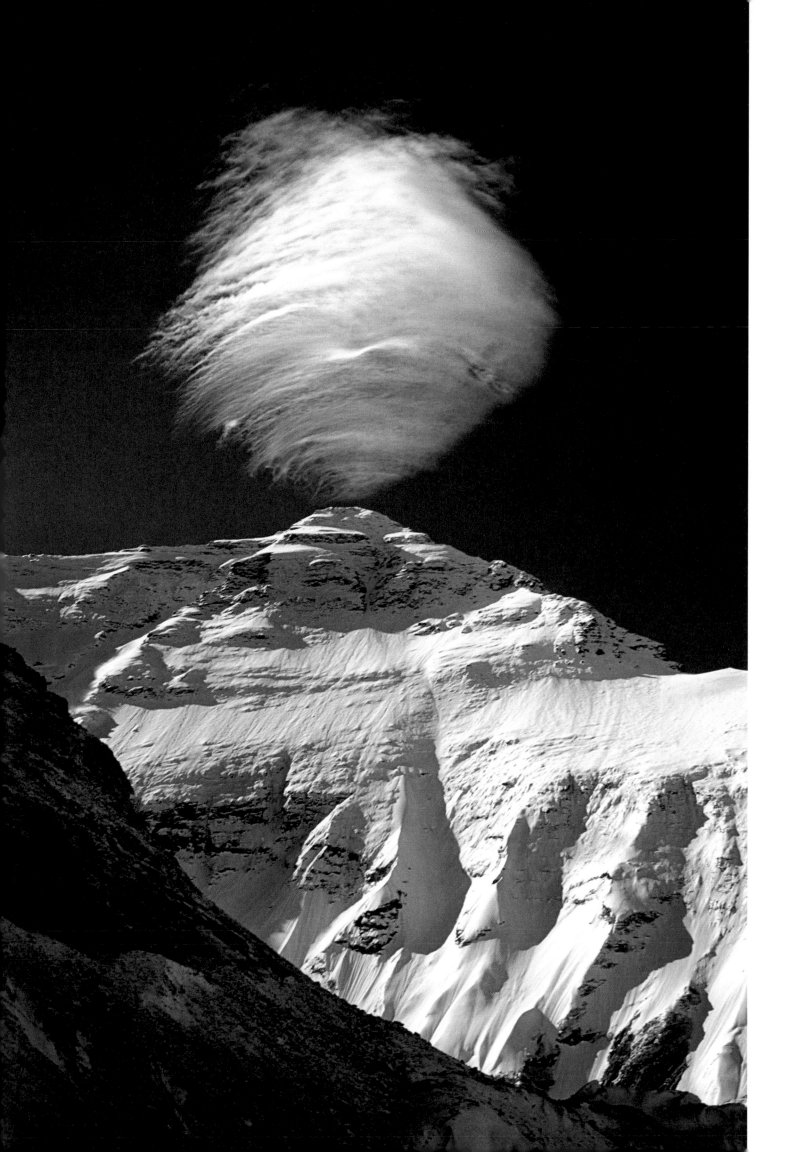

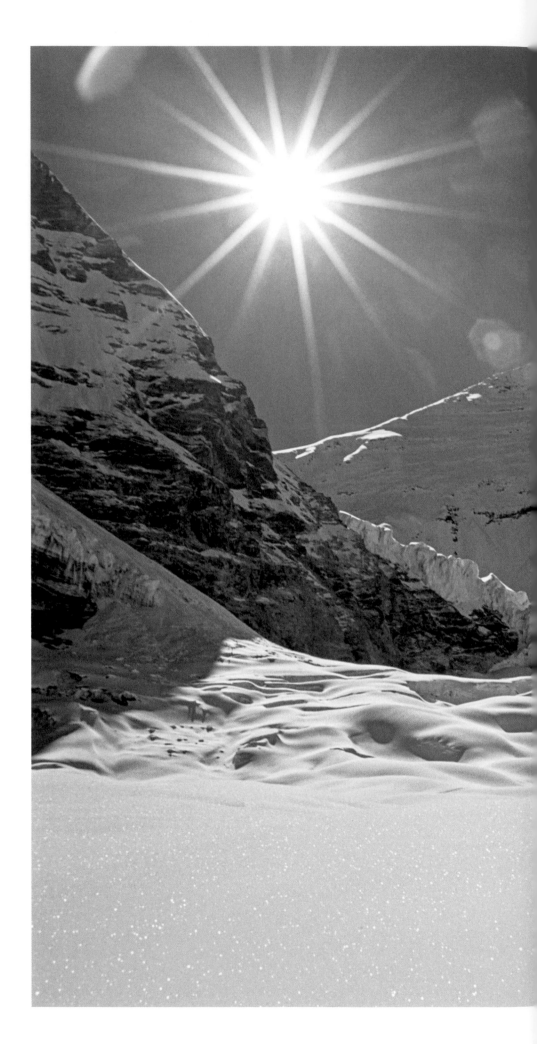

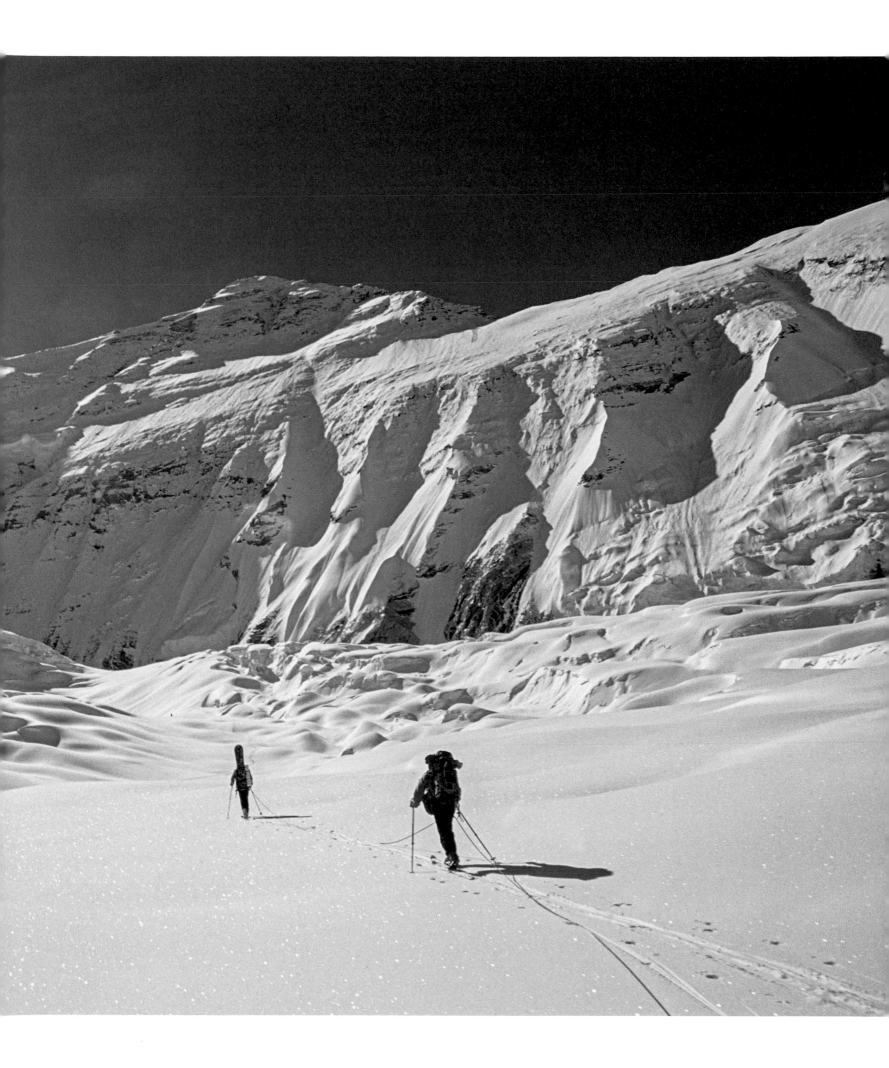

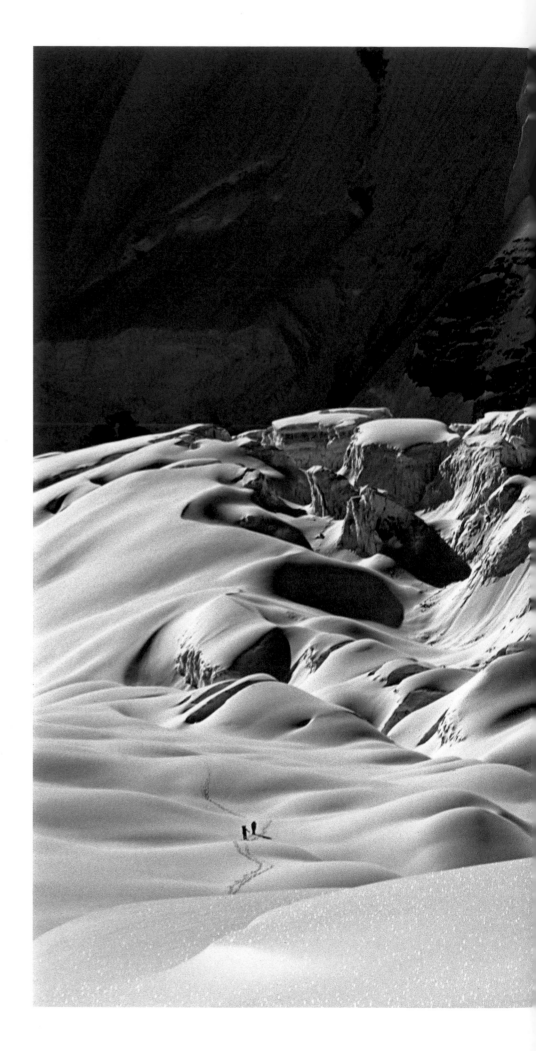

**RIGHT** Stephen Koch and Eric Henderson assessing the crevassed approach to the base of the north face of Everest. Central Rongbuk Glacier, Tibet.

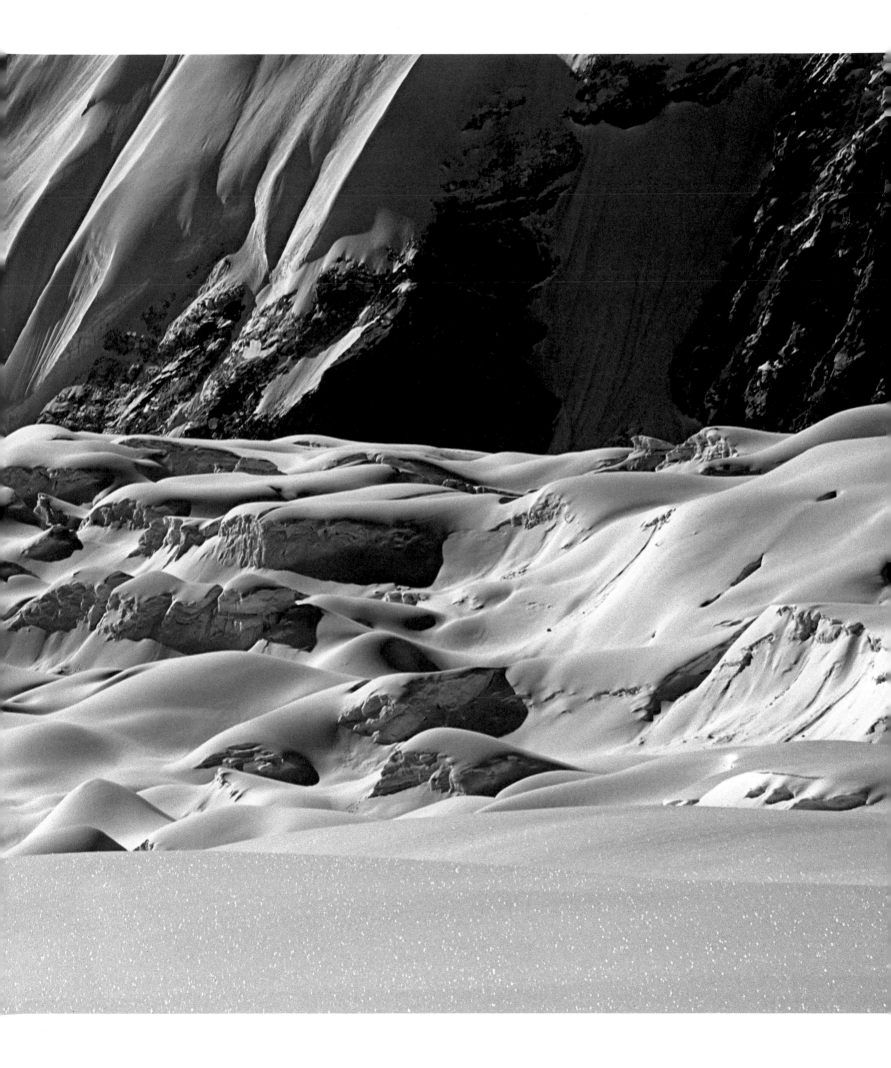

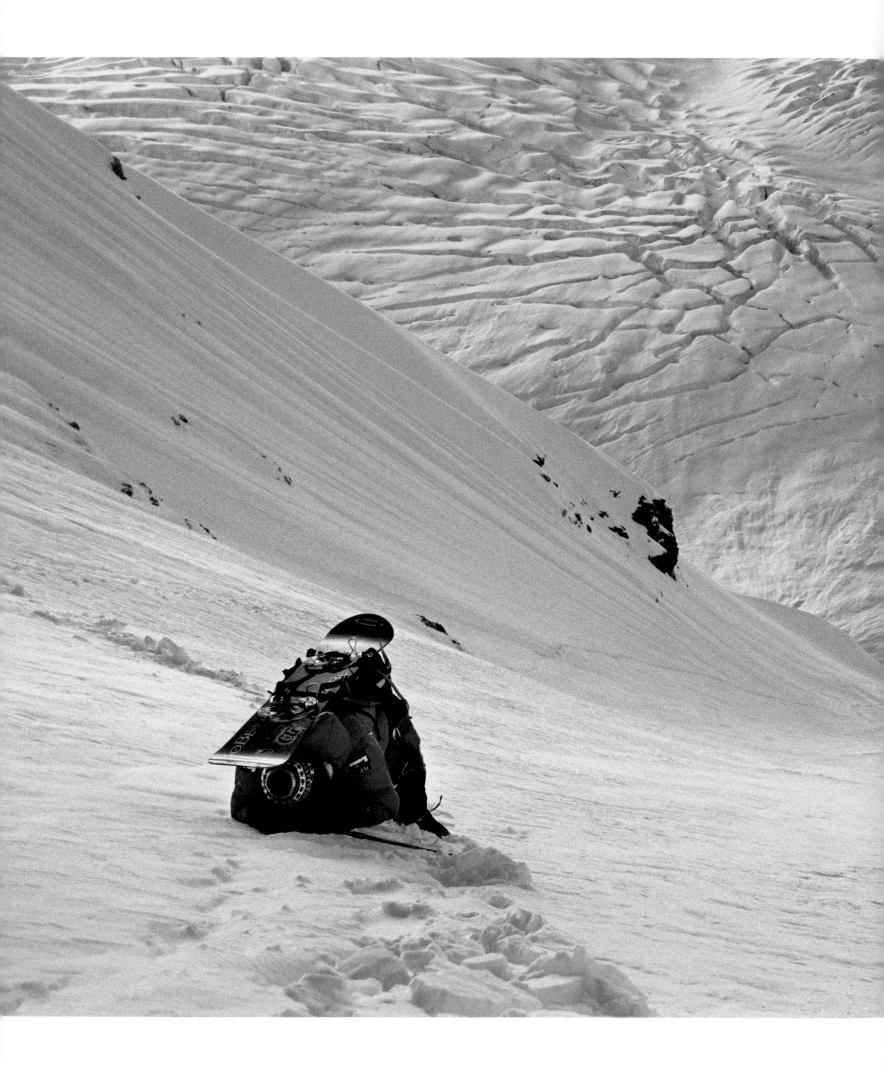

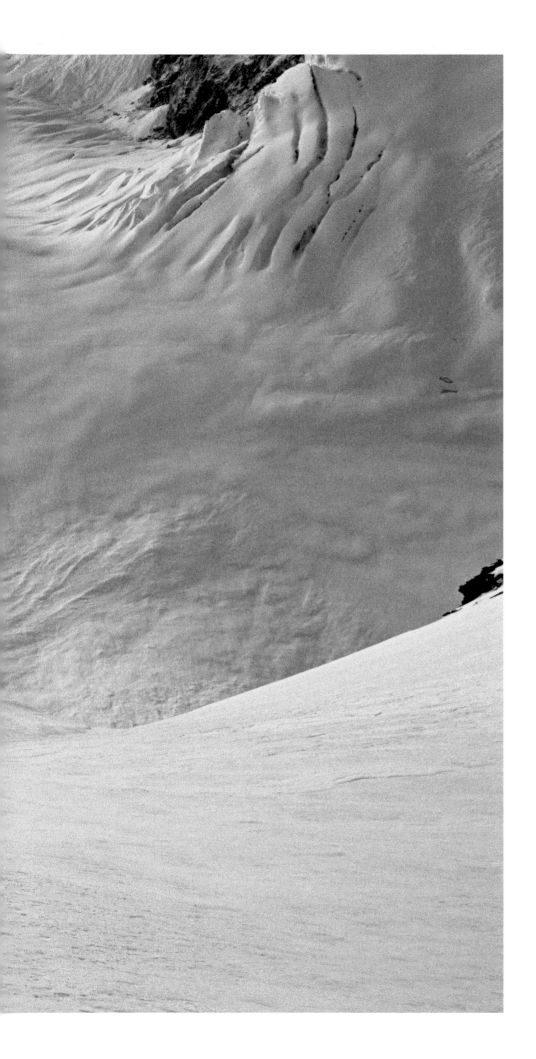

**LEFT** Stephen Koch fighting a losing battle against the altitude in the Japanese Couloir.

**FOLLOWING** Stephen making his first turns in the Japanese Couloir on the north face of Everest.

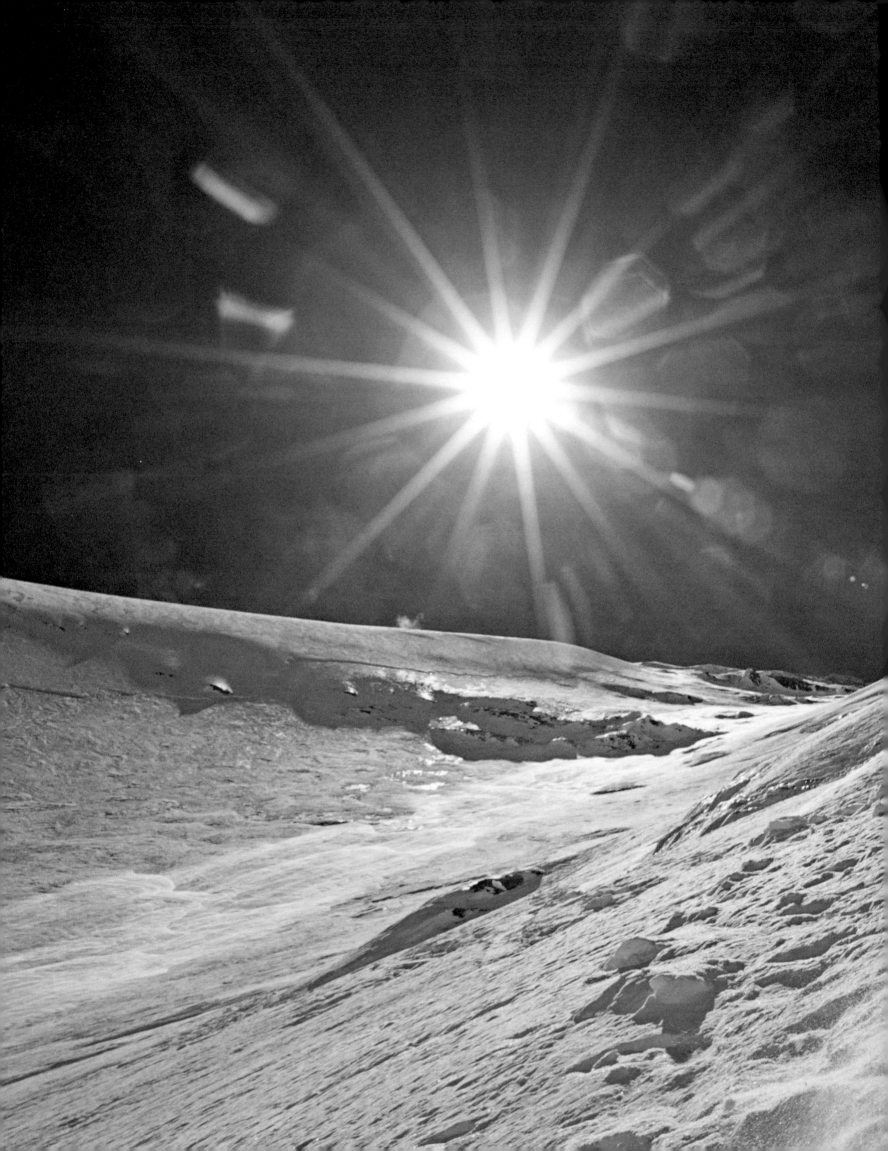

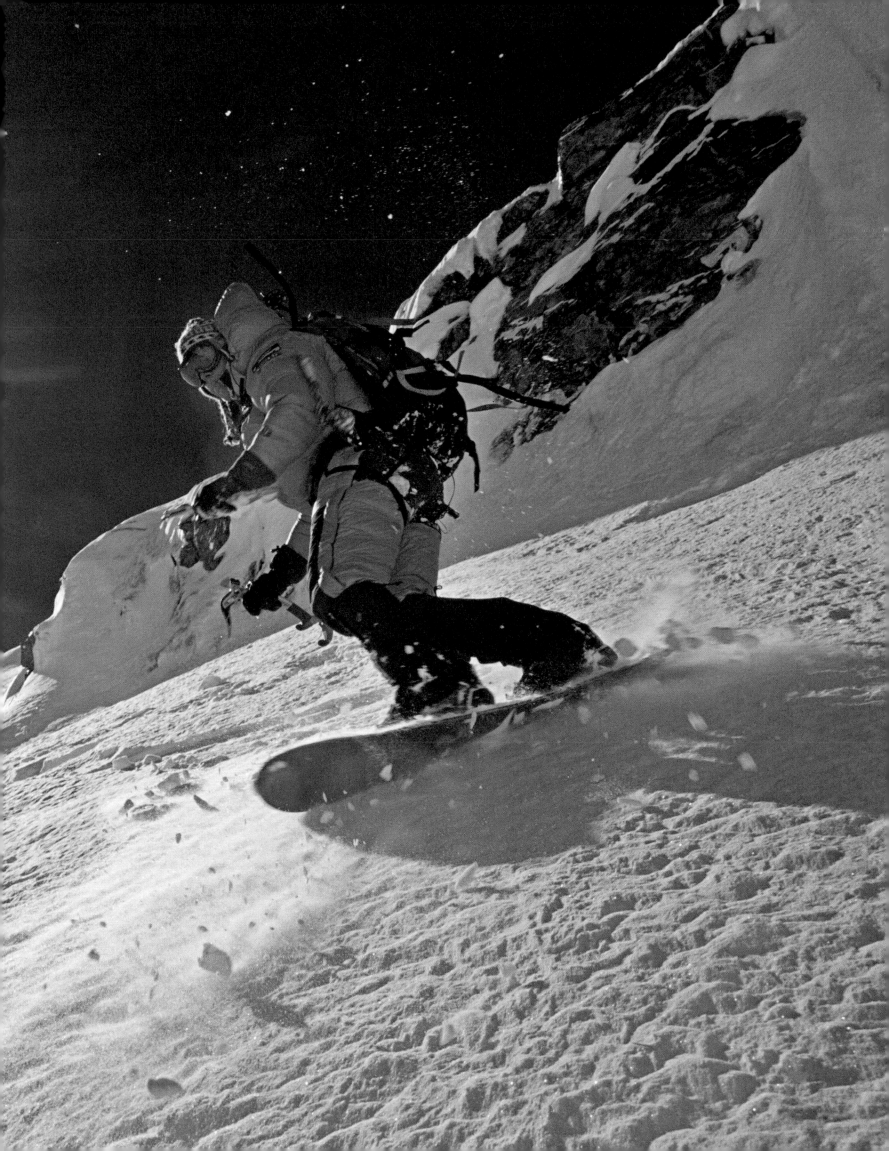

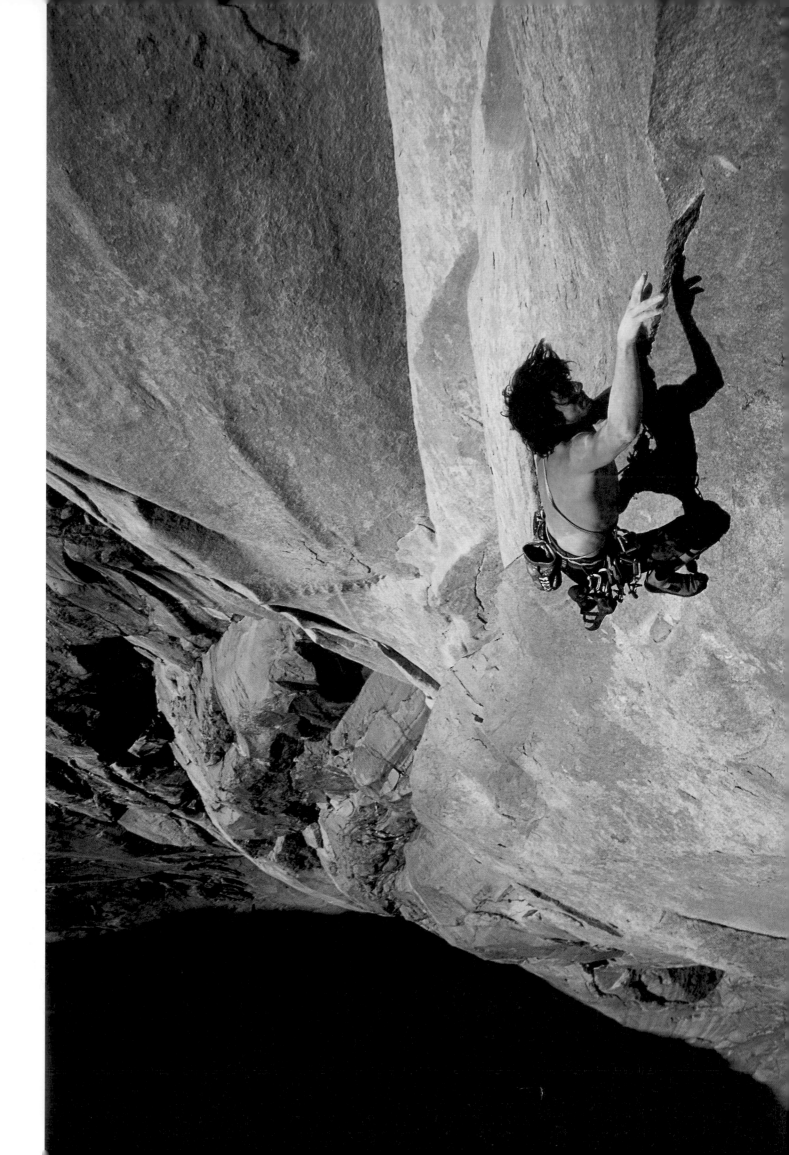

# DEAN POTTER

Dean Potter was a close friend, a mentor, and one of the most visionary athletes I've ever known. We shot a lot together over the years. I looked up to him.

Dean was a complicated character. He was a mystic and a gladiator. He was mischievous and loved a good laugh but the intensity in which he pushed his physical and mental boundaries intimidated people. He stood six feet five inches tall and his body seemed to be hewn straight out of the miles of granite he climbed every day.

Dean lived by his own set of standards that few others could live up to. He demanded a lot from his friendships, but you couldn't find a more loyal friend when you needed one.

Working with Dean could be difficult. There was an urgency to his life that was hard to keep up with. I learned a lot chasing and photographing Dean on his seemingly endless exploits. He can be credited for my obsessive preparations before shoots. I was petrified of slowing him down while he climbed on El Cap or prepared to cross a terrifying highline. He pushed me to the brink more than a few times.

Dean made groundbreaking free solos, held speed climbing records all over Yosemite, and climbed difficult new alpine routes in Patagonia, often by himself. For two decades, he was the de facto leader of the Yosemite Stone Monkeys and pioneered and refined what he called "the dark arts": free soloing, speed climbing, BASE jumping, wingsuit flying, and highlining. I can't think of another athlete who defined and pushed the edge of so many different sports.

Dean died BASE jumping in Yosemite on May 16, 2015. He was forty-three. I miss him.

OPPOSITE  Dean Potter climbing pitch 25 (5.11d) on Freerider. El Capitan.

FOLLOWING  I took this portrait of Dean watching the sunset from the belay next to Thank God Ledge on the Northwest Regular Route on Half Dome.

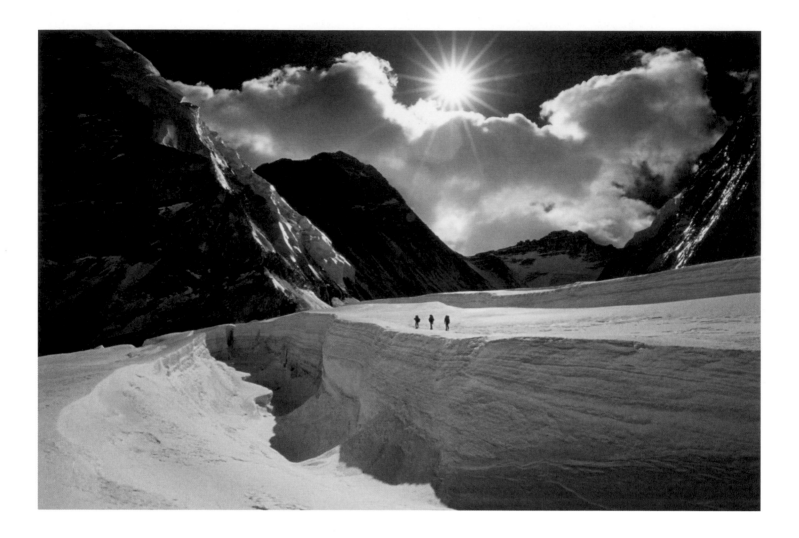

## FILMING EVEREST

In anticipation of a Hollywood feature film recounting the 1996 Everest tragedy, David Breashears was hired in 2004 to climb the peak and film scenic background plates all the way to the summit. David asked me to shoot photographs and film the behind-the-scenes of the production and the climb. I worked on the mountain for two months with David, Ed Viesturs, Veikka Gustafsson, and Robert Schauer.

The experience was a masterclass in climbing Everest and filming on a big production at altitude. I summitted with the team in May. Since I had tried and failed to ski Everest from the north in 2003, I paid close attention to whether or not the terrain on the south side of the mountain was skiable. This helped inform the strategy for my next ski expedition to Everest in 2006.

**ABOVE** David Breashears, Ed Viesturs, and Veikka Gustaffson heading toward Camp 2 on the Western Cwm, Mount Everest.

**OPPOSITE** Mingma Sherpa climbing above the Balcony at 27,750ft on Everest.

**FOLLOWING** Climbing mountains does not usually entail climbing ladders, but on the south side of Everest, ladders, lashed together end to end and installed by climbing Sherpas, are the norm for navigating the lower part of the mountain. David commits to a set of creaking ladders in the Khumbu Icefall.

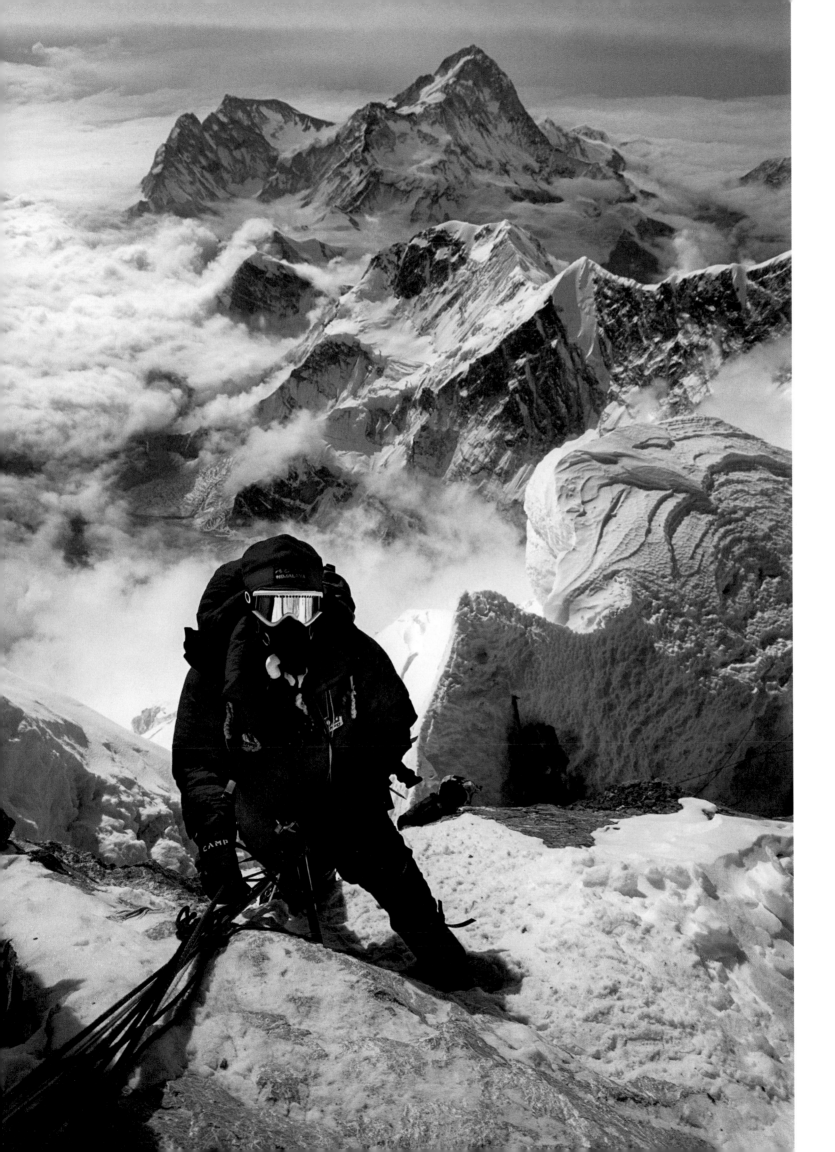

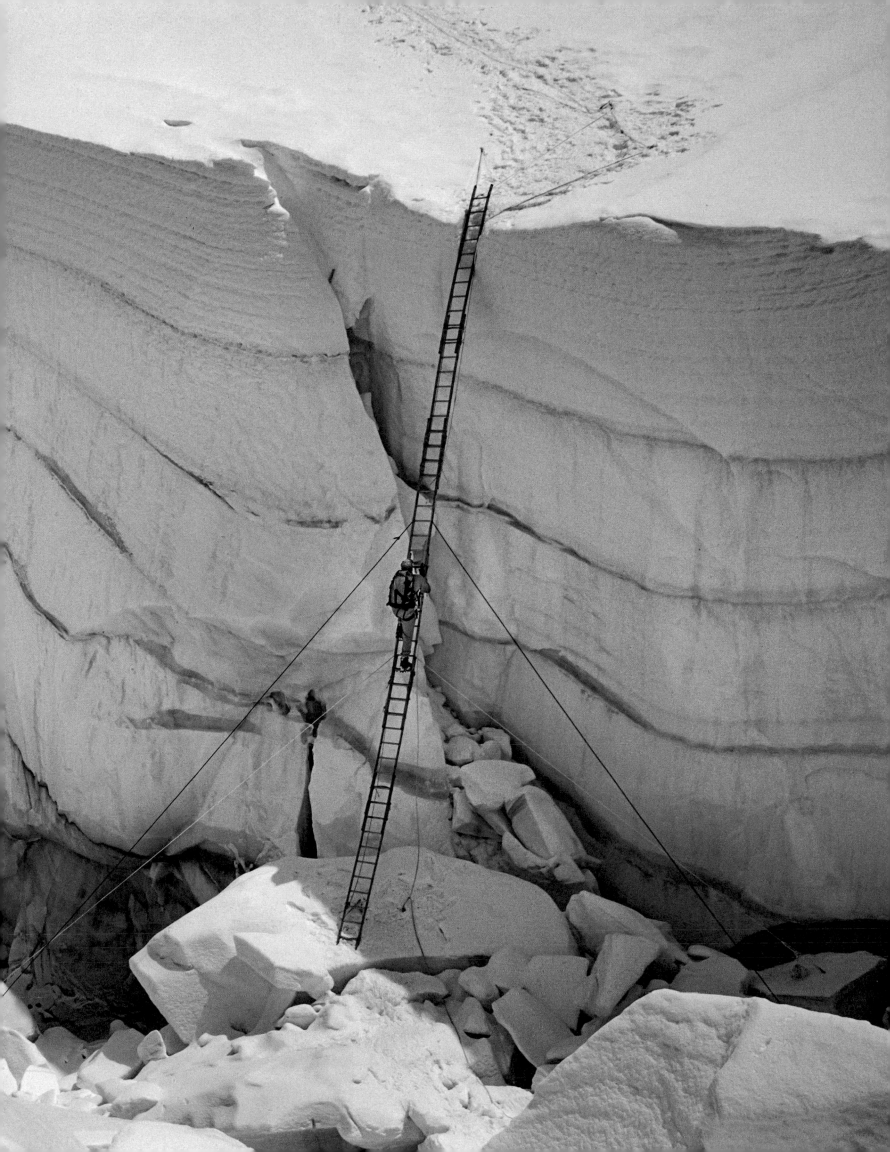

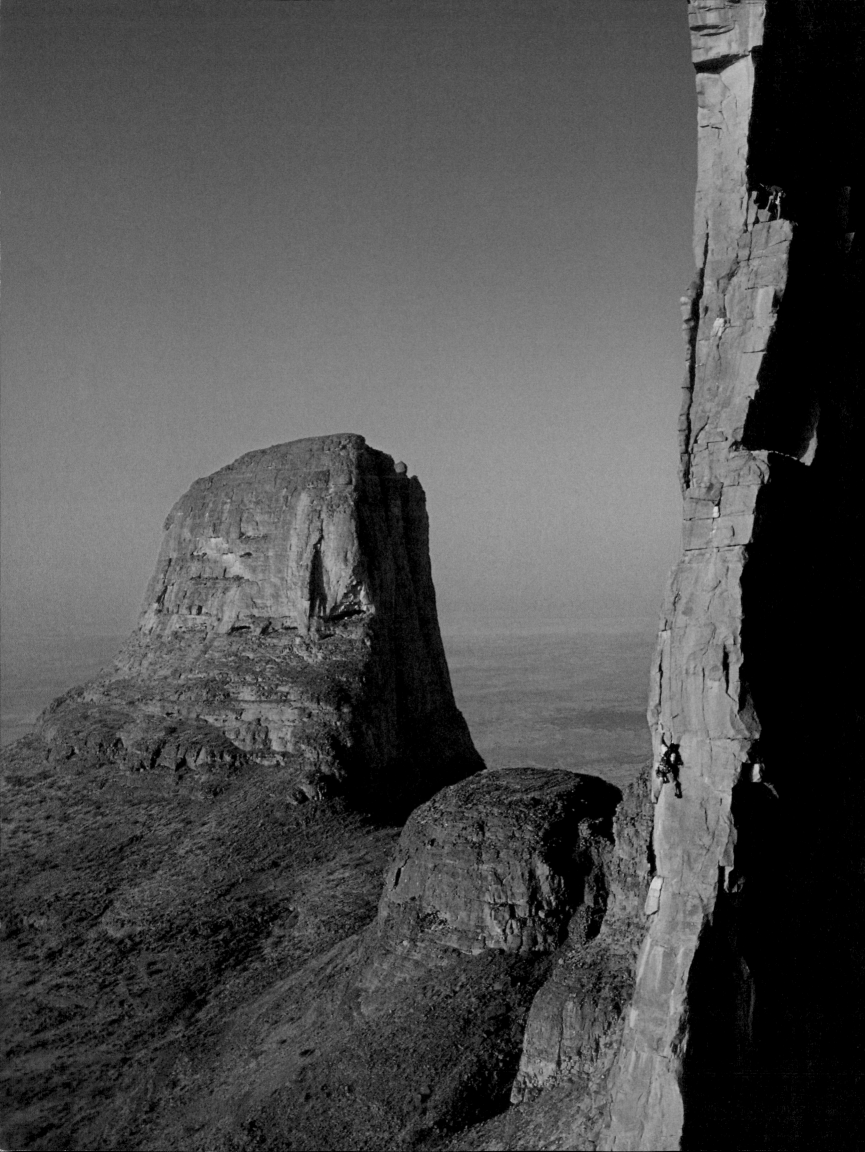

MALI 2004

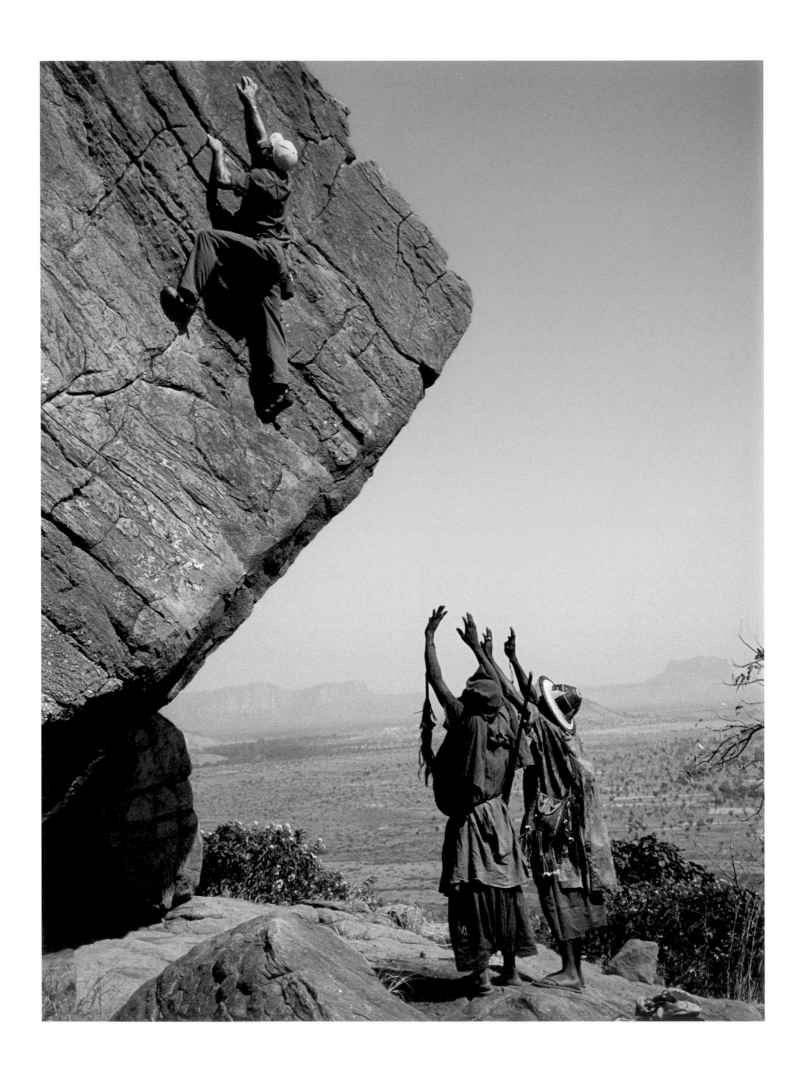

# The best assignments present you with images you never imagined seeing.

Instead of focusing on climbing, this trip to Mali was my first expedition where I prioritized photography. I was assigned to follow North Face climbers Cedar Wright and Kevin Thaw and shoot the expedition. In the process, I wanted to make images that captured the essence of the desert and the people who inhabited it. I also hoped to make pictures no one had ever seen before.

Our climbing destination was the Hand of Fatima, a complex of the tallest freestanding sandstone towers in the world. Sitting deep in the southern Sahara, the Hand of Fatima resembles fingers reaching toward the sky. Each finger symbolizes one of the Five Pillars of Islam: profession of faith, prayer, almsgiving, fasting, and pilgrimage.

I feel at home in the desert. I love that only the hardiest plants, animals, and people survive there. When we camped in the Bandiagara Escarpment on our way to the Hand of Fatima, we spent a few days with the local Dogon tribe, an ethnic group indigenous to the central plateau of Mali. Many of them lived in the cliff dwellings their ancestors had inhabited for over a millennium. Incredibly gracious, they invited us into their homes and gave us a glimpse into a different world from a different time.

After a thousand miles of driving, we arrived at the colossal towers. When I photograph an area like the Hand of Fatima, I aim to capture its beauty, size, and scale. I want to do justice to the landscape, but over the years, I've learned it's impossible to do true justice to any landscape. Landscapes have moods. Light changes constantly. The way landscapes look and feel is forever dynamic. Since I can't capture the landscape in its entirety, I do my best to imbue each frame with the feeling of the place that hopefully gives a sense of the whole.

Over two weeks, we climbed miles of bird-guano-filled cracks and endured the choking bouts of harmattan winds that seemed to carry all the sand in the Sahara. We also endured hours of downtime, shriveling in the heat, waiting for the rock to cool off enough in the shade to be able to touch, let alone climb it.

By our trip's end we managed to climb all the towers. It took most of the trip, but I finally found the image I wanted. I would need to position myself high on one of the towers called Kaga Pumori to capture an interesting perspective of Cedar and Kevin climbing the 2,500-foot Kaga Tondo tower. The climbers would give the photo scale. The high angle would illustrate the tower's height, and the shadows in the backdrop would show all five fingers. We spent our last day rigging ropes and climbed into position at sunset.

When the perfect shot lines up, my heart races. I triple-check my settings. I almost forget to push the shutter button as I look through the viewfinder because sometimes I just want to enjoy what's inside the frame.

**PREVIOUS** Kevin Thaw and Cedar Wright climbing the south pillar of Kaga Tondo. At over 2,500 feet from the base to the summit, Kaga Tondo is the tallest freestanding sandstone tower in the world.

**OPPOSITE** Dogon villagers spot Cedar while he tries one of the many highball boulder problems in the Bandiagara, Mali.

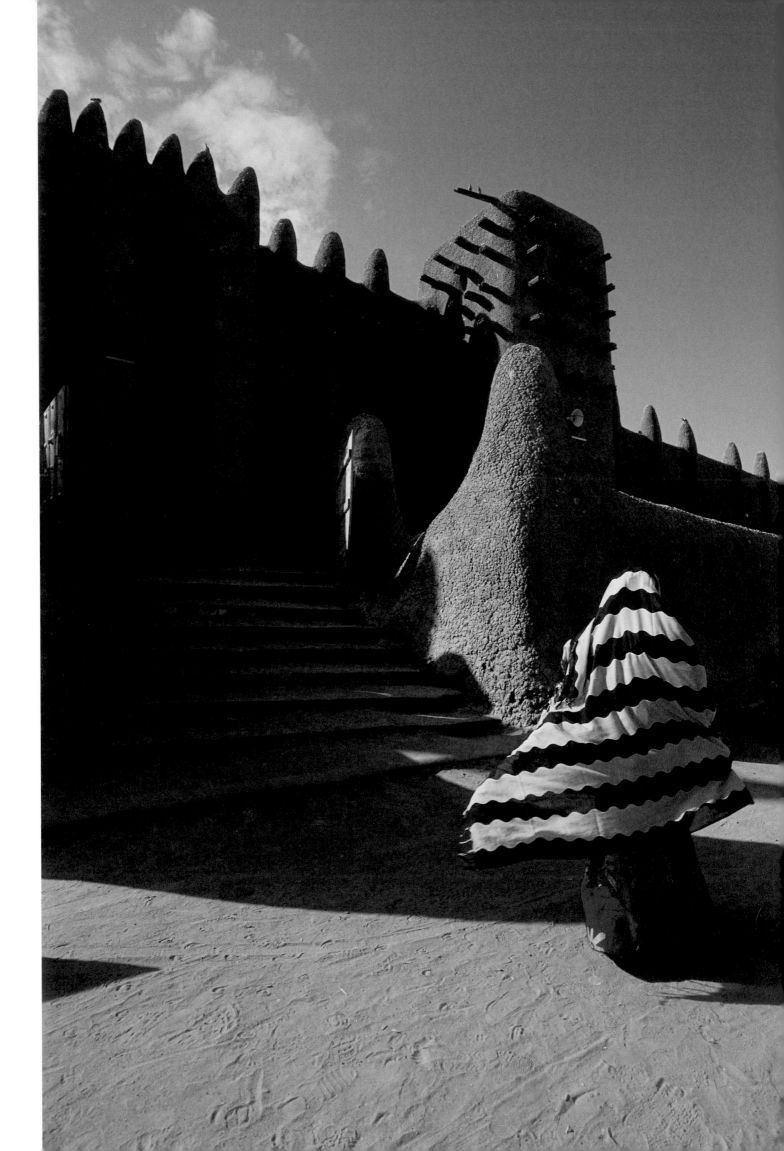

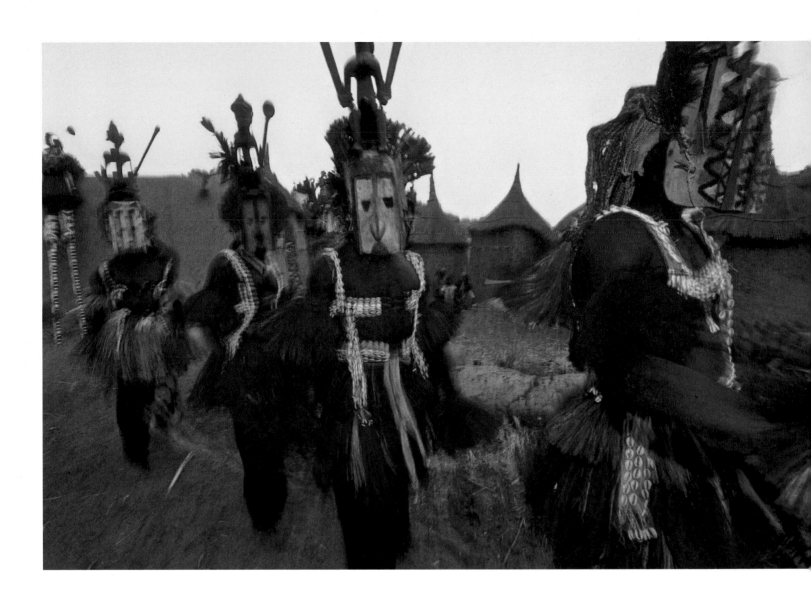

**ABOVE** Dogon dancers. Bandiagara, Mali.

**OPPOSITE** Great Mosque of Djenné. Djenné, Mali.

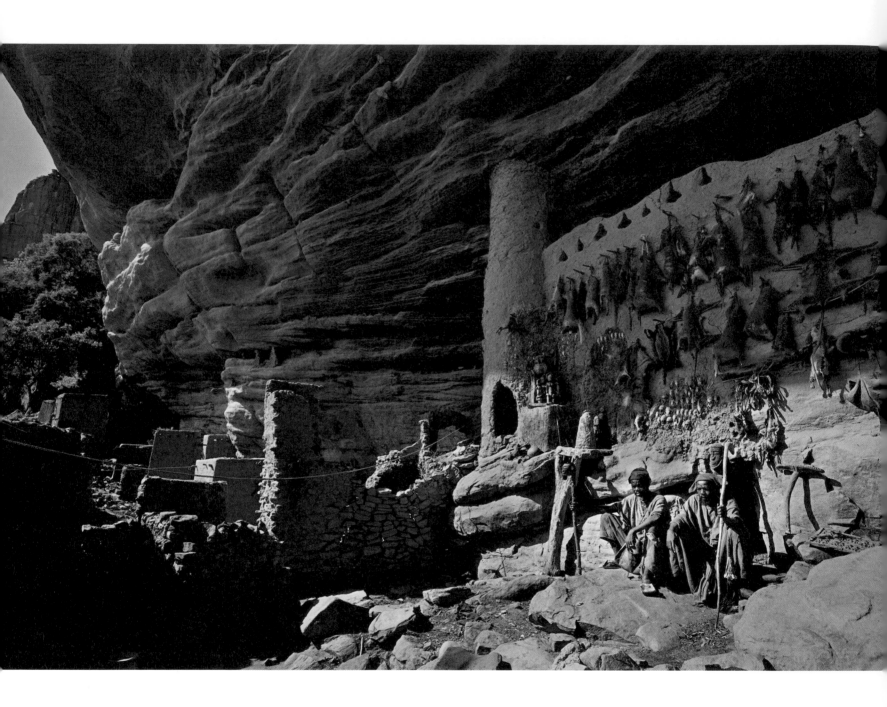

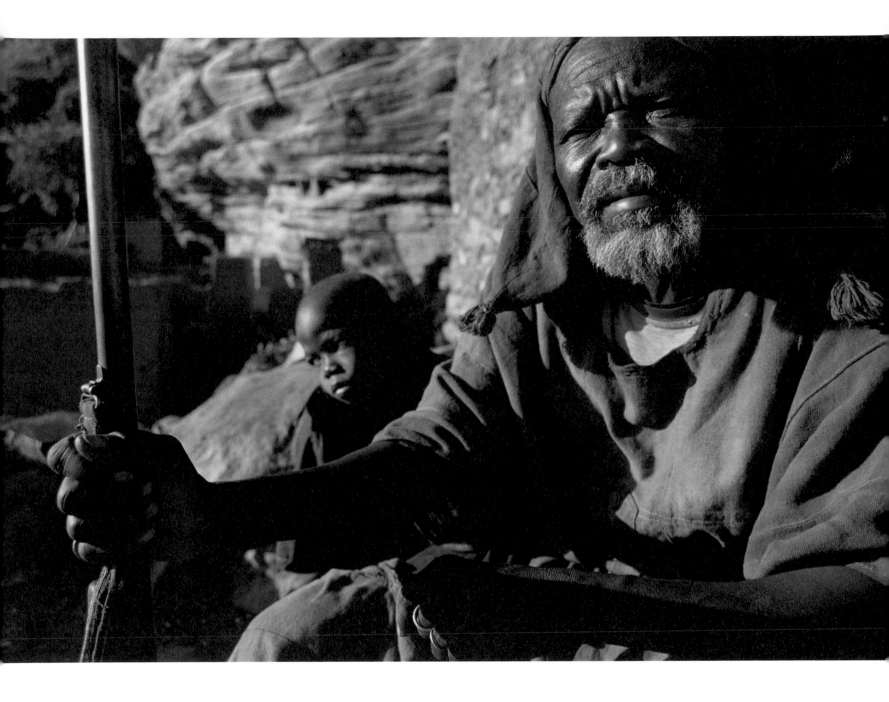

**OPPOSITE** Dogon villagers taking in the first light of day. Their dwellings are built straight into the sandstone cliffs. Bandiagara, Mali.

**ABOVE** A Dogon elder sits with his grandson at the entrance to their home.

**RIGHT**  The Hand of Fatima formation outside of Hombori, Mali.

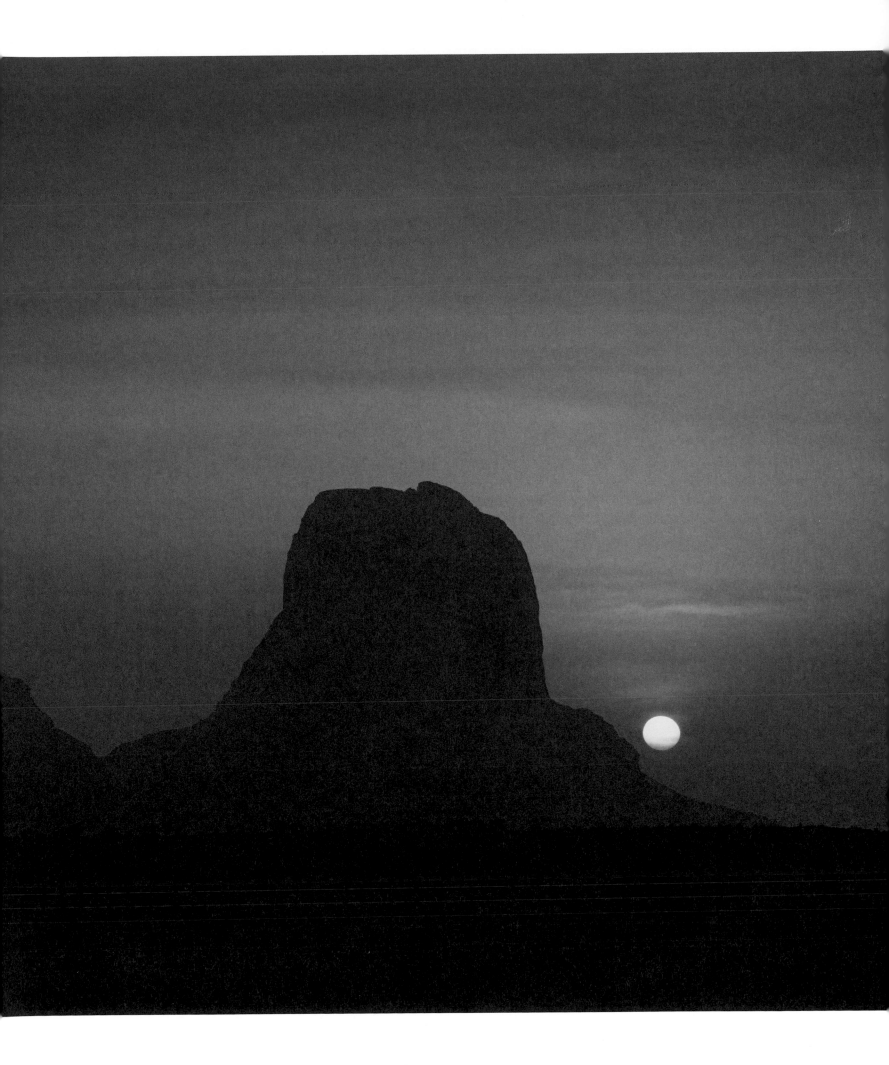

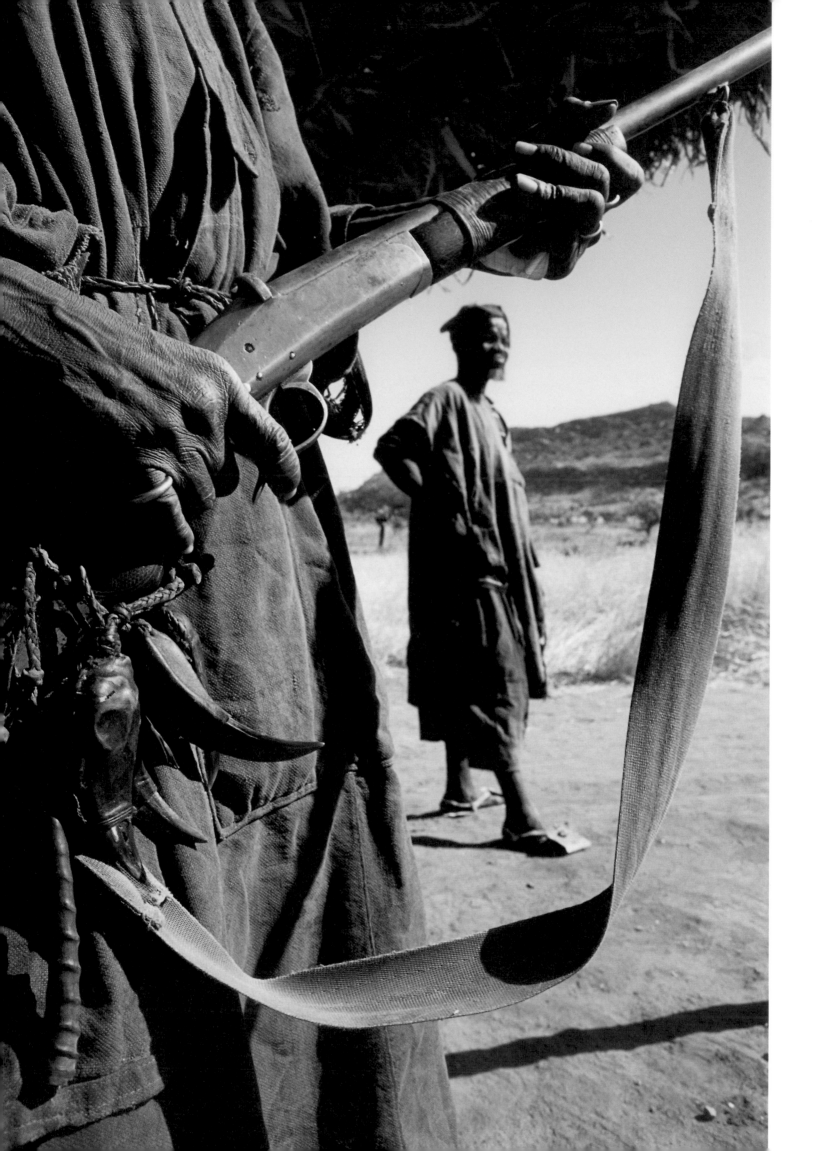

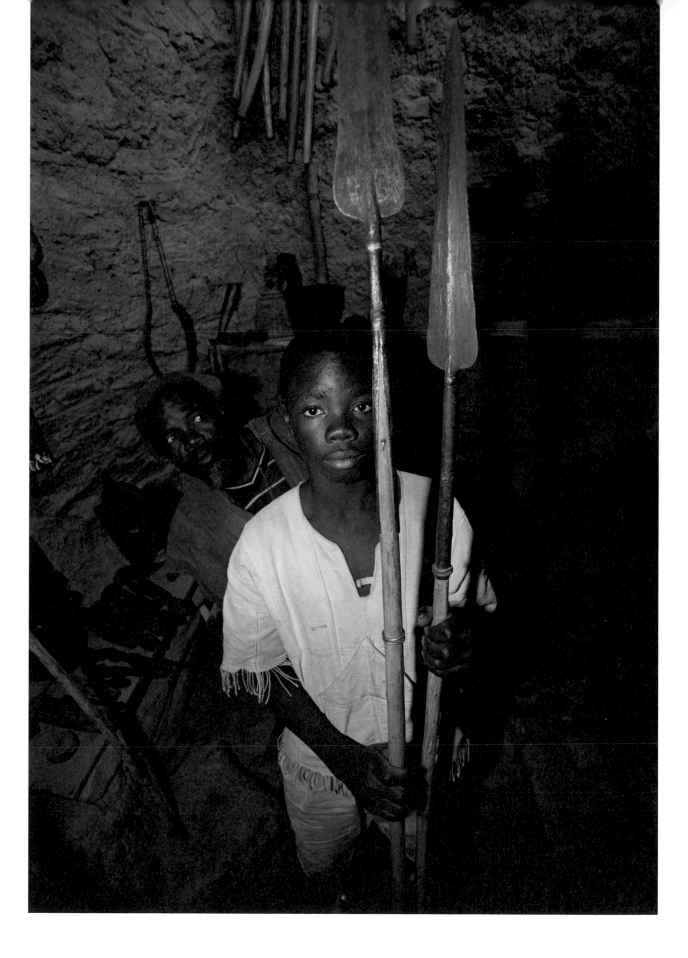

**OPPOSITE** Dogon hunters. Bandiagara, Mali.

**ABOVE** A Dogon son and his father showcase their snake-hunting spears. Bandiagara, Mali.

**FOLLOWING** Cedar Wright climbing perfect sandstone high above the Sahara on Kaga Pumori, one of the "fingers" on the Hand of Fatima.

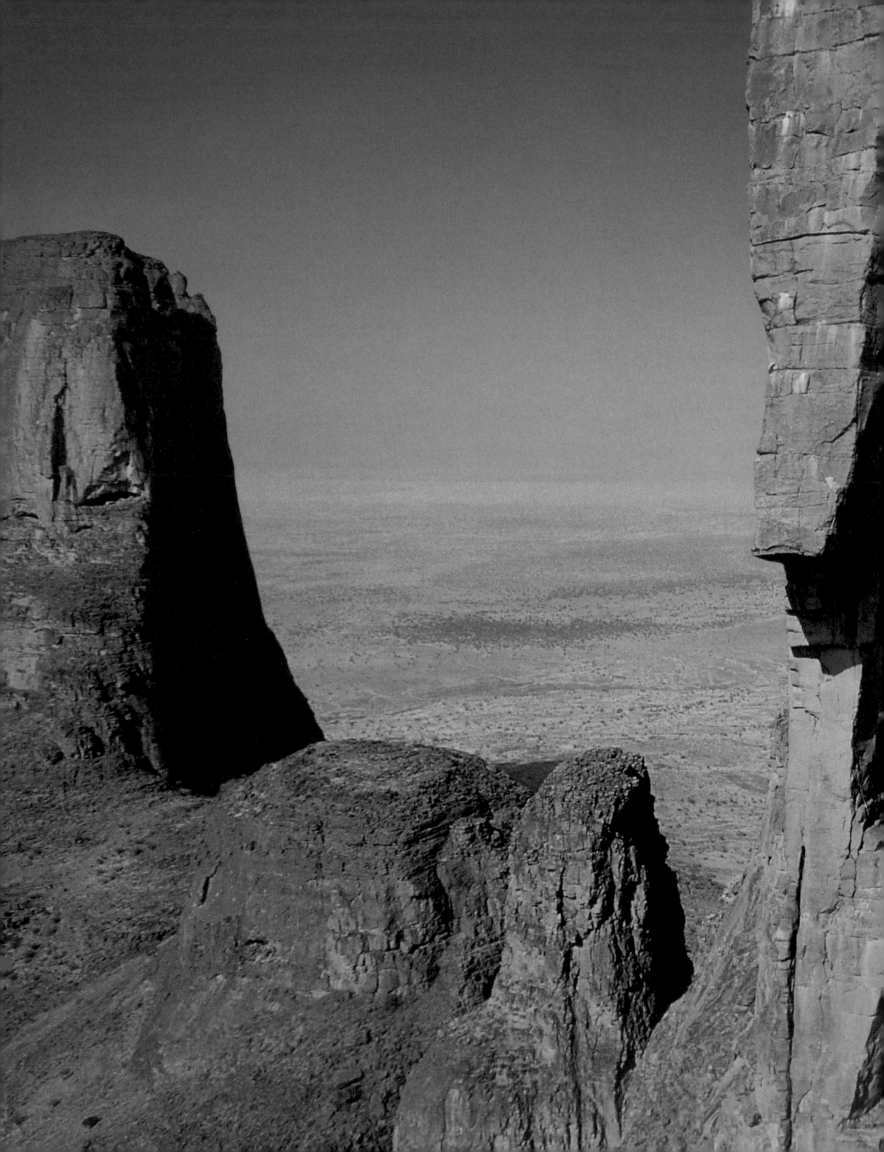

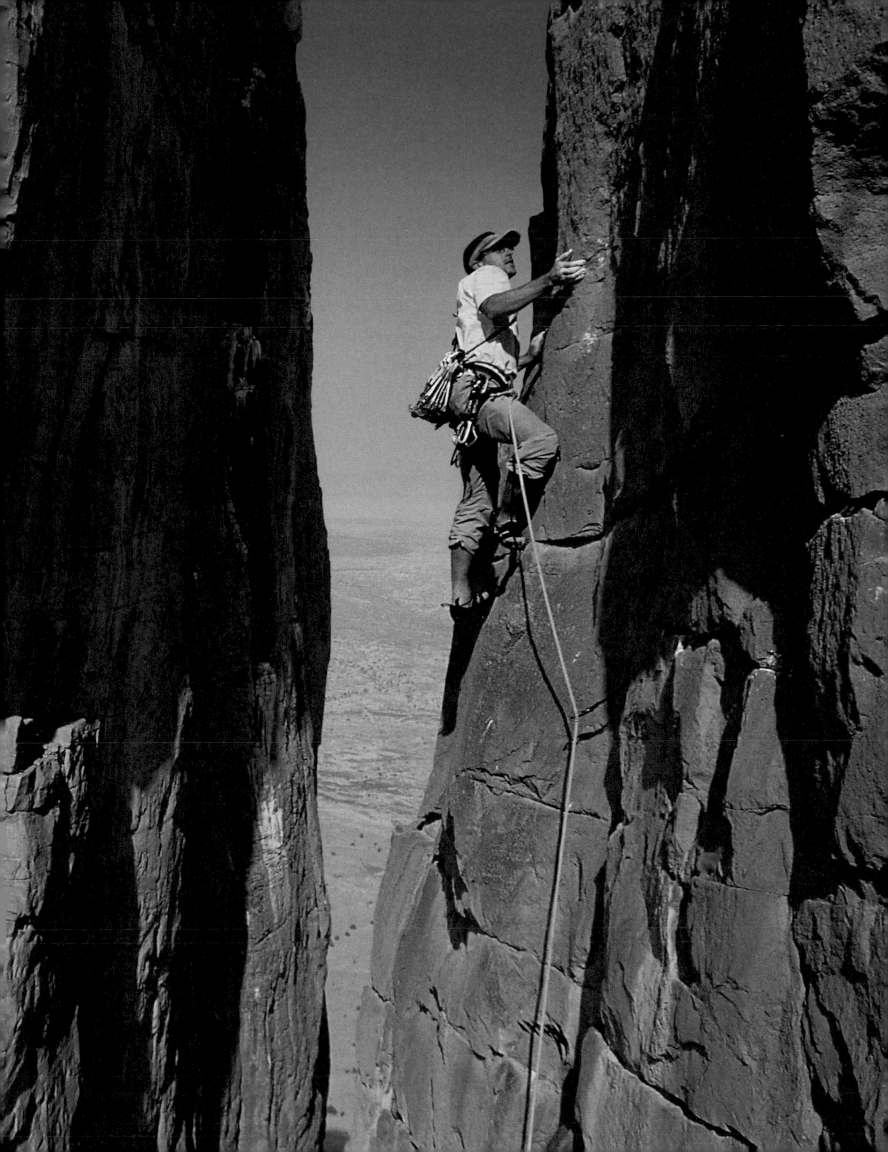

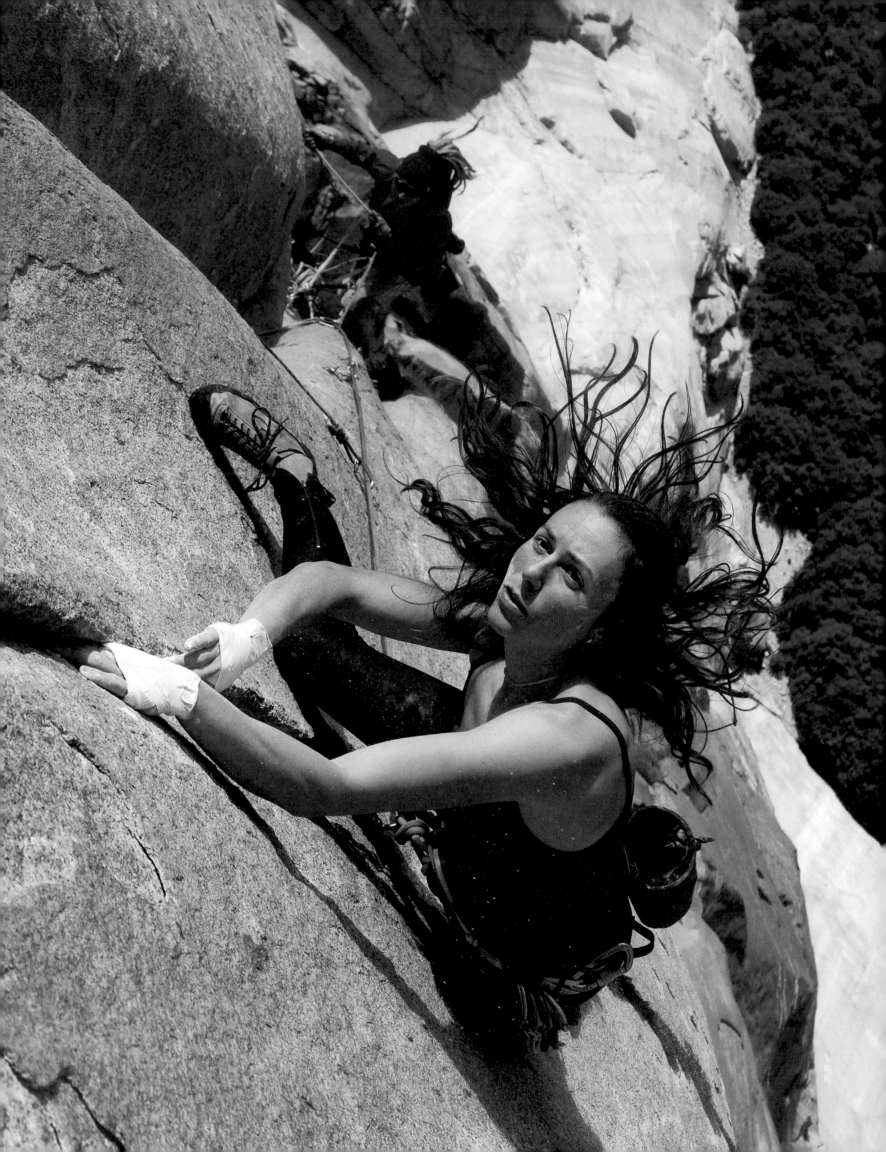

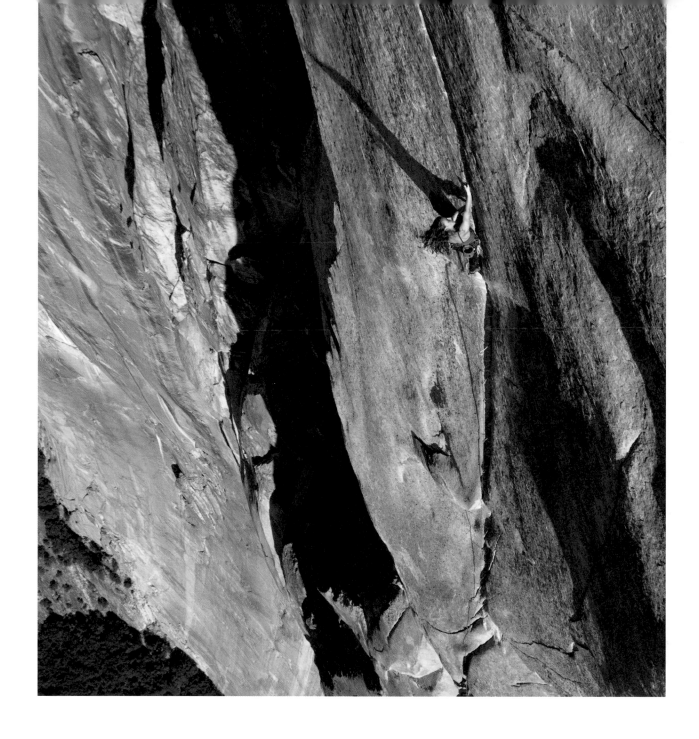

## STEPH DAVIS

I first met Steph Davis in Yosemite's dusty Camp 4 parking lot. She was living out of an old green Ford Ranger. I had just started taking pictures and Steph was one of my first creative collaborators. We shot together on countless trips to Yosemite and the deserts of Utah. She was the subject of my images, but she was also the one who found the best climbs to photograph, figured out when we would have the best light, and often helped rig my ropes to shoot from. My photographs of Steph were among some of my first published images.

Steph sought out big challenging climbs both in Yosemite and abroad. She climbed difficult first ascents in the Karakoram, and was the first woman to climb Torre Egger, and all the peaks in the Fitzroy massif, in Patagonia. In Yosemite, she made the first female free ascent of the coveted thirty-five-pitch Salathe Route on El Cap. She also became only the second woman to free-climb El Cap in one day. Steph's achievements set a high bar for future generations of climbers. Steph has gone on to become an author and a world-class BASE jumper.

**OPPOSITE** Steph Davis flows through a technical section at the base of the headwall on the Salathe Route, El Capitan, Yosemite National Park.

**ABOVE** Steph climbing the steep headwall pitch (5.13b) and crux of the Salathe Route, one of the most spectacular pitches on El Cap.

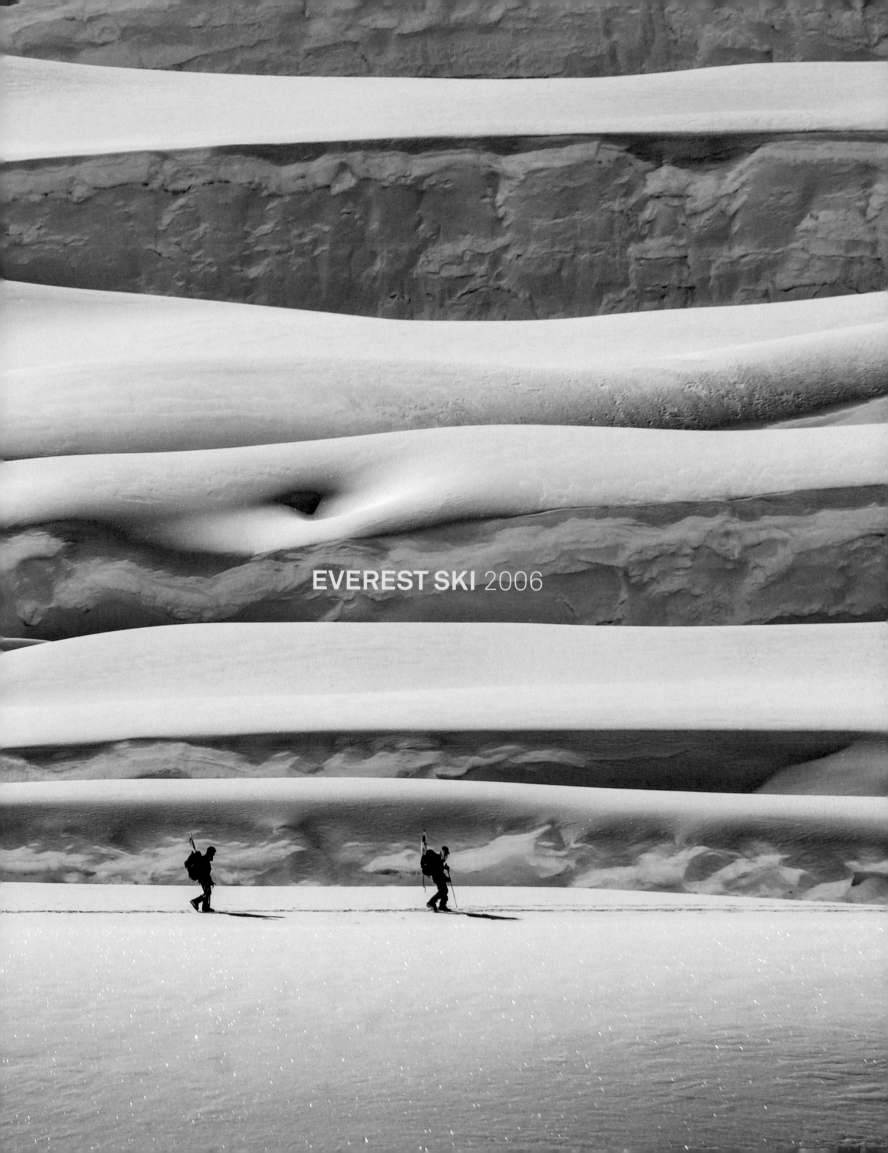

EVEREST SKI 2006

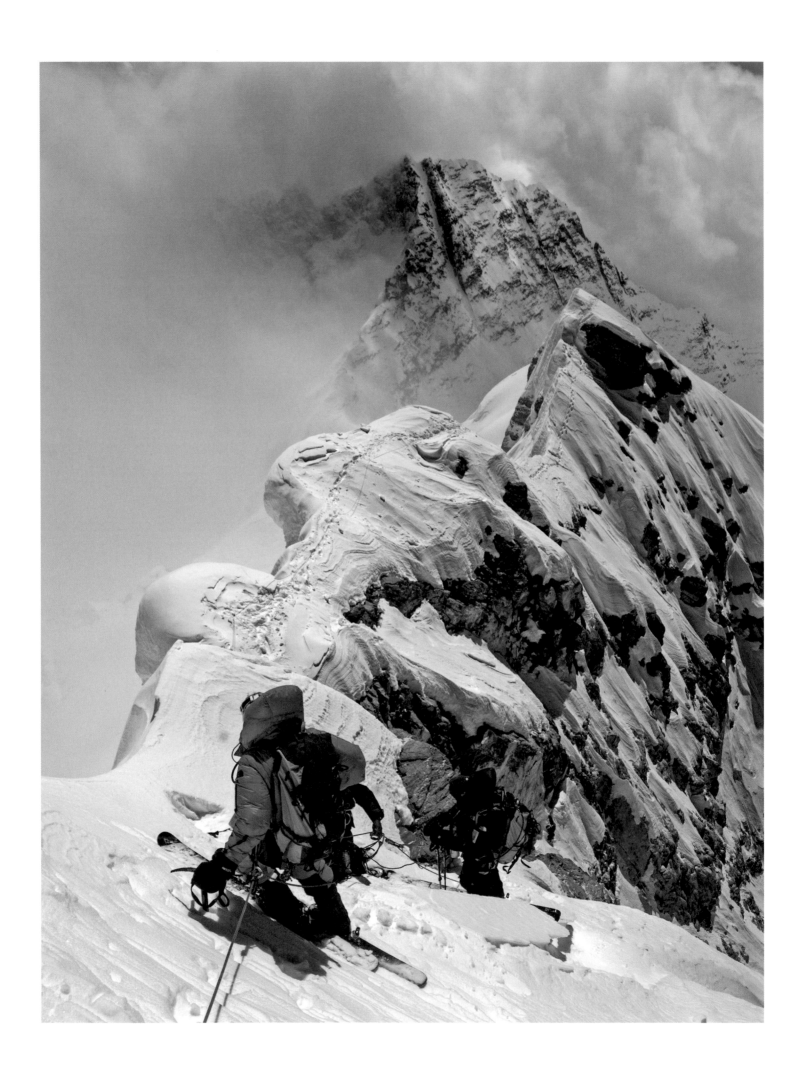

# I never imagined it could take two hours to put on ski boots.

But I'd never tried putting on a pair of frozen, rock-hard boots inside a cramped tent at 26,000ft above sea level. The exertion required felt like doing deadlifts with a plastic bag over my head. I eventually succeeded—a small victory relative to the task at hand. In a few minutes I would step into my bindings and ski down the Lhotse Face of the Everest massif with my good friends Rob and Kit DesLauriers.

We had spent a sleepless night at Camp 4, having climbed and skied from the summit the day before. Skiing the South Pillar route on the Lhotse Face would entail descending a slope tilted at 50 degrees for five thousand vertical feet. Conditions were not good: below us stretched an expanse of bulletproof blue ice streaked with intermittent bands of wind-hammered névé that was only marginally more forgiving than the ice. Once we dropped over the edge of the South Col, there would be no safe exit until we were at the bottom of the face. We would be going down one way or another.

Our journey to this moment began in spring 2006, when Kit, who had just won her second straight Women's Free Skiing World Championship, called me. Kit had been working toward climbing and skiing the Seven Summits, and only Everest remained on her list. She wanted to know if skiing it was possible. I had assessed Everest for ski routes on prior trips, and I told her that I thought it was "skiable," a term open to interpretation. That summer, I trained with Kit and her husband, Rob, a legendary skier himself.

By September, Kit, Rob, eleven-time summiter Dave Hahn, and I arrived at Everest, where twelve hand-picked Sherpa friends heroically built a route through the Khumbu Icefall to the summit. We were the only team on the mountain during the post-monsoon season.

To ski Everest, you need to leave enough gas in the tank during the ascent to make precise and committing turns on the descent. But the mental discipline necessary to constantly anticipate and make split-second decisions about potentially lethal predicaments is even more important. Catastrophic events like avalanches are certainly a hazard, but underestimating smaller, seemingly innocuous problems probably poses an even greater risk. When temperatures drop to -40°F, something as insignificant as removing a glove to adjust a jammed zipper could initiate a series of compounding mistakes that might kill you.

We hadn't slept or eaten more than a few bites for three days. After a windy night spent staring at the flapping nylon ceiling of our tent, we double-checked our ski bindings and slid over the edge of the Lhotse Face. Skiing our line would require two hours of unwavering focus. The steel edges of our skis penetrated the ice only a millimeter or two. Every jump turn had to be perfectly executed. If you blew an edge you'd shoot straight down the mountain. We call this type of terrain a "no fall zone" for obvious reasons.

When we reached the bottom, Kit, Rob, and I became the first Americans to ski from the summit of Everest, and the first ever to ski the South Pillar route. We laughed about spending two months on the mountain to ski the worst run of our lives.

**PREVIOUS** Kami Sherpa and Mingma Sherpa carrying loads toward Camp 2 through the Western Cwm on Mount Everest.

**OPPOSITE** Kit DesLauriers, in yellow, and Rob DesLauriers, in black, roping up at 28,500ft to rappel the Hillary Step during our ski descent on the southeast ridge of Everest.

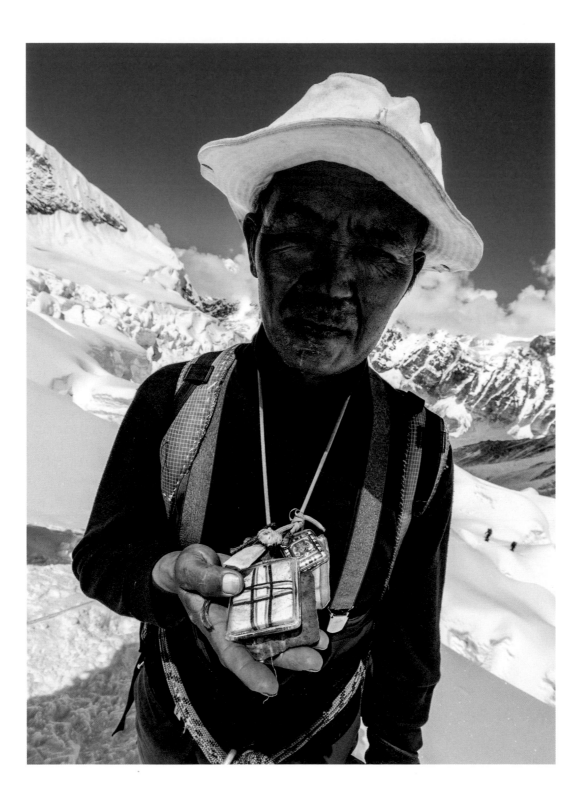

**ABOVE** Panuru Sherpa holding amulets for safe passage. Each amulet is blessed by a Buddhist lama and has a special mantra concealed inside it.

**OPPOSITE** The "Icefall Doctors" build a ladder route through the Khumbu Icefall at the foot of the Western Cwm. Without the strength and efforts of the Sherpa team, we would never have been able to climb and ski the mountain.

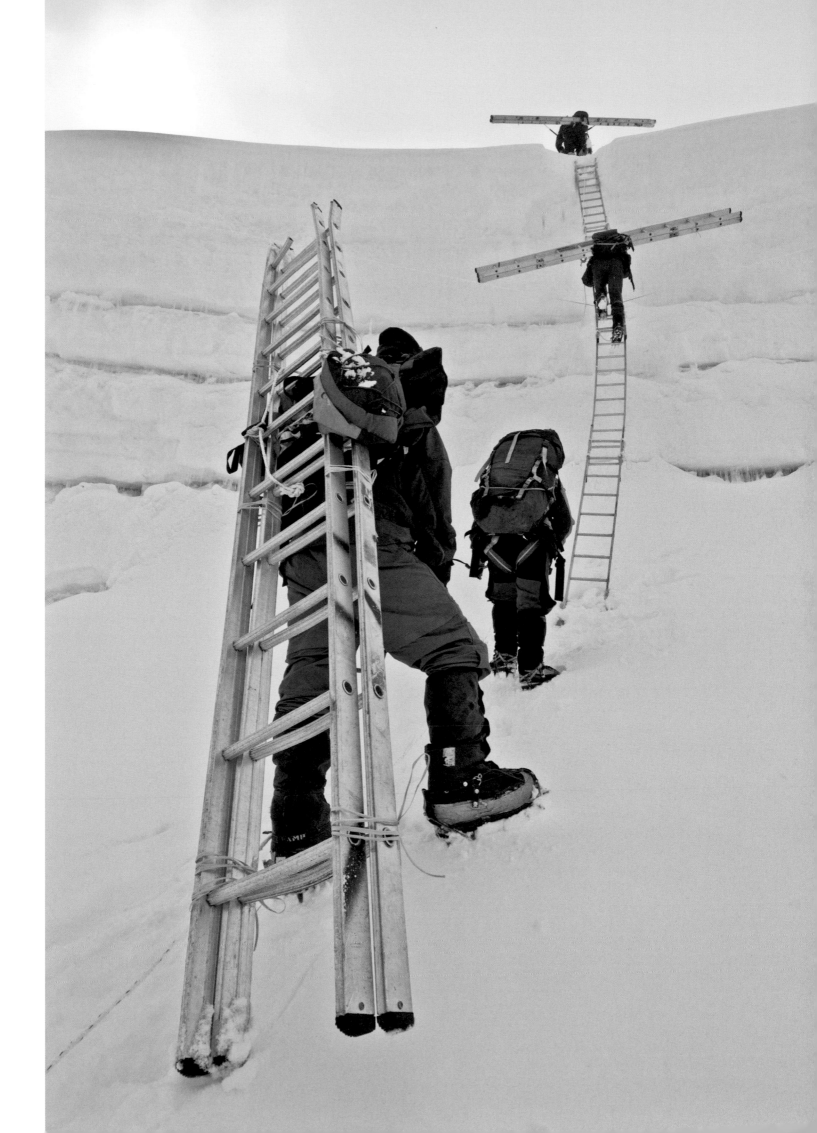

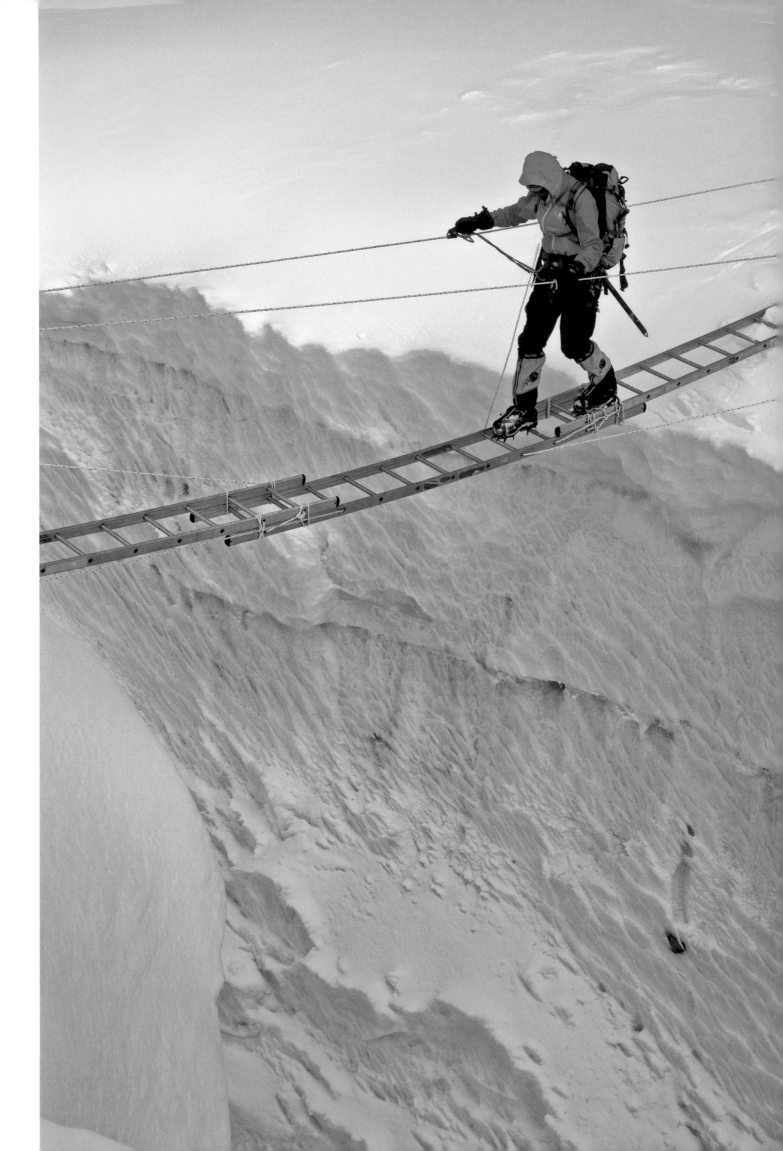

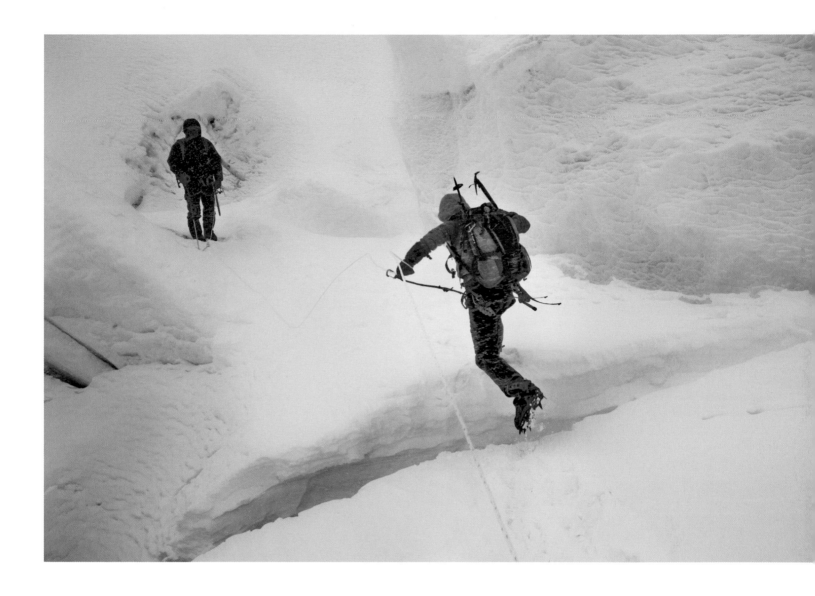

**ABOVE** Kit DesLauriers crevasse hopping at 20,000ft in the Khumbu Icefall as her husband, Rob DesLauriers, looks on. The Khumbu Icefall is the most unstable part of the mountain and is considered the most dangerous aspect of climbing Everest from the south side.

**OPPOSITE** Kit crossing one of many ladders bridging crevasses on the Western Cwm.

**FOLLOWING** Kit entering the Western Cwm above the Khumbu Icefall.

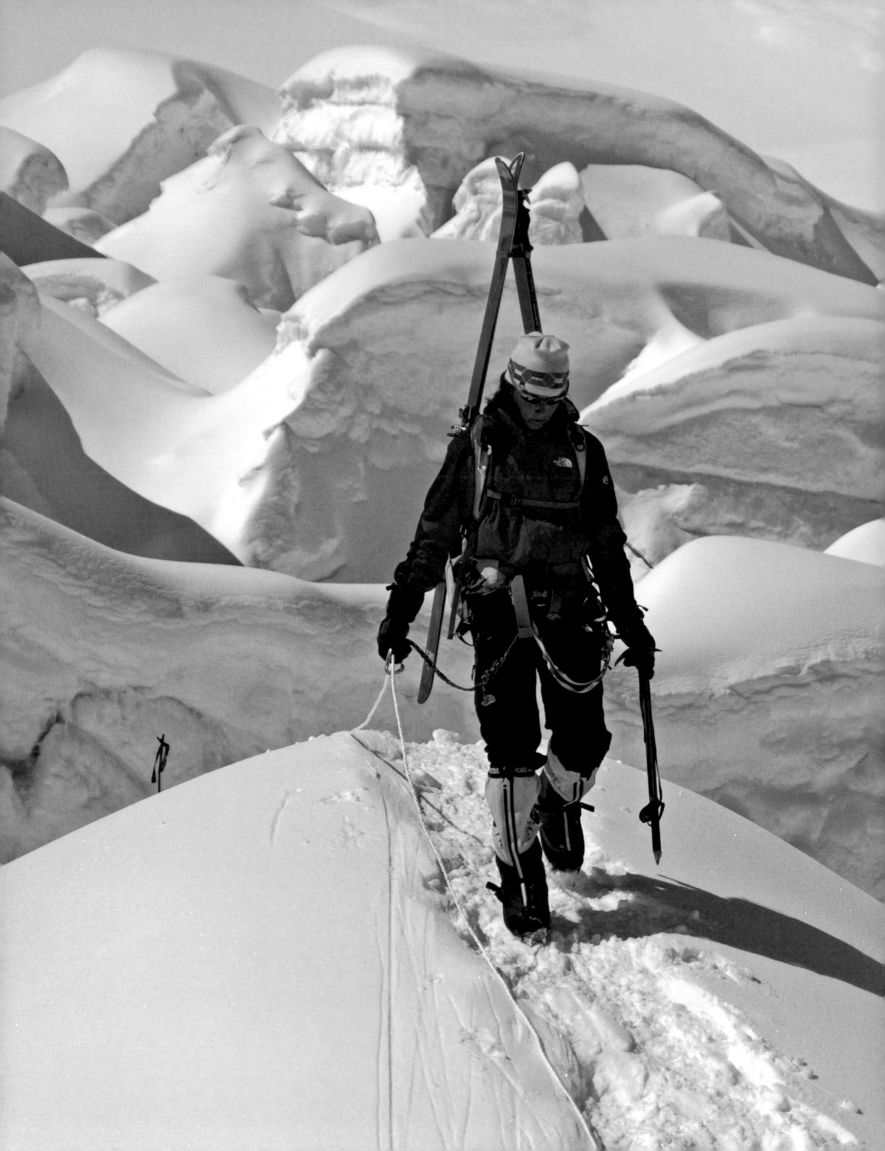

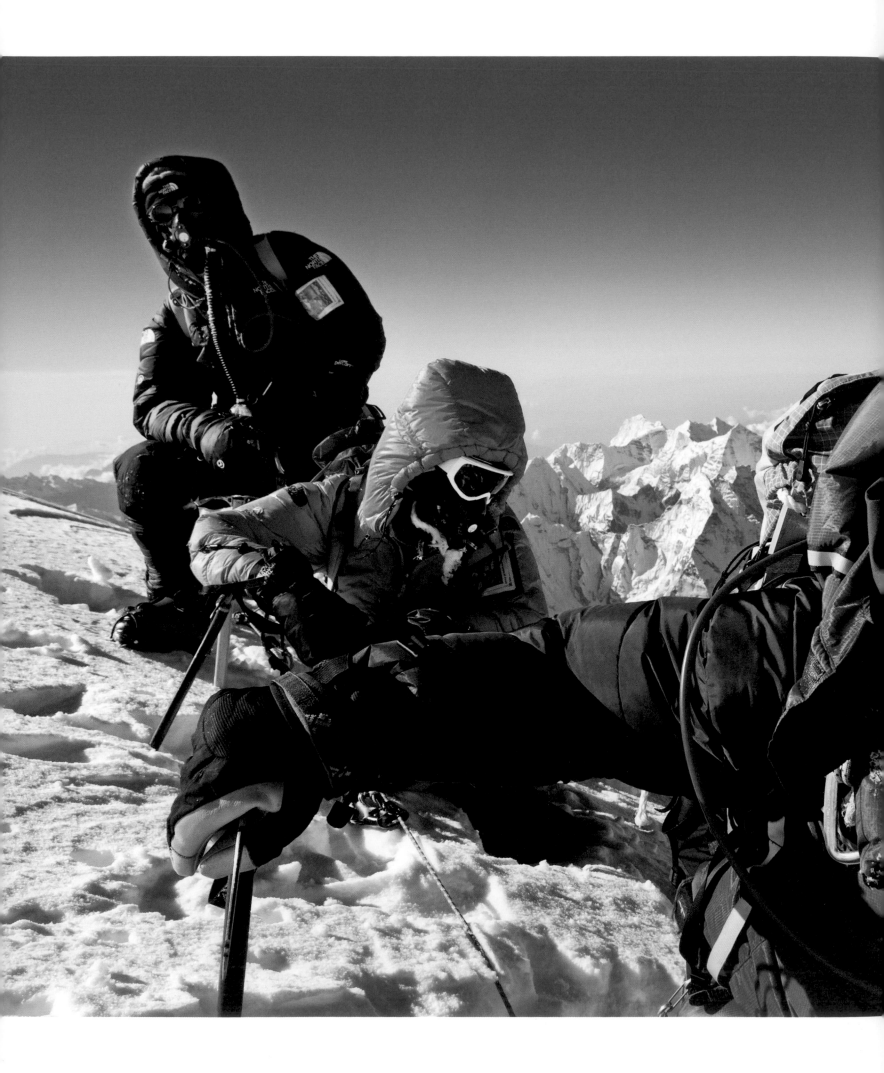

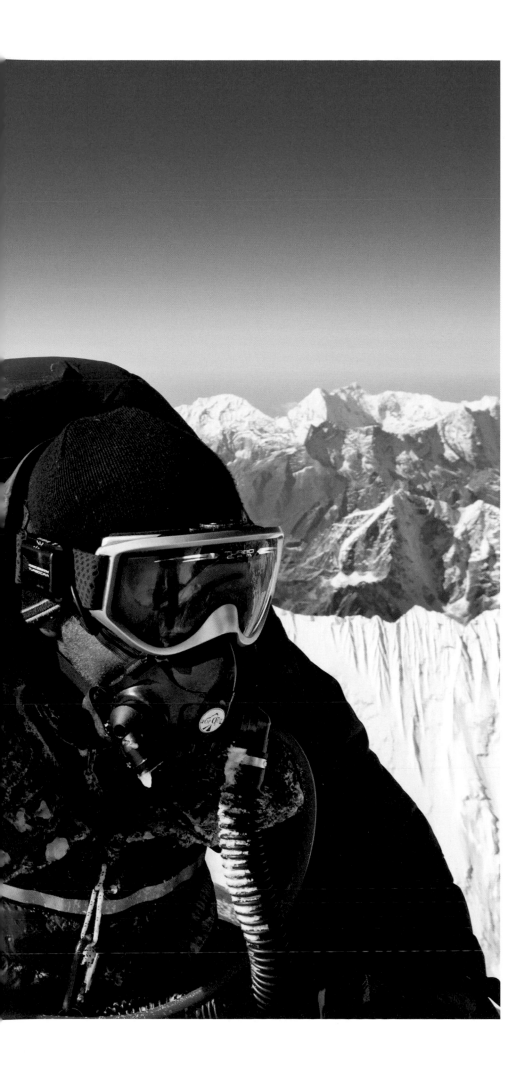

**LEFT** Summit day: From left, Rob DesLauriers, Kit DesLauriers, and Dave Hahn taking a break on the South Summit of Everest before climbing the final summit ridge.

**FOLLOWING** Kit and Rob, approaching the summit of Mount Everest on October 18, almost two months after arriving at the mountain.

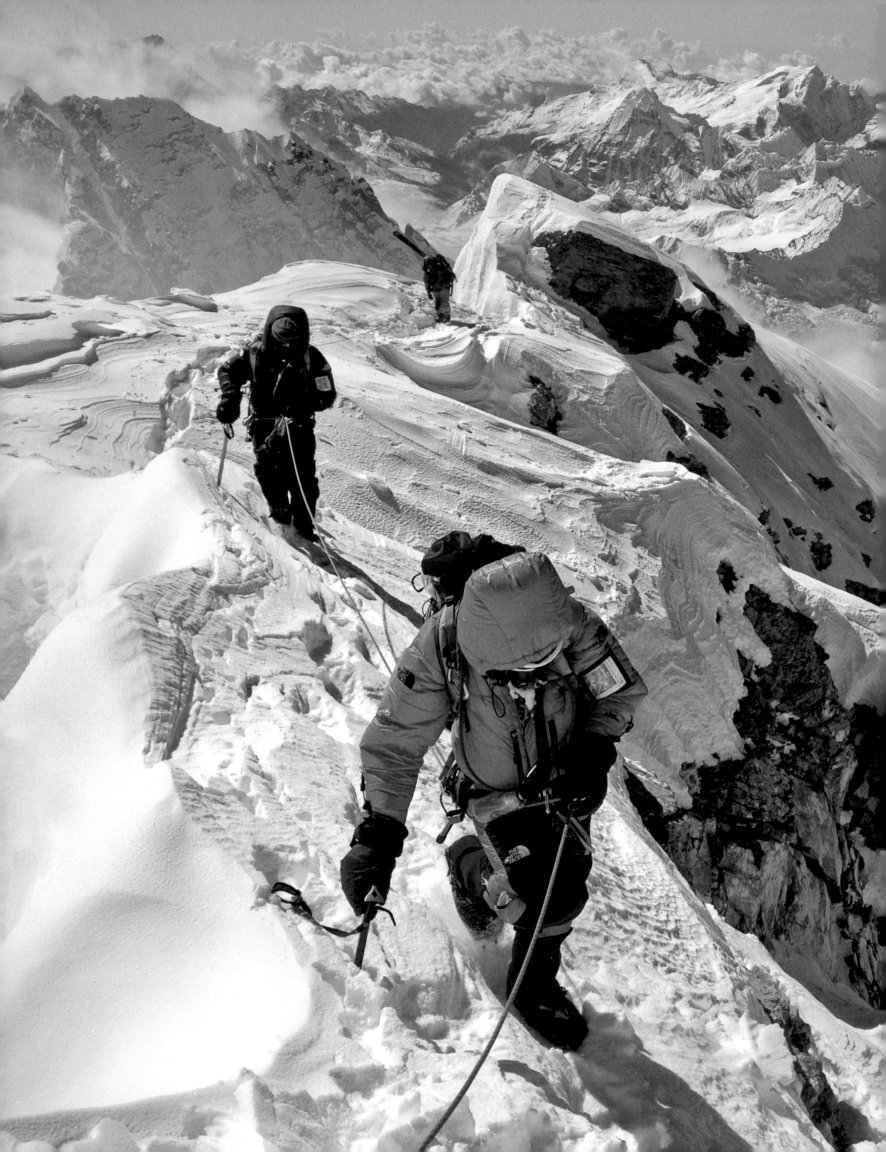

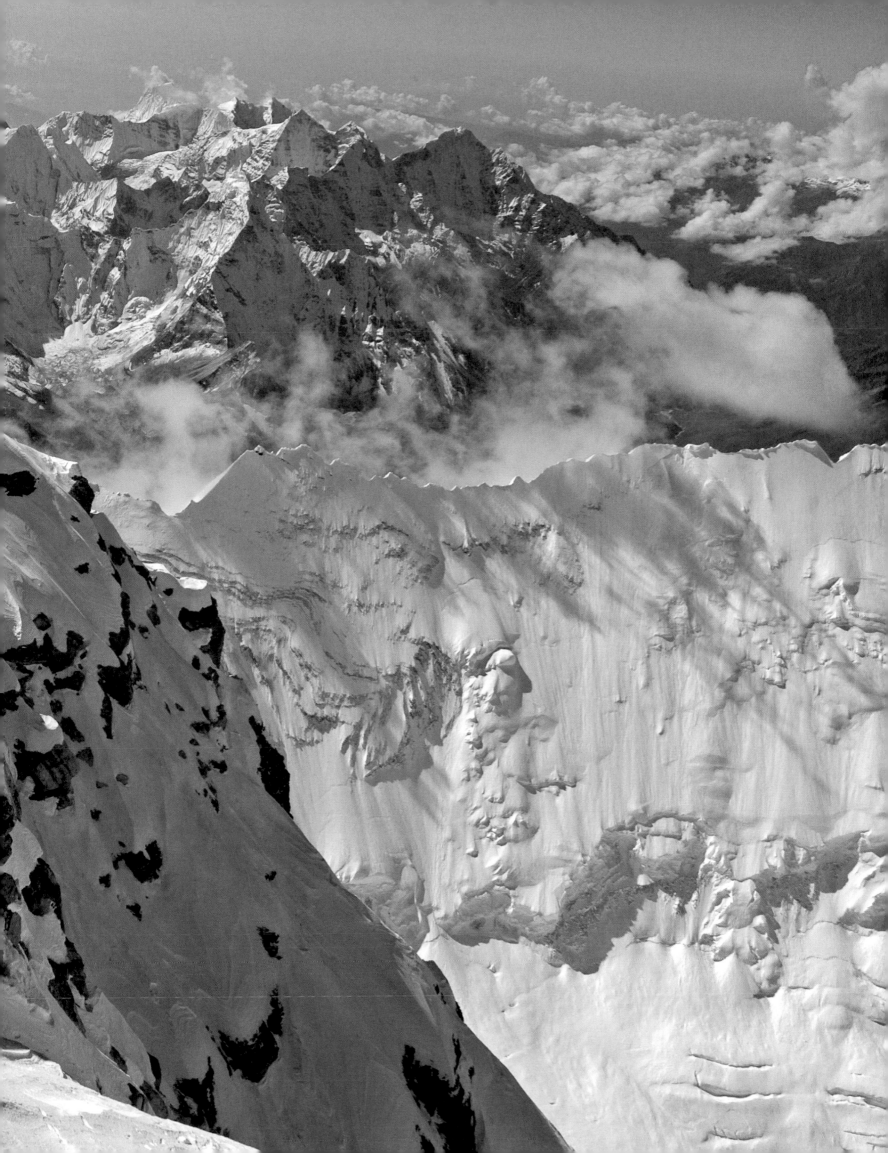

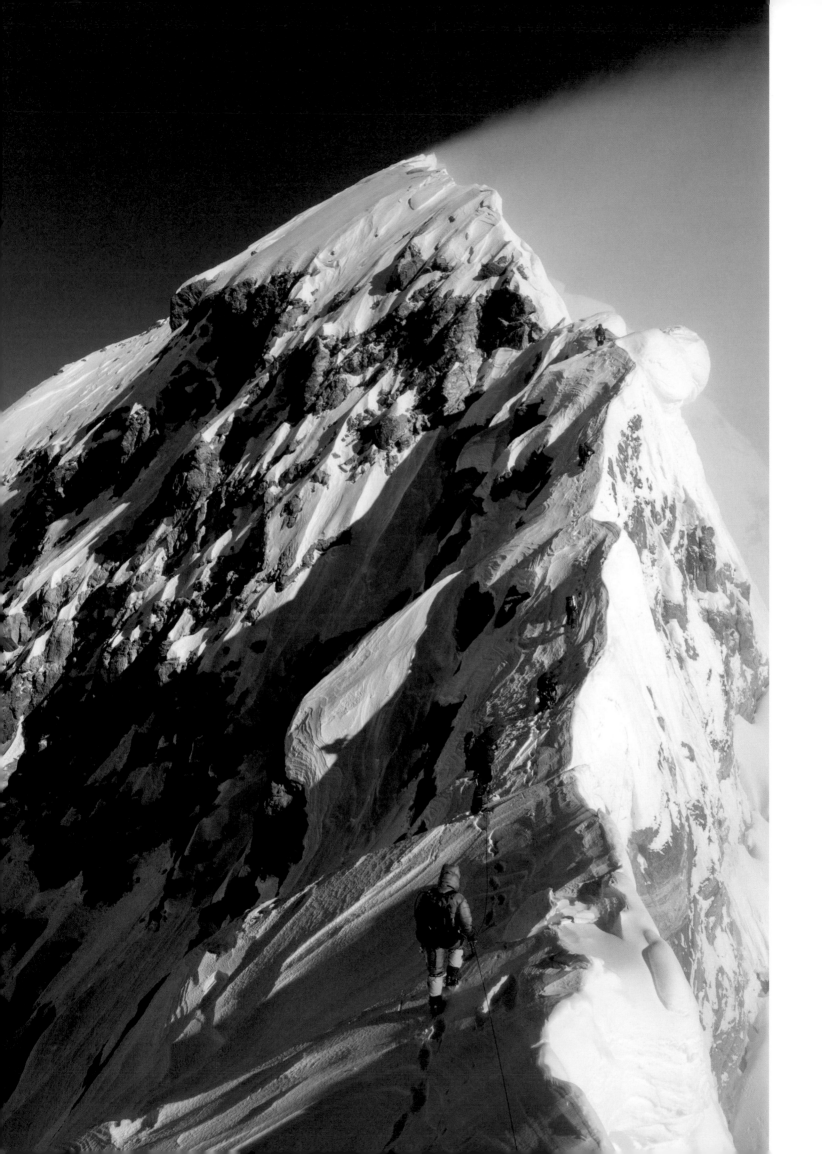

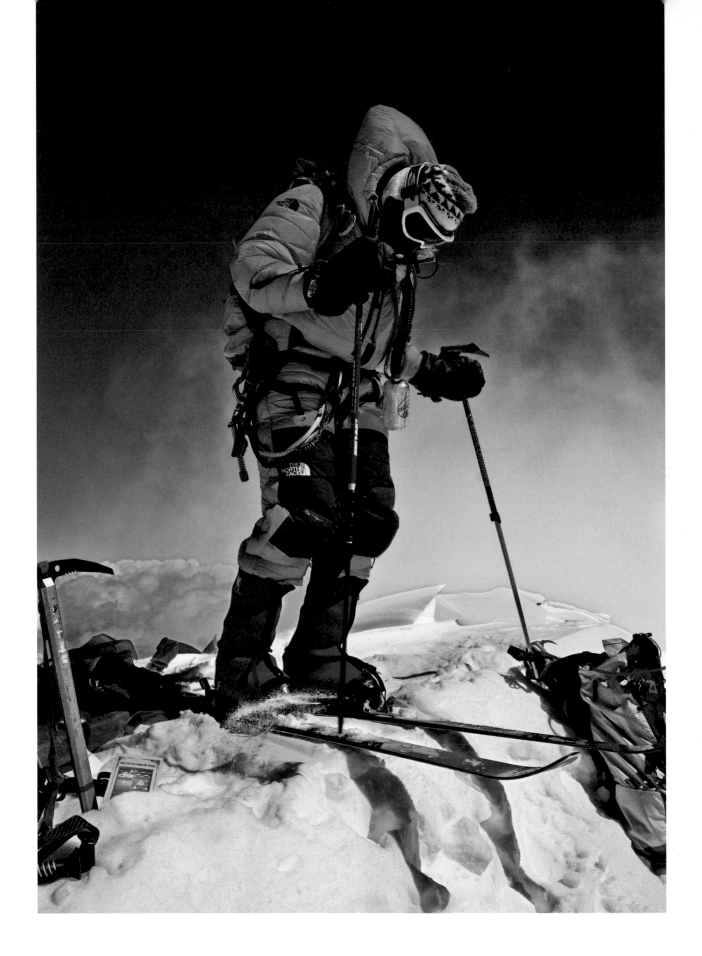

**OPPOSITE** Our team tackles the summit ridge on Everest. We were the only team on the mountain during the 2006 post-monsoon season.

**ABOVE** Kit DesLauriers stepping into her bindings at 29,032ft as she prepares to ski off the summit of Mount Everest. Kit would become the first woman to ski from the summit of Everest, completing her goal of becoming the first person to ski the Seven Summits.

**FOLLOWING** Kit skiing the Lhotse Face. With a slope angle of 50 degrees, the Lhotse Face would be the most technical and committing part of the descent. Ski conditions were far from ideal. We skied the face on a mix of windswept hardpack and blue ice.

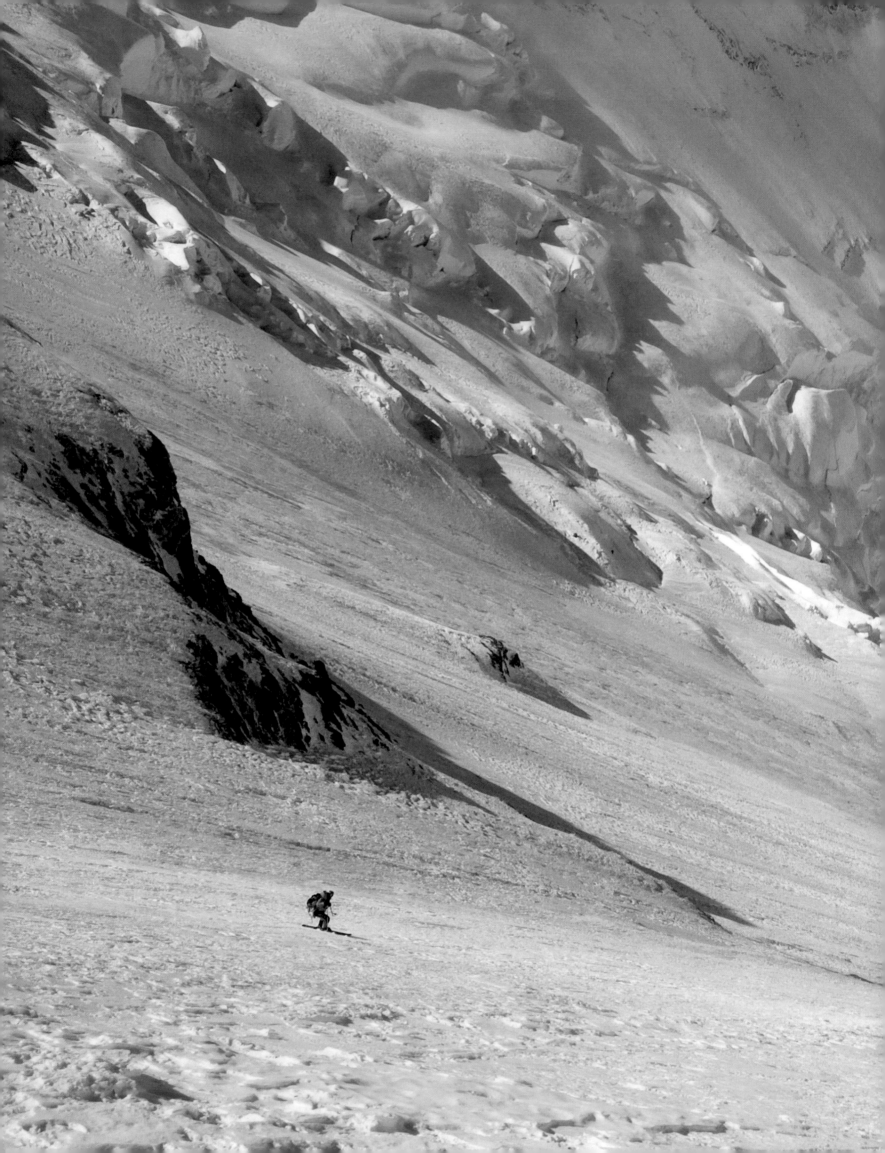

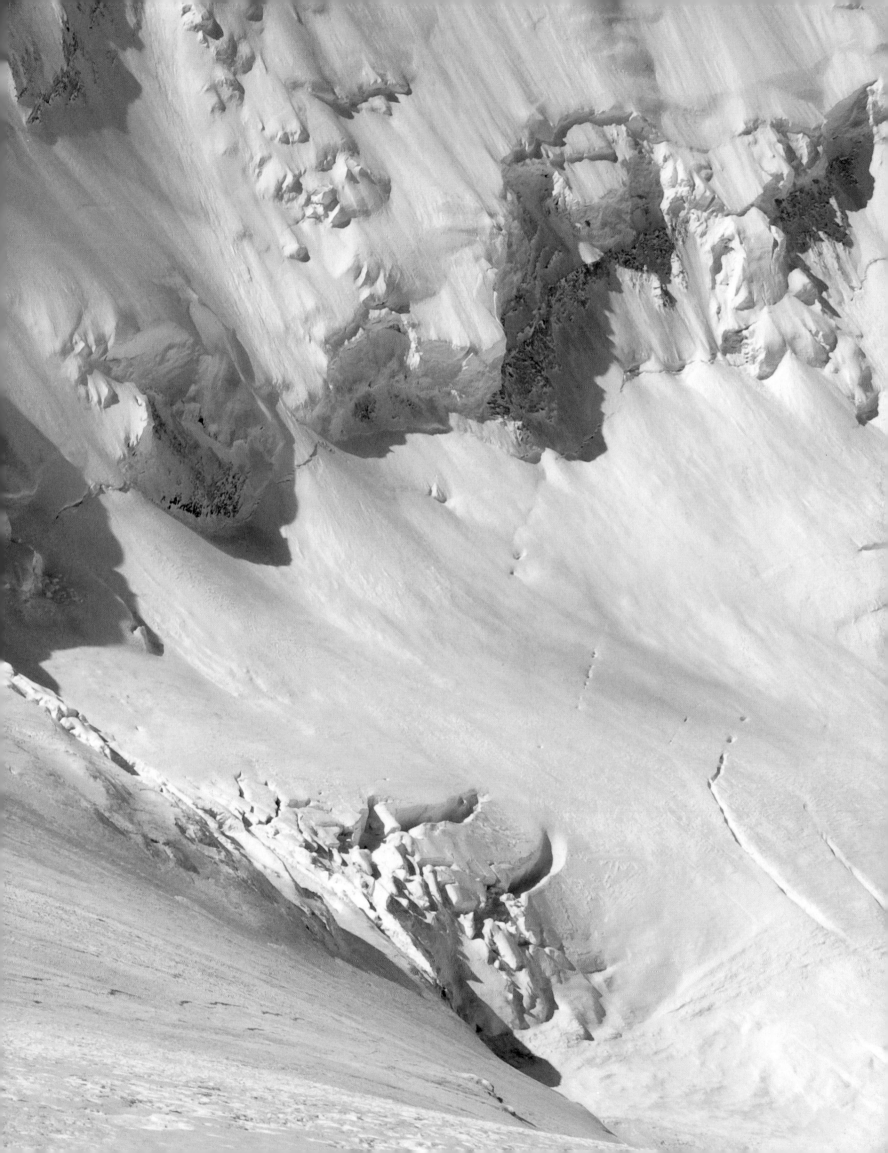

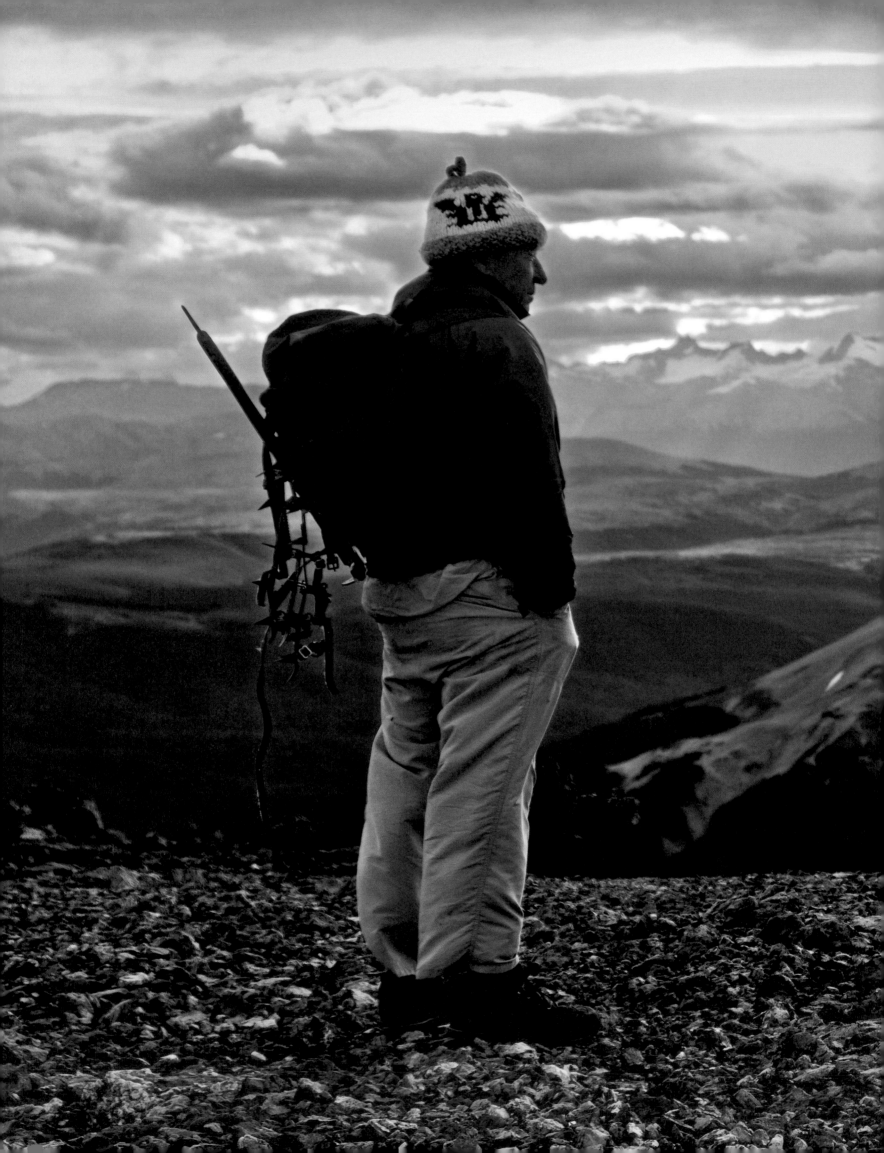

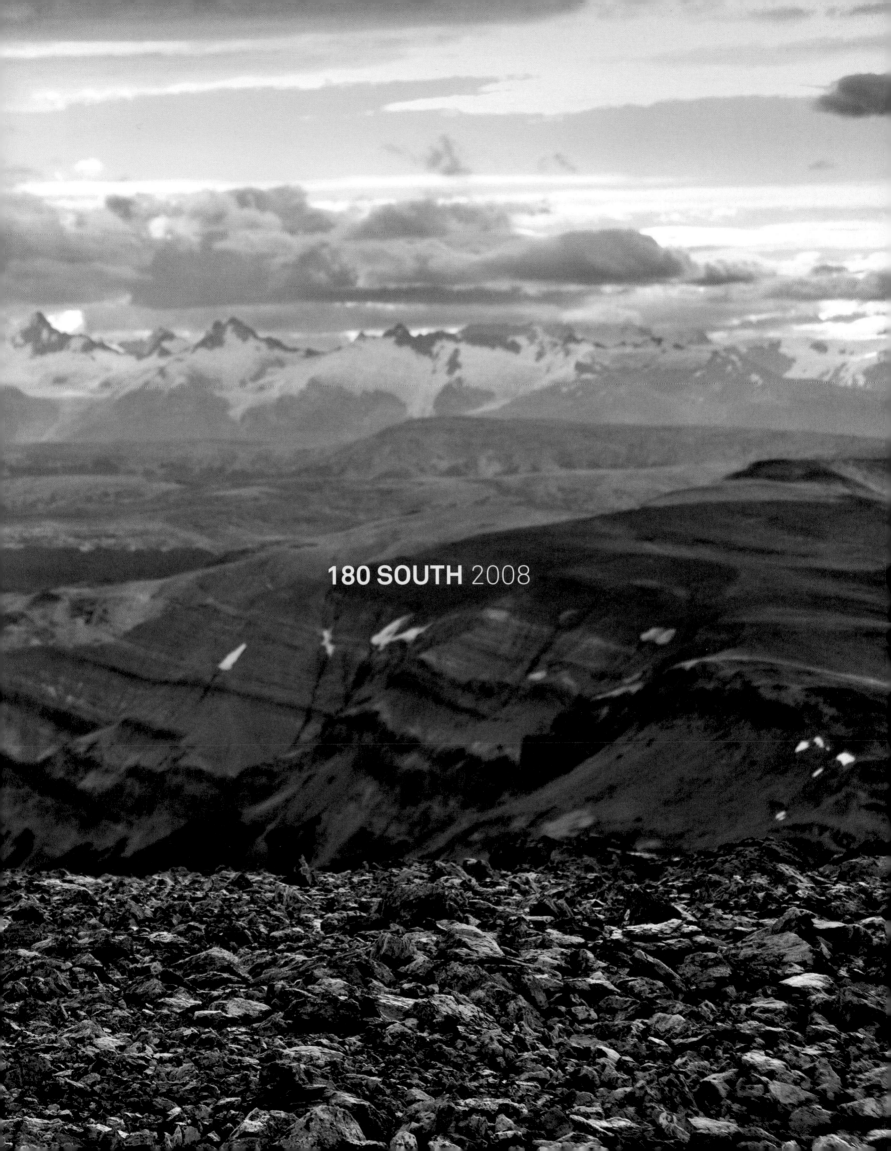

180 SOUTH 2008

# By 2003, I'd been living out of the back of my blue Subaru Loyale for six years.

When Yvon Chouinard heard I was driving down the California coast, he offered to let me stay at his house in Ventura for a few homemade meals and a real bed.

Yvon is one of the most respected climbers of his generation—the author of significant first ascents in mountain ranges around the world. He is equally celebrated for his work protecting the environment. In 1973, Yvon founded Patagonia, the outdoor clothing company.

During my stay, I found an old VHS tape marked "The Mountain of Storms." Narrated by Tom Brokaw, the film chronicled the infamous "Fun Hogs" trip in 1968 when Yvon, Doug Tompkins, Dick Dorworth, and Lito Tejada-Flores drove an old Ford van from California to the southern tip of South America. They surfed unnamed breaks, skied volcanoes, and climbed a new route on Fitz Roy, a notoriously difficult peak in Patagonia. Their legendary journey, and the ethos of climbing and vagabonding they embodied, would inspire generations of climbers, surfers, and ski bums. I was one of them.

In February 2009, I was recruited by Rick Ridgeway to join Chris and Keith Malloy, Danny Moder, Timmy O'Neill, Jeff Johnson, Makohe Ika, and a ragtag group of climbers, surfers, and filmmakers in Chile. They were making a film called *180 South*, loosely memorializing the Fun Hogs trip. Yvon and Doug Tompkins joined us for a few outings.

Near the end of the trip, we set out to climb an unnamed, unclimbed mountain that Yvon and Doug had tried once before. They had turned back the first time because the ancient leather boots Yvon wore back then disintegrated just beyond the trailhead.

On our climb, Yvon wore sturdier shoes, but he also wore the pair of glacier glasses he'd used on Fitz Roy in '68 and wind pants from the '80s. I thought his antique crampons would blow apart at every step. Despite owning a large clothing company, Yvon's dirtbag mindset still dictated that clothes and gear should be worn until worn out.

Near the summit, separated from our compatriots, Yvon and I looked up at a steep corner split by a long, arching crack. Yvon had more years of climbing experience than I had been alive, but I felt some responsibility to look after him. I put my pack down and opened it.

"Hey Yvon, you want a rope here?" I asked him.

"Huh?" he responded. "No. Why? You need one?" Then he launched up the arching crack, soon disappearing around the corner. I laughed and put the rope away.

After the climb, Yvon wanted to name the mountain Cerro Geezer. Doug wanted to name it after his wife, Kristine Tompkins. Doug won.

Doug and Kristine later preserved the sprawling, spectacular landscape around us as Parque Nacional Patagonia, part of a 14.2-million-acre gift to the Chilean people. Their life's work would become the largest private-public conservation land transfer in history.

This would be Doug's and Yvon's last big climb. Doug perished in a kayaking accident in 2015, and Yvon eventually hung up his crampons. In fitting style, they both finished their climbing careers with the first ascent of a beautiful mountain.

PREVIOUS Yvon Chouinard surveying the weather over the southern Andes as we approached Cerro Kristine. Parque Nacional Patagonia, Chile.

OPPOSITE Yvon Chouinard. Chacabuco Valley, Chile.

RIGHT The intrepid production crew from *180 South*.

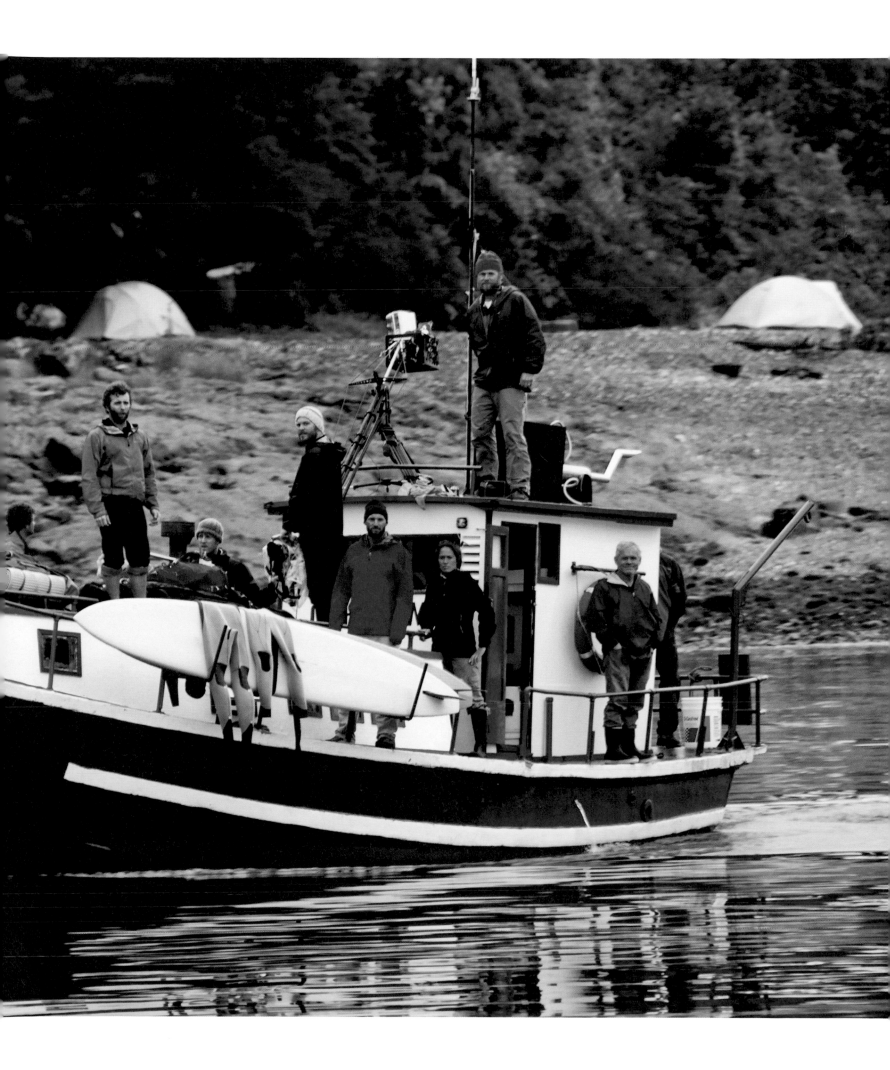

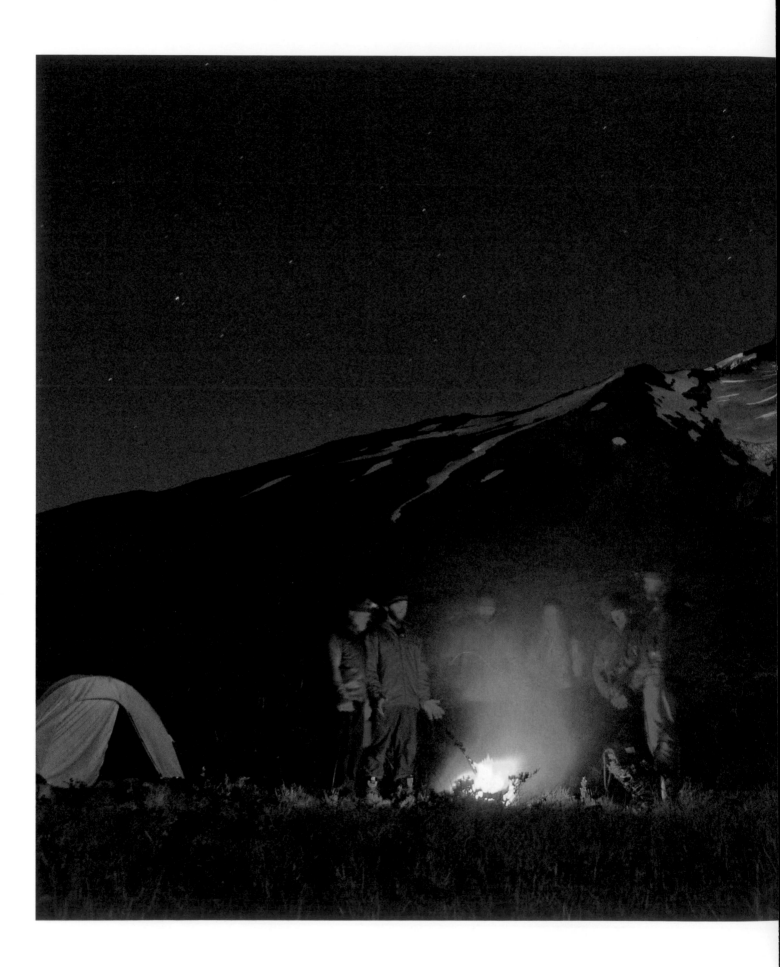

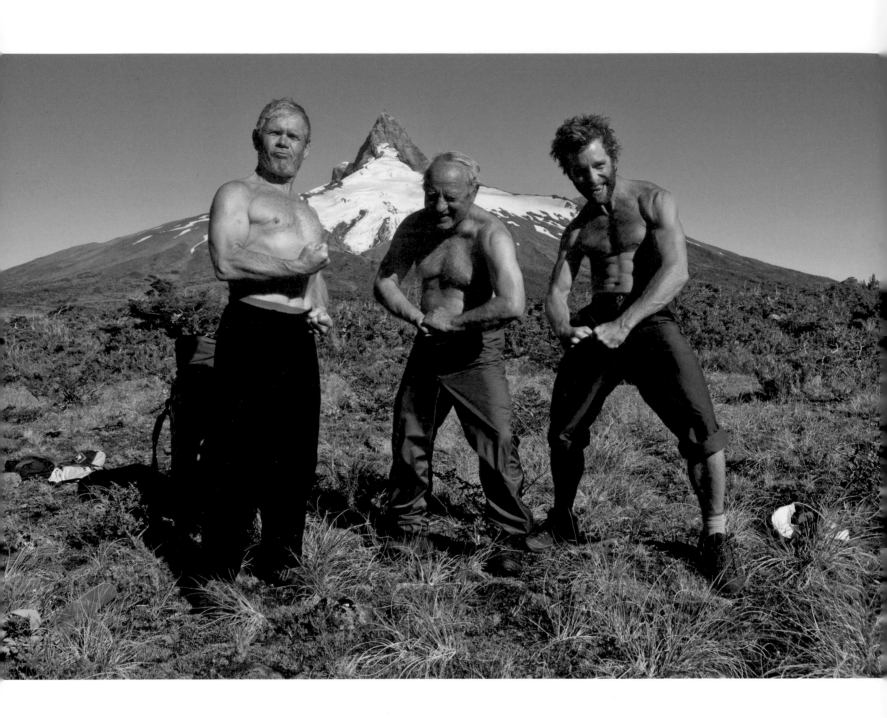

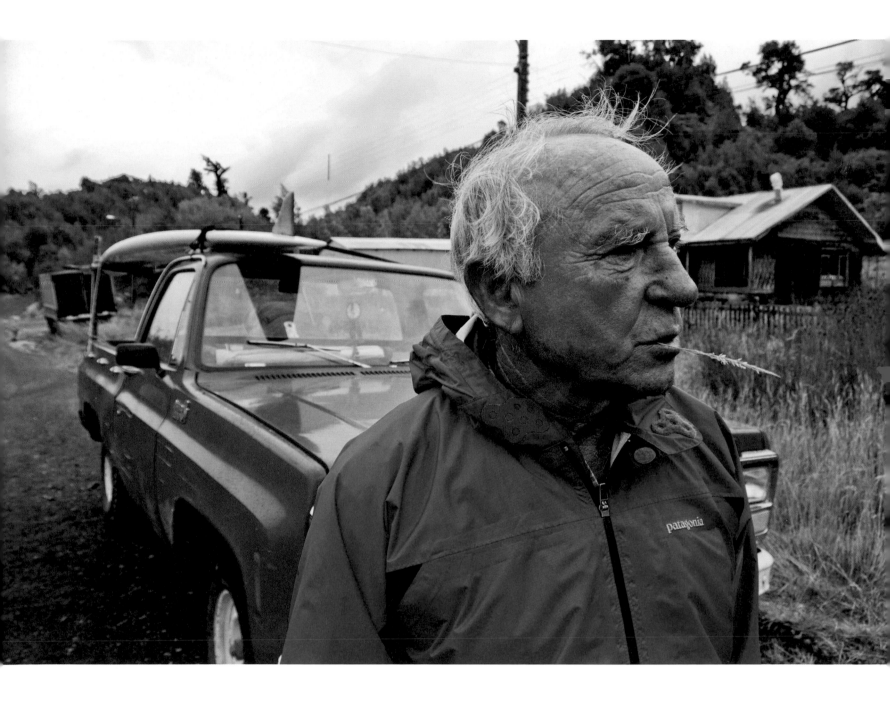

**PREVIOUS** Campfire below Corcovado Volcano.

**OPPOSITE** From left: Rick Ridgeway, Yvon Chouinard, and Timmy O'Neill flexing on our way in to climb Corcovado Volcano, Chile. Despite the appearance of this wayward looking crew, their collective climbing resumes include the first American ascent of K2 without supplemental oxygen, the speed record on the Nose route on El Capitan in Yosemite, and difficult first ascents on all seven continents.

**ABOVE** Yvon Chouinard. Chaitén, Chile.

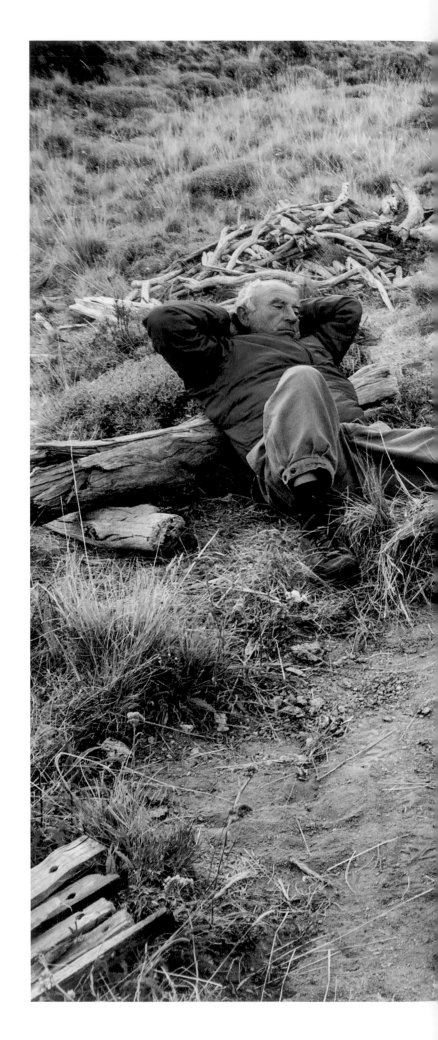

**RIGHT** From left, Yvon Chouinard, Jeff Johnson, Makohe Ika, and Keith Malloy hungrily waiting for their backcountry asado to finish cooking after a long day on the trail. Chacabuco, Chile.

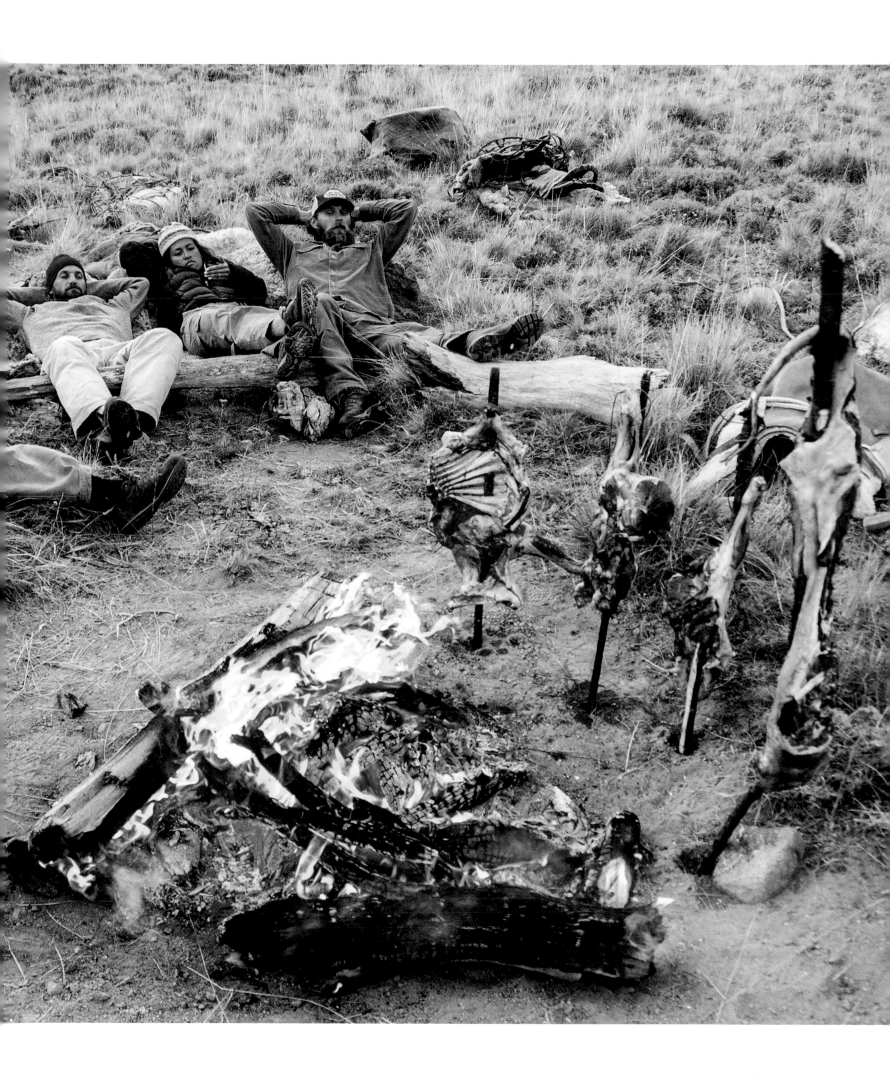

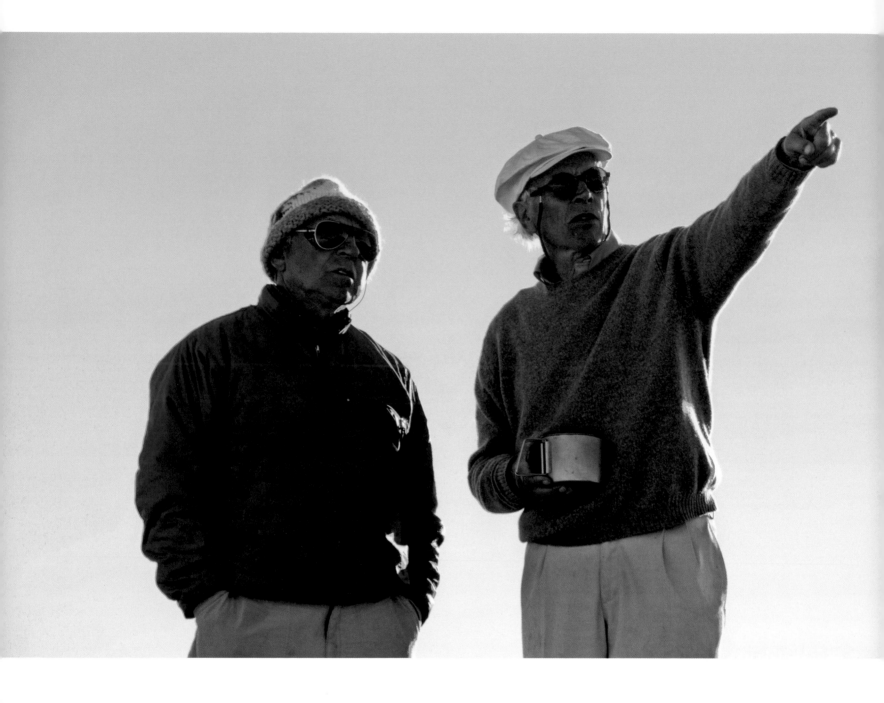

**ABOVE** Yvon Chouinard, left, and Doug Tompkins discuss the approach to Cerro Kristine.

**OPPOSITE** Yvon and Doug taking a break on our approach to climb the first ascent of Cerro Kristine.

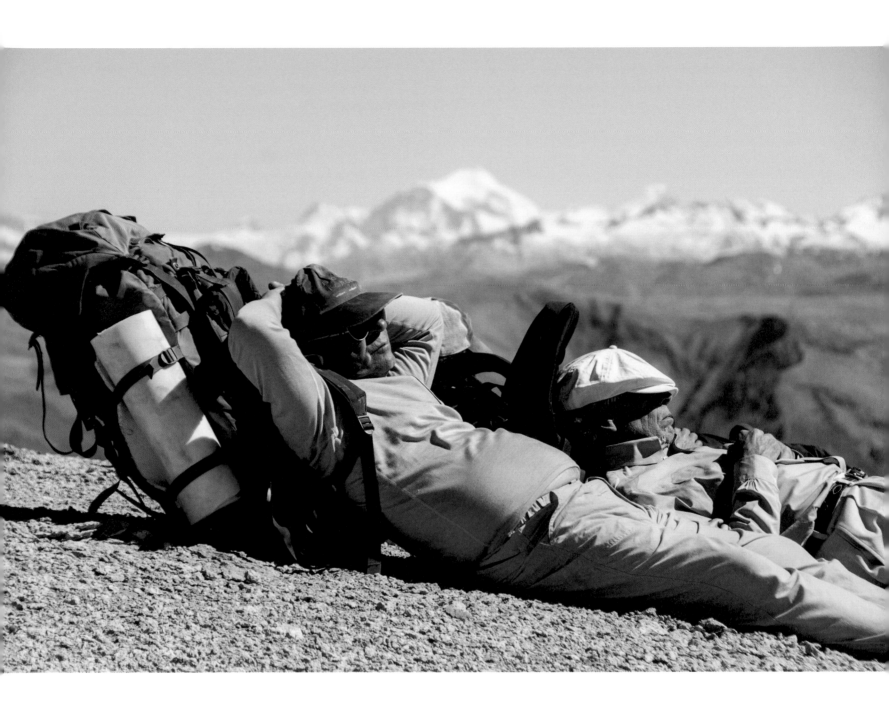

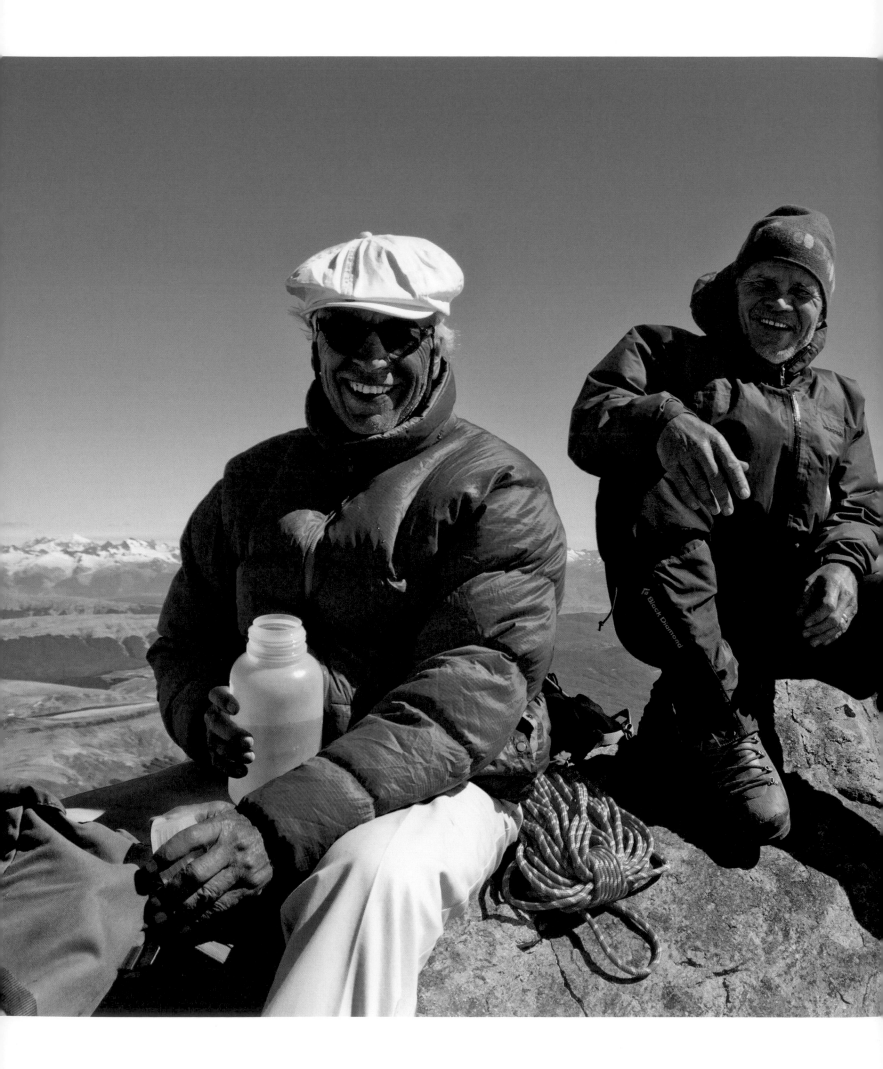

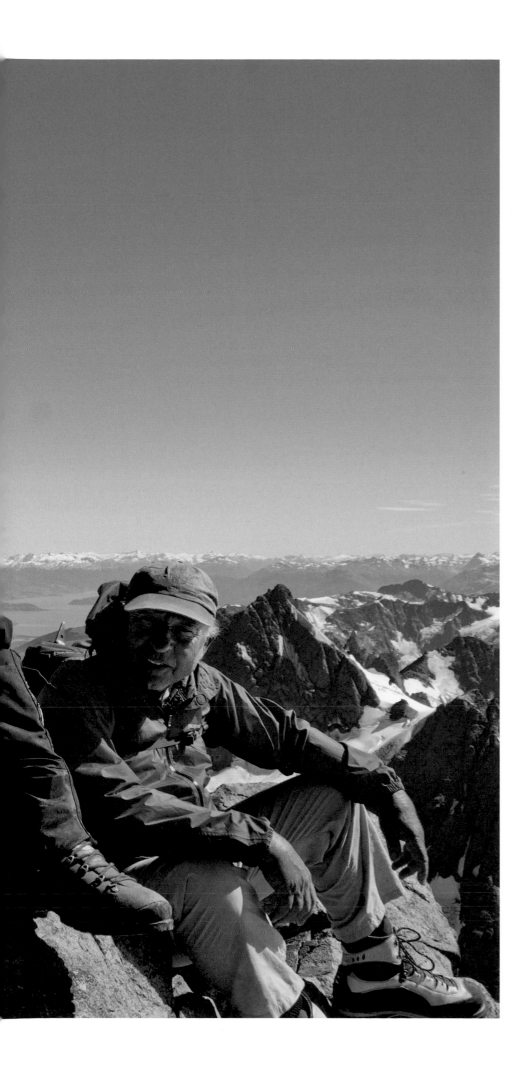

**LEFT** From left, Doug Tompkins, Rick Ridgeway, and Yvon Chouinard enjoying a summit moment on the first ascent of Cerro Kristine. After the first ascent, Yvon wanted to name the mountain Cerro Geezer. Doug wanted to name it after his wife, Kristine Tompkins. Doug won.

**FOLLOWING** Even the most seasoned adventurers like naps. From left, Jeff Johnson, Doug, and Yvon take a quick break on the long approach to climb Cerro Kristine.

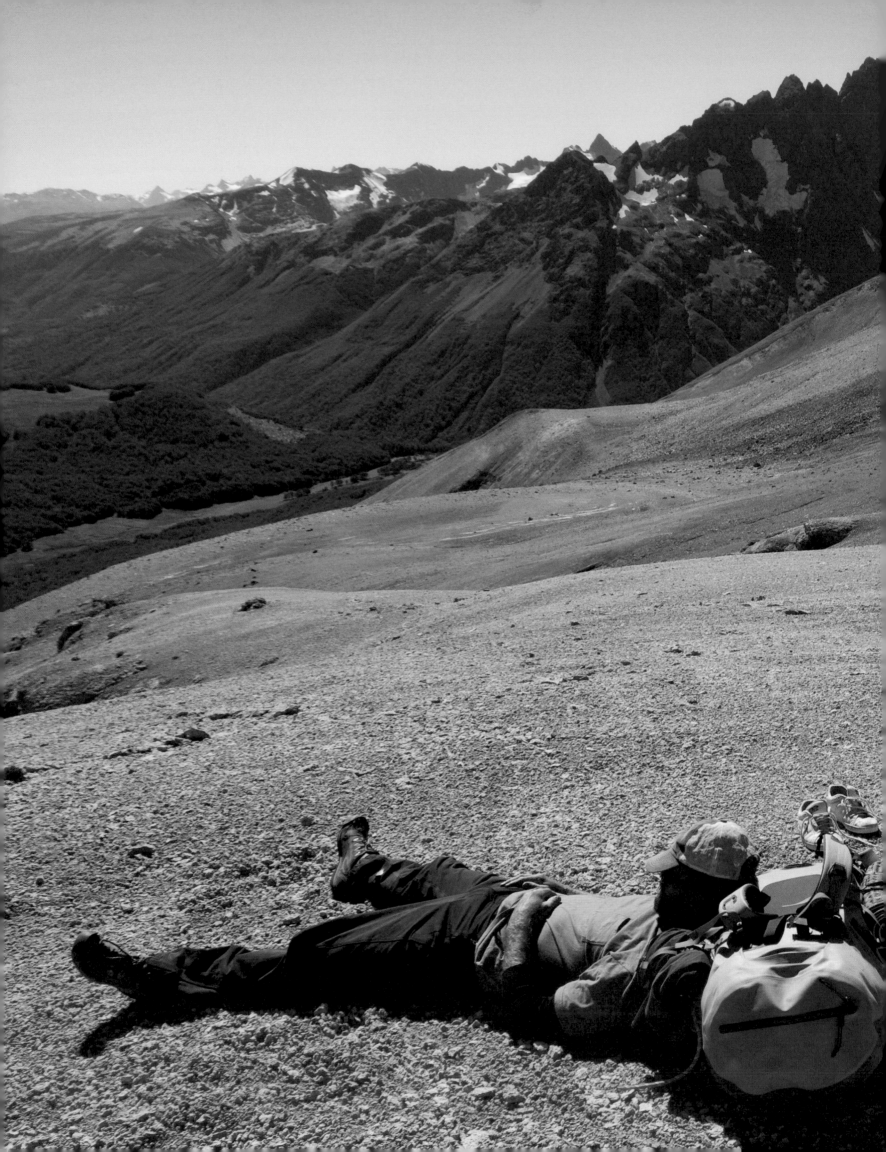

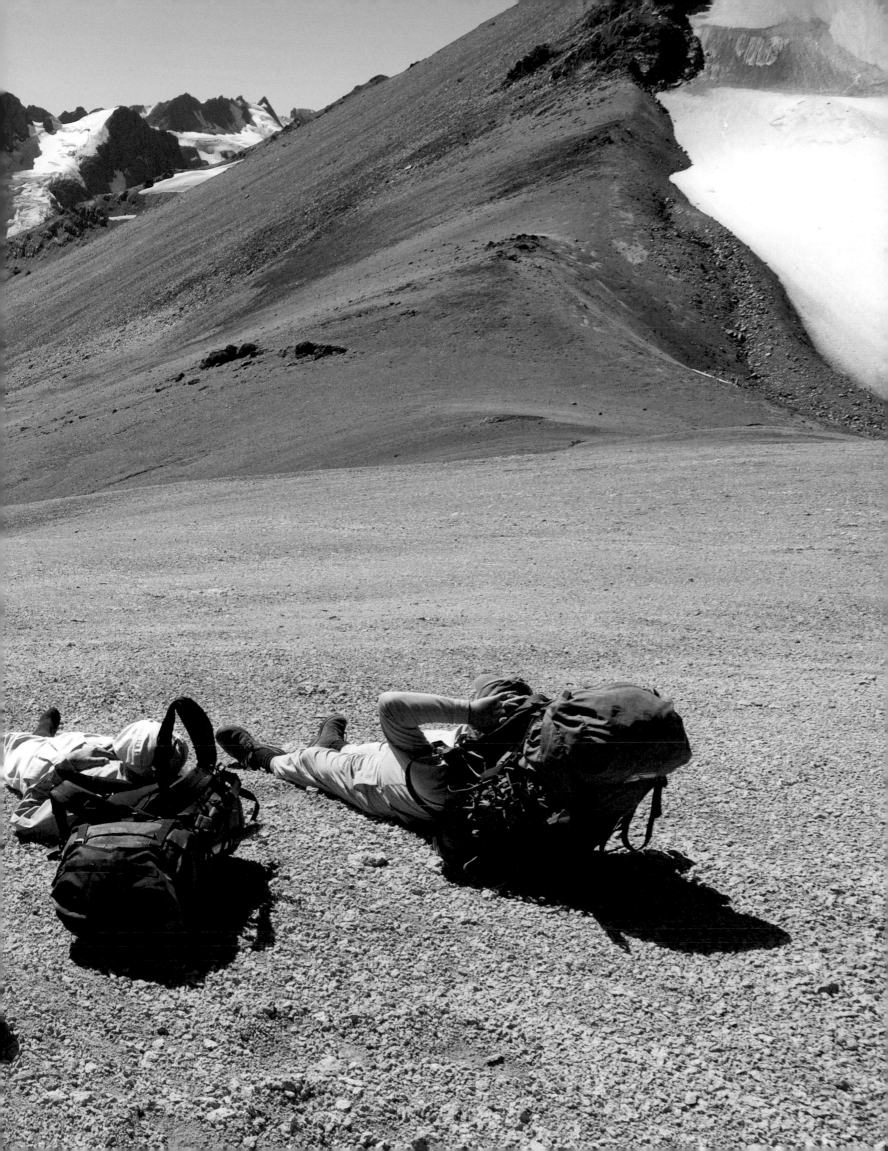

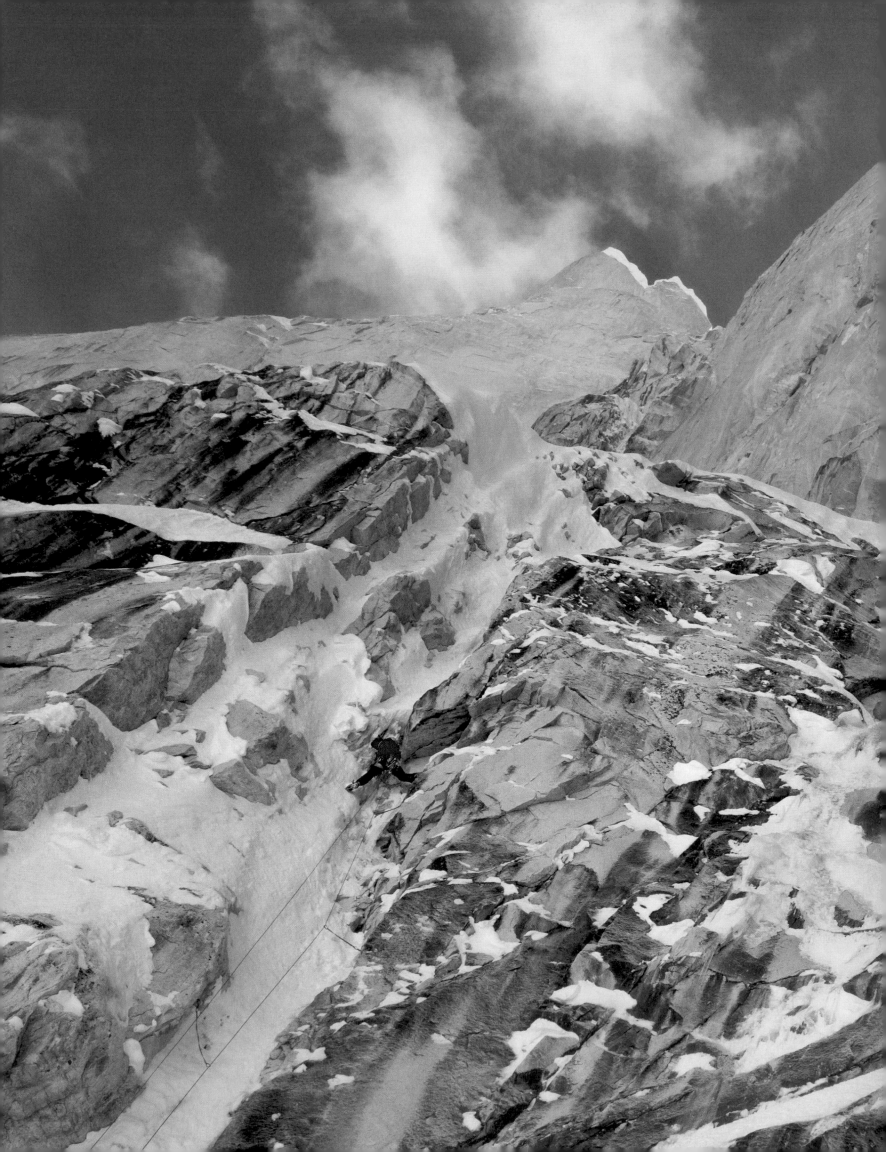

MERU 2008

# The sun was setting and we weren't at the top.

In the fading light, the elephantine peaks around us glowed pink. It was our seventeenth day on the mountain, we'd been climbing fifteen hours, and the summit ridge still loomed above us. Exhausted and bone-cold, Conrad Anker, Renan Ozturk, and I sat in silence for a moment, mulling our options.

The climbing history of the Shark's Fin—the central summit of Meru Peak in India's Garhwal Himalaya—is a chronicle of failure. Before we arrived to try the Fin in 2008, at least twenty expeditions had already attempted it. Each team had underestimated Meru's spectrum of difficulties: alpine climbing on the lower half, an overhanging big wall above it, and hard mixed climbing all the way to its 20,702ft summit.

Our attempt to climb Meru had been a battle with uncertainty. After climbing two days up the initial snowy alpine pitches, a blizzard slammed into the Garhwal Range with such ferocity that five porters, lost in the snowstorm, died from hypothermia in the valley below. The three of us lay in our two-person portaledge like sardines in a can for four days. As we dangled from the prow of an overhanging granite arête, avalanches roared down on either side of us. Over and over, wind gusts barreled up the wall, lifting our portaledge into the air and then dropping us back onto our anchor with a violent jolt.

After the storm cleared, we continued to ascend, rationing the seven days of food we had brought. Every rope-length upward seemed more difficult or dangerous than the last. Climbing in thick gloves and clunky mountain boots on an overhanging rock wall was slow. Each day we were forced to cut our meager rations of couscous and gorp even further.

What had stopped many of the previous groups was the severe upper headwall. Thanks to Conrad's first crack at the Shark's Fin in 2003, he knew we needed specific gear for aid climbing that other parties weren't willing to carry up—a heavy rack of pitons, hooks, and specialized cams. He handed them to me when I took the sharp end of the rope for an aid pitch, which we christened the House of Cards.

I looked up at a teetering mass of immense granite shards. Ascending it would require analyzing the physics of the detached, overlapping slabs balanced on their edges, then carefully tapping hooks and pitons into the gaps between them. The trick would be moving my weight onto each piece of gear without detaching the whole mess from the wall—which would have plunged all three of us into the void. Climbing the House of Cards depended less on physical skill than on staying calm, along with a bit of luck.

After a few more days of climbing and several heroic leads by Conrad on poorly protected mixed terrain, we had finally arrived at our limits on the seventeenth day.

We hung in our harnesses two hundred feet from the summit. To continue would require a night out in the open and frostbite or worse. When you seek the edge, sometimes you find it. Numb and defeated, we prepared for the long descent into the night. I stole one last look at the summit above, and vowed to never come back.

It's never a good idea to say never.

**PREVIOUS** Conrad Anker battling steep mixed climbing above the Gauntlet pitch and below the looming headwall. This was one of the most technical and difficult mixed pitches on the lower half of the climb. I was thankful Conrad had taken the lead.

**OPPOSITE** I took this portrait of Conrad after our nineteen-day odyssey on the Shark's Fin.

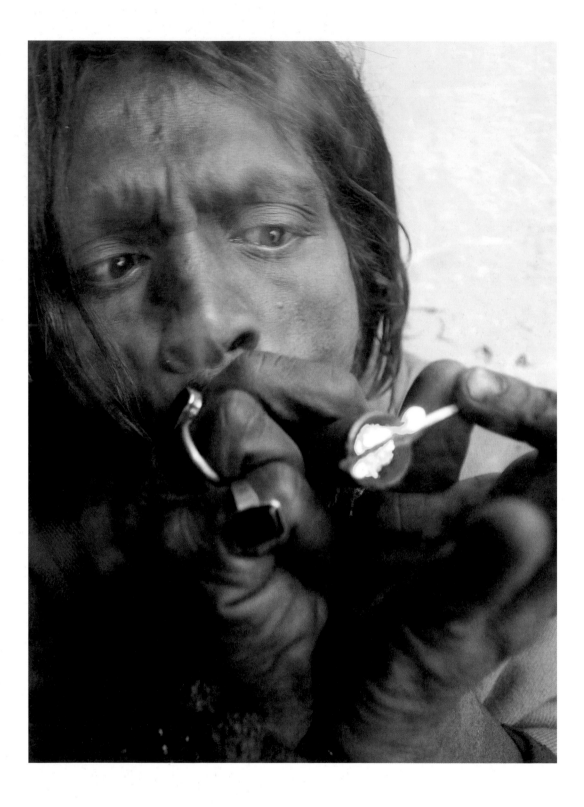

**ABOVE** A Sadhu lights up his chillum, Gangotri, India.

**OPPOSITE** Meditation station. Renan Ozturk sits on a boulder above base camp. The northwest face of Bhagirathi III stands proud in the background.

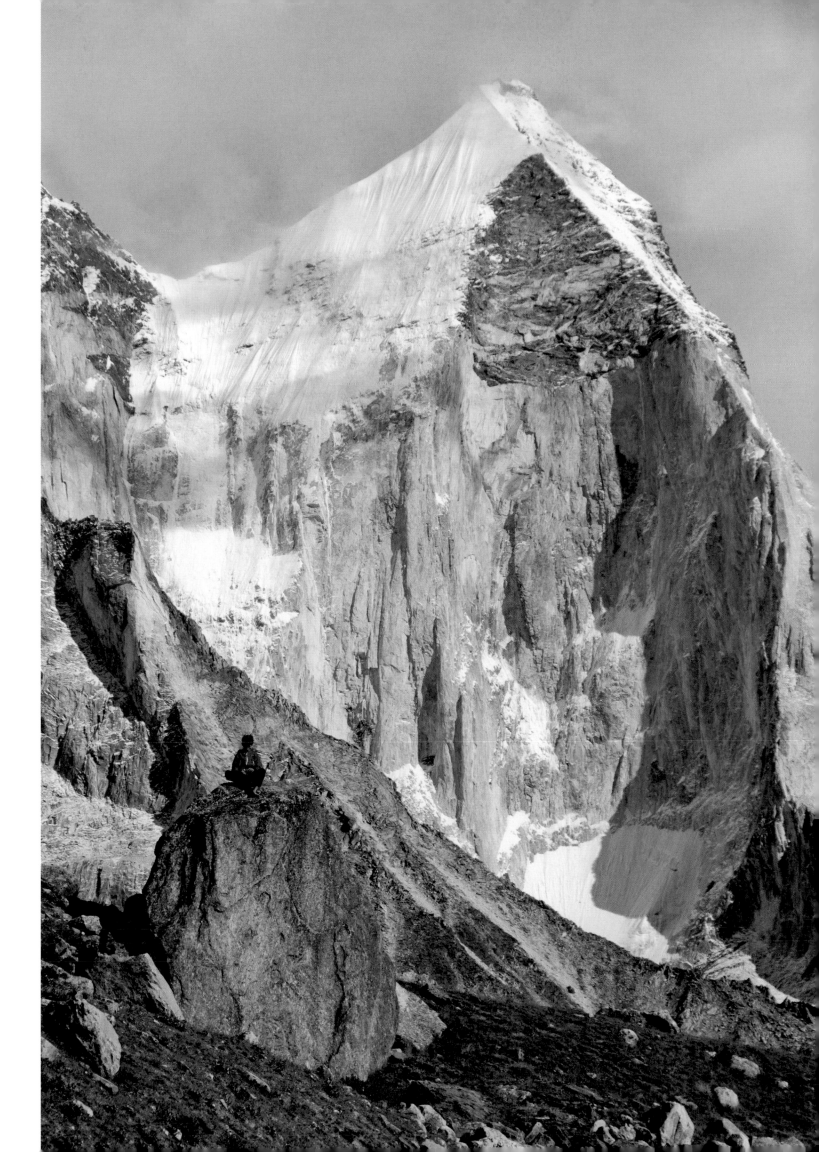

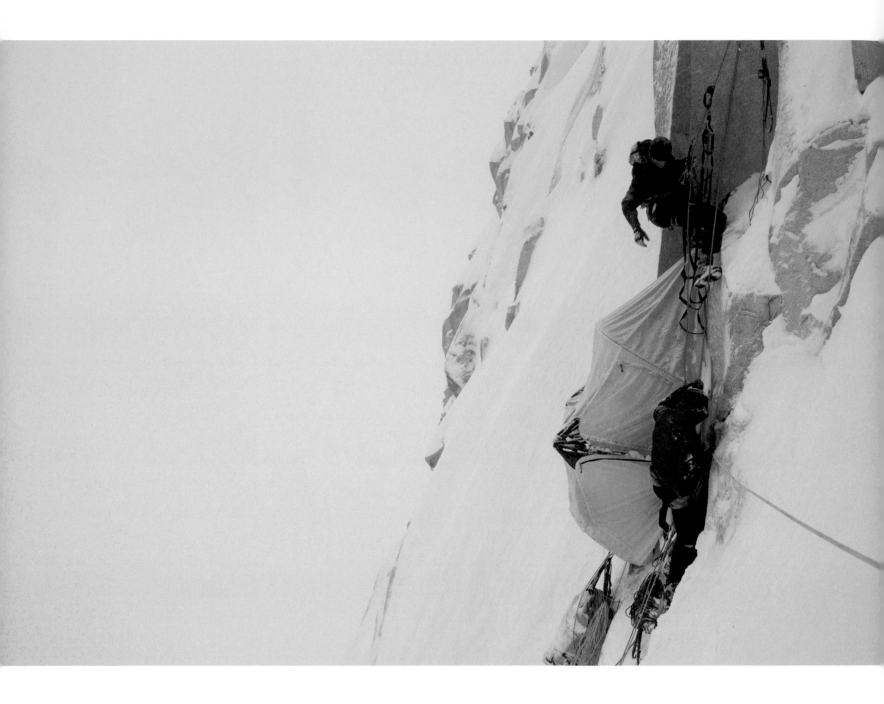

**ABOVE** A storm moves in on our second day of the climb. Conrad Anker and Renan Ozturk struggle to put up the portaledge in rising winds and spindrift. We got pinned here for four days while avalanches roared around us.

**OPPOSITE** Renan trying to manage the anxiety of the moment and "the screaming barfies"—the name given to the pain resulting from rewarming frozen hands and fingers.

**FOLLOWING** Renan taking in the sun and the view after a −20°F night at our second portaledge camp. Due to the aspect of the wall, we only had an hour of direct sun every day. We never took its warmth for granted.

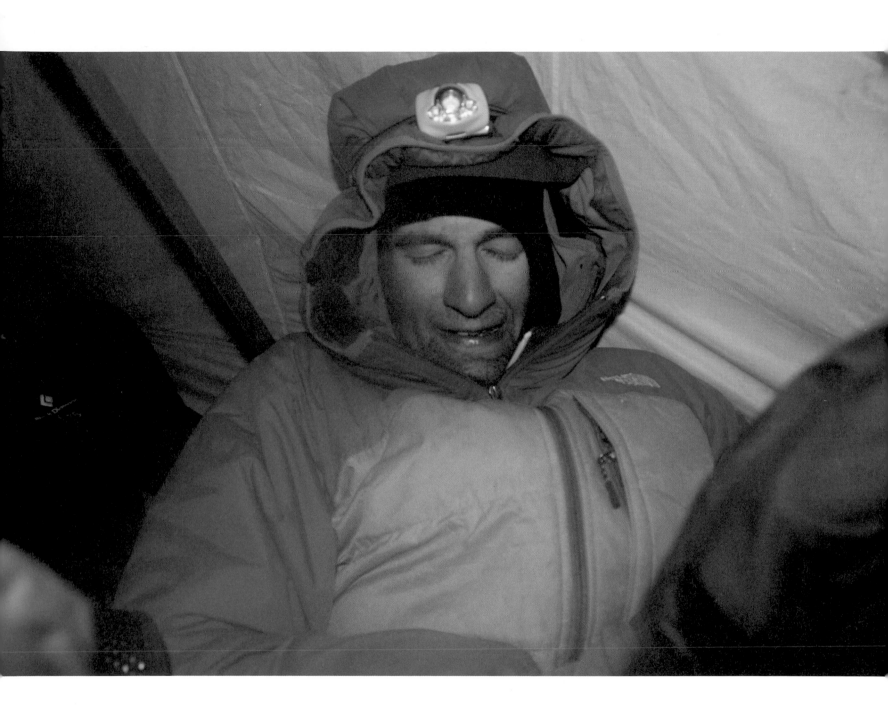

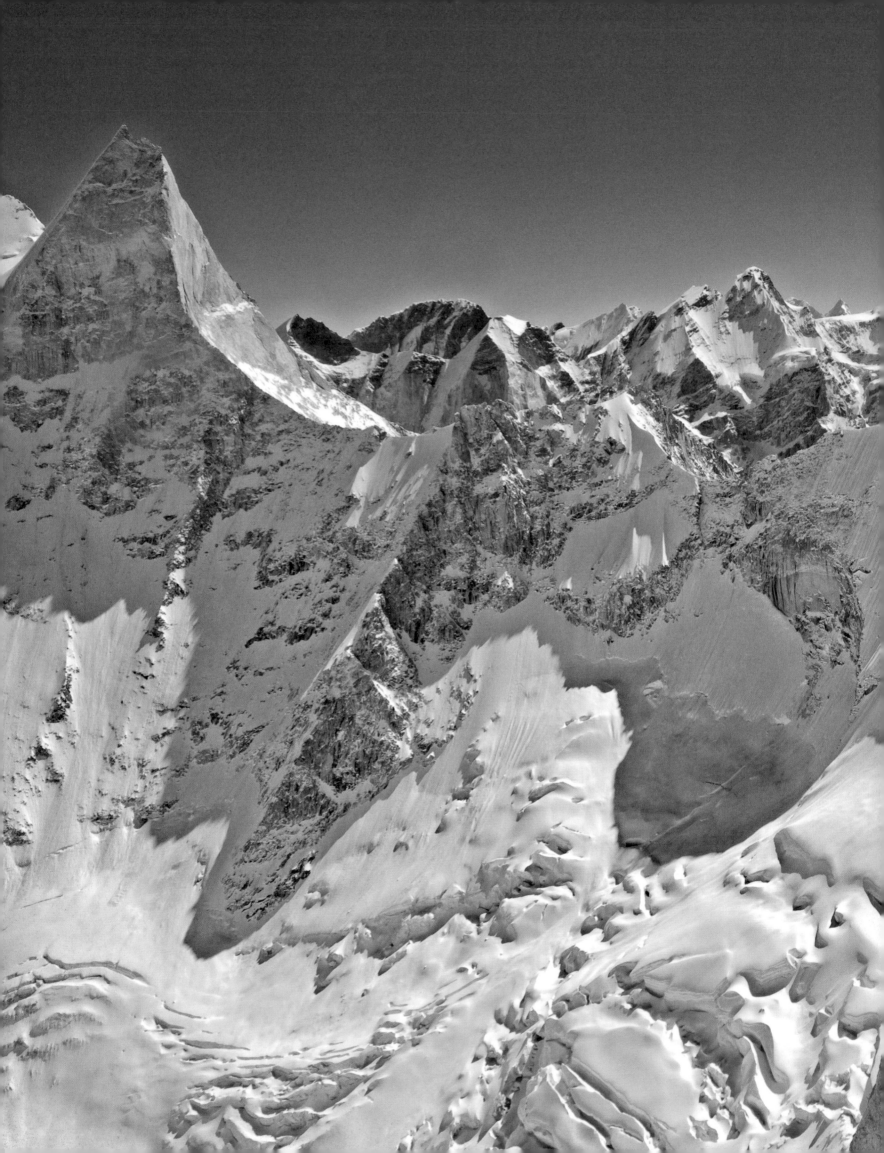

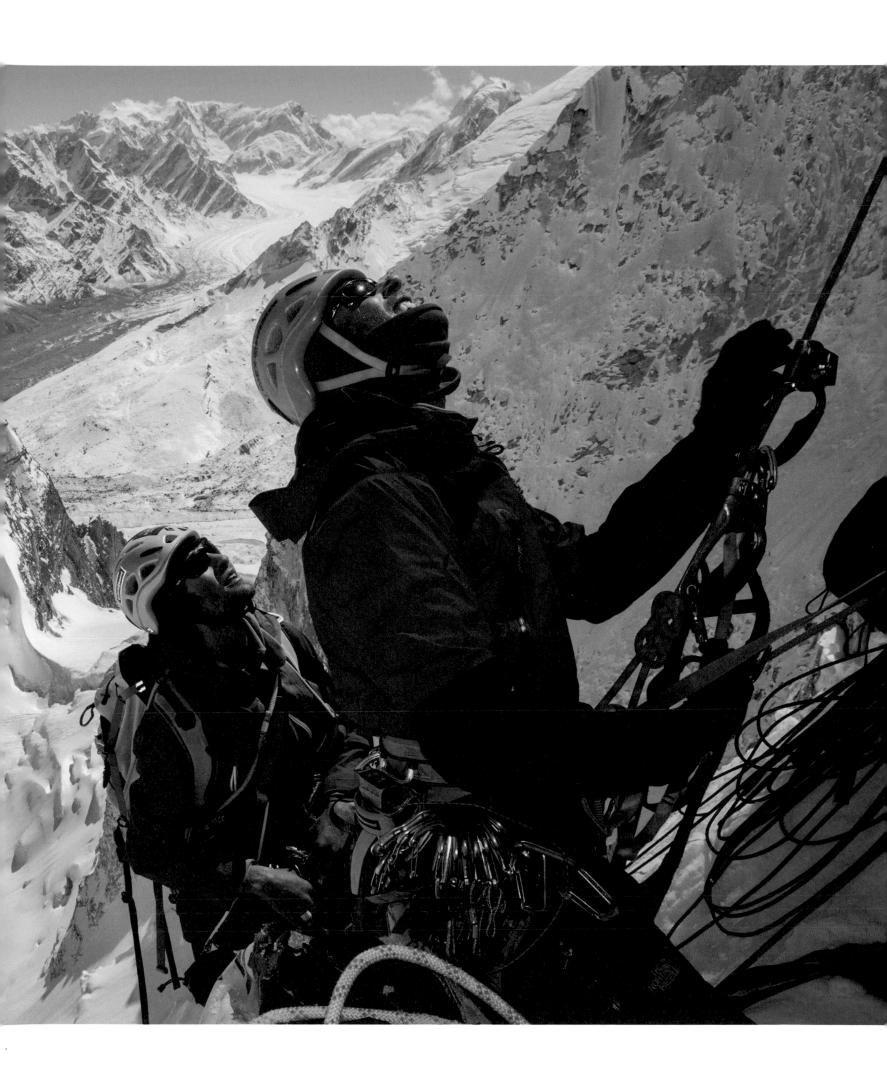

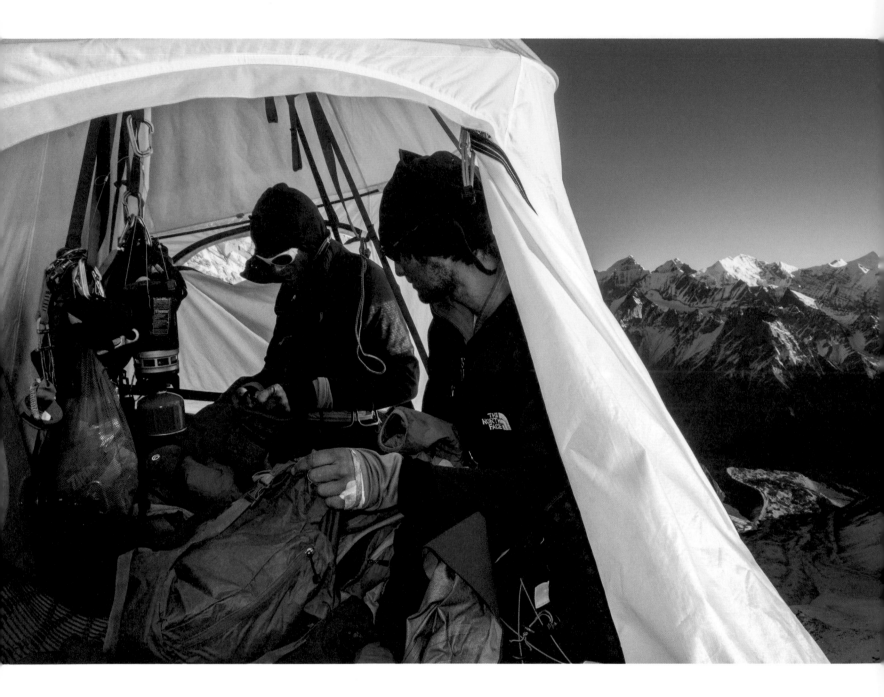

**ABOVE** Conrad Anker and Renan Ozturk prep gear in our room with a view. It was a tight fit for three people.

**OPPOSITE** Conrad weighing our options during the storm while avalanches rage by outside.

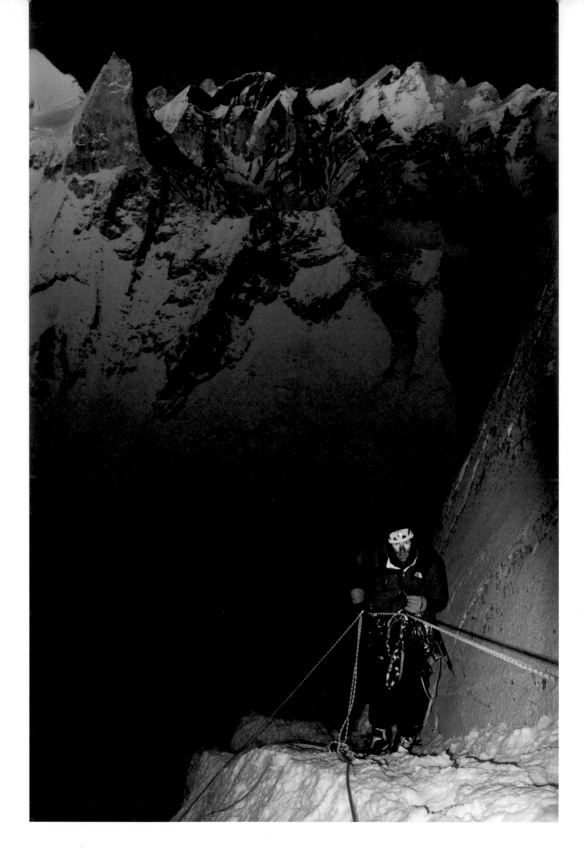

**ABOVE**  The thousand-yard stare. After seventeen days of climbing on seven days of food, Conrad Anker begins the rappel back to our hanging portaledge camp far below.

**OPPOSITE**  We rappel for two days after our failed attempt. Conrad retreats back to the glacier.

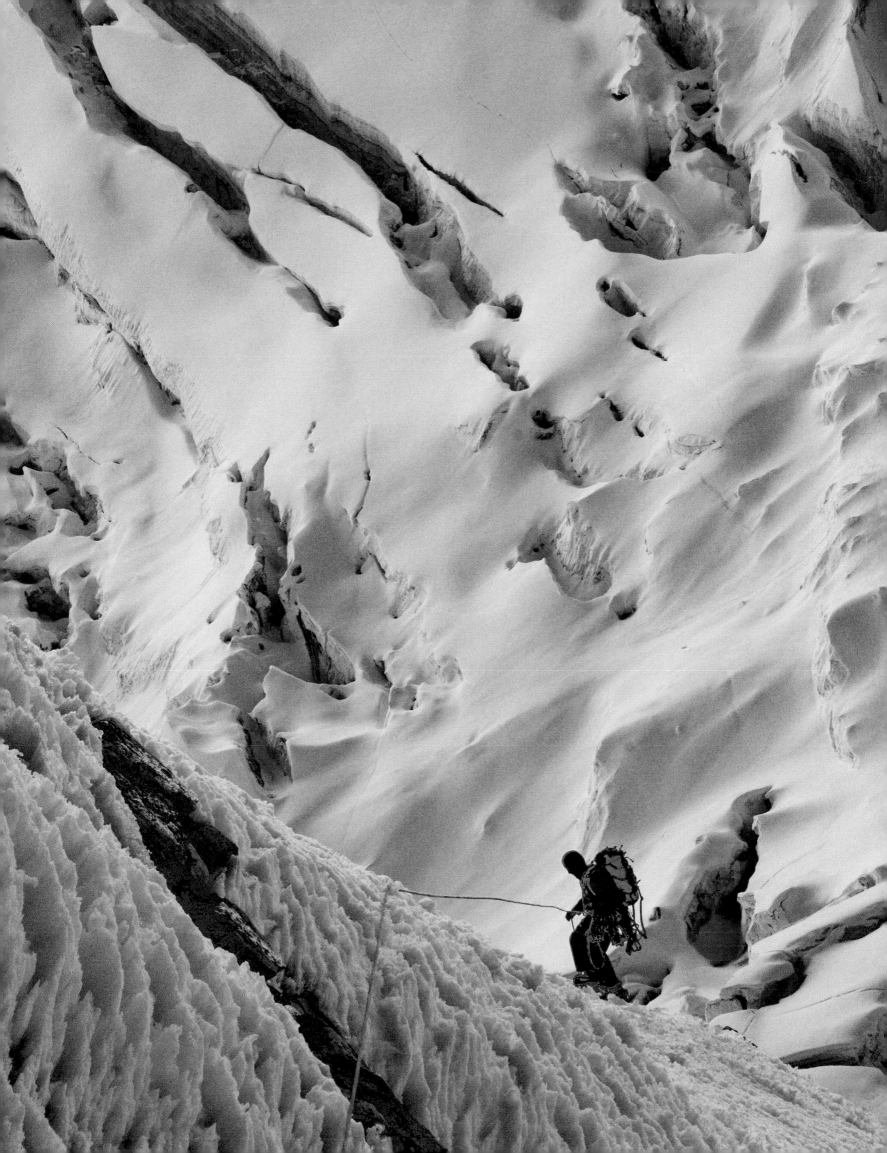

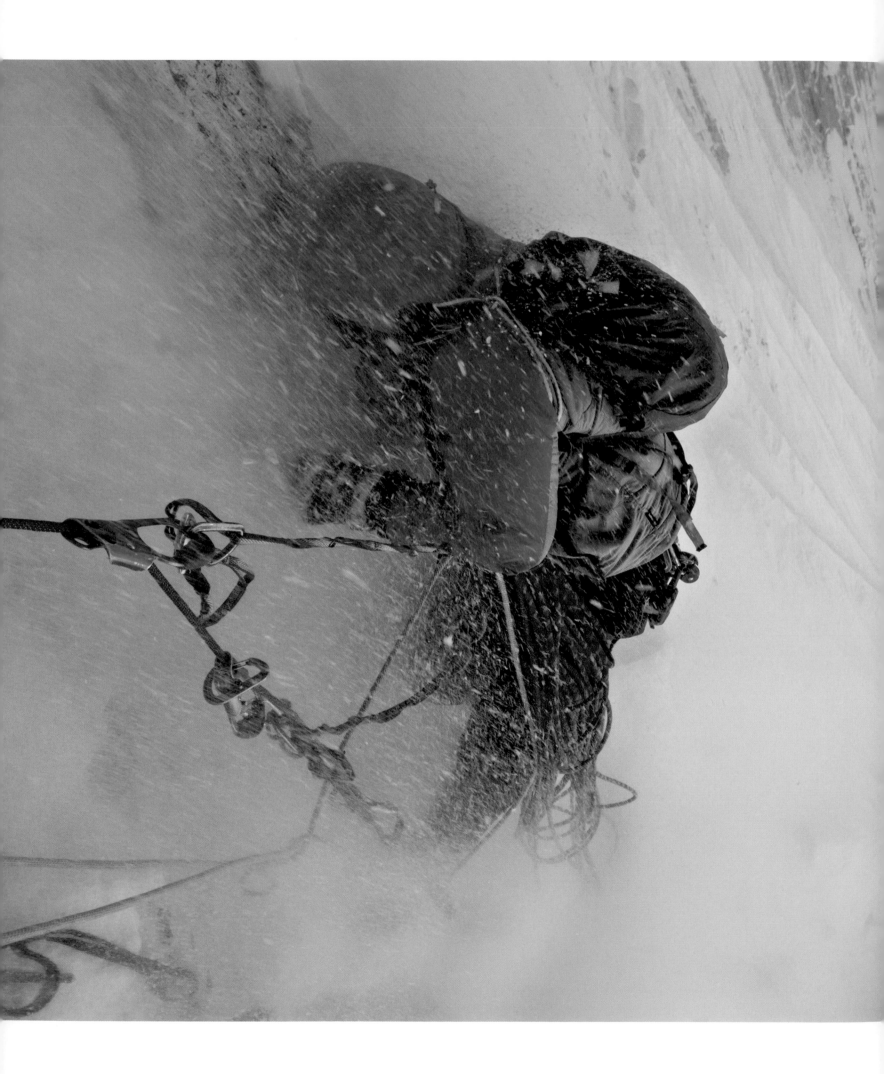

**LEFT** After belaying Conrad Anker for over two hours in −20°F temperatures, Renan Ozturk gets pummeled by snow and ice as Conrad tunnels through a cornice far above.

**FOLLOWING** Conrad approaching the Gauntlet pitch with Shivling's dual summits in the background.

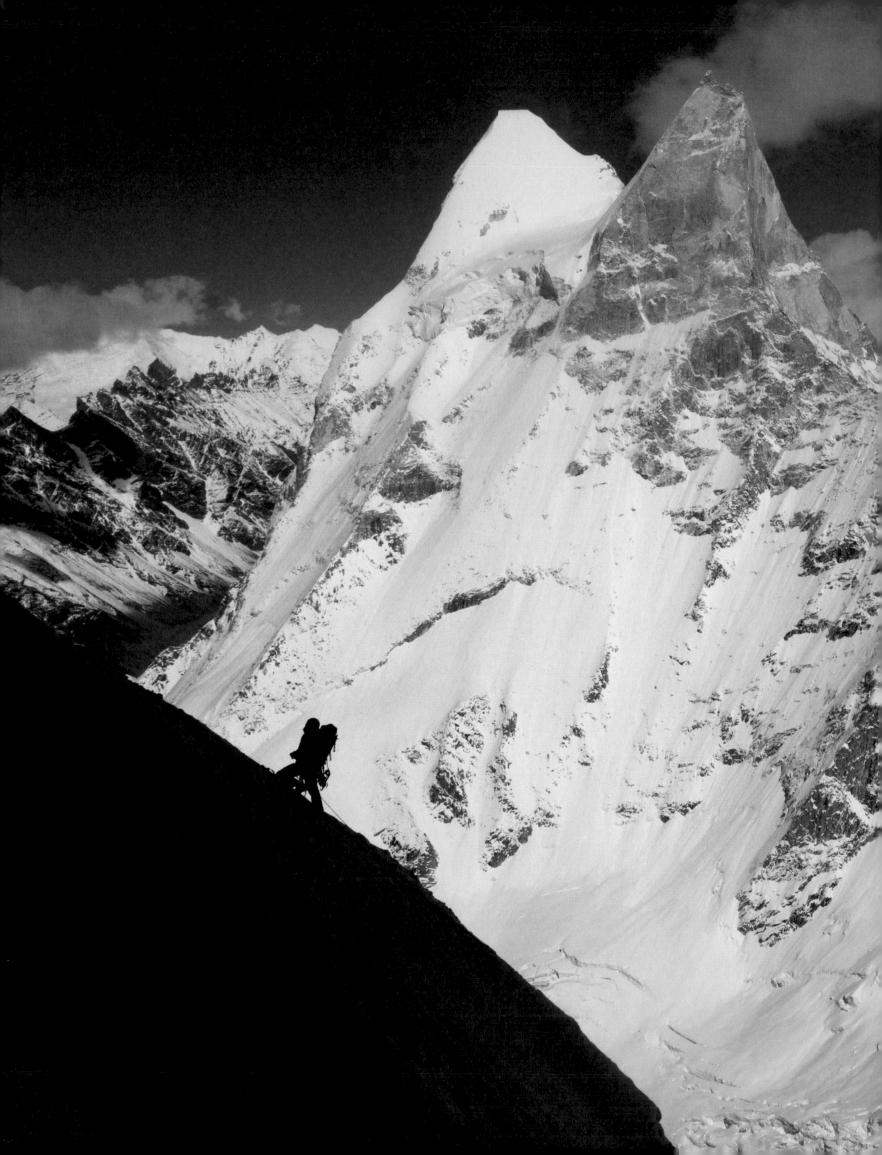

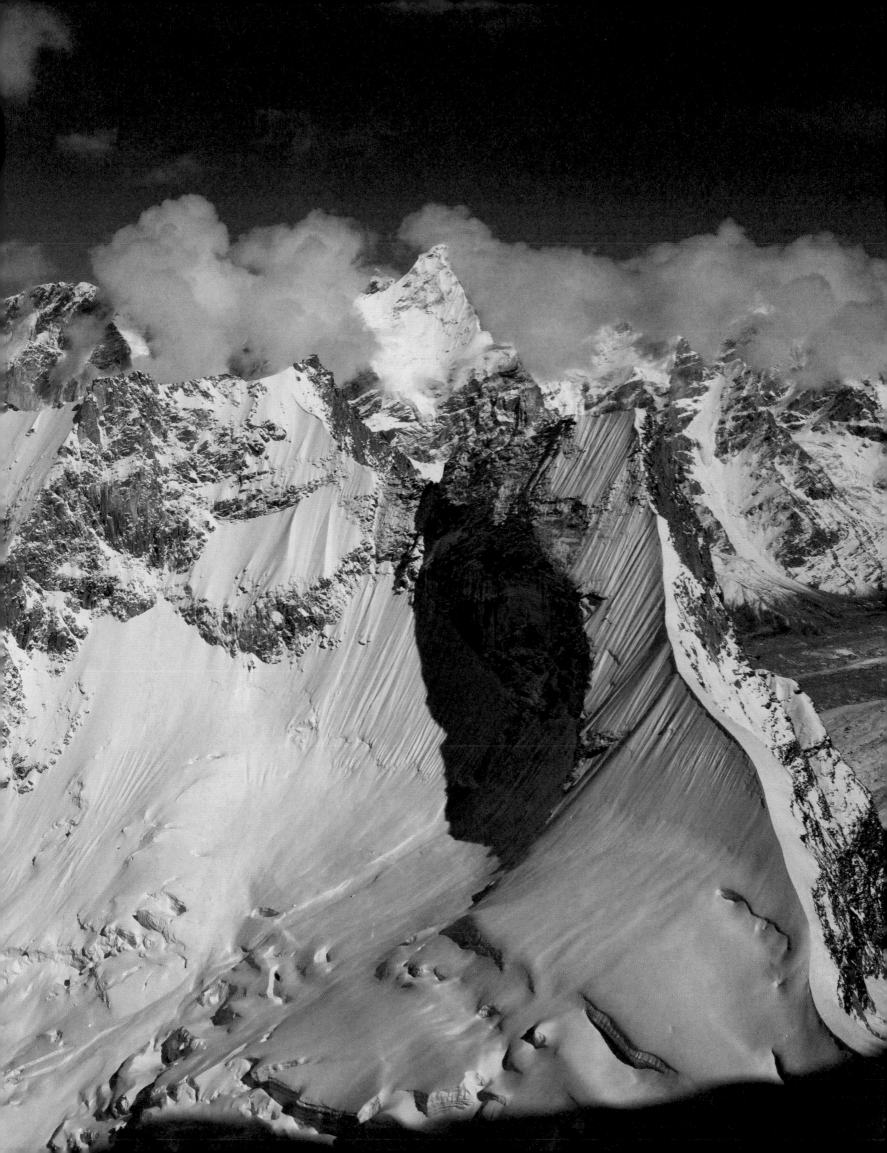

## BORNEO BIG WALL

Mark Synnott has a gift for finding climbing in the most remote and obscure places. Over the years, he's convinced me to join him on several misconceived adventures. On many of our trips, the climbing was marginal or nonexistent and getting to the destination and back alive turned out to be the real adventure. When he told me he'd found a giant overhanging big wall on a 14,000ft peak in the middle of the South China Sea, I reluctantly agreed to go.

In April of 2009, Mark, Conrad Anker, Kevin Thaw, Alex Honnold, and I ventured to Borneo to explore a potential big wall climb on Mount Kinabalu, the highest summit in Southeast Asia.

Alex was twenty-four and had just joined the North Face team. He had just burst onto the scene after free soloing the two-thousand-foot Northwest Regular Route on Half Dome. The feat was so outrageous that we initially questioned if it was true. Alex, the untried young gun, was now spending the month with the silverbacks who made up our team. We were curious to see how he would fare on his first international climbing expedition.

When we arrived at Low's Gully below Mount Kinabalu, we discovered Mark had actually pinpointed a formidable big wall in the middle of Borneo. Halfway up the 2,500-foot wall, we encountered a steep and scary aid pitch. Alex scoffed at the thought of aid climbing and volunteered to take the lead. As he quested off into blank, unprotected, and completely uncharted 5.12 terrain, we double-checked our anchor and wondered if it would hold a hundred-plus-foot fall. We held our breath as he climbed.

Alex finished the pitch and practically yawned. It was the boldest lead any of us had ever witnessed. We knew the next generation had arrived.

**OPPOSITE**  High above the South China Sea, Alex Honnold rappels back to our hanging camp after a wind- and rain-lashed day of climbing.

**FOLLOWING**  Low's Gully. We built our portaledge camp a thousand feet up the overhanging wall on Mount Kinabalu.

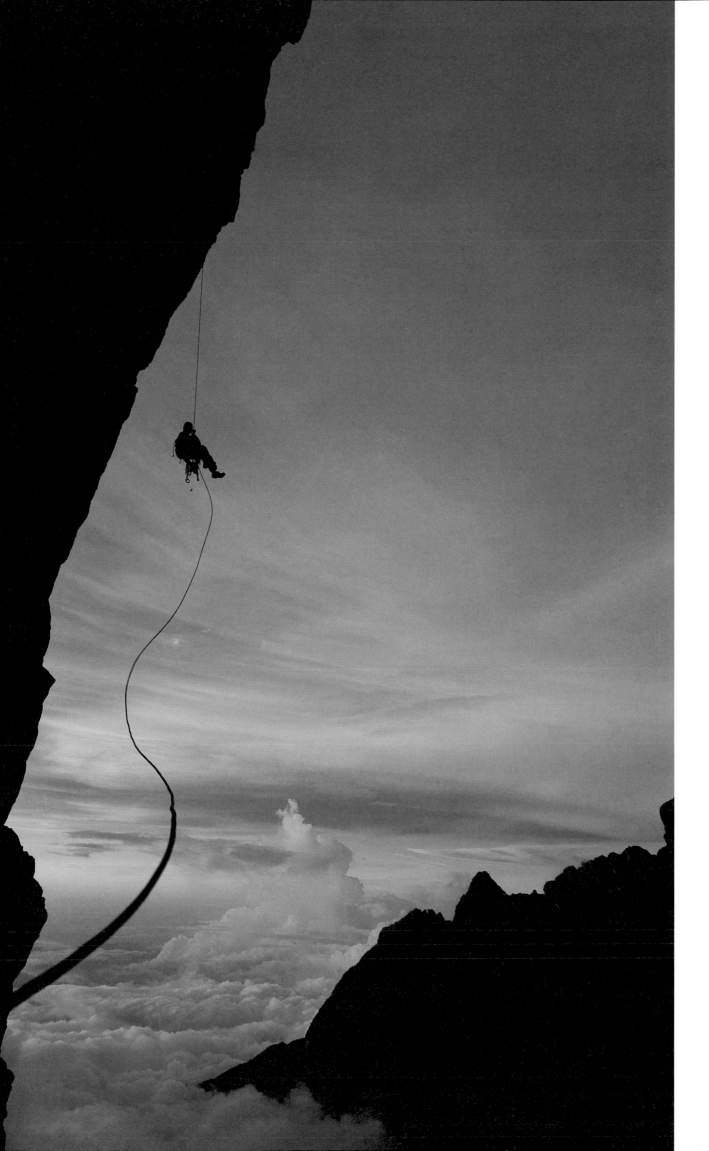

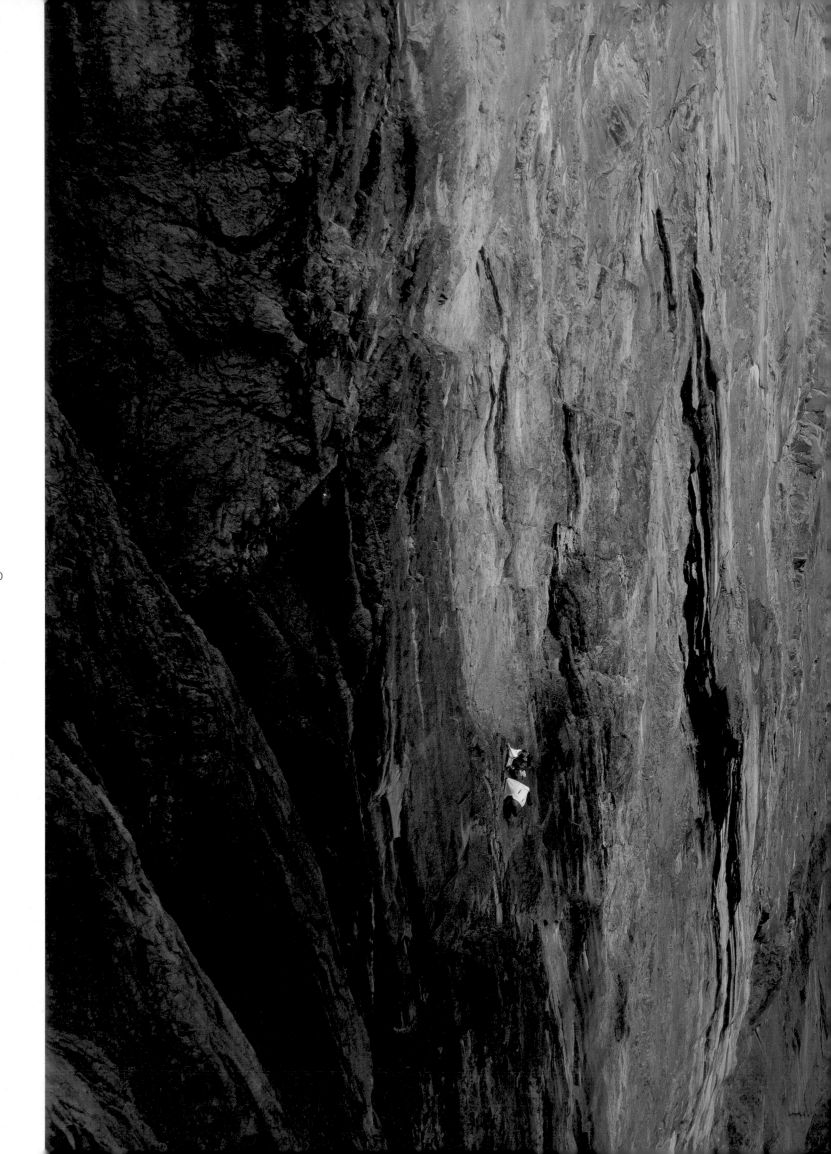

## SHANGRI-LA EXPEDITION

In late September of 2009, Ingrid Backstrom, Kasha Rigby, Giulia Monego, and I headed to the Minya Konka Range at the western edge of Sichuan Province in China. Our goal was to climb and ski the west ridge of a stunning 20,052ft peak in the heart of the range called Reddomaine.

Ingrid was one of the top free-skiers in the world. She'd starred in over twenty ski films and had won all the best female performance awards in the ski industry for multiple years in a row. She had put the expedition together in her pursuit of becoming an equally strong ski mountaineer. Kasha and Giulia had both spent years honing their skills on the steeps in Chamonix and climbing and skiing difficult ski mountaineering lines around the world. All three of them ripped. I felt fortunate to join the team as the photographer.

I prefer expeditions to lesser-known mountain ranges. You never know what you might find. As we made our way toward Reddomaine, we followed along a holy Buddhist circumambulation of Kawa Karpa peak. The trek was an unexpected discovery.

When we finally arrived at the mountain, we established a base camp below the west face. We spent a week acclimatizing before carrying our gear up to a hanging glacier and camping at 17,000ft. The next day we climbed mixed rock and snow, eventually breaking trail up a long snowy ridgeline. We navigated between crevasses on one side and an overhanging cornice on the other in near-whiteout conditions. We stopped several times to discuss turning around. After twelve hours of climbing, we finally summitted Reddomaine on October 15 and skied back to our high camp, making the first ski descent of the mountain.

OPPOSITE  After days of rain-drenched trekking in the Minya Konka Range, we clambered over a high mountain pass to see a giant stash of Tibetan prayer flags (or darchog in Tibetan) and this Specter of the Brocken, the psychedelic result of our bodies casting shadows on the clouds below us.

FOLLOWING  Kasha Rigby traversing above the clouds on the way to our high camp on the west ridge of Reddomaine Peak.

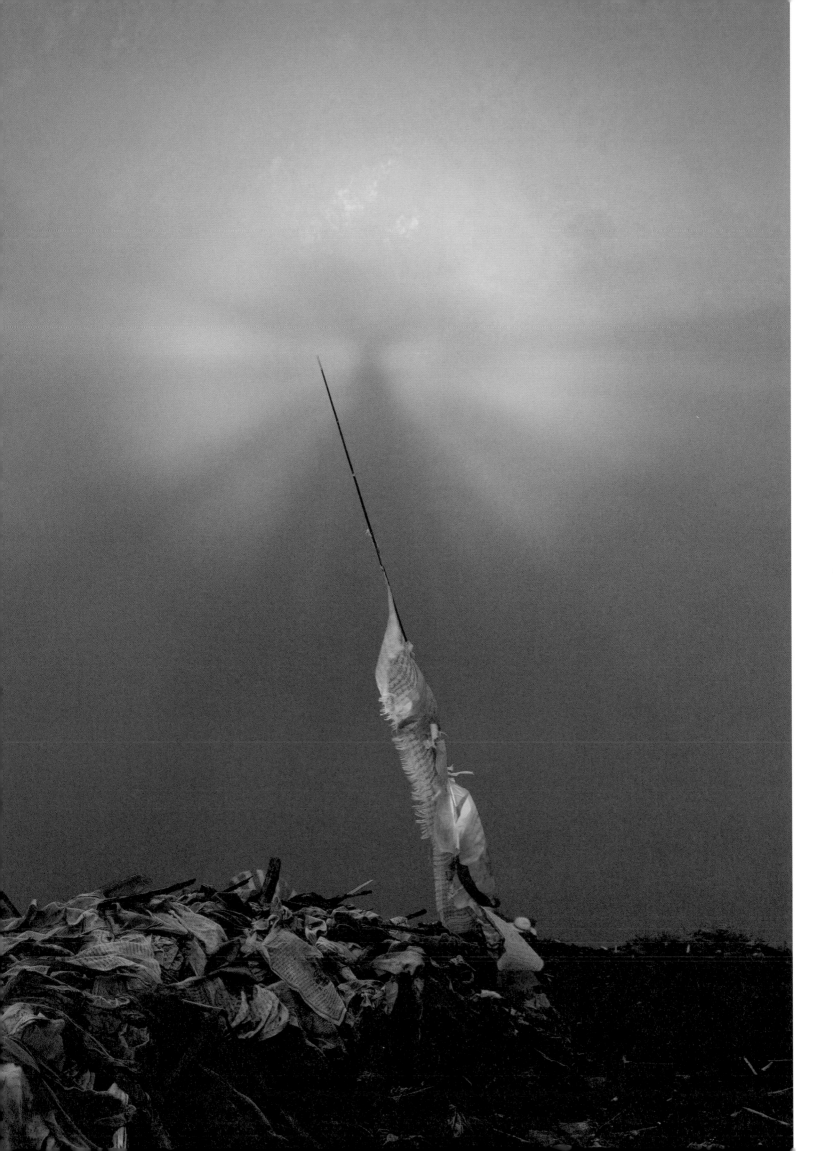

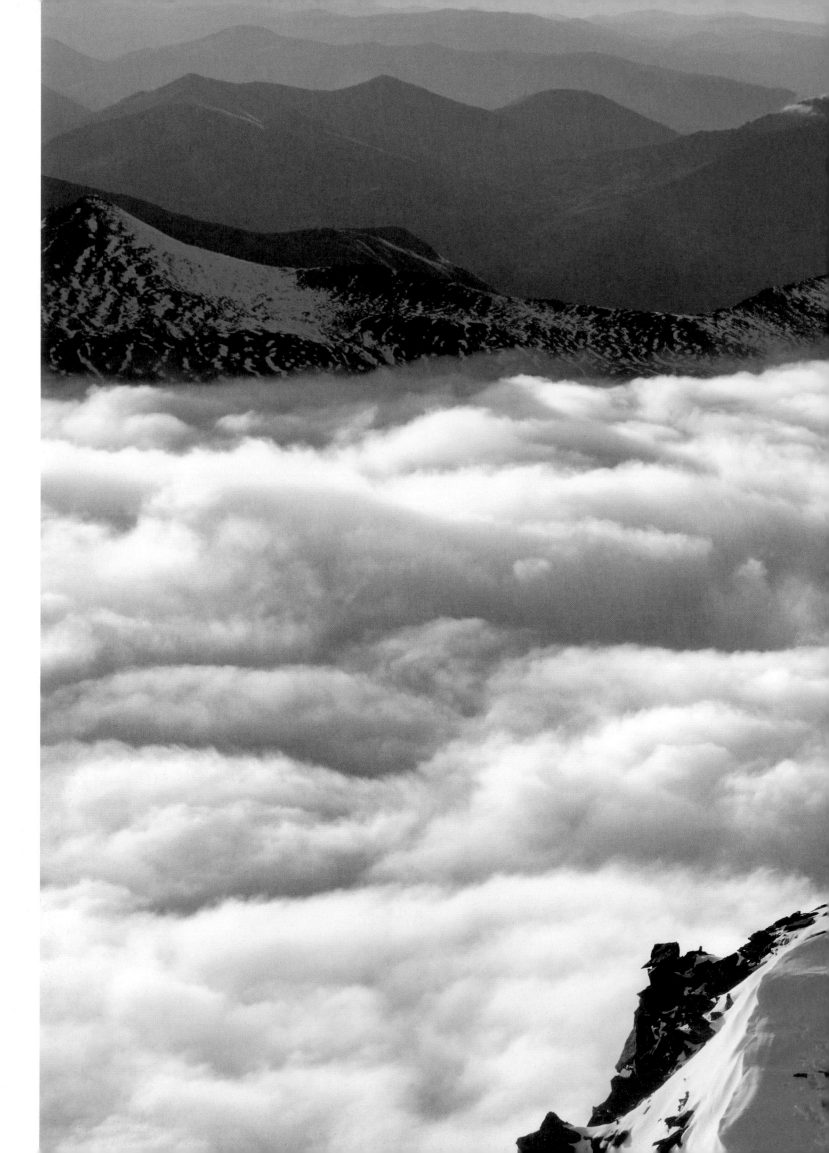

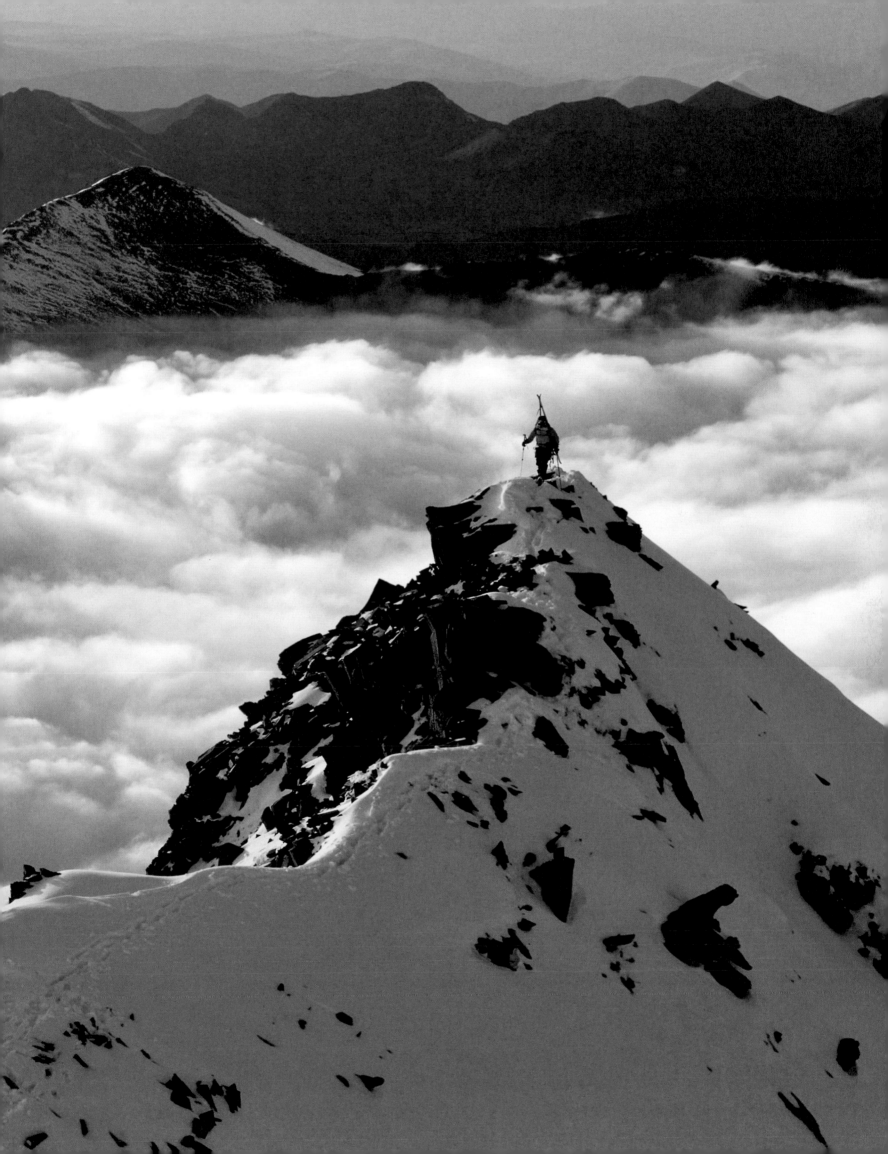

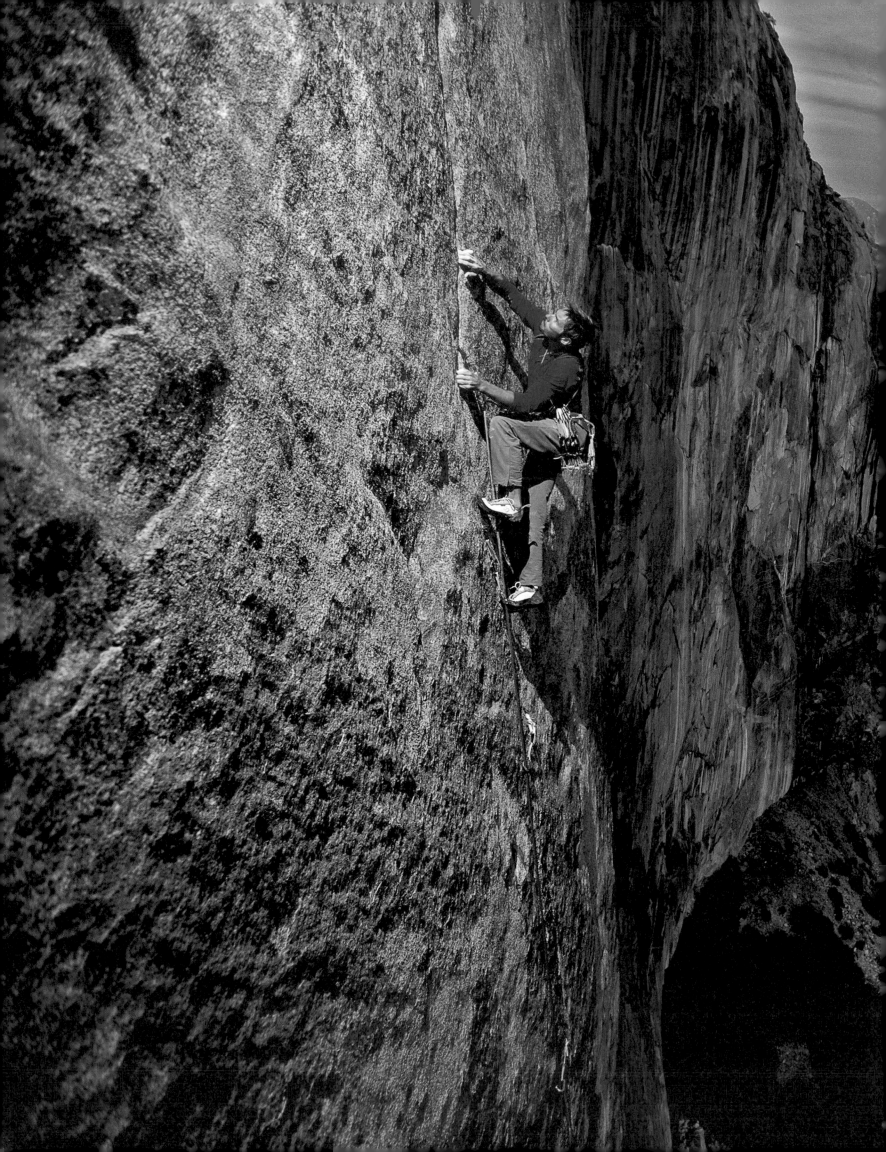

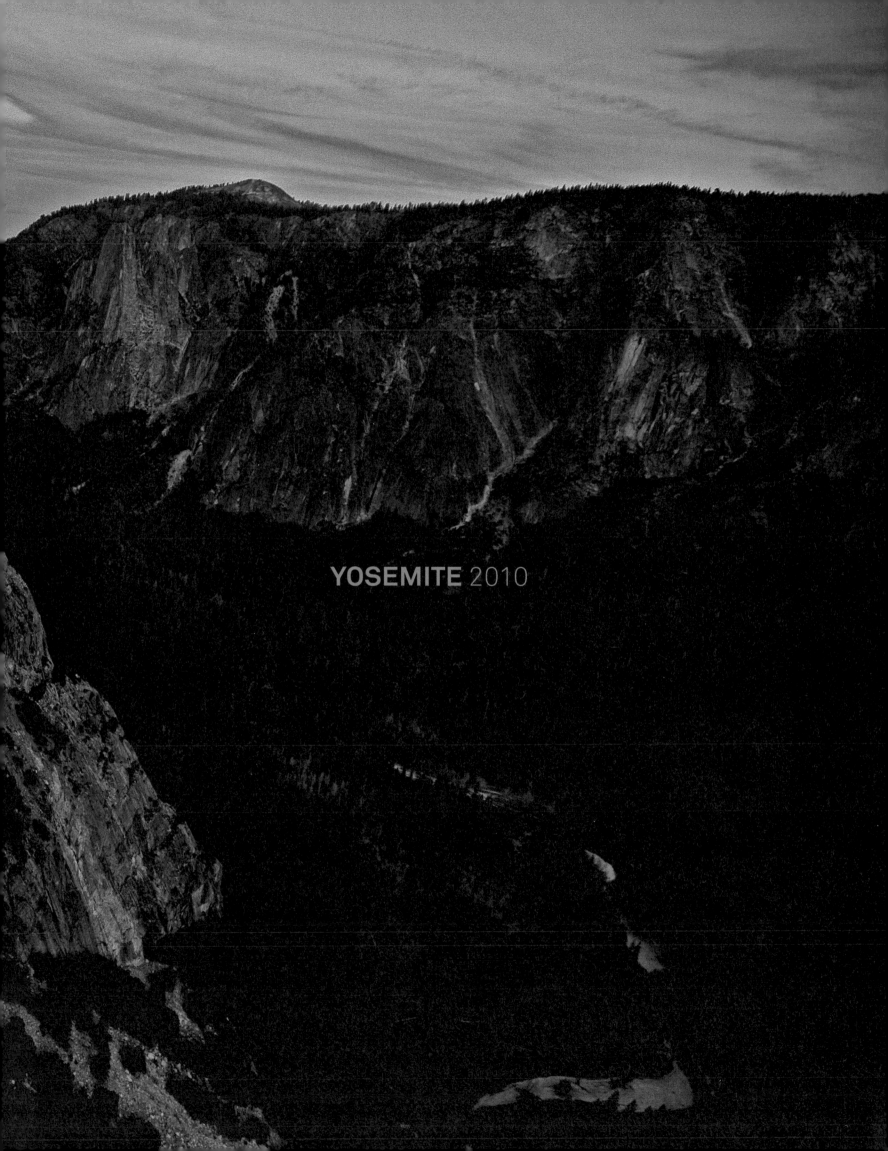

YOSEMITE 2010

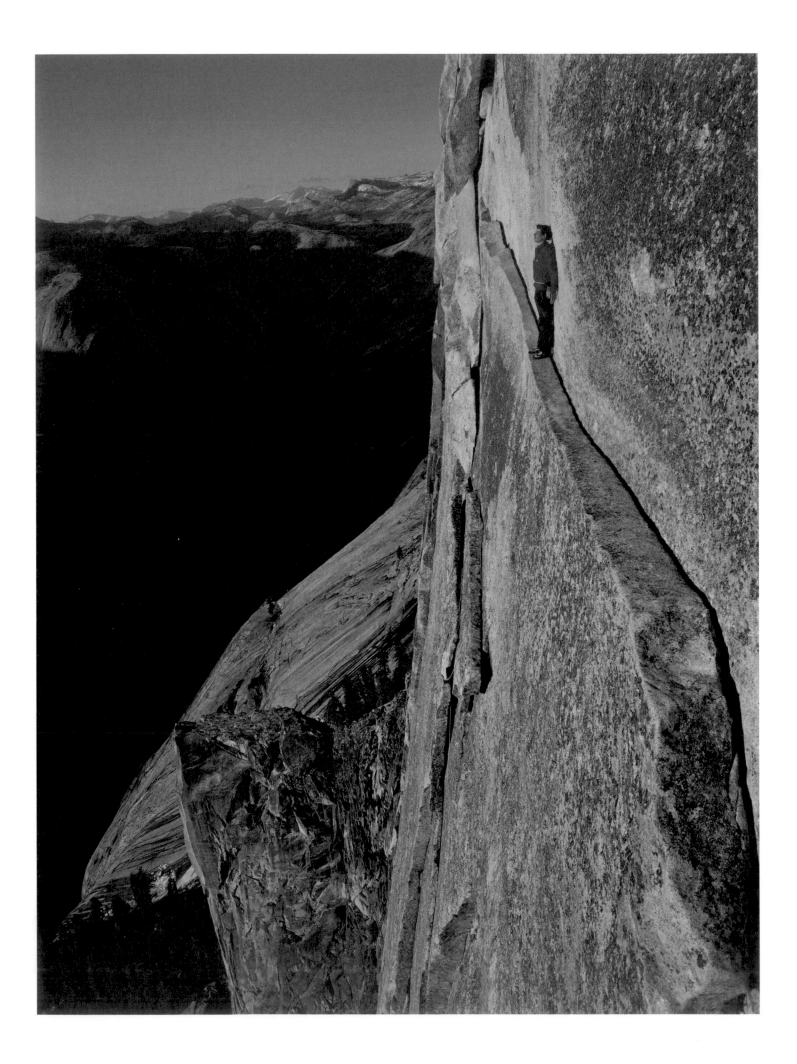

# Yosemite Valley has influenced my life and career more than any landscape in the world.

I began migrating to the Valley in my late teens. I've returned countless times. On an early trip, my friend Brady Robinson and I scratched out our first big climbs—one-day ascents of Half Dome and El Capitan. On another trip, Brady handed me his camera on El Cap and I took my first published photo. The money I made from that photo paid for my first camera.

Many of the people I have looked up to in my life—along with many of my mentors and lifelong friends—spent formative years in the Valley. Yosemite, the ancestral home of the Ahwahneechee, has long connected a mixed tribe of vagabonds, world-class athletes, mystics, and misfits, all in the pursuit of adventure and bliss on its towering granite shields. Generations of wilderness devotees from John Muir and Yvon Chouinard to present-day teenagers have dropped out of polite society to live at the fringes and sleep in the dirt, on the sides of mountains, or in their cars to exist among its trees, waterfalls, and walls.

There is no place else in the world with such immediate access to the size and scale of climbing that Yosemite offers. Climbing in the Valley hones your ability to move quickly over a lot of vertical. The climbing will push your physical and mental boundaries to their limits no matter who you are or how well you climb. The Valley makes you strong.

In the fall of 2009, I set out on my first feature assignment for *National Geographic* to capture the spirit of the climbing culture and the evolution of cutting-edge climbing in Yosemite. I wanted to show a different perspective of Yosemite to the world.

With the highest editorial photography standards in the world, *National Geographic* places a specific burden on those who shoot for it: upholding its legacy. The magazine sends photographers off for months or even years to shoot assignments. Sometimes photographers come back after long assignments, and the work is rejected and never published. I found this fact both terrifying and highly motivating.

Every day I was conscious that there were pictures happening somewhere in the valley that I was missing. It made me frantic to shoot, and I ran from location to location, knowing longtime senior photo editor Sadie Quarrier would be scrutinizing every single one of the tens of thousands of frames I would shoot for the story.

Working with my assistant, Mikey Schaefer, we spent two complete seasons, spring and fall, chasing Yosemite locals and a roster of some of the finest climbers in the world: Dean Potter, Alex Honnold, Leo Houlding, Kate Rutherford, Sean Leary, Brad Gobright, Ueli Steck, Tommy Caldwell, and others.

Some images required days of climbing and rigging to get a single shot. Other moments appeared spontaneously while hanging out in the meadows below El Cap or in Camp 4 on a rainy morning. I am deeply grateful for those days. Some of the people I photographed are no longer with us, and I treasure the memories of our last shared experiences together. In the end, the photographs were published in the May 2010 issue of the magazine, and my image of Alex Honnold on Half Dome made the cover.

**PREVIOUS** Kevin Jorgeson climbing the poorly protected pitch 22 (5.12c) on the Dawn Wall. Kevin and Tommy Caldwell often climbed at night to take advantage of cooler temperatures and better friction.

**OPPOSITE** Alex Honnold shuffles ropeless across Thank God Ledge on Half Dome.

**ABOVE** Climbers gather in El Cap Meadows to talk about the day and plan for the next.

**OPPOSITE** Climbers spend a rainy day at the Alcove Swing on El Cap.

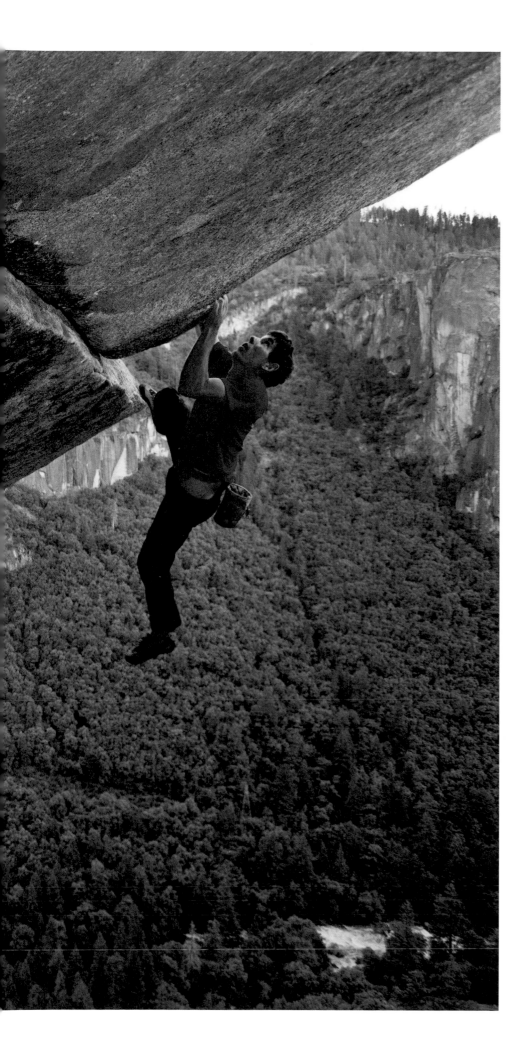

**LEFT**  Alex Honnold free-soloing
Separate Reality (5.11d).

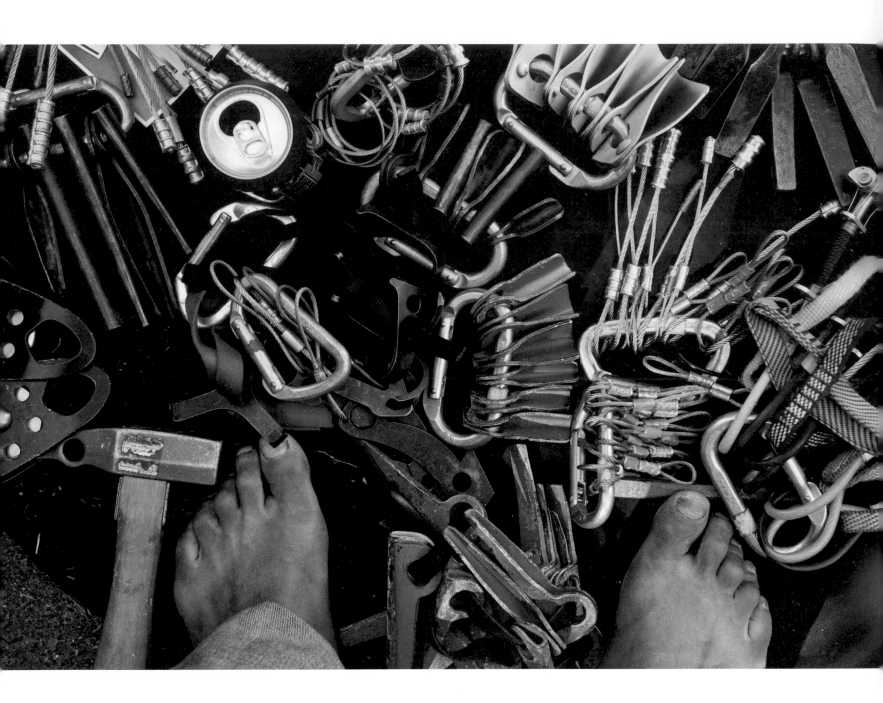

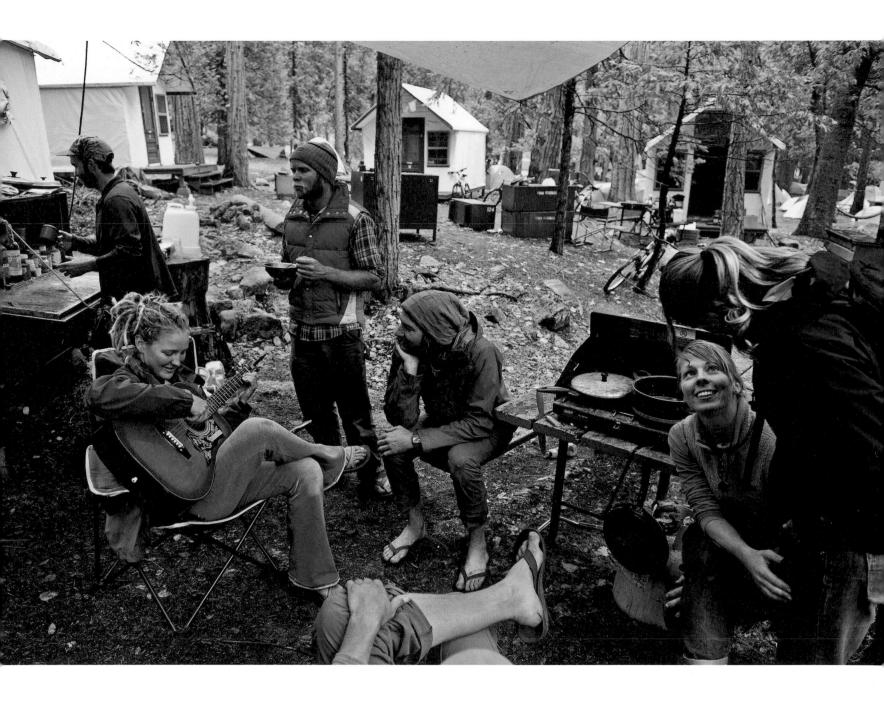

OPPOSITE  The Yosemite wall rack.

ABOVE  Life at the Yosemite Search and Rescue (YOSAR) camp during a rainy day.

FOLLOWING  Dean Potter walking a highline above Yosemite Falls. Dean was the first person to set up and walk the Yosemite Falls highline.

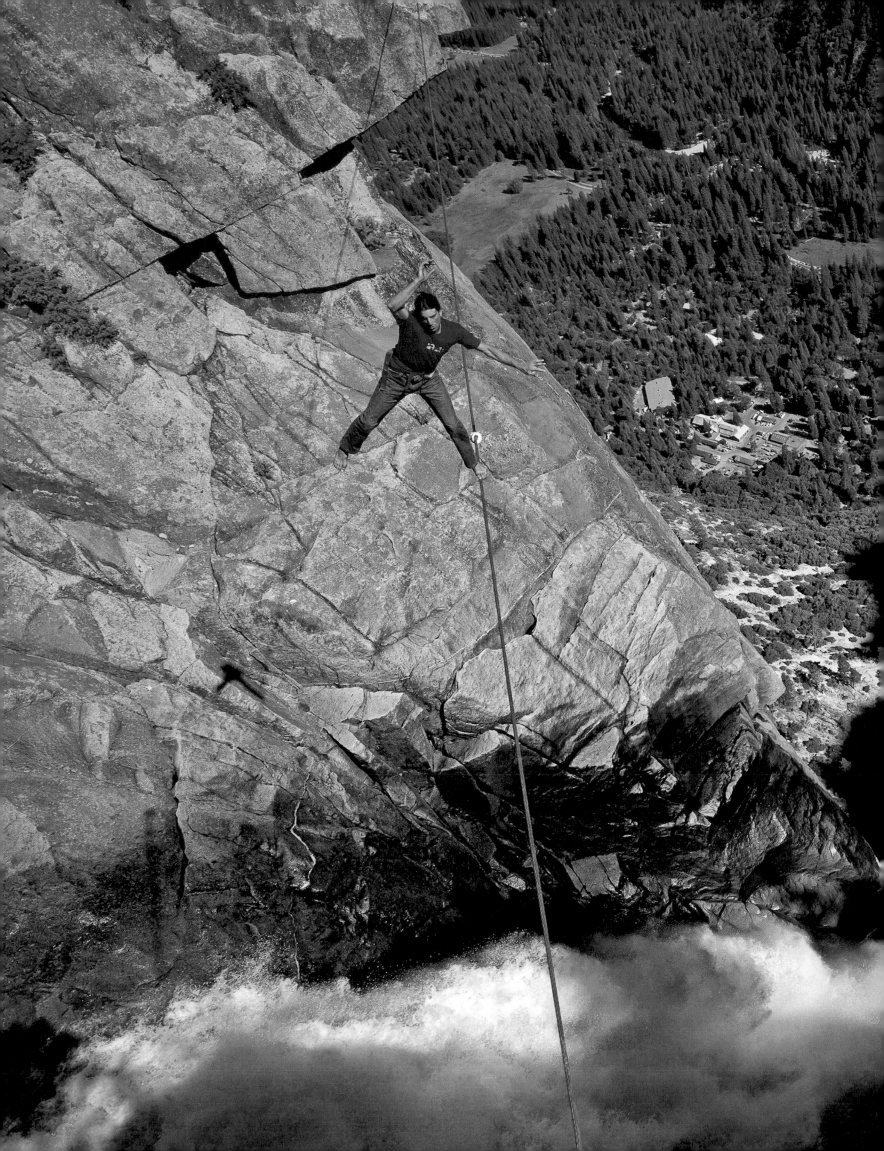

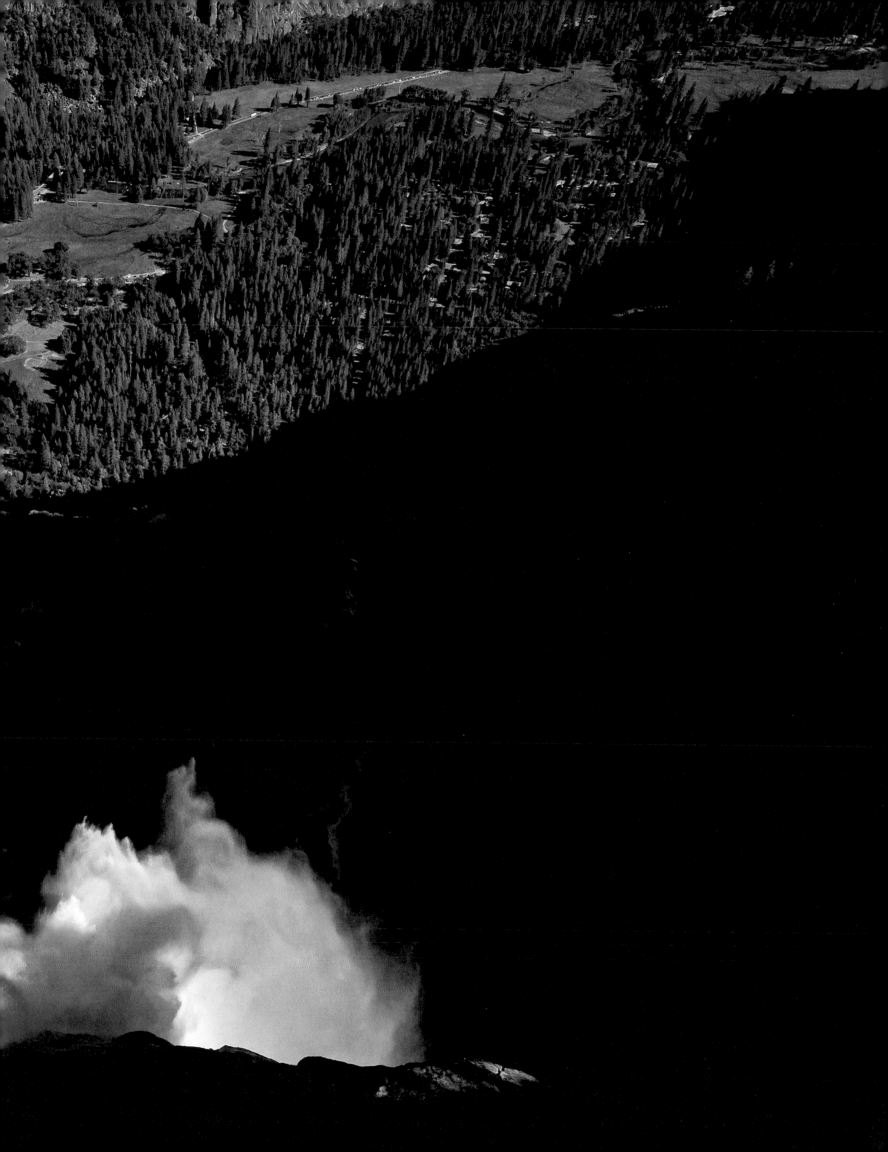

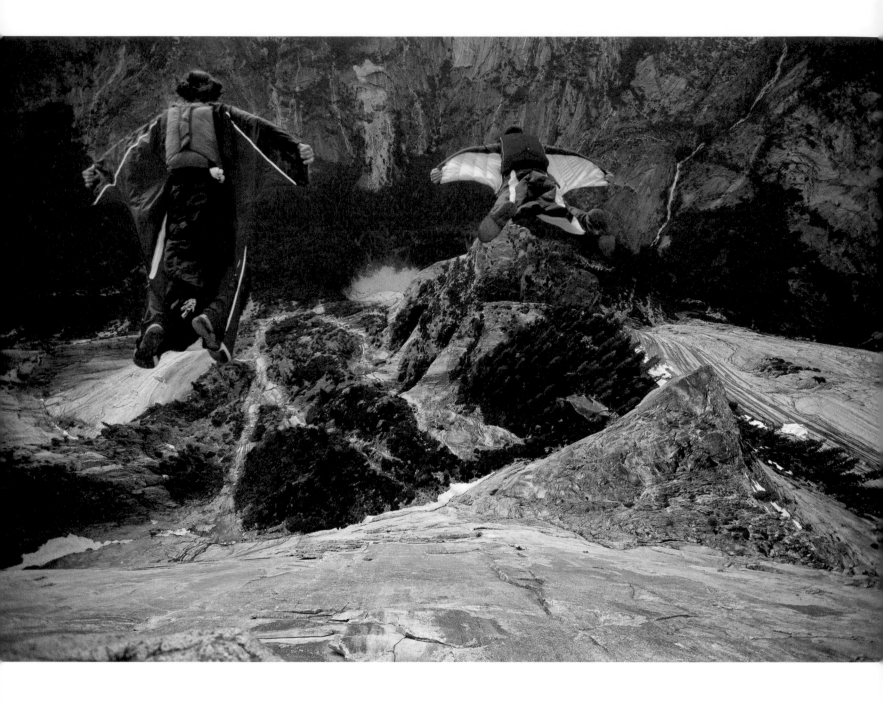

**ABOVE** BASE jumpers taking flight off the diving board on Half Dome.

**OPPOSITE** Climbers on top of Higher Cathedral Spire.

**FOLLOWING** Phantoms at dusk. Since BASE jumping is illegal in Yosemite National Park, flights are often made at first light or last light to avoid detection.

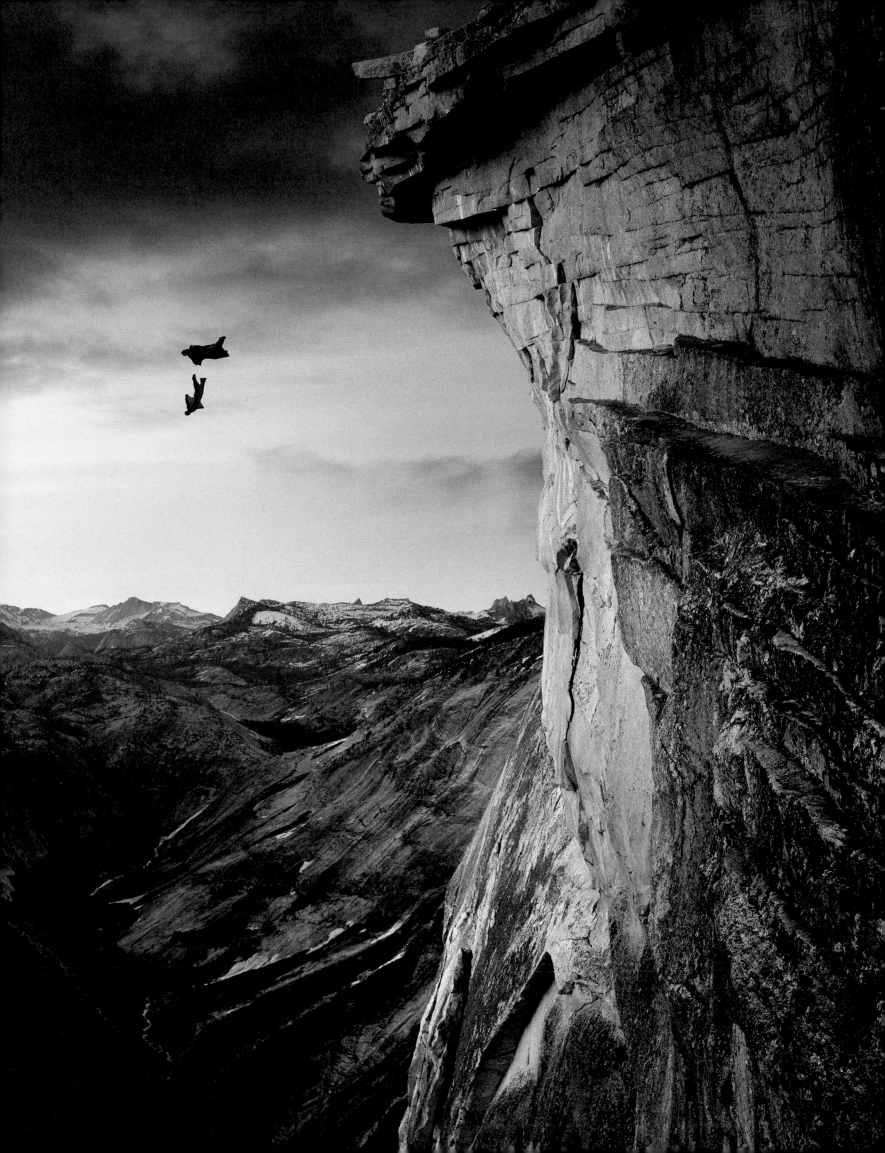

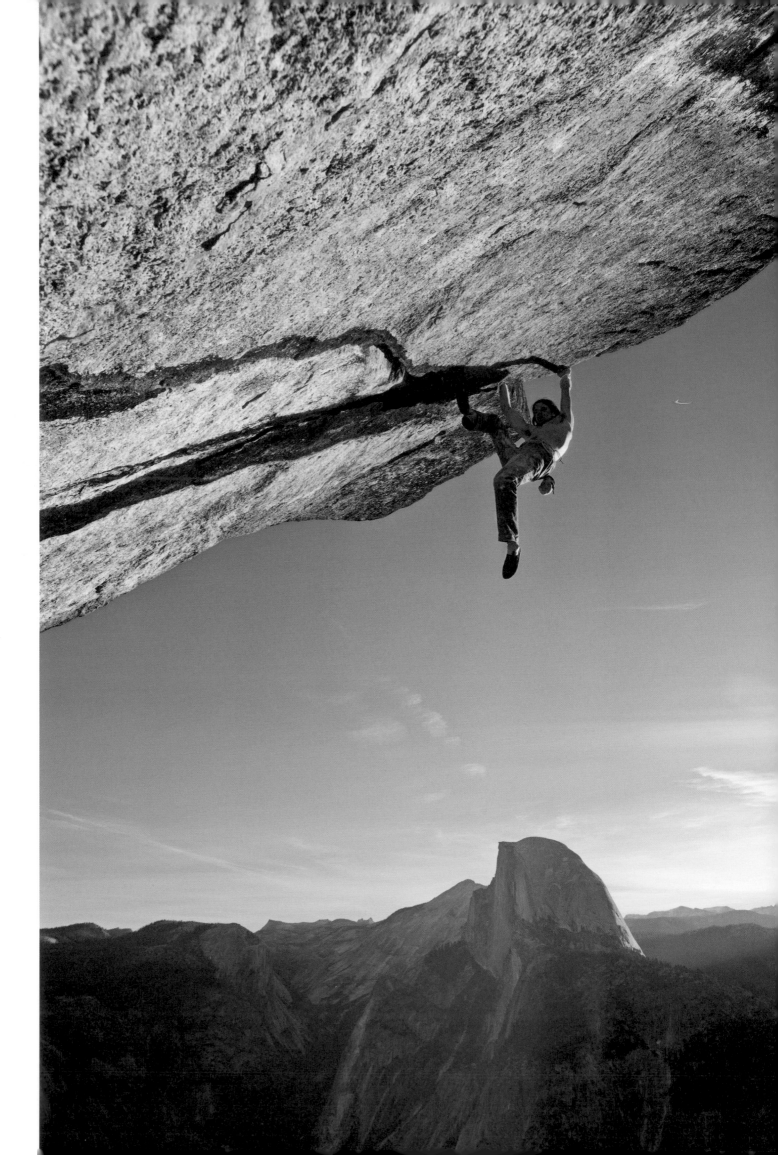

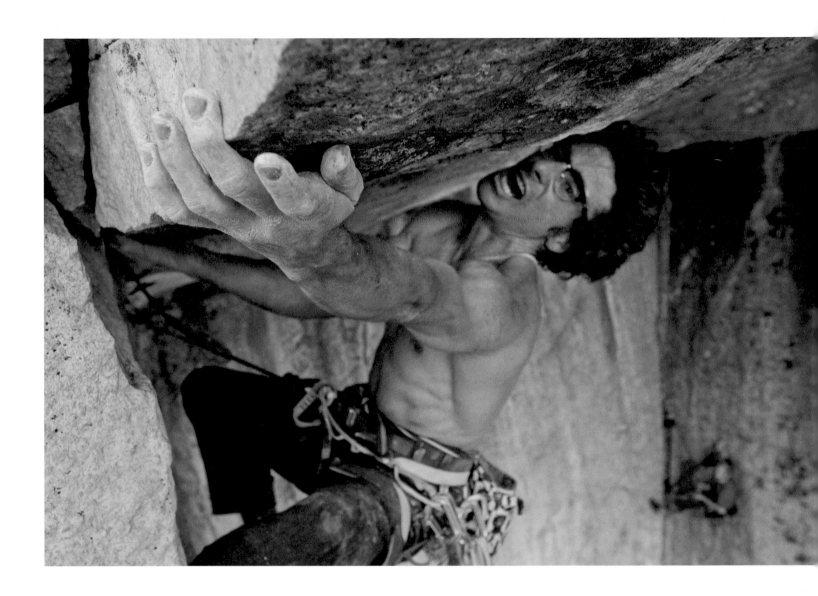

**OPPOSITE** Dean Potter free-soloing Heaven (5.12d).
Dean made the first free-solo ascent of this severely
overhanging finger crack.

**ABOVE** Cedar Wright battling gravity through the
Gravity Ceiling (5.13a), Upper Cathedral.

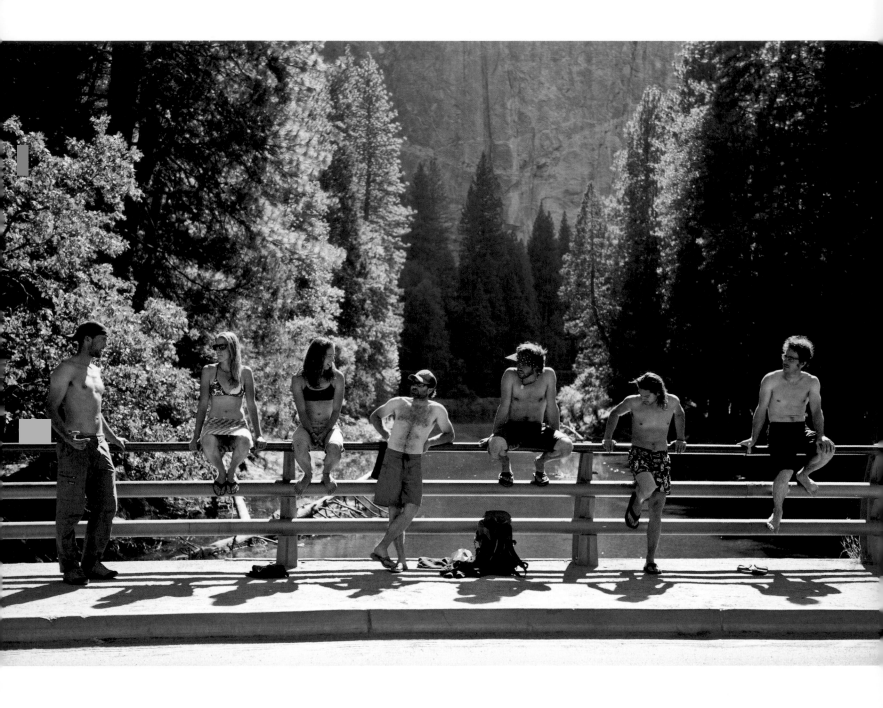

**ABOVE** If you're looking for climbing beta or Valley gossip, the bridge below El Cap is a good place to get it and a classic meeting spot for Stone Monkeys. From left, Dave Turner, Kate Rutherford, Ashley Helms, Mikey Schaefer, Aaron Jones, Lucho Rivera, and Cedar Wright.

**OPPOSITE** Kate climbing Freestone, a long, burly test piece next to Yosemite Falls.

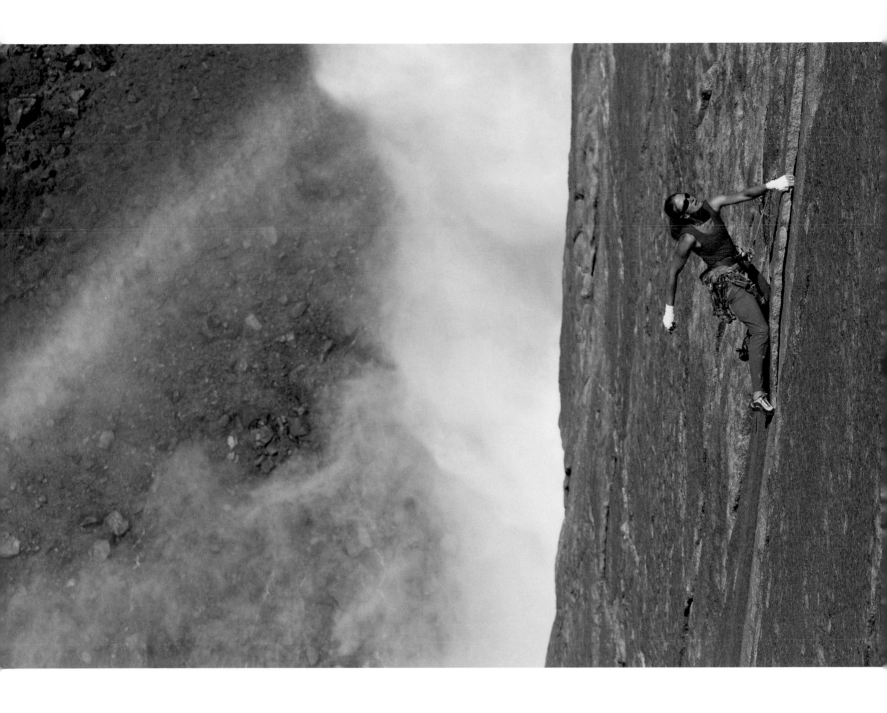

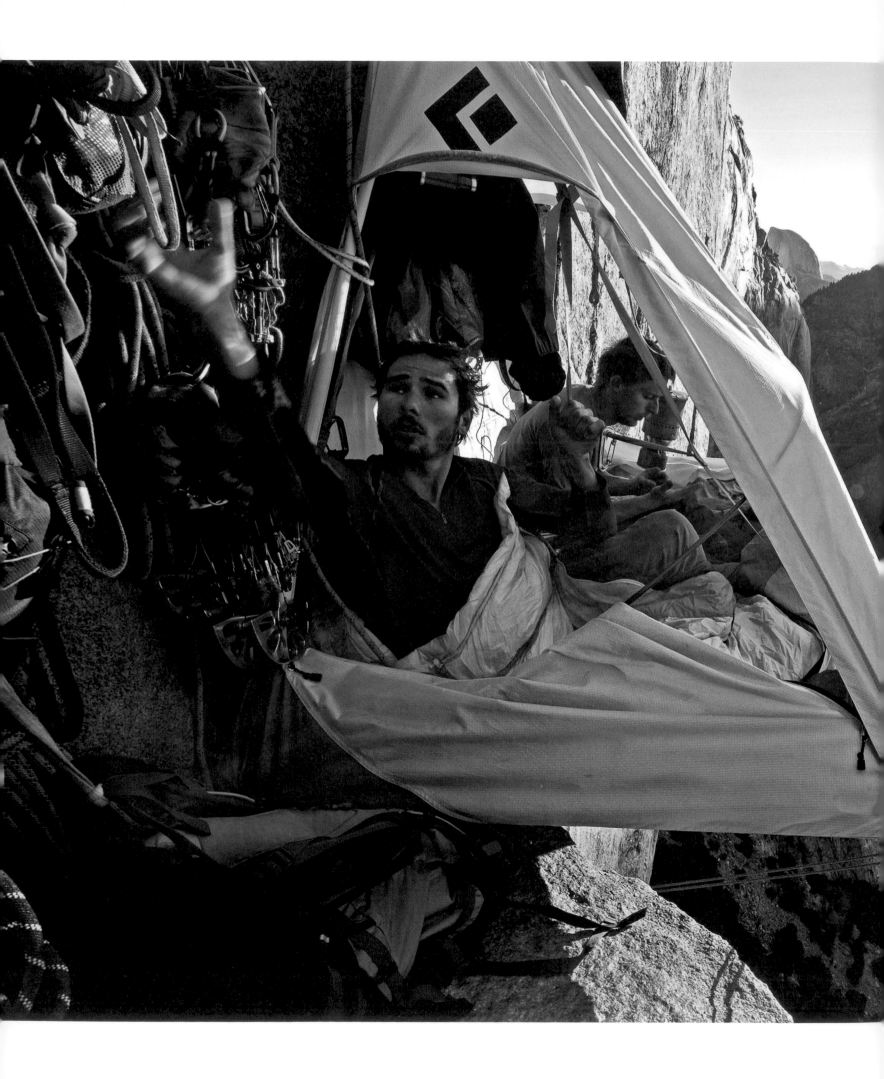

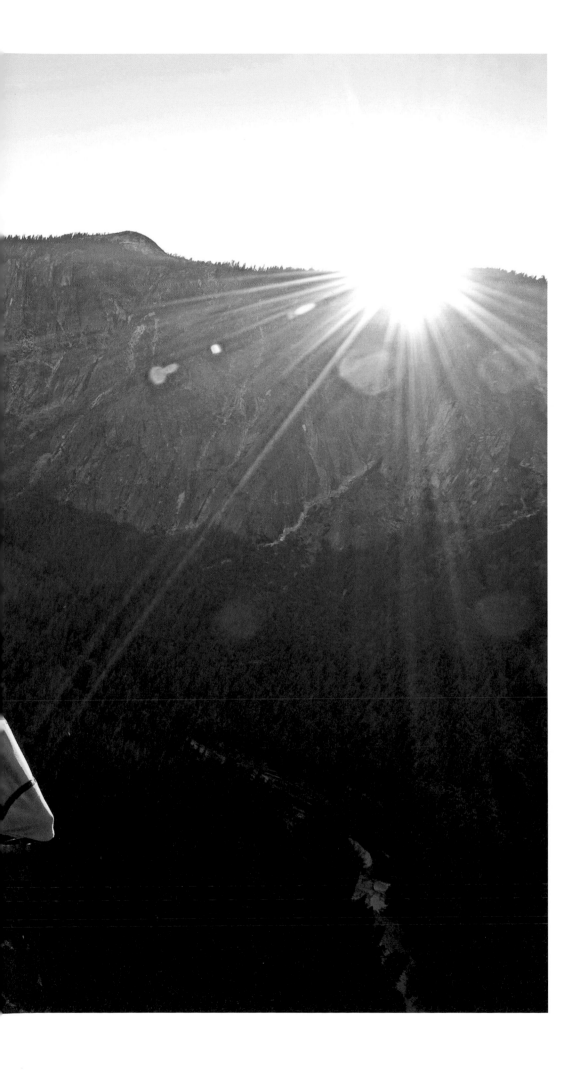

**LEFT** Kevin Jorgeson and Tommy Caldwell gearing up at sunrise on the Dawn Wall.

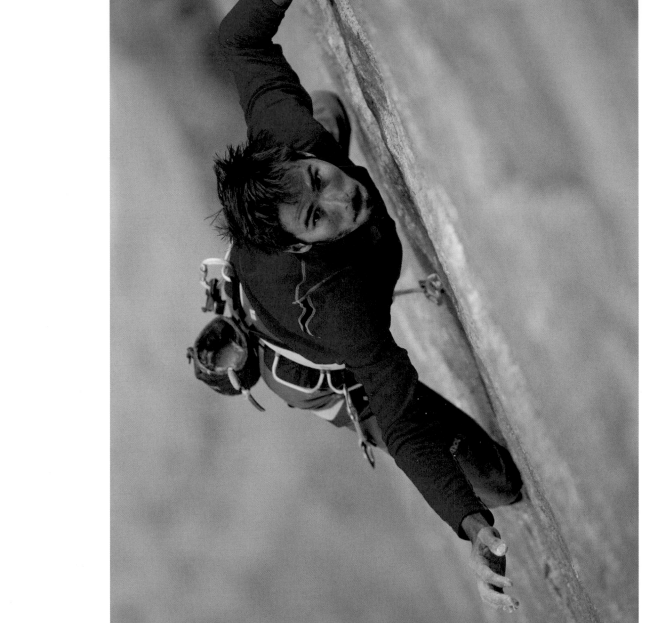

**ABOVE** Kevin Jorgeson. Pitch 19 (5.13d), the Dawn Wall.

**OPPOSITE** Kevin crimping and tiptoeing up the highly technical pitch 19 (5.13d) on the Dawn Wall.

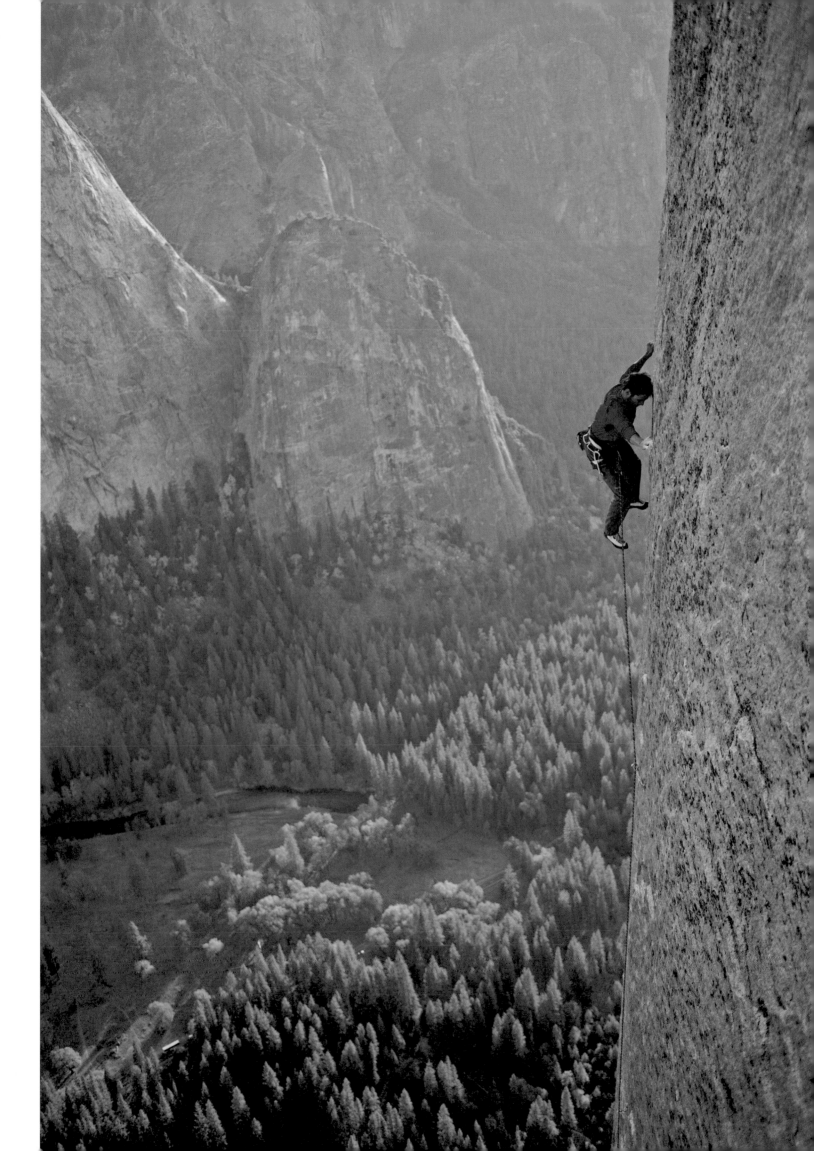

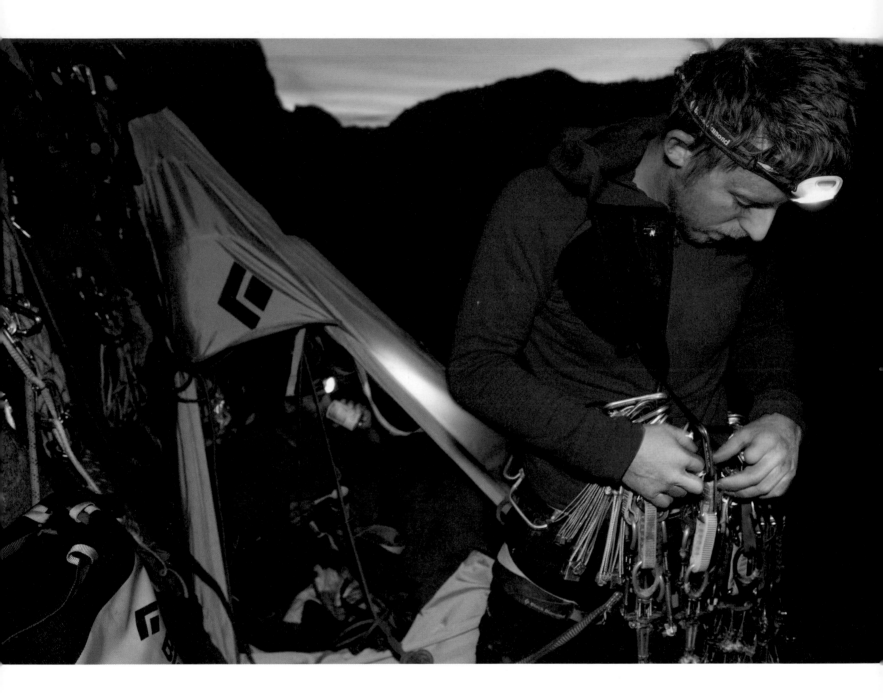

**ABOVE** Tommy Caldwell and Kevin Jorgeson preparing for battle. Climbing at night was the norm while they worked on the route and during the actual free ascent. Cooler temperatures mean better friction. When you're climbing 5.14 on dime-sized edges two thousand feet up El Cap, every extra advantage counts.

**OPPOSITE** Tommy leading out during a night session to work the crux 5.14d traverse pitch on the Dawn Wall. El Capitan.

**FOLLOWING** Yosemite Valley after a storm.

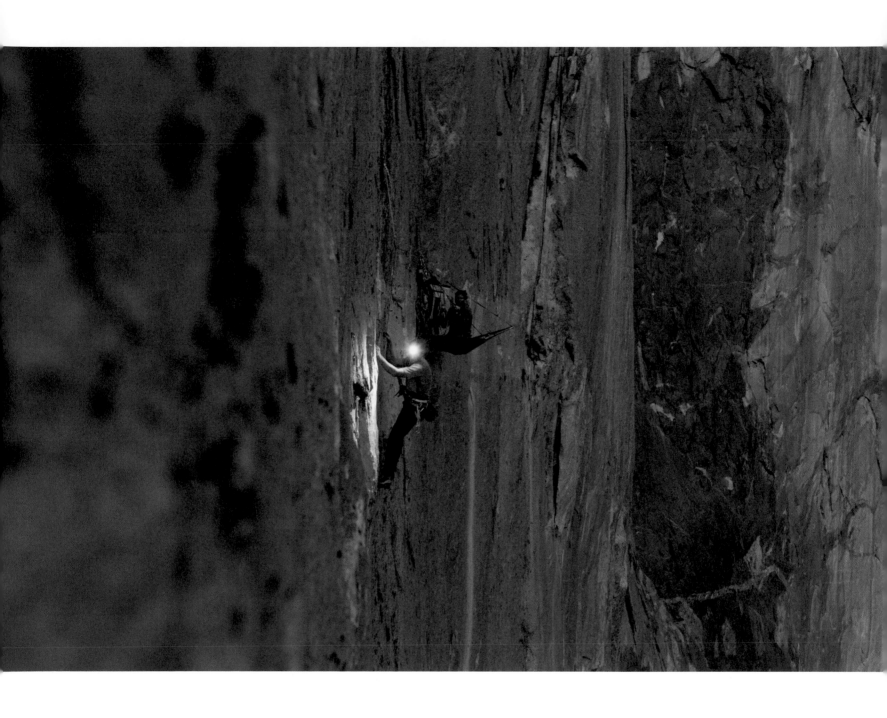

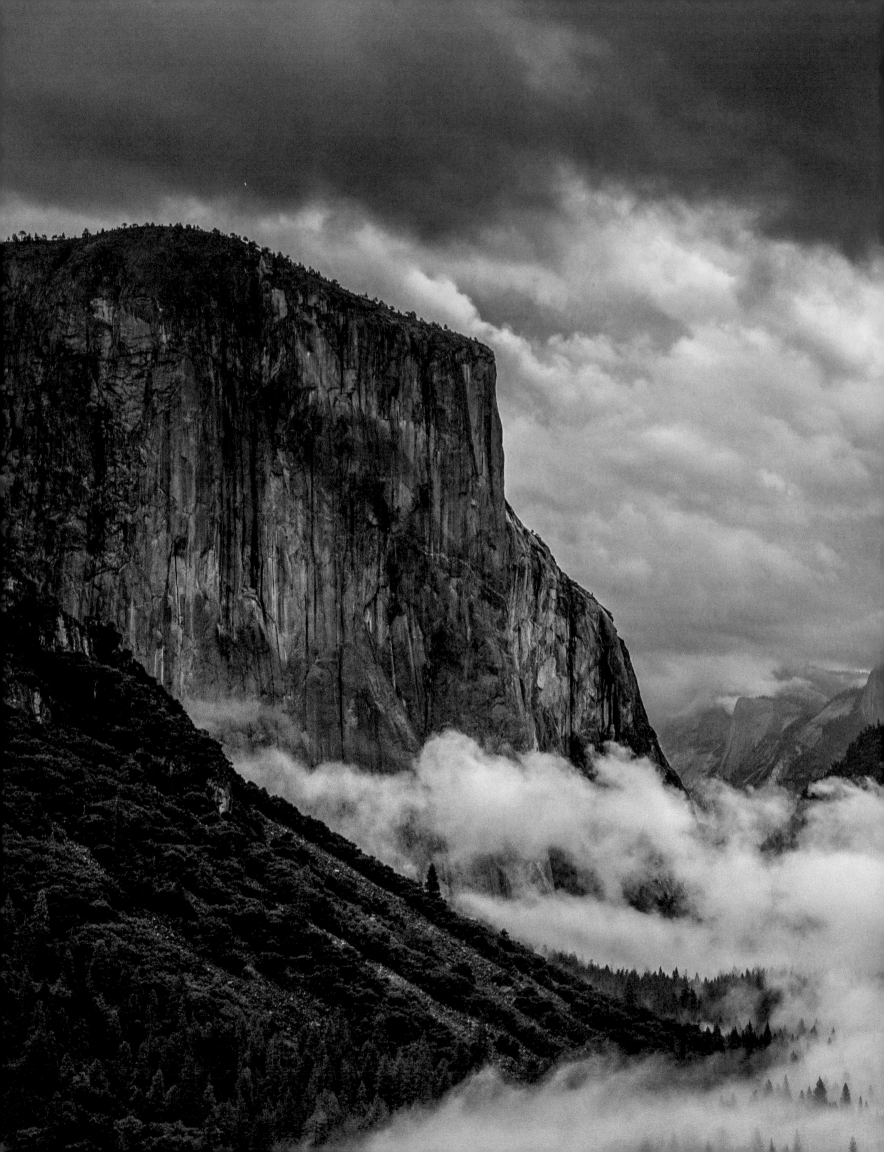

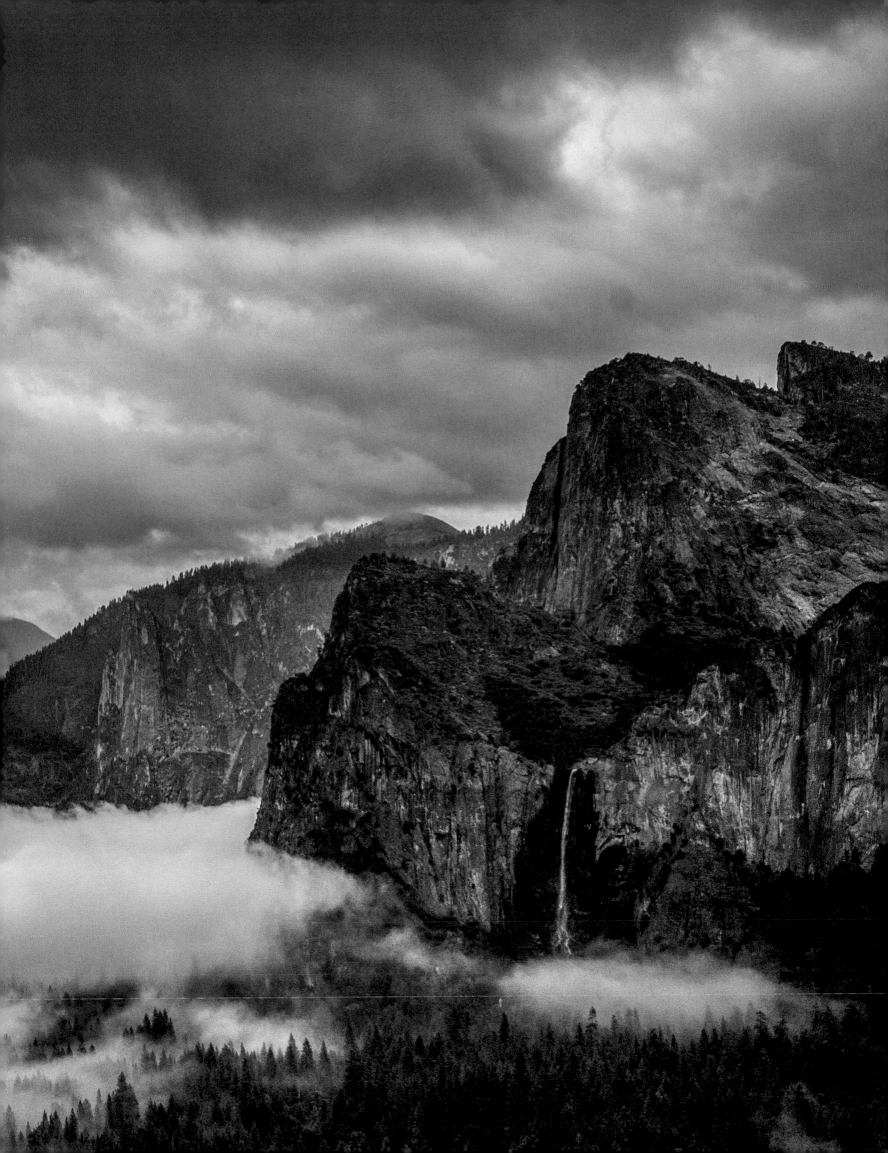

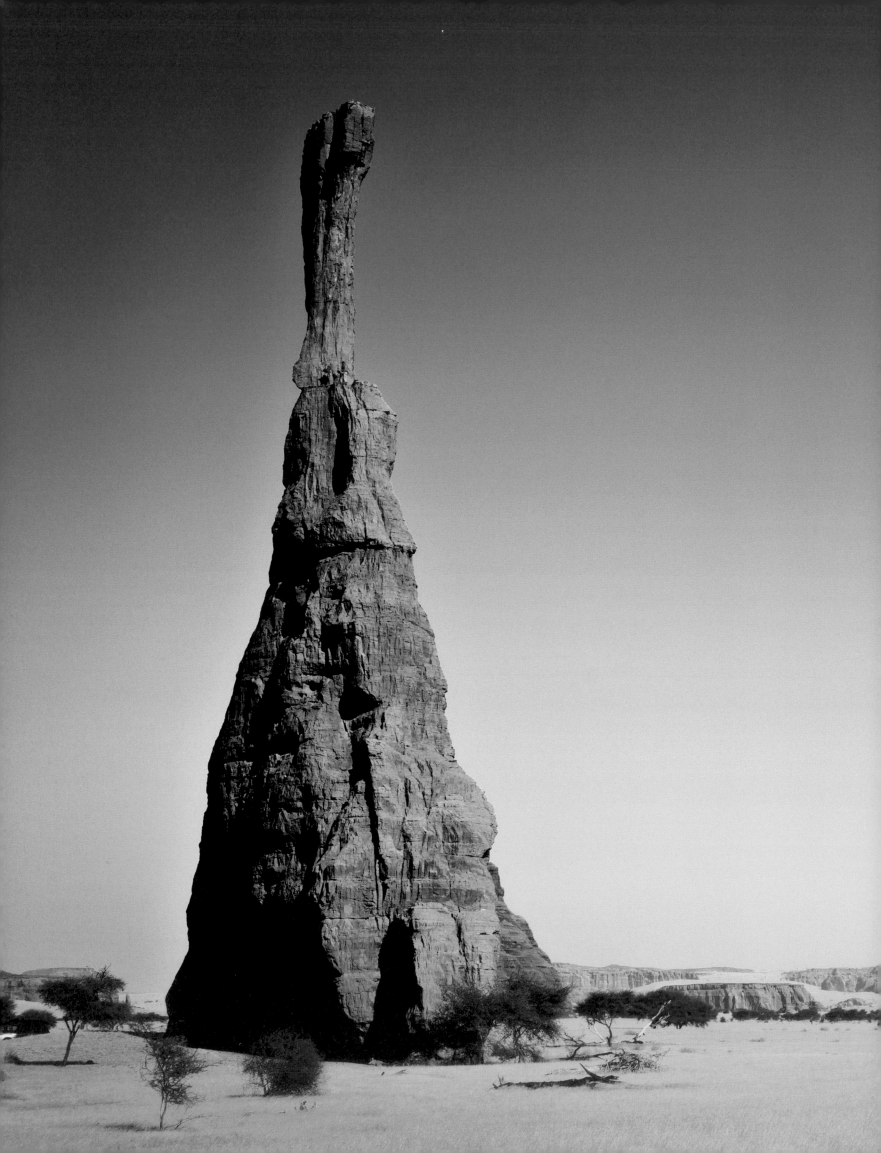

CHAD 2010

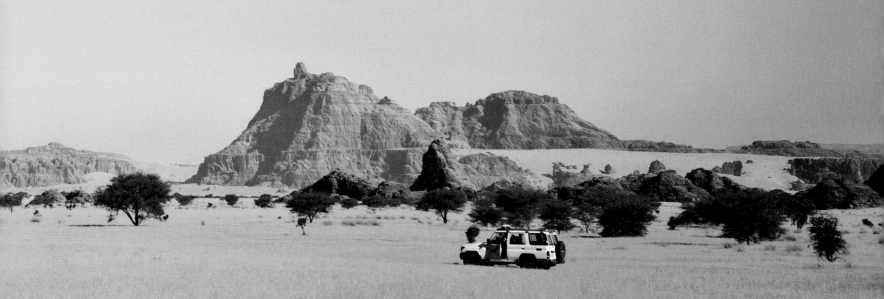

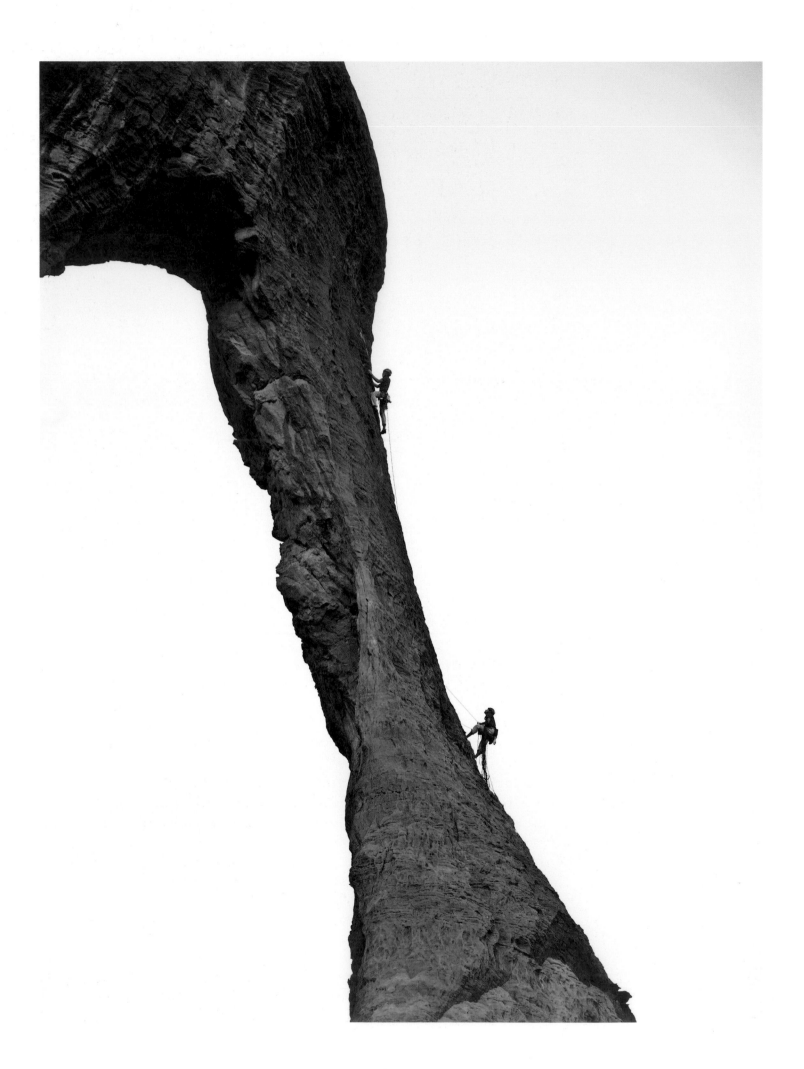

# Holding a grapefruit-sized rock over my head felt ridiculous, but it was the only weapon I could find on short notice.

The man coming toward me with a homemade steel shank paused. Standing behind me, clutching a gnarled tree root repurposed as a club, was my friend Mark Synnott. He was to blame for the current situation. It was his idea to venture to the Republic of Chad for an exploratory climbing expedition in the Ennedi Desert.

Mark excels at finding new places to contend with gravity. We'd come with two of the world's finest contenders, Alex Honnold and James Pearson. We all were keen to climb and document first ascents on these unclimbed sandstone towers.

The trip was going well until our tenth day. We wandered a few miles too far from our guide in search of a worthy climb. Bad idea. A band of men brandishing fifteen-inch daggers appeared out of nowhere and tried to ambush us under a huge sandstone arch.

I locked eyes with my assailant. Contemplating my crazed expression as I wielded my rock, he backed off, and his group vanished into the desert as quickly as they'd arrived.

The Ennedi Desert looks like a larger, more spectacular version of Arizona and Utah's Monument Valley, with immense towers, arches, and canyons spread across a vast expanse of sand. Unlike Monument Valley, it's usually 110°F during the "cool" season. Summer temperatures can reach 140°F.

Getting to the Ennedi required five days of off-road driving. Because our Land Cruisers had no air conditioning, we kept the windows open. It felt like having a giant hair dryer blasting in your face.

At some point during our drive, two Bedouin on camels materialized out of the shimmering horizon. Pretty much the only people we encountered on the five-day drive, they were carrying everything they owned in bundles strapped to their camels.

We exited our vehicles to say hello. One of the Bedouin splashed light brown liquid from a goatskin into a bowl and handed it to us. It was rancid camel milk. Without hesitation, he had shared his only sustenance with strangers.

"There is no choice. You have to drink some," Piero, our guide, told us. We all sipped cautiously. Later, we all fell ill.

Piero had once been a climber himself. He knew what kind of journey we sought. He brought us to the area's most dramatic formations, including the spindly Arch of Bashikele and another known as the Wine Bottle. Our team managed to make first ascents of both, despite gritty rock and questionable protection.

It may be unforgiving, but the Ennedi holds the allure of all deserts—the austerity of the landscape, the cool quiet nights, and the endless stars to fall asleep beneath. But surviving in a desert as harsh as the Ennedi is an unending task. For us this was a temporary two-week adventure. For the people of the Ennedi, it is a lifelong struggle.

**PREVIOUS** The Wine Bottle—one of the many striking towers in Chad on which we climbed first ascents.

**OPPOSITE** James Pearson and Mark Synnott climbing the first ascent of the Arch of Bashikele.

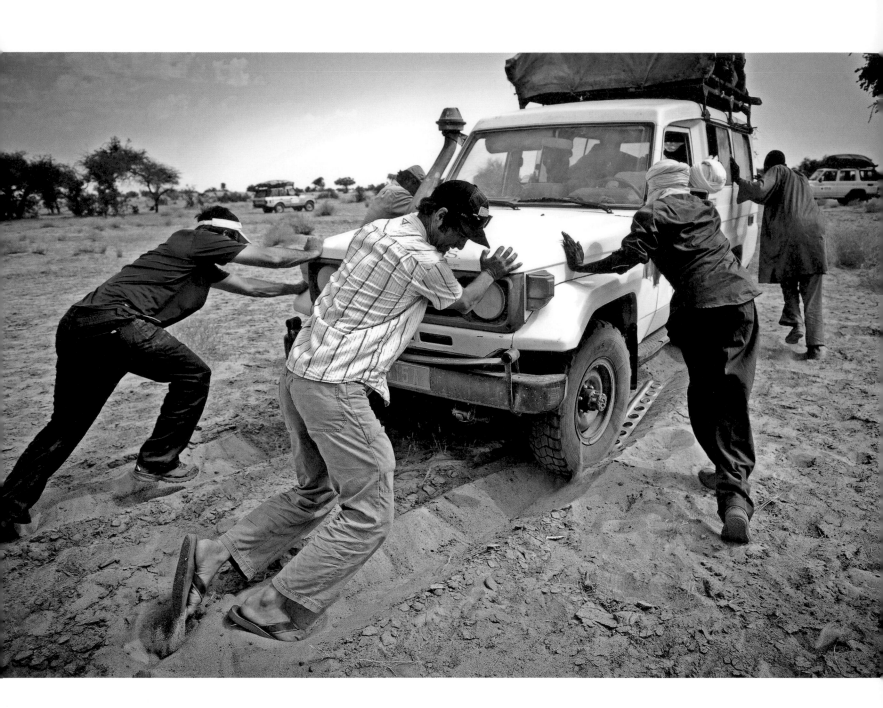

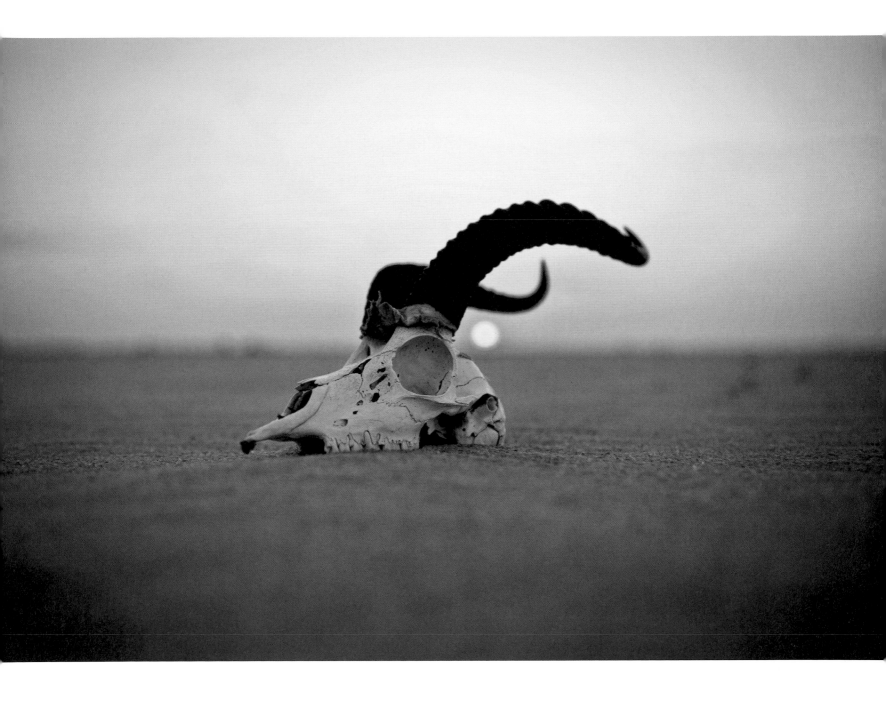

**OPPOSITE** Sand trap. We drove off road for five days from N'Djamena, the capital of Chad, to get to the Ennedi Desert.

**ABOVE** Sunset, Ennedi Desert.

**FOLLOWING** One of our many epic camps in the Ennedi Desert.

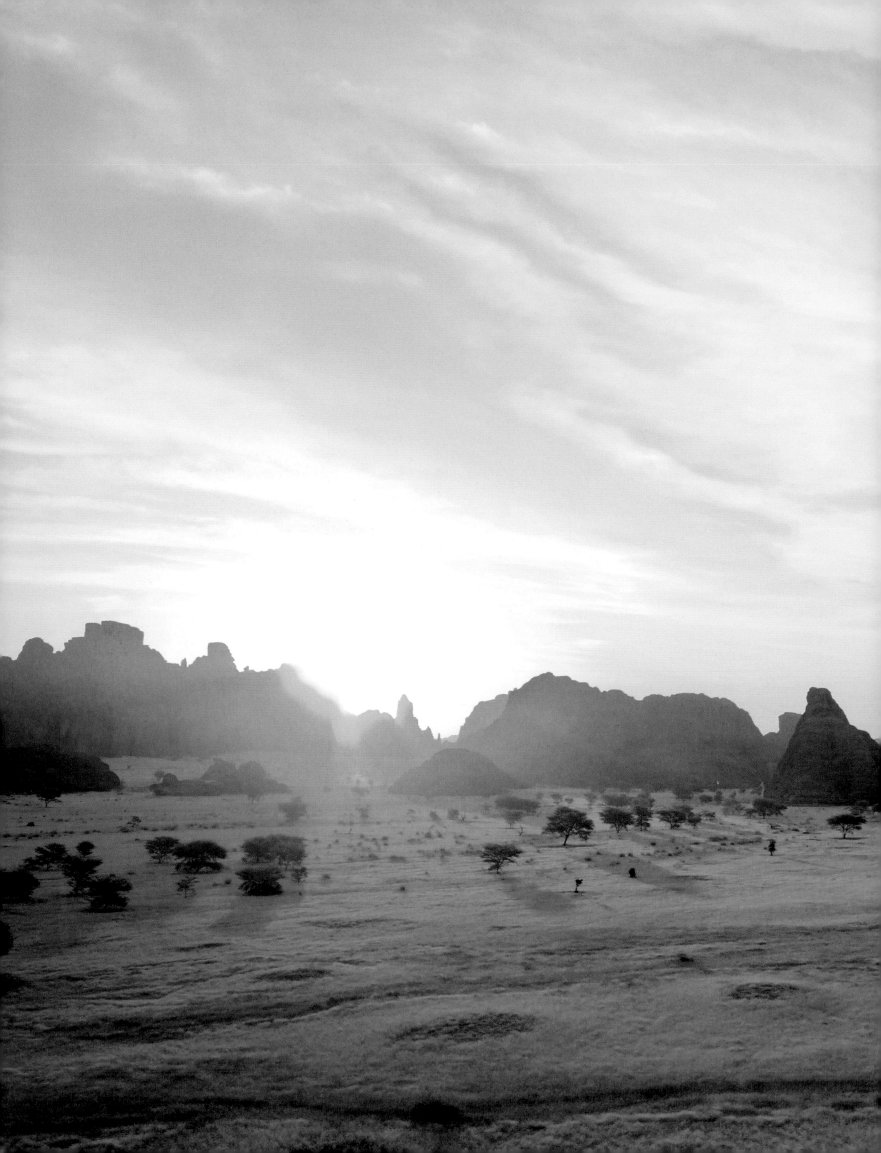

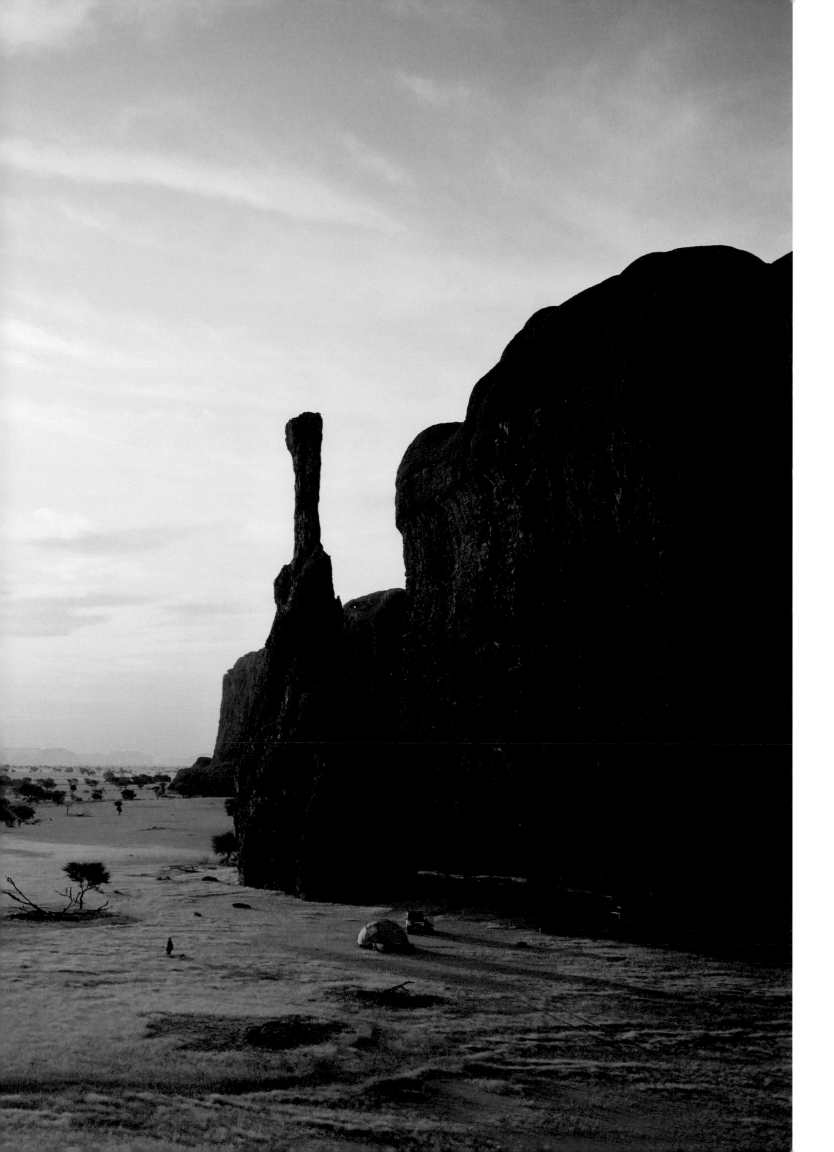

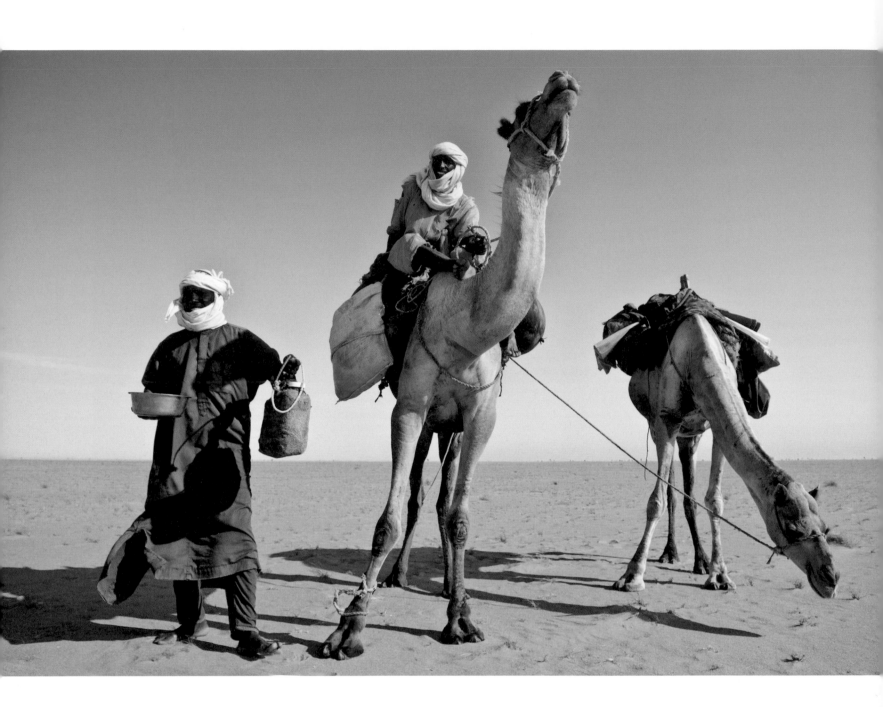

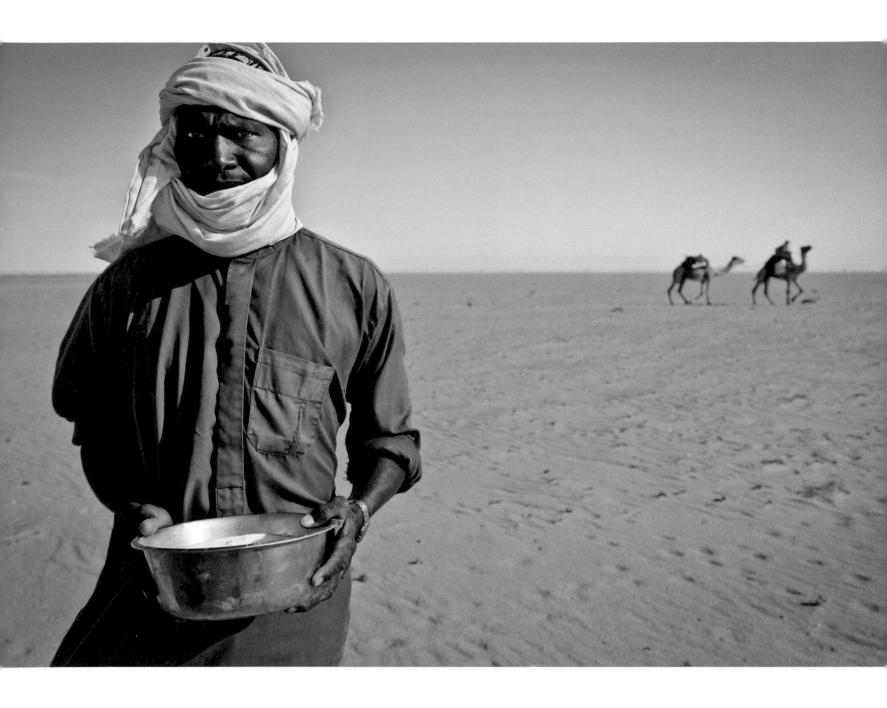

**OPPOSITE** Five days into our roadless drive across the Sahara, we came across these Bedouin men. It wasn't clear where they came from. They offered some of the only sustenance they carried: camel's milk.

**ABOVE** A generous warm camel milk offering. To uphold tradition, we each held the bowl up to our lips and drank. It didn't turn out well for us.

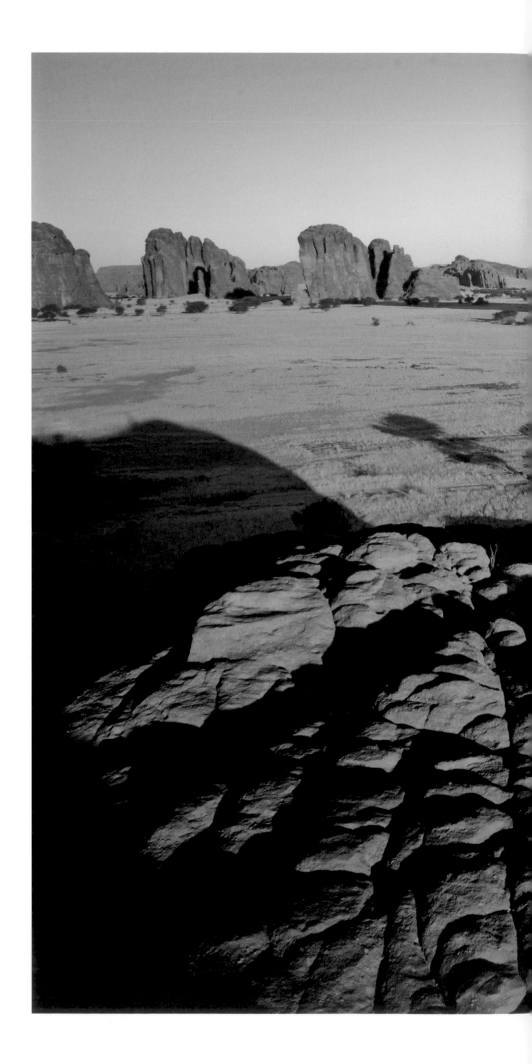

**RIGHT** Desert life. Ennedi Desert, Chad.

**FOLLOWING** James Pearson climbing the first ascent of the Arch of Bashikele.

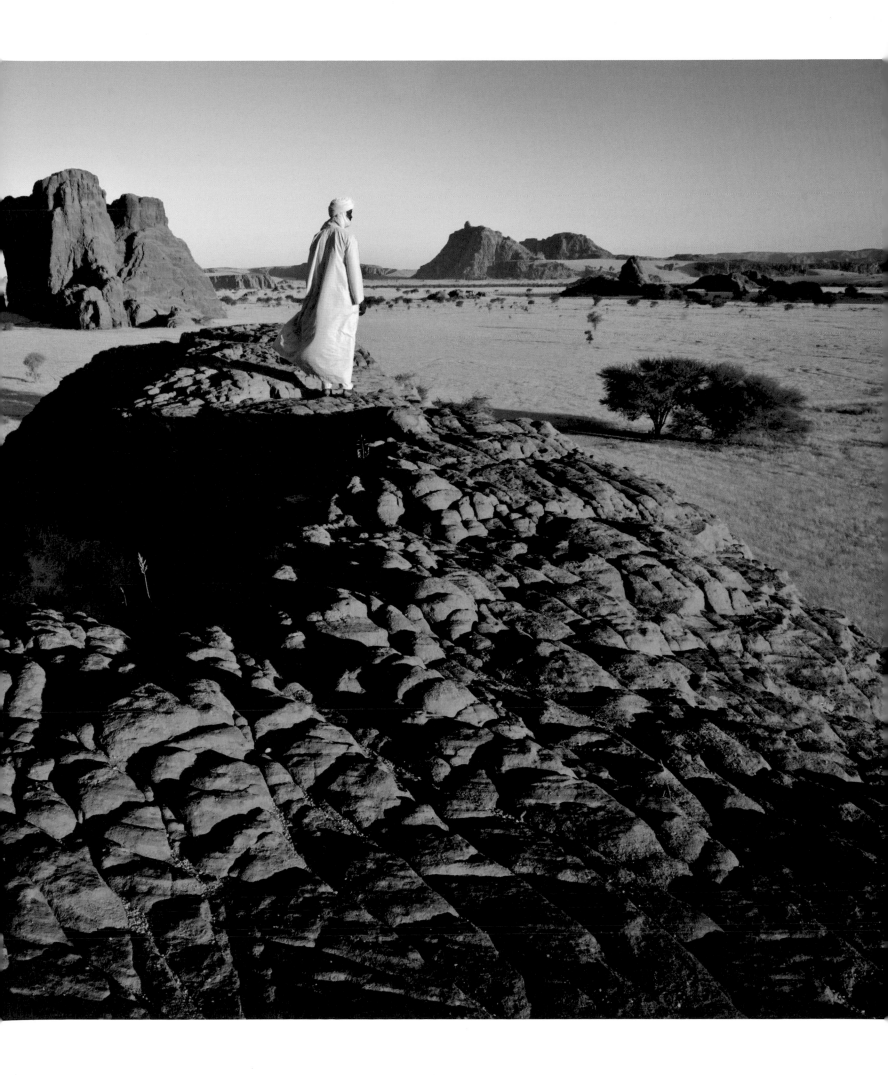

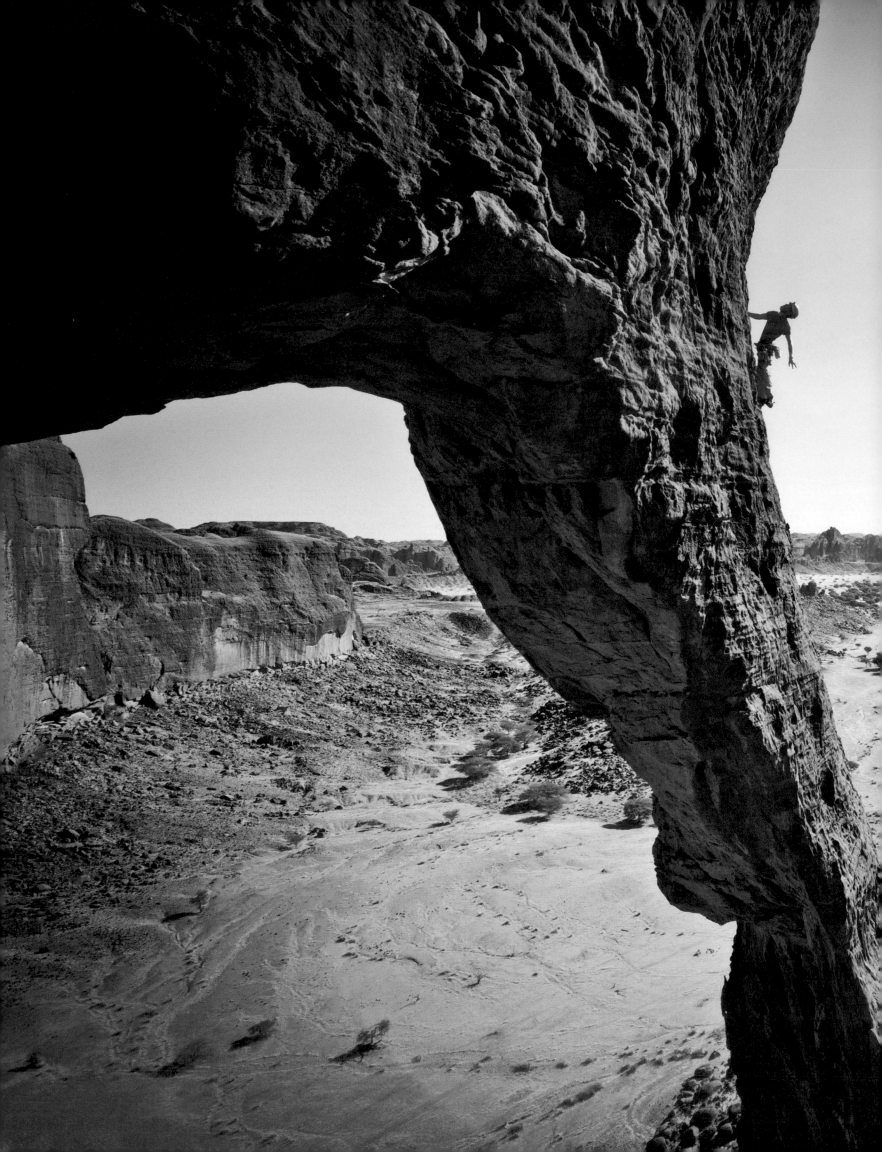

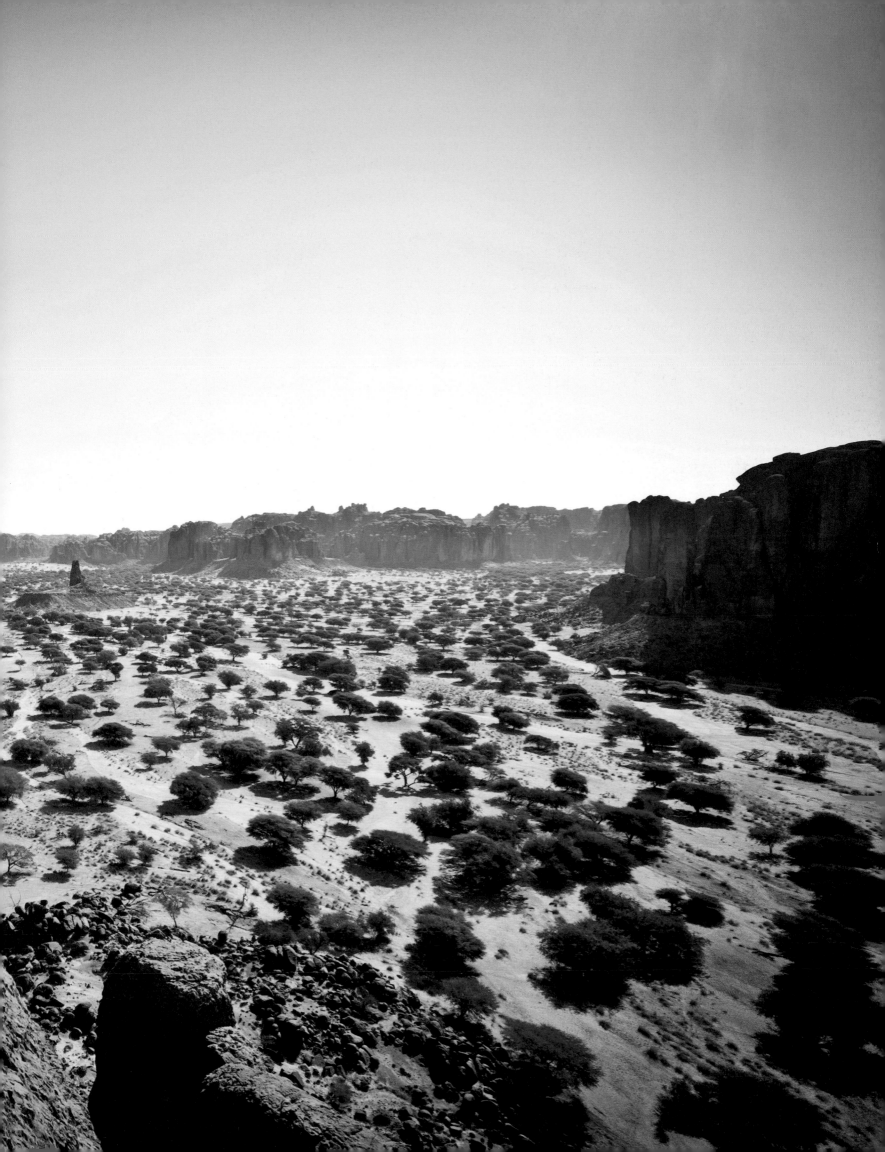

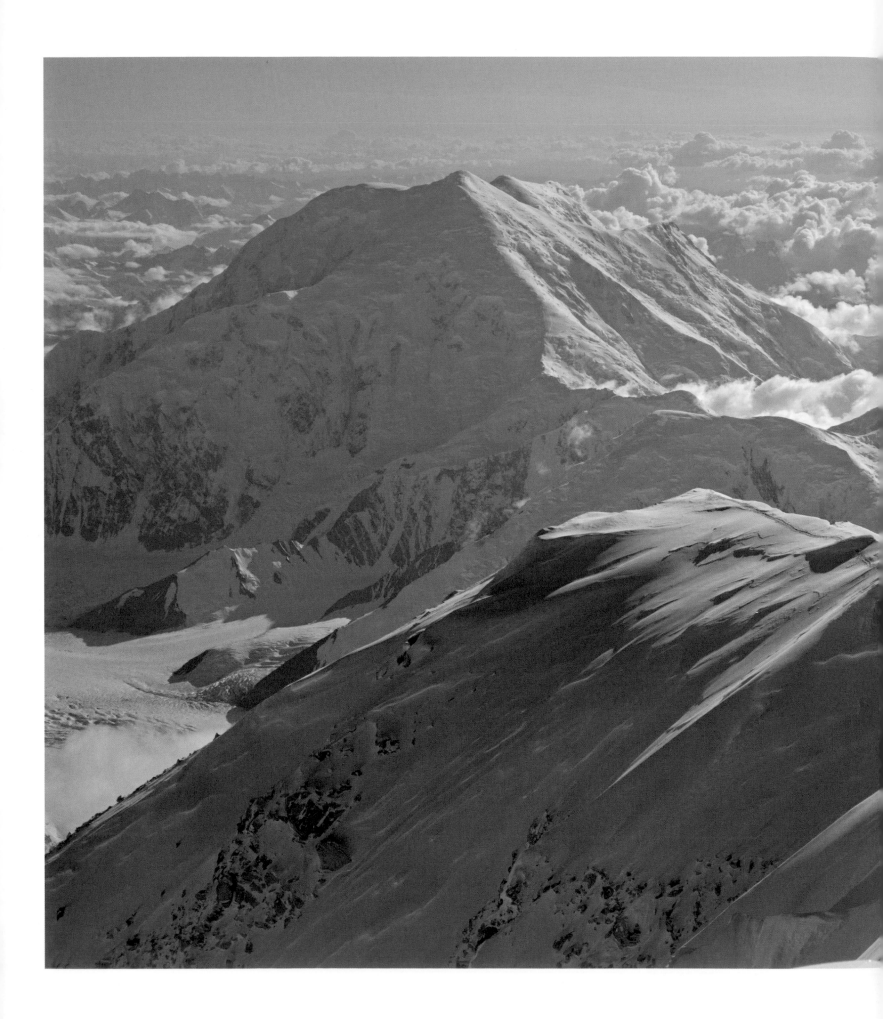

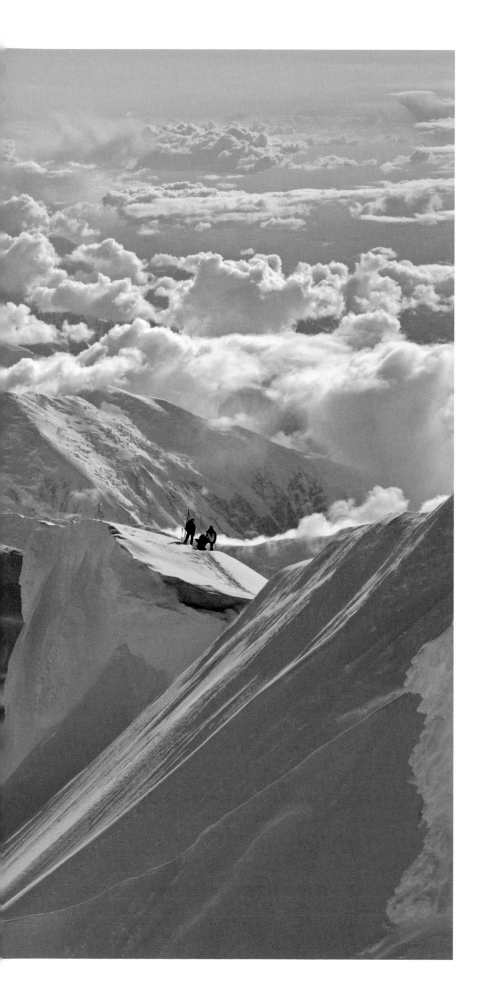

## SKIING DENALI

In the spring of 2011, The North Face brought some of the best free-skiers and freeride snowboarders in the world together with top ski mountaineers to climb and shred North America's highest point. Thanks to an awesome crew and perfect weather, we were able to ski powder from the summit of Denali. Here, Sage Cattabriga-Alosa, Ingrid Backstrom, and Hilaree Nelson ascend the summit ridge at 20,000ft.

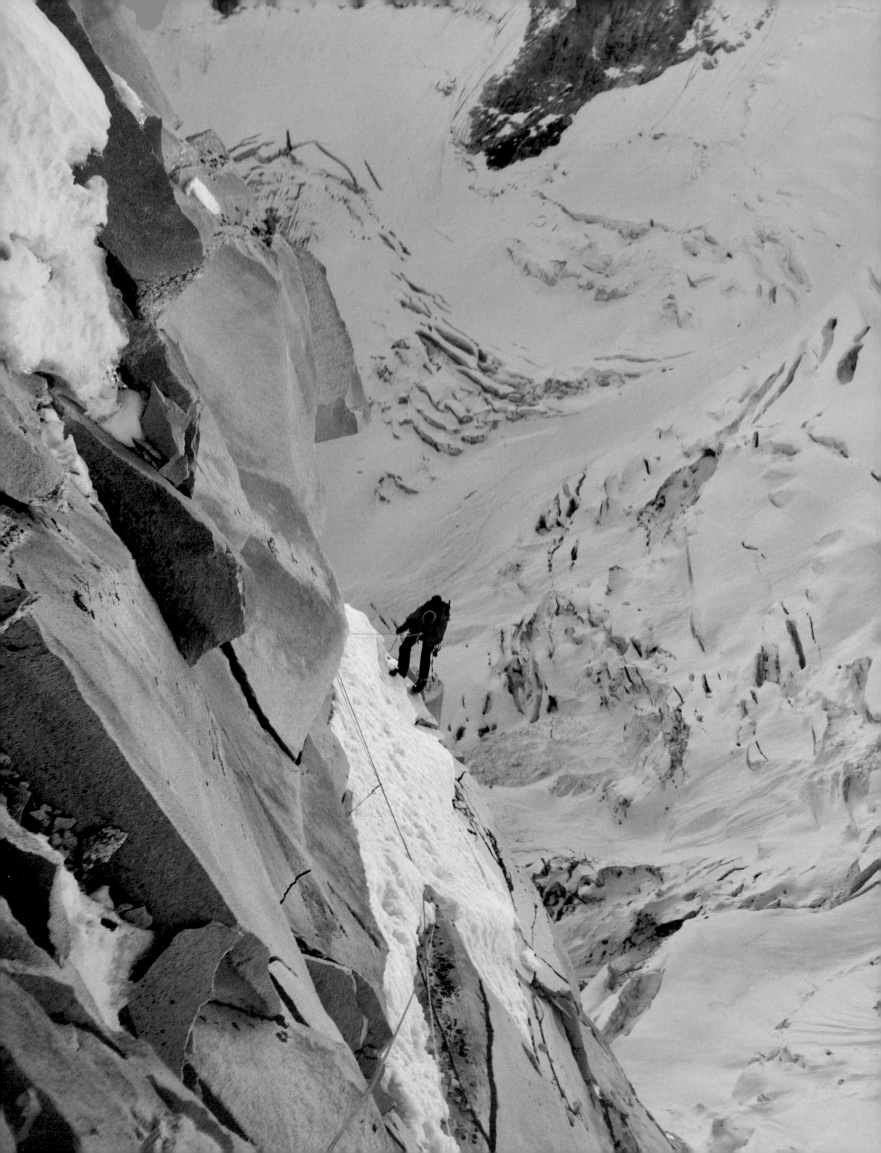

MERU 2011

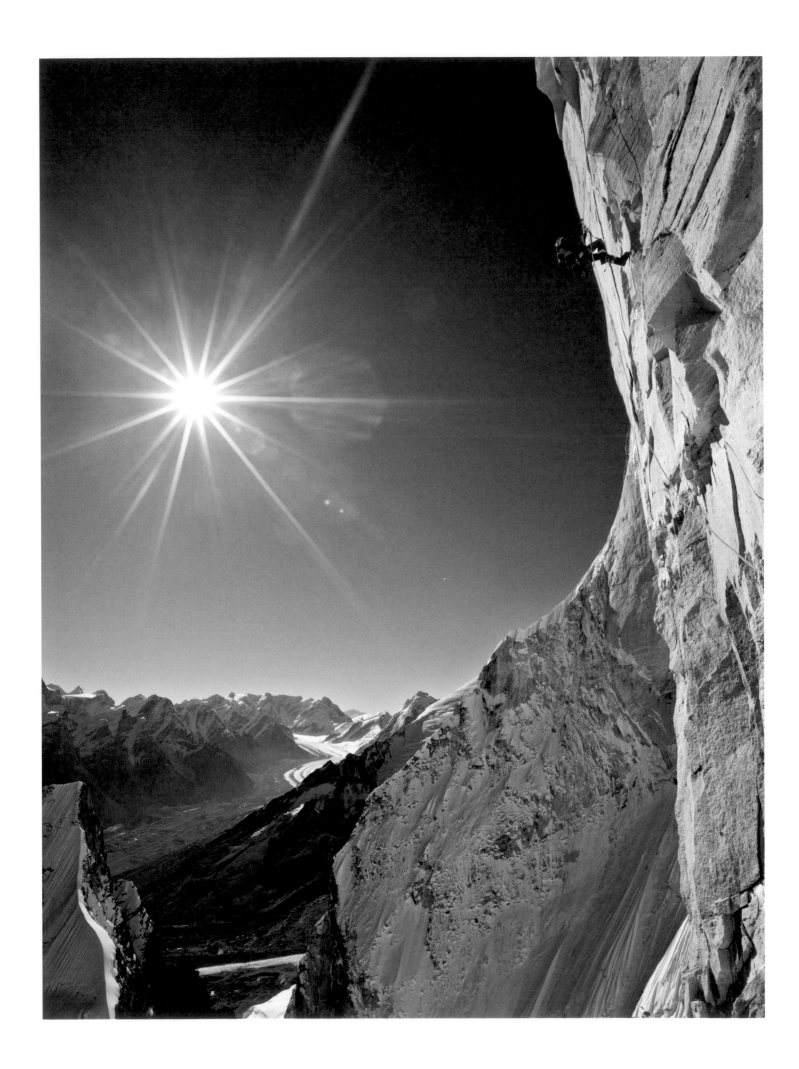

# After turning back just shy of Meru's summit in 2008, Conrad Anker, Renan Ozturk, and I made a plan.

We began discussing what we'd do differently on the next attempt before we were even back on flat ground. We knew the next try wouldn't happen immediately. We needed some time to forget the pain, the suffering, and the defeat. Three years proved enough, and we were ready to take another shot at the Shark's Fin.

Then fate intervened. Renan and I both suffered calamitous skiing accidents. A massive avalanche swept me down a mountain, almost burying me alive. Renan tumbled over a cliff, breaking his neck and compromising his spinal column.

But Meru still held a powerful allure for each of us. I eventually found my motivation to return to the mountains. And though Renan's recovery was uncertain given the seriousness of his injuries, he rejoined the team when it came time to commit to another go. We all wanted the same lineup for both halves of the game.

When we arrived in the Garhwal Range, we hit the ground running. Our first day on the mountain, in a single eighteen-hour push, we ascended three thousand vertical feet of snow, ice, and rock before collapsing, exhausted, to spend our first night on the wall. In 2008, due to a storm, we hadn't surpassed that height until our eighth day of climbing.

Putting together a portaledge at night in subzero temperatures at 18,000ft is hard, but on a wall as sheer and devoid of shelter as the Shark's Fin, you have no choice. Since a portaledge is essentially a hanging cot with a tent draped over it, two or three people must work in concert to push and pull aluminum tubes through stiff nylon sheaths and a nest of tangled straps in order to assemble it. Then the whole mess needs to be pulled taut and suspended from a precarious anchor point, all done while hanging over the void in your harness. The entire endeavor brings to mind a vertical wrestling match. And if anyone drops something, everyone is hosed. On a big wall like this, you simply can't afford to make even small mistakes.

Traumatized by our previous attempt, we began toiling up the wall every morning by praying for another day of good weather. At one of our hanging camps, we were blessed with a windless night and a full moon. The entire Garhwal glowed below us in an eerie shade of blue. In this rare moment of calm, I peered out the open door of our tiny nylon perch and reveled in the otherworldly beauty.

Despite our dress rehearsal in 2008, the climbing on the upper Fin didn't seem any less desperate. But after twelve days of ascent we arrived on the most improbable summit of our lives. "I got it for you, Mugs," Conrad declared when he topped out, his voice thick with emotion. He'd settled a piece of unfinished business for his departed friend and mentor, Mugs Stump.

The three of us had done the same for each other.

PREVIOUS After a sixteen-hour summit push, Conrad Anker begins the rappel from the summit ridge at sunset. It would be a long, difficult night getting back to our high camp.

OPPOSITE Conrad ascending the overhanging fixed lines above the House of Cards pitch at 20,000ft.

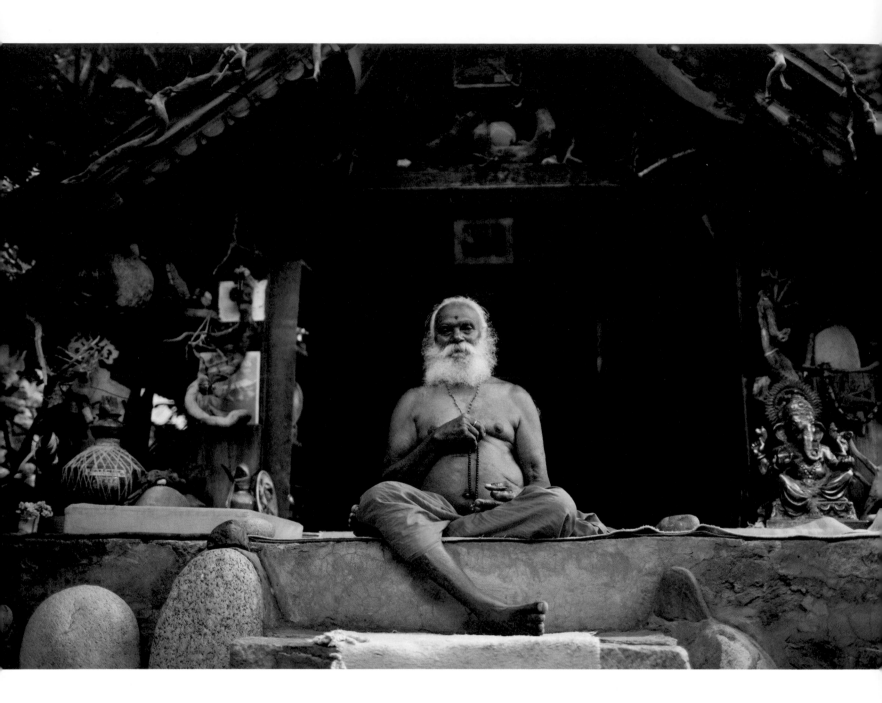

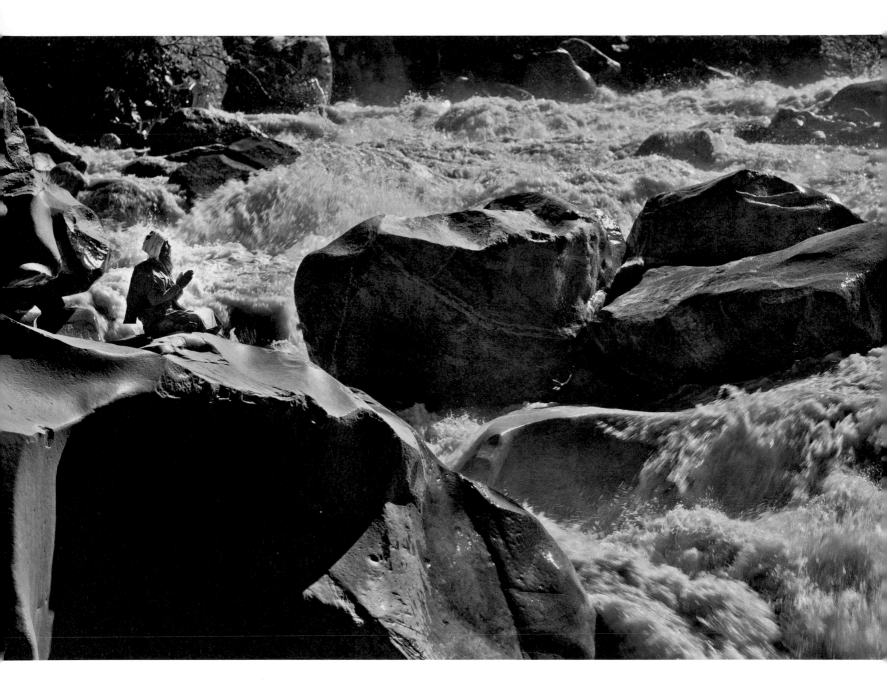

**OPPOSITE** Swami Sundaranand, also known as the Clicking Swami, meditating at his small hut in Gangotri. He had lived in this modest home next to the headwater of the Ganges since 1948. He is surrounded by wood and stones, shaped like the Sanskrit om, that he had collected over the years. He kindly blessed us before both of our attempts on the Shark's Fin.

**ABOVE** A sadhu meditates along the Ganges River. Gangotri, India.

**FOLLOWING** Renan Ozturk stargazing at Tapovan base camp below Shivling and Meru. Garhwal Himalaya, India.

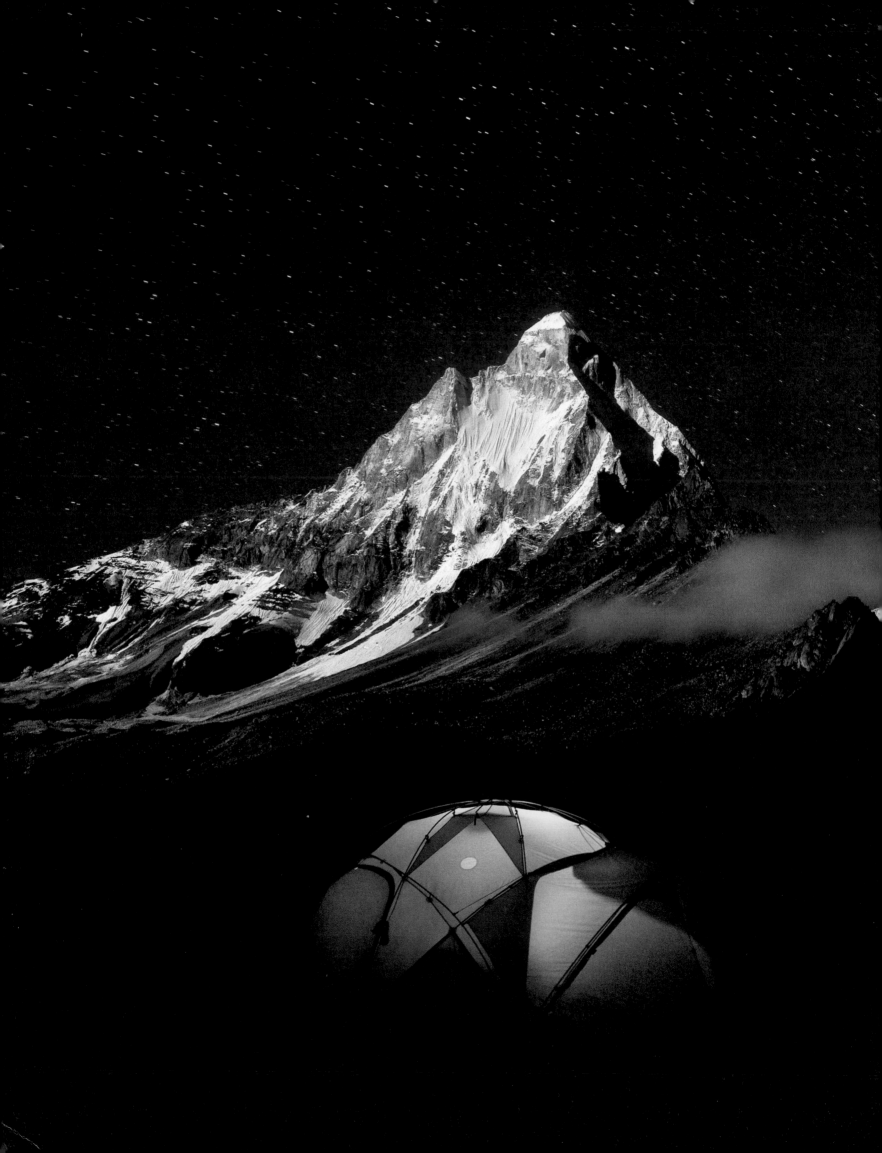

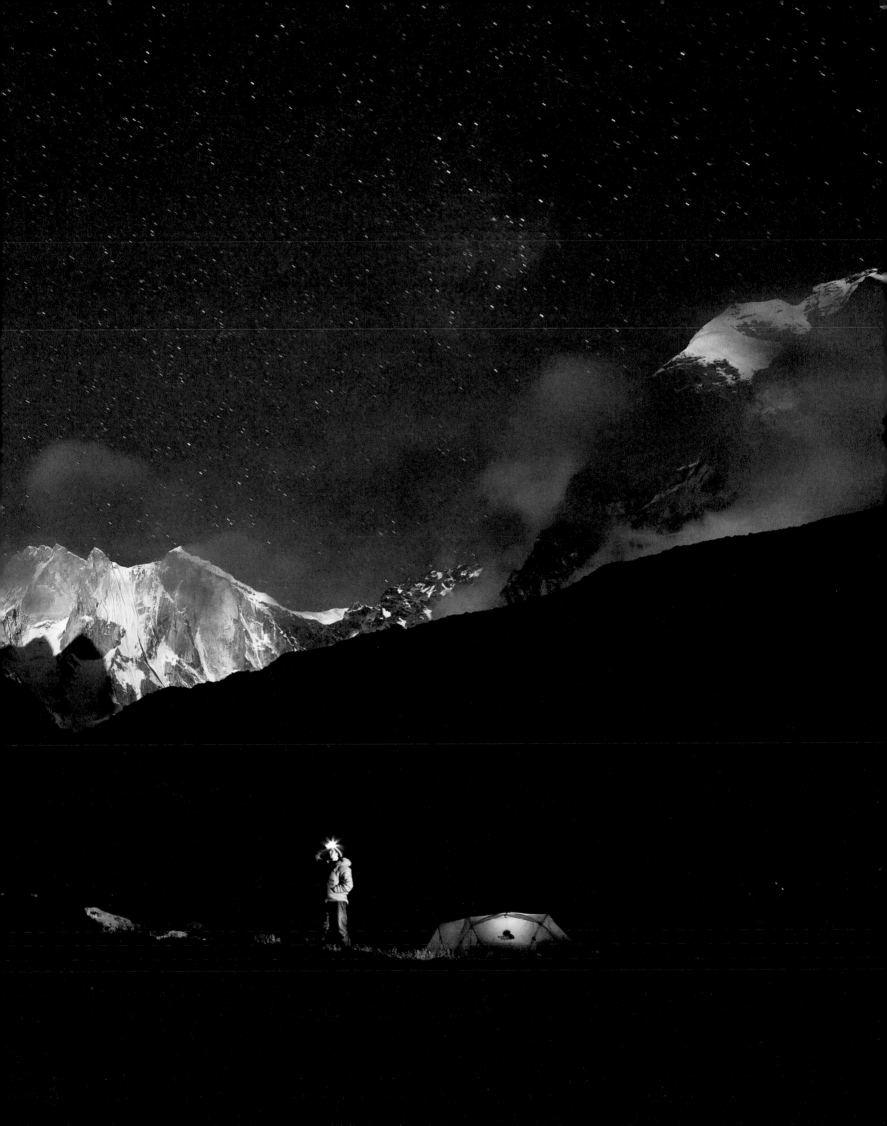

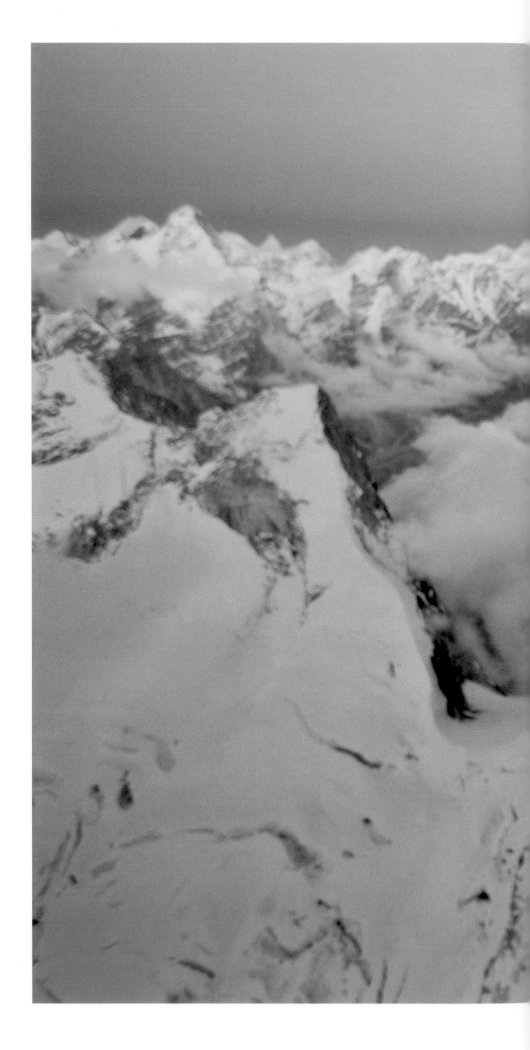

**RIGHT** Temperatures drop as the sun sets behind the horizon. Conrad Anker and Renan Ozturk prepare to set up our portaledge camp after our fifth day of climbing.

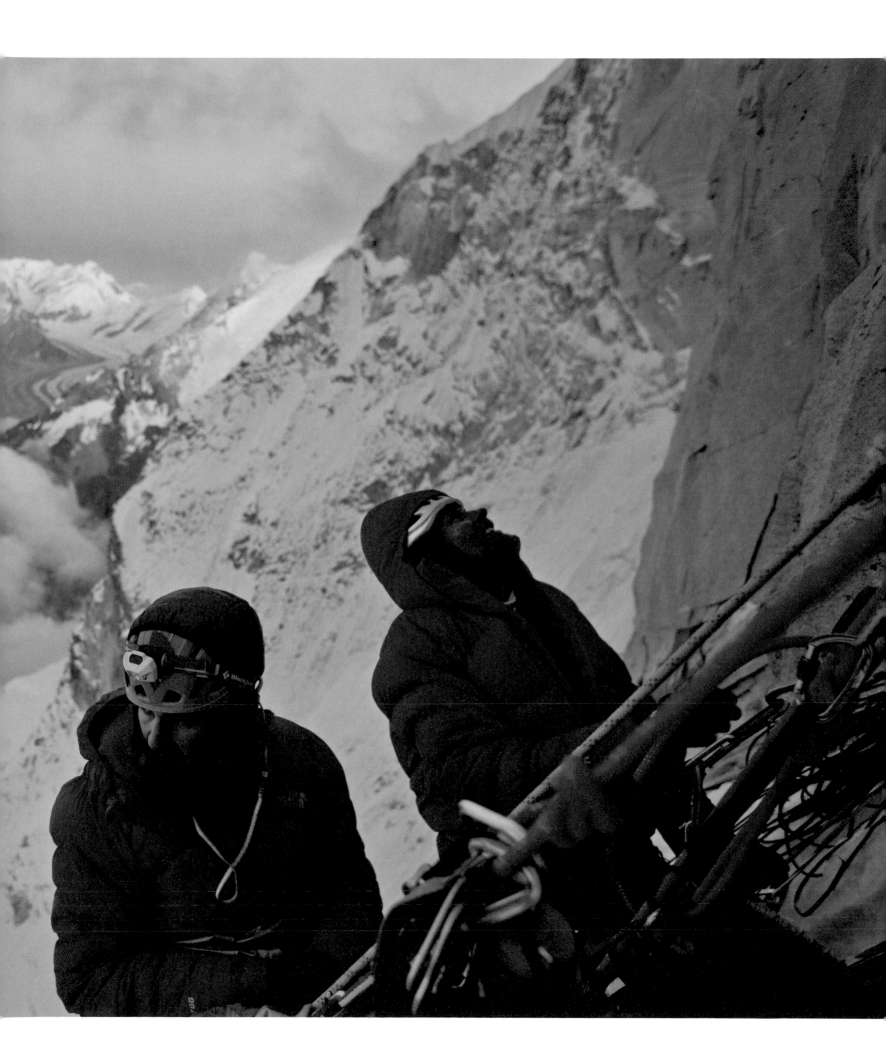

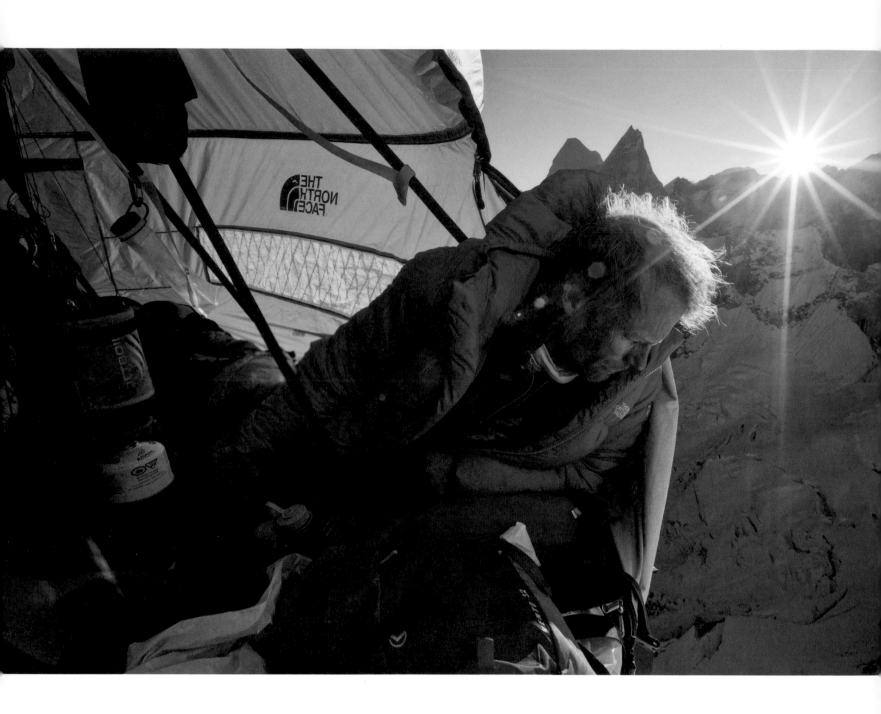

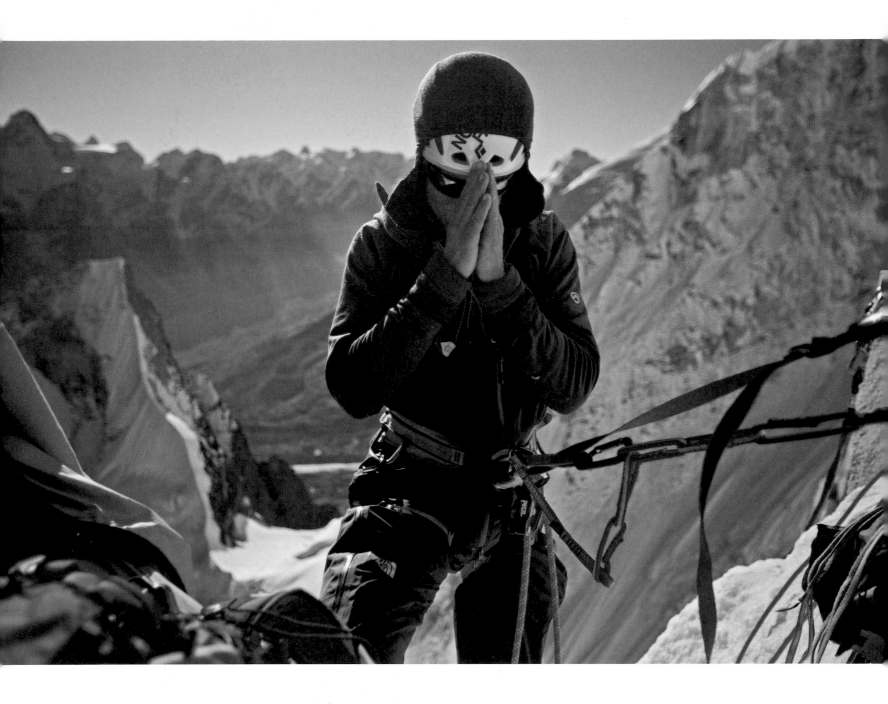

**OPPOSITE** Conrad Anker contemplating the void before another day of pushing the route on the overhanging headwall above.

**ABOVE** Conrad taking a moment to ask for safe passage through the difficult pitches above.

**FOLLOWING** Shivling at sunset as seen from our high camp on the Shark's Fin.

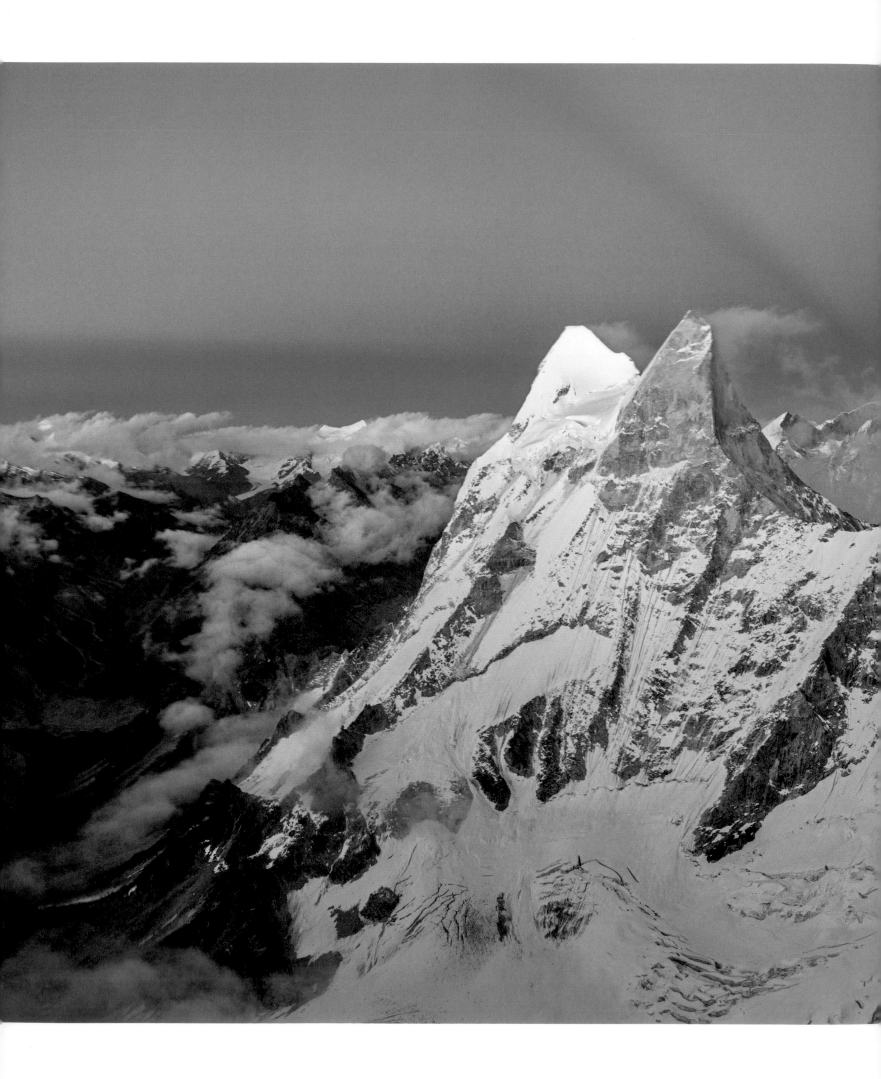

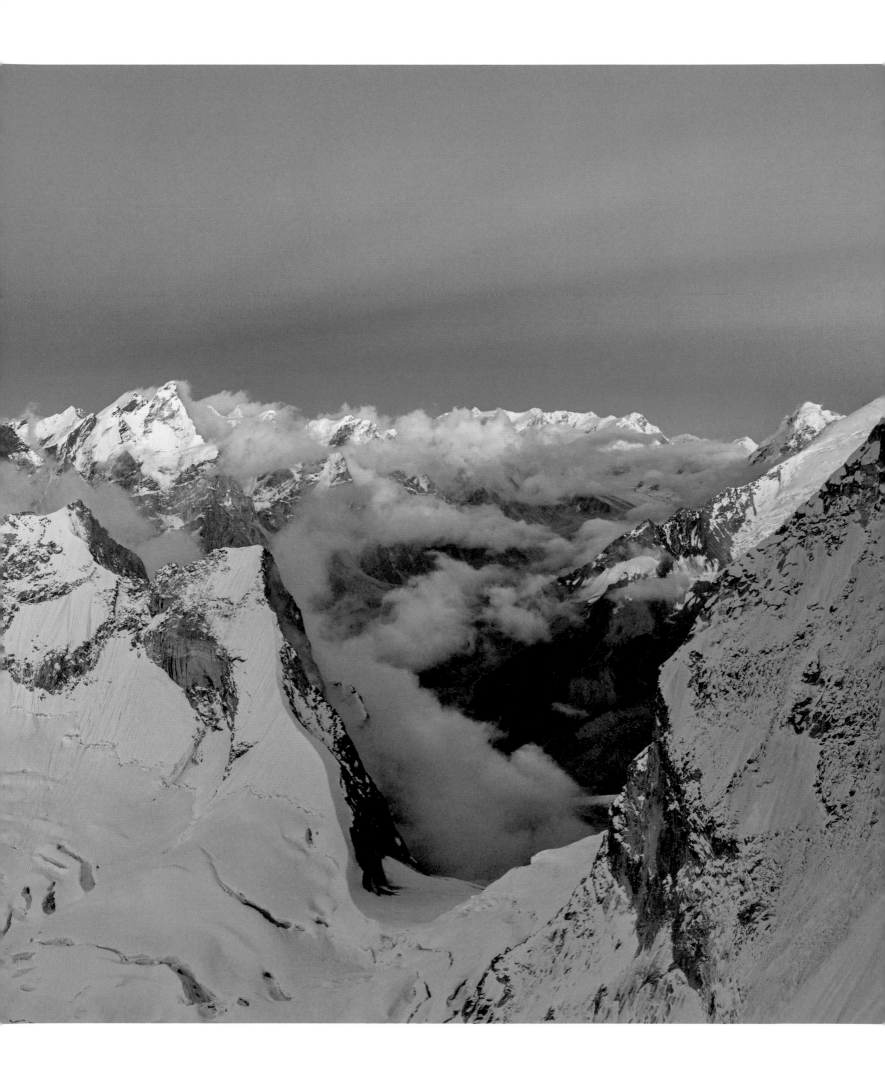

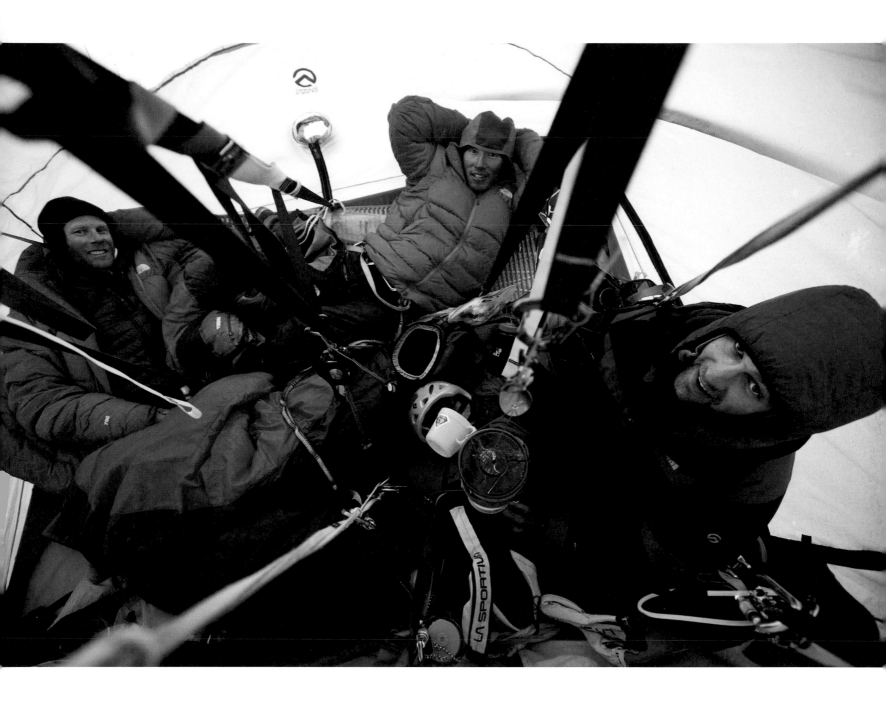

**OPPOSITE** Renan Ozturk and I suffered severe trench foot after our first attempt on the Shark's Fin. Trench foot is a painful and debilitating affliction that happens when you leave your feet in cold, wet boots for too many days. On our second attempt, Conrad Anker made us take the time to dry out our feet whenever there was an opportunity. This was a rare moment when we all got to take our feet out of our boots and dry them in the sun.

**ABOVE** One-bedroom loft, kitchen, no bath.

**RIGHT** First light on our summit push. Renan Ozturk examines the upper ice pitches as Conrad Anker racks up to climb in the bitter cold at 21,000ft.

**FOLLOWING** One last look. Renan gazing back up at the summit before rappelling off the summit ridgeline back to our high camp.

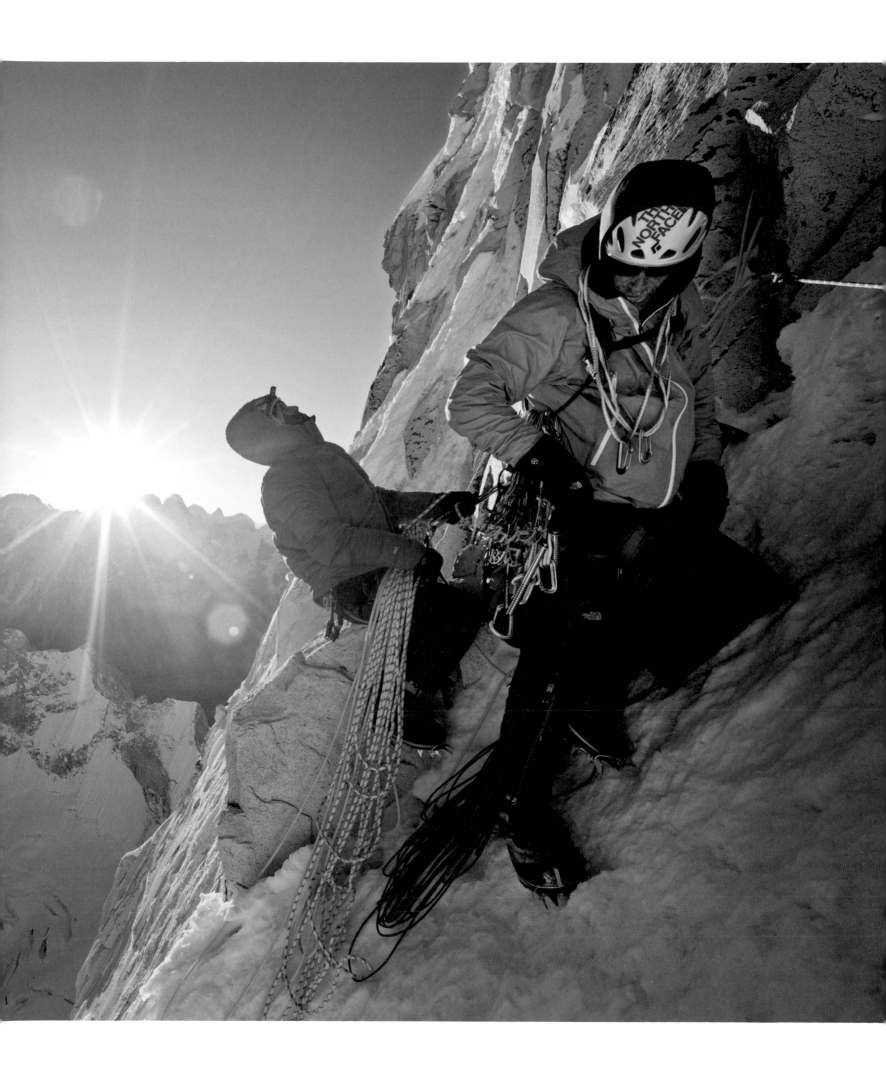

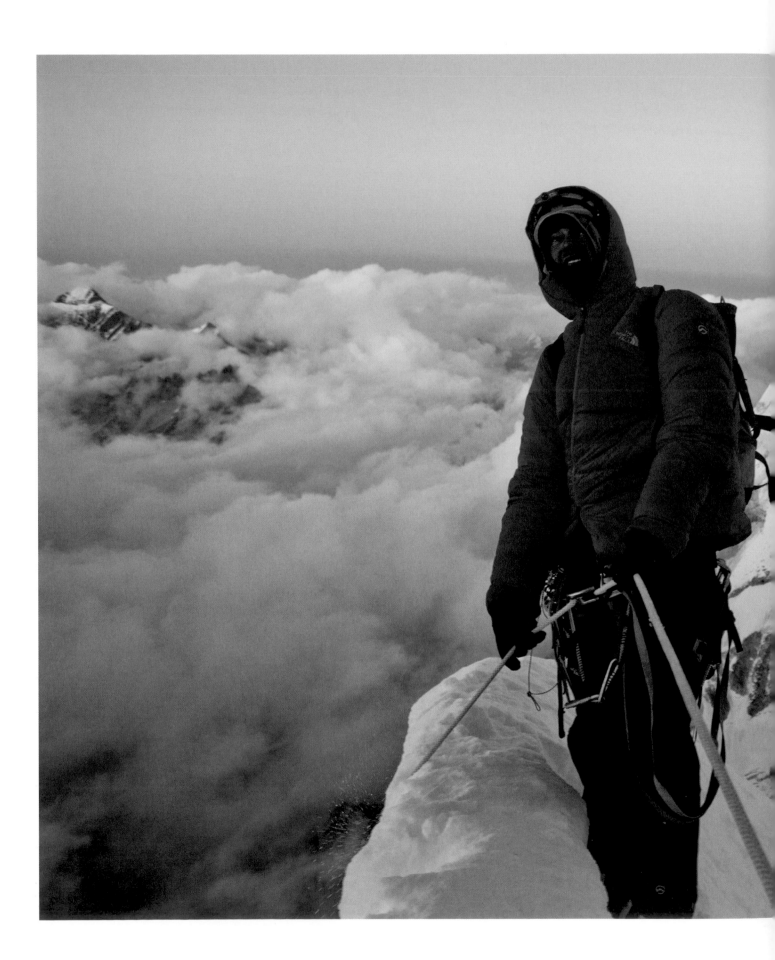

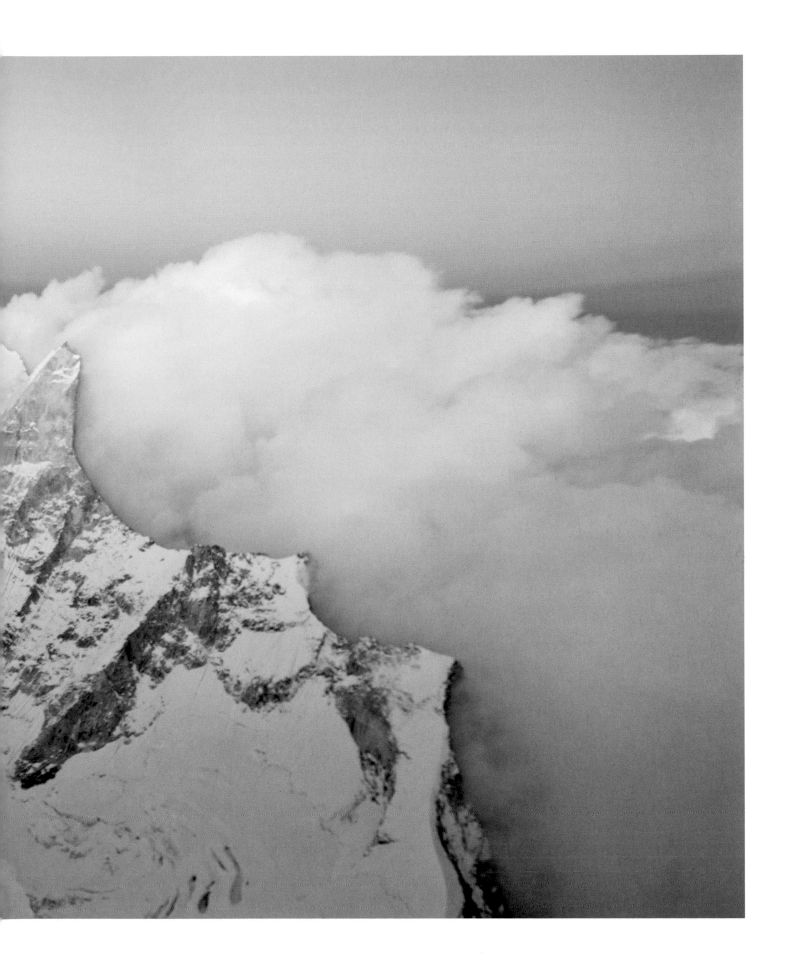

**RIGHT** The descent is often the most dangerous part of a climb. Exhaustion sets in after a long summit-day push. At each rappel, we double-check each other's rappel systems and remind each other to watch the end of the ropes. Renan Ozturk begins the long descent into the night.

**FOLLOWING** Mount Meru. The Shark's Fin can be seen in the middle of the Meru massif.

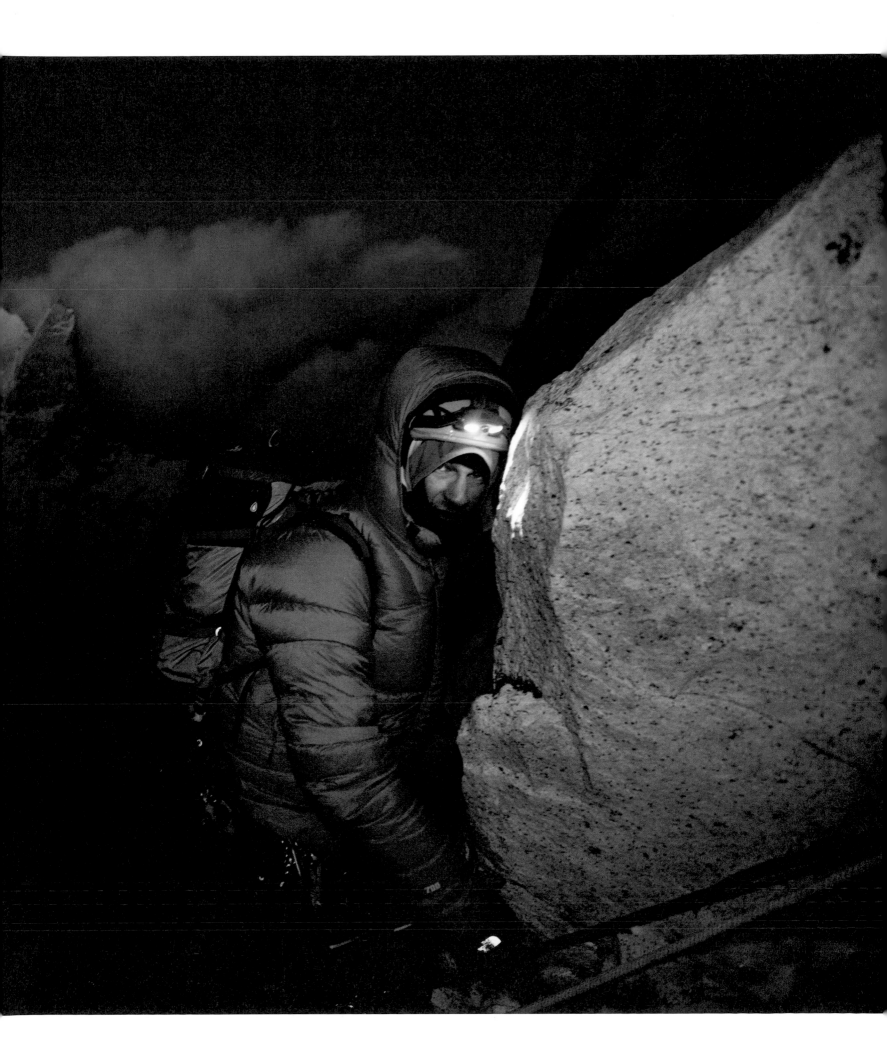

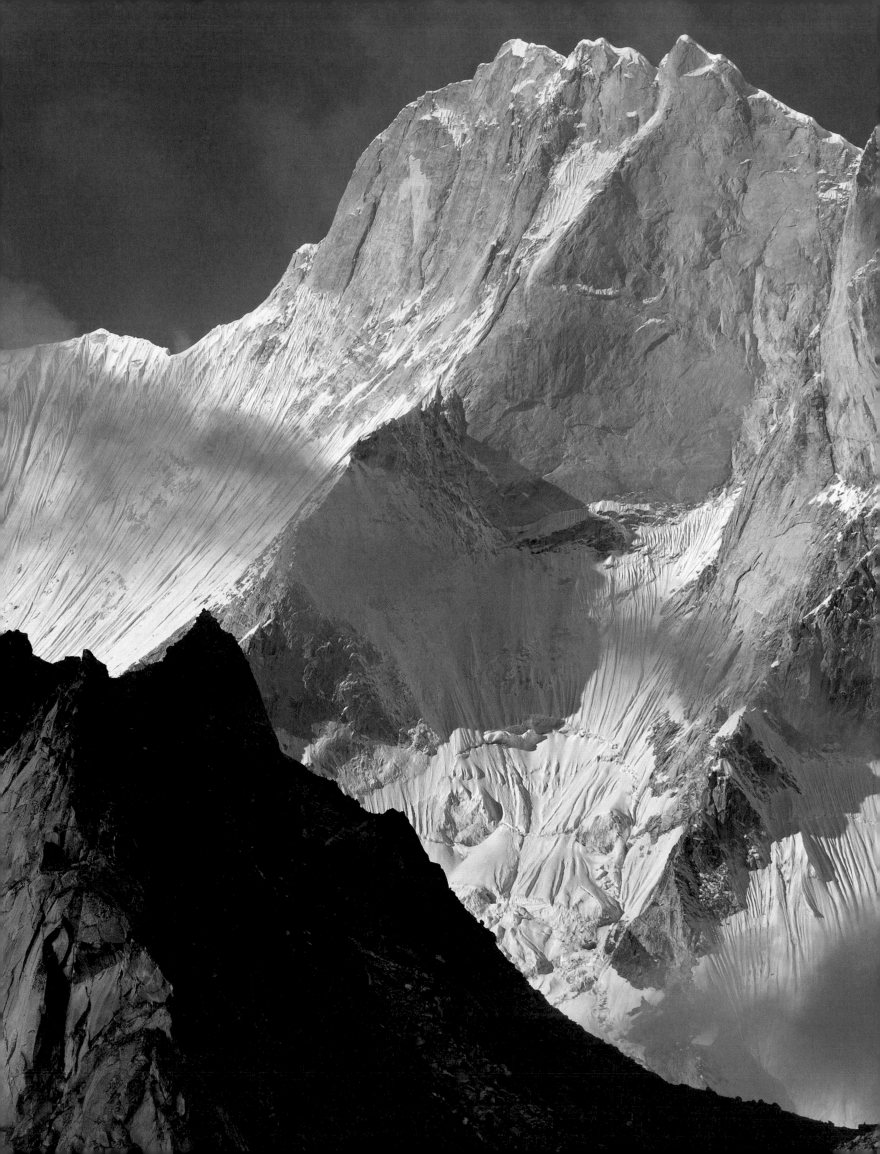

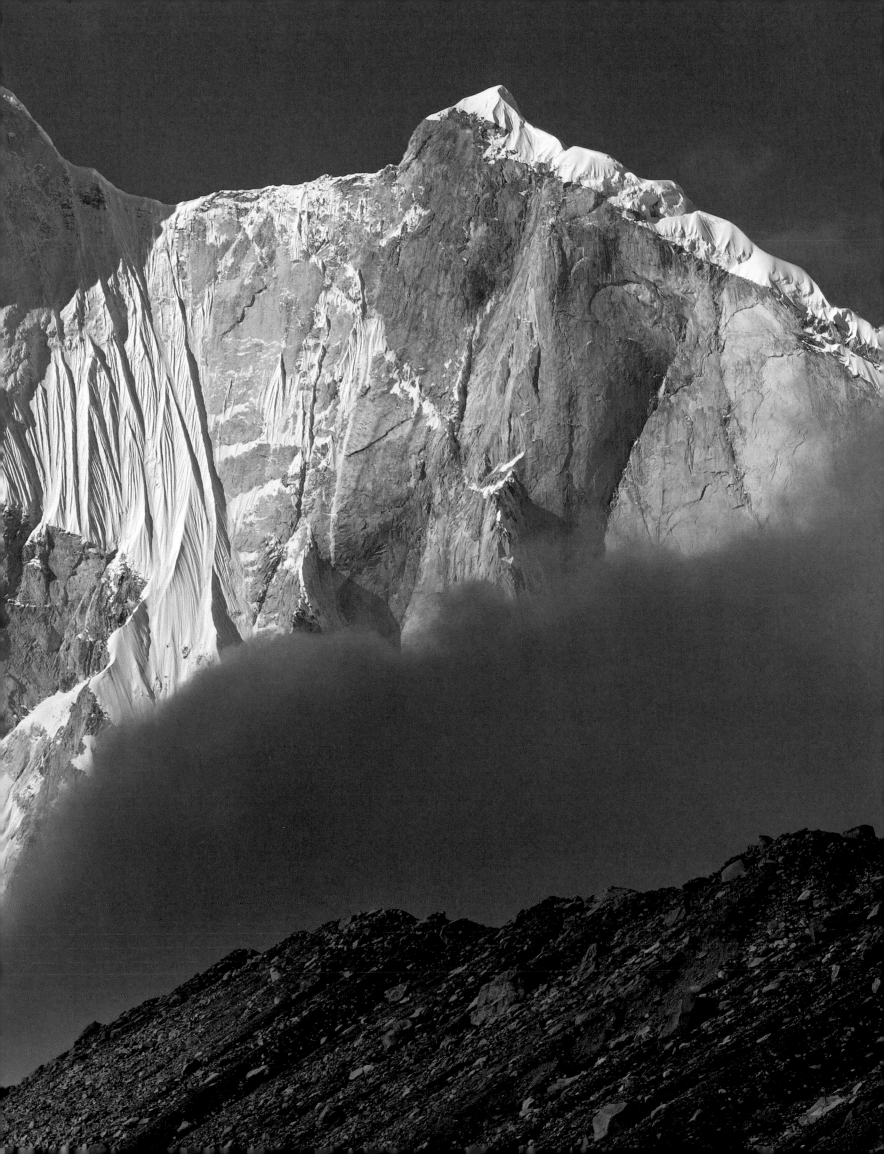

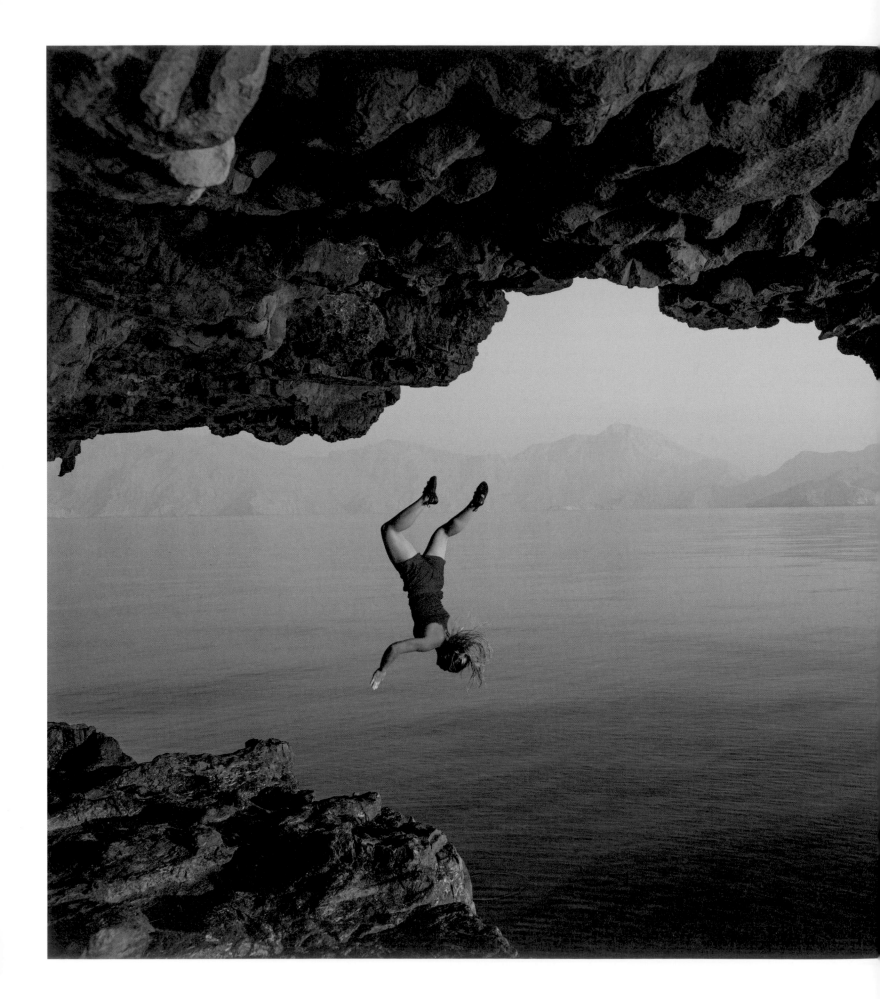

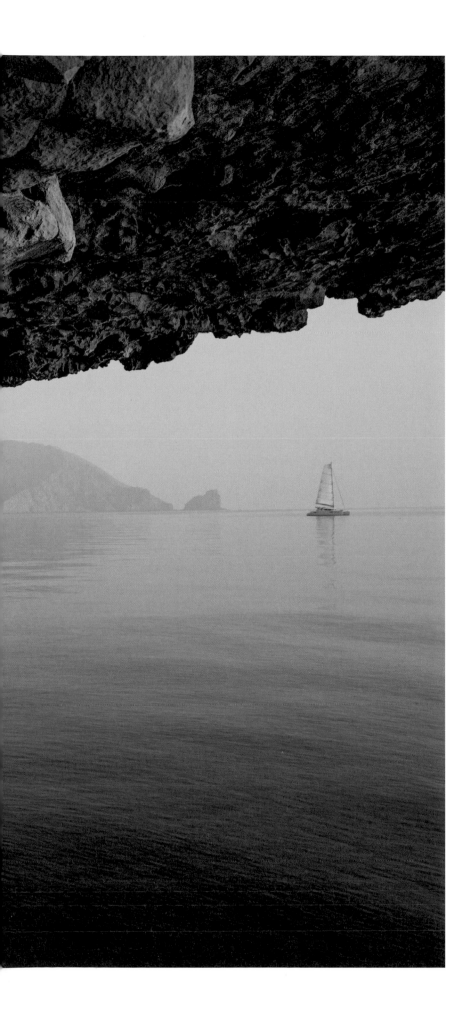

## OMAN

Lured by an obscure description of the "fascinating and mysterious Musandam Peninsula," Mark Synnott gathered together a crew of climbers and filmmakers in 2013 for a sailing tour of the northern coast of Oman, looking for adventure climbing and deep-water soloing. We found both.

As Hazel Findlay finds here, if the climbing doesn't agree with you in Oman, the diving is only moments away.

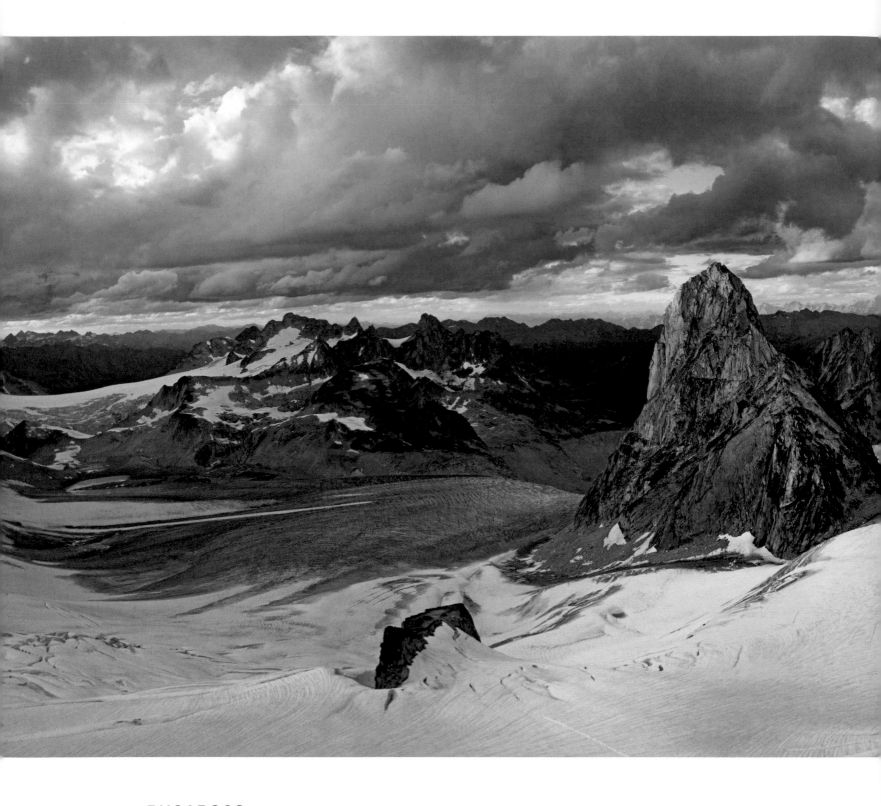

## BUGABOOS

In August 2015, Conrad Anker, Renan Ozturk, Alex Honnold, and I spent two weeks climbing in Bugaboos Provincial Park, British Columbia. Conrad has a hard time staying stationary, so on one of our rest days he rallied the team for a quick "hike" up Pigeon Peak, near our camp.

Not to be outdone, Alex Honnold, on another one of our rest days, strolled out of camp at 9 a.m. to on-sight

solo two big multipitch routes, rated 5.12a and 5.11c. He wandered back to camp at 3 p.m. for a bite to eat, then headed out at 4 p.m. for a ropeless "cool down" lap on the nineteen-pitch Beckey-Chouinard route on the South Howser Tower. He was back before dark. It was the biggest day of difficult free-soloing anyone had ever done in the Bugaboos, but it was just another rest day for Alex.

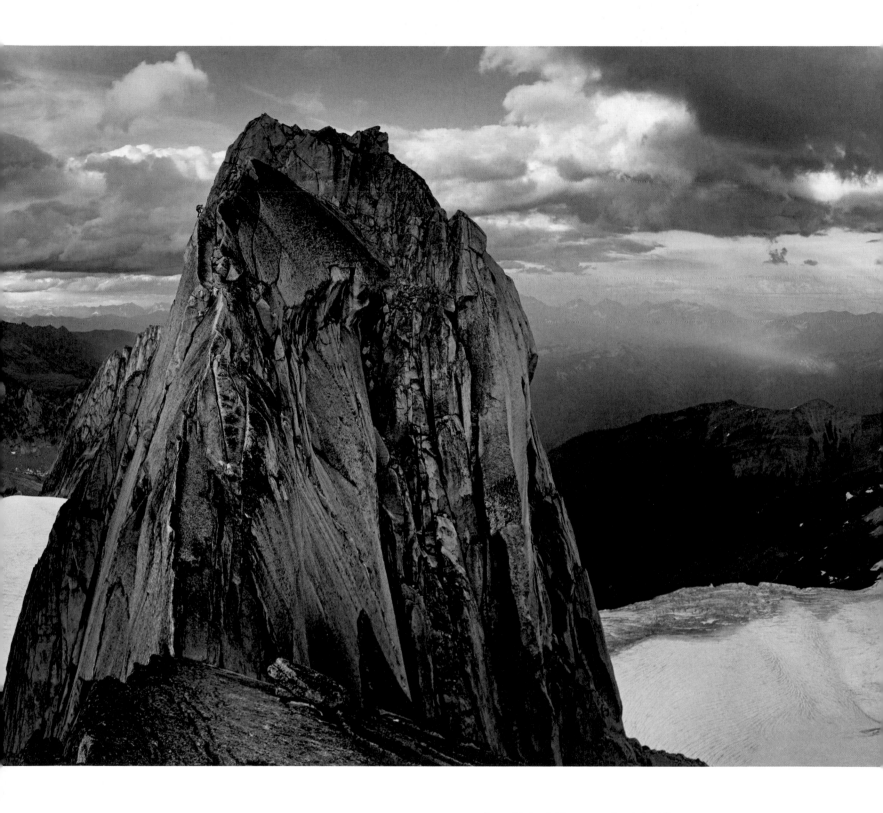

**ABOVE** Conrad Anker taking a casual rest-day hike up Pigeon Peak.

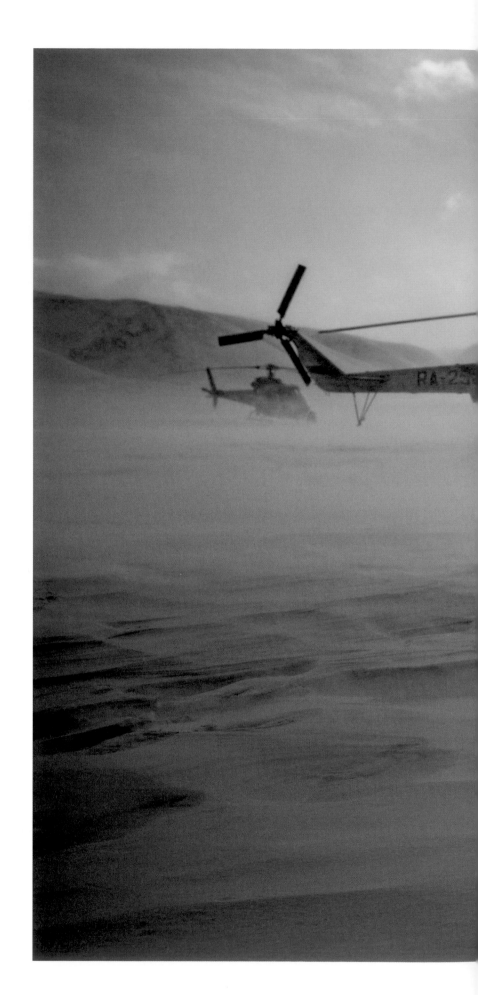

## TRAVIS RICE

Travis Rice, along with snowboarders Eric Jackson and Mark Landvik, spent the month of February 2014 on the Kamchatka Peninsula while filming for Travis's movie *The Fourth Phase*. Travis is one of the most prolific snowboarders of his generation. Between his power and grace on big Alaskan spine lines, huge technical airs, and multiple X Games gold medals, Travis has defined the evolution of snowboarding.

**RIGHT** Travis Rice leans into the relentless wind of the Kamchatka Peninsula. We used a Russian twin-turbine Mi-17 helicopter for transport and production in Kamchatka.

**FOLLOWING** Here, the Mi-17 is parked outside our makeshift home for the night, a remote, abandoned volcano research station. The Karymsky Volcano erupts in the background.

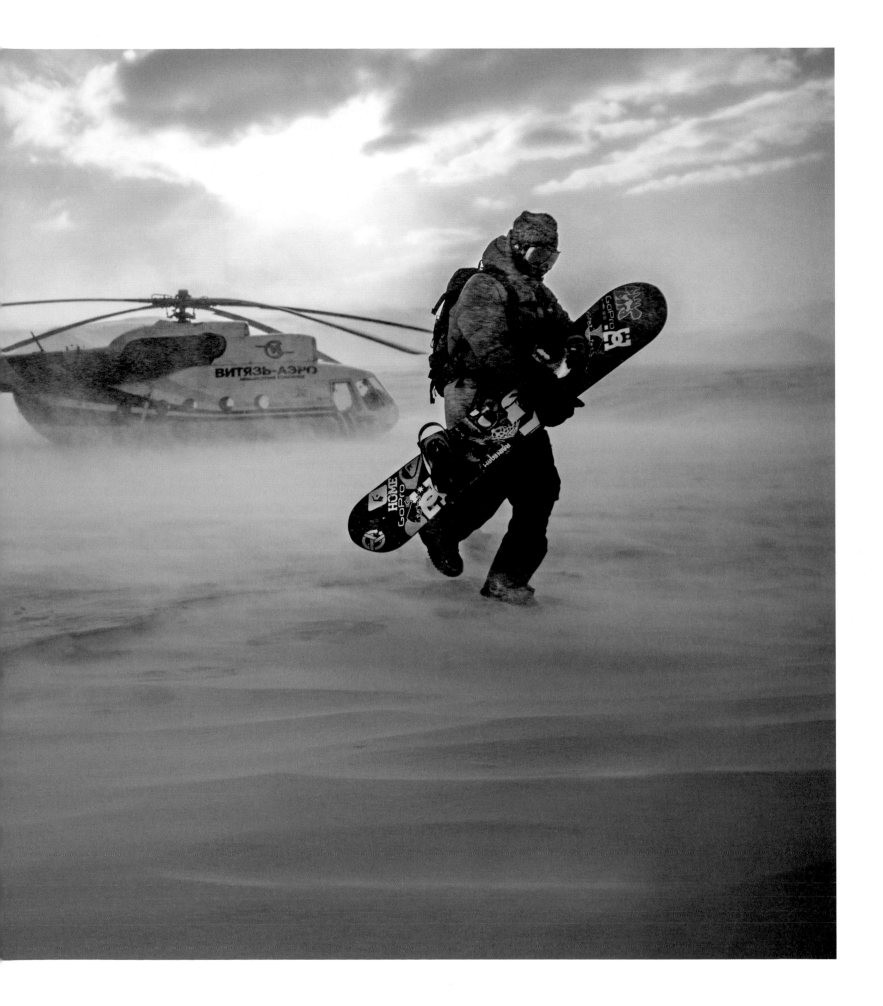

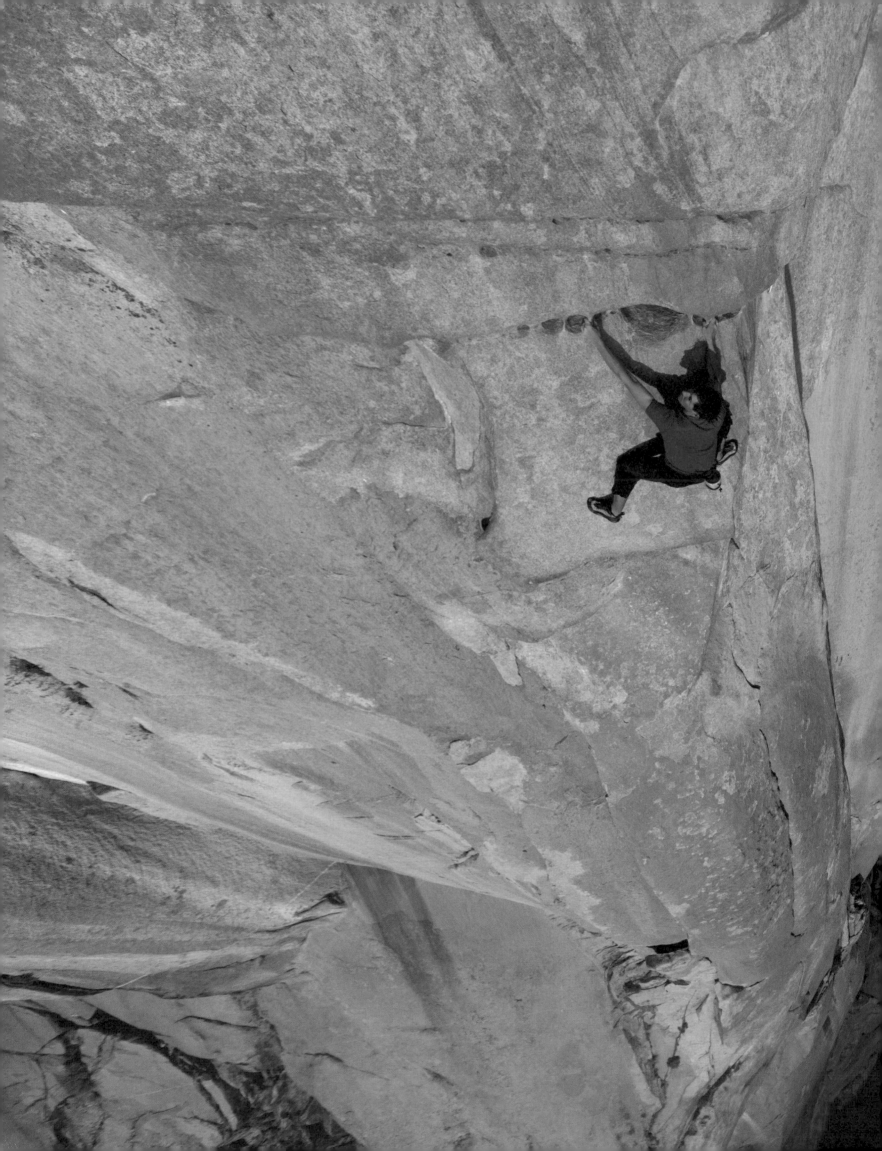

FREE SOLO 2016

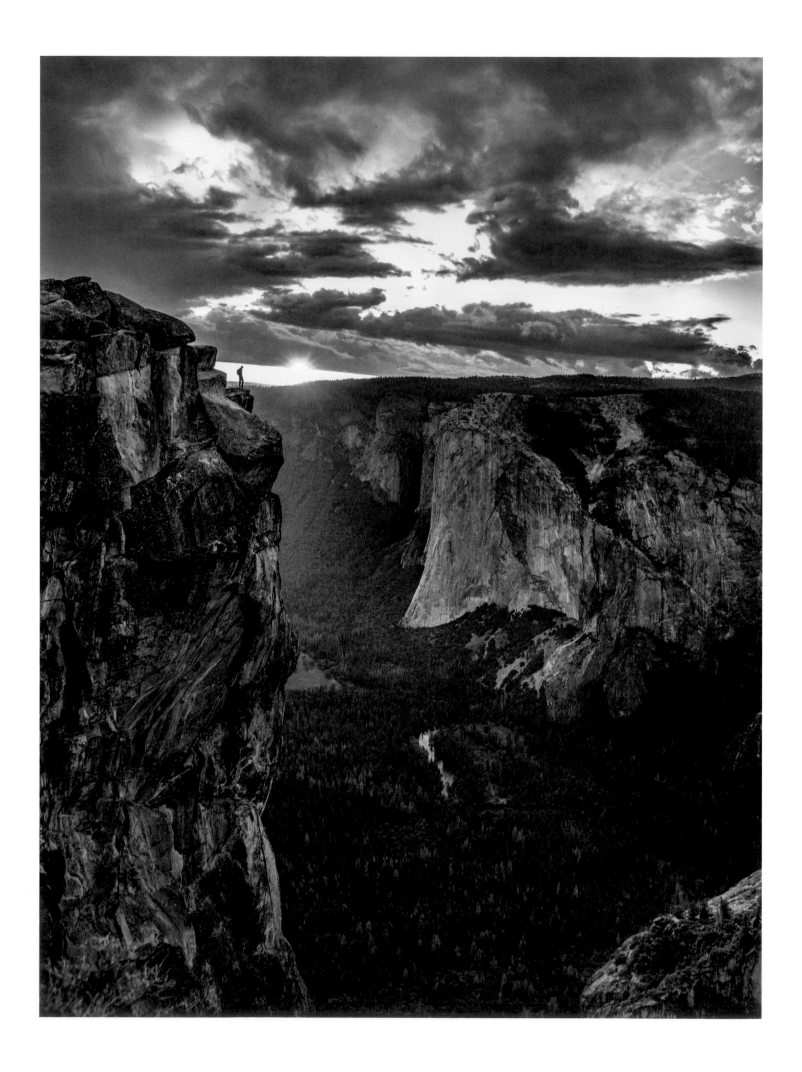

# "No mistakes tomorrow," I said. "Focus on your job. Worrying about Alex isn't going to help."

The mood was somber as I stood with my team of riggers and high-angle cinematographers near El Cap Meadow. It was the night before our friend Alex Honnold was planning to scale the massive wall soaring over our heads without a rope.

As we'd filmed Alex training for over two years, we'd been carefully choreographing and refining how we would shoot his free solo. While he practiced his movements up the wall, memorizing key holds and refining his body positions, we practiced our own movements, memorizing key filming positions and refining the best angles.

Even before filming for *Free Solo* began, my wife and codirector, Chai Vasarhelyi, and I decided that Alex's needs would always take priority over the needs of the film. He was a friend first, a subject second. We were there to support him as much as we were there to capture his climb. That meant never asking Alex when he was going to solo El Cap. We never wanted him to feel pressure from us to do it. He had plenty of pressure to contend with already. But when he told us on the afternoon of June 2, 2017, "I'm going scrambling tomorrow," that was it. He was going to do the climb.

Alex's entire life of climbing, methodical training, and successively harder free solos had led him to this moment. My years shooting expeditions and other high-stakes situations with elite athletes had led me here, too. Together, Alex and I had built a strong foundation of trust over the previous decade. We'd been on multiple expeditions and climbed, photographed, and filmed together often. On this film, we needed perfect faith in each other. Three years of walking a tightrope with Alex, filming and photographing his life on and off the wall, culminated on the dawn of June 3, when Alex squeezed into his climbing shoes, chalked up his hands, and began spidering up the Captain.

Three and a half hours later, Alex had cruised through twenty-two pitches of climbing, including the horrifically insecure and acrobatic Boulder Problem, which we'd filmed with remote cameras. I planned to capture him at the climb's final crux, the Enduro Corner. It's an enormous open book of polished granite with a narrow and punishingly steep crack in the corner. It had spat out many an expert climber. If that were to happen to Alex, I didn't want anyone else having to witness it firsthand.

The weight of what was happening hit me as I hung twenty-five hundred feet in the air. My arms strained to hold my cinema camera. I had a photo camera bolted on top so I could shoot stills and film at the same time. I thought of the directive I'd given my team: "No mistakes. Focus on your job."

And there came Alex, calmly and steadily climbing hand over hand up the sickeningly exposed crack. I was riveted to each of his moves through my viewfinder. I knew I was witnessing the sublime. Then I focused on my job.

**PREVIOUS** Alex Honnold crossing the Traverse pitch (5.12a) on Freerider, one of the most exposed pitches of rock climbing on El Capitan.

**OPPOSITE** Alex watching sunset over Yosemite Valley.

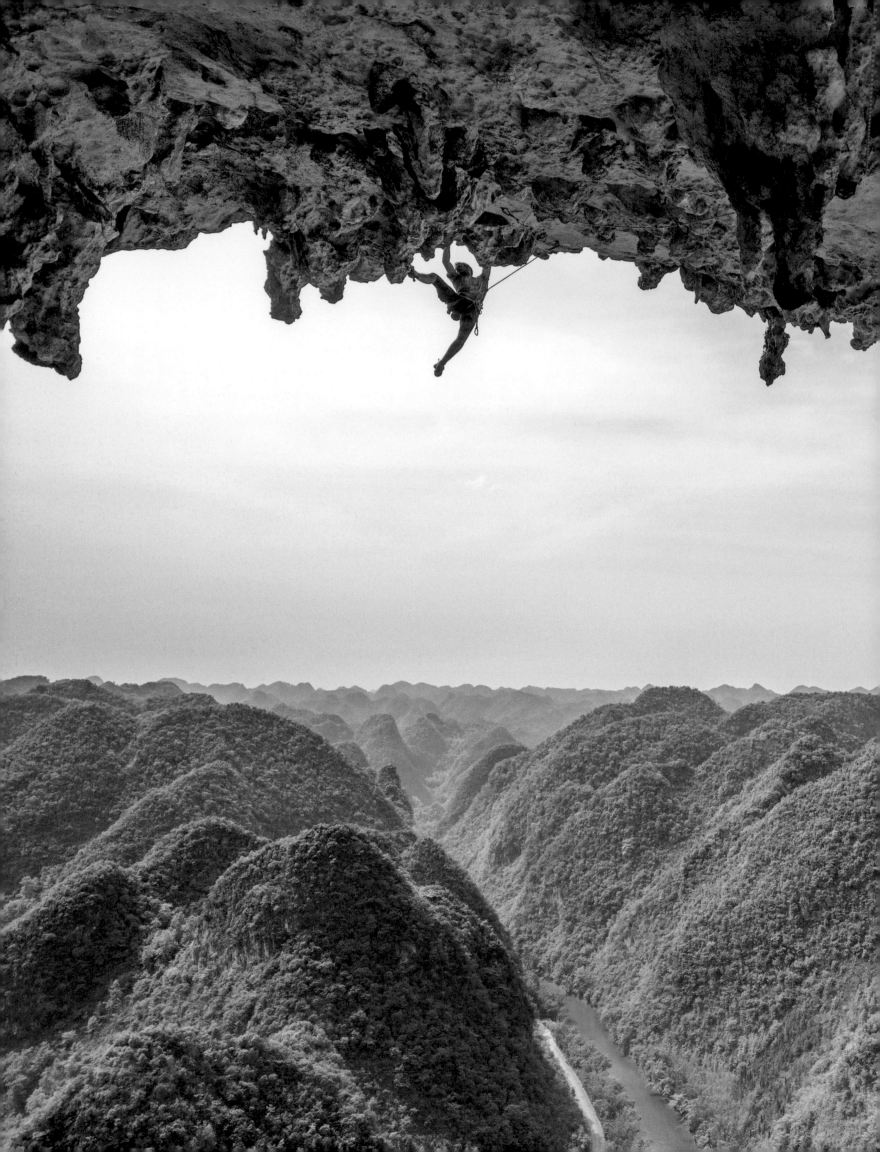

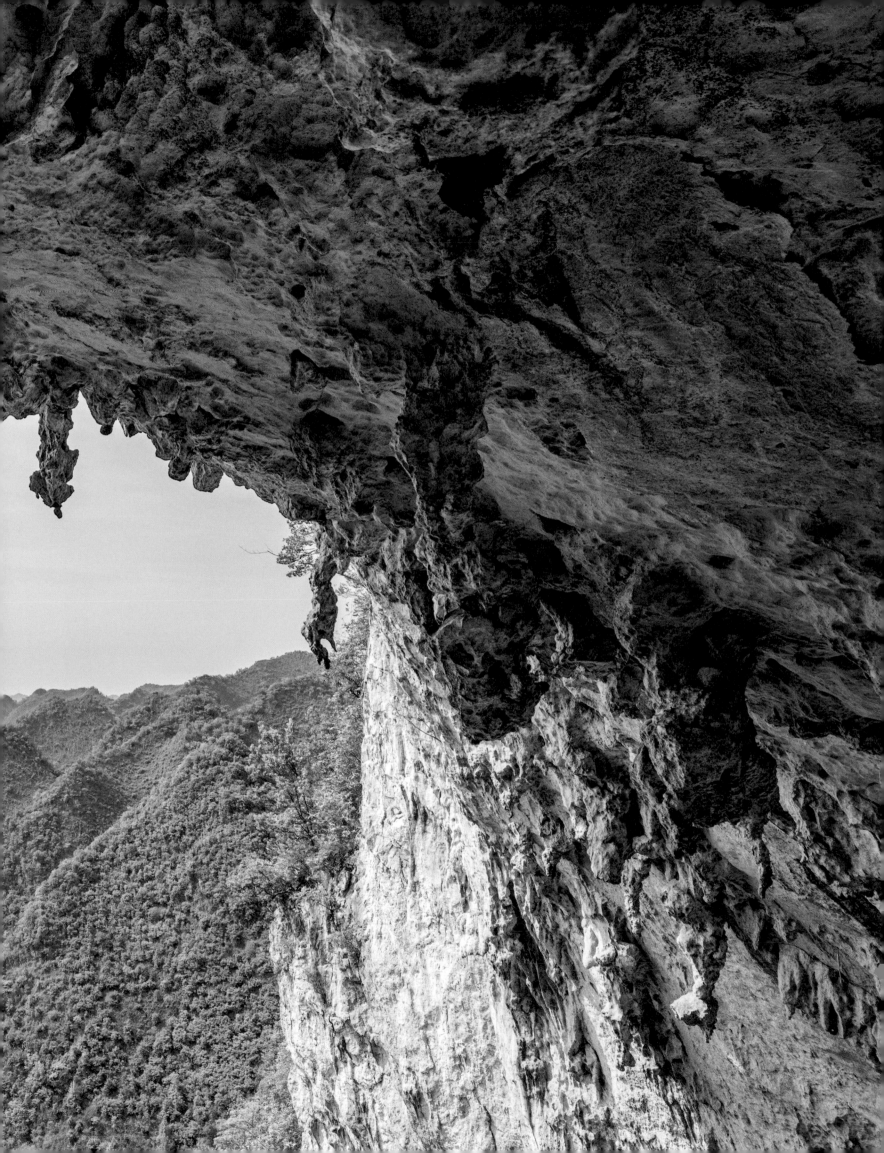

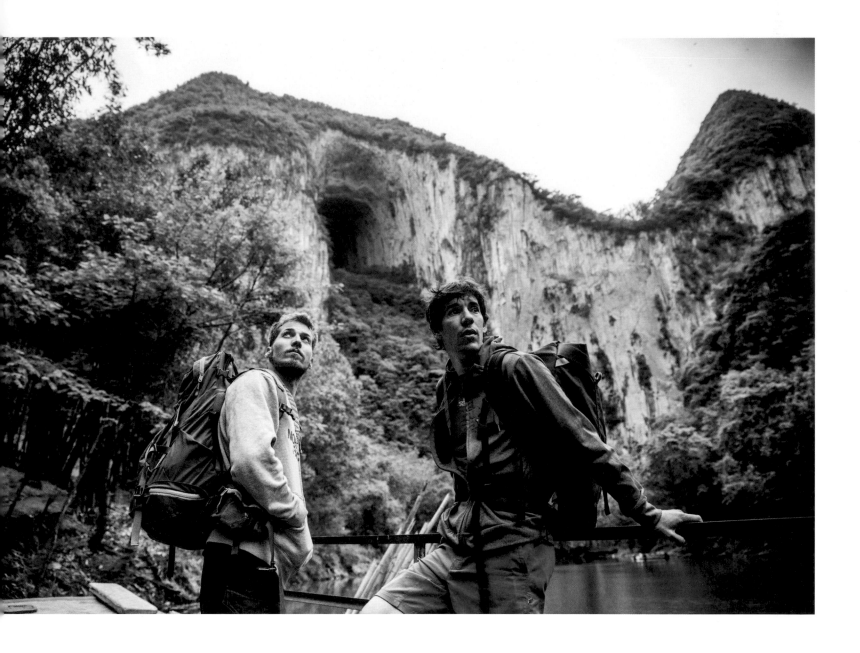

**PREVIOUS** Felipe Camargo climbing the massively overhanging eight-pitch (5.14b) on Corazón de Ensueño route. Getu Arch, Getu, China.

**ABOVE** As part of Alex Honnold's preparation for his eventual free solo of Free Rider, he came to the Getu Arch in Guizhou, China, to train his power endurance climbing on some of the longest overhanging multi-pitch climbs in the world. Alex recruited the talented Brazilian climber Felipe Camargo to climb with him. Here, Felipe and Alex cross the Getu River on the barge. The Getu Arch is visible above them.

**OPPOSITE** Alex and Felipe rappelling from the Getu Arch, Getu, China.

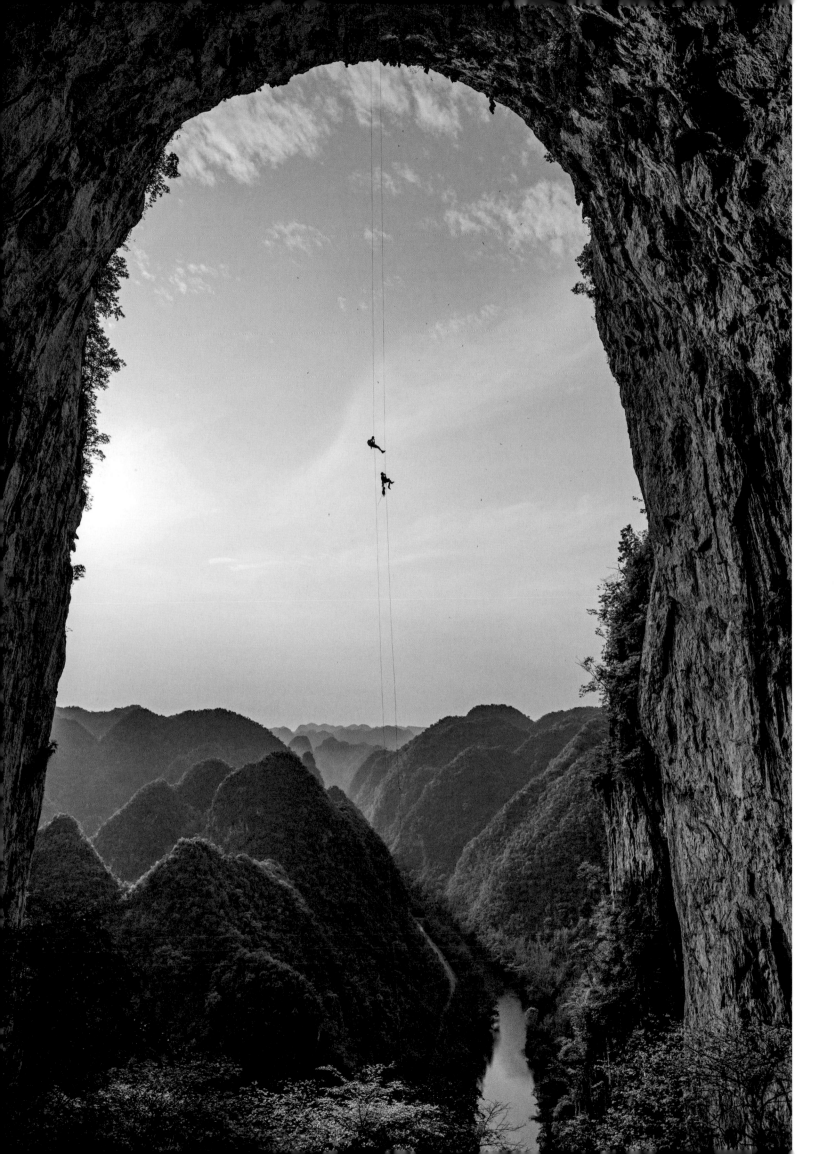

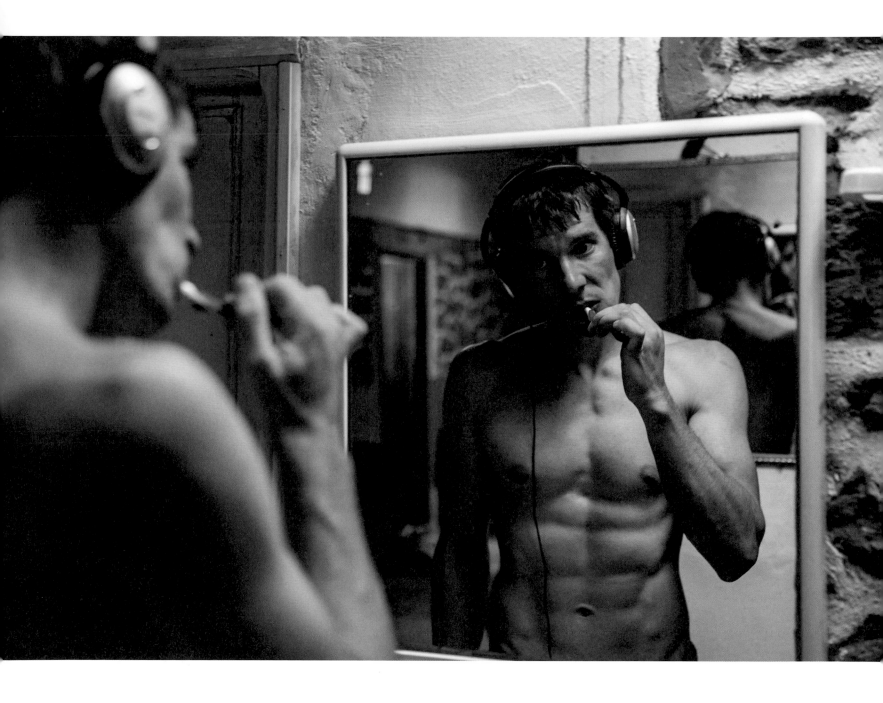

**OPPOSITE** Alex Honnold and Tommy Caldwell roomed together in Morocco. That's a lot of climbing talent in one room. Together, they are arguably the greatest climbing partnership of their generation. Alex spent his rest days reading or watching bad action movies on his laptop, while Tommy worked on writing his book *Push*.

**ABOVE** Alex is a strong believer in dental hygiene and core exercises.

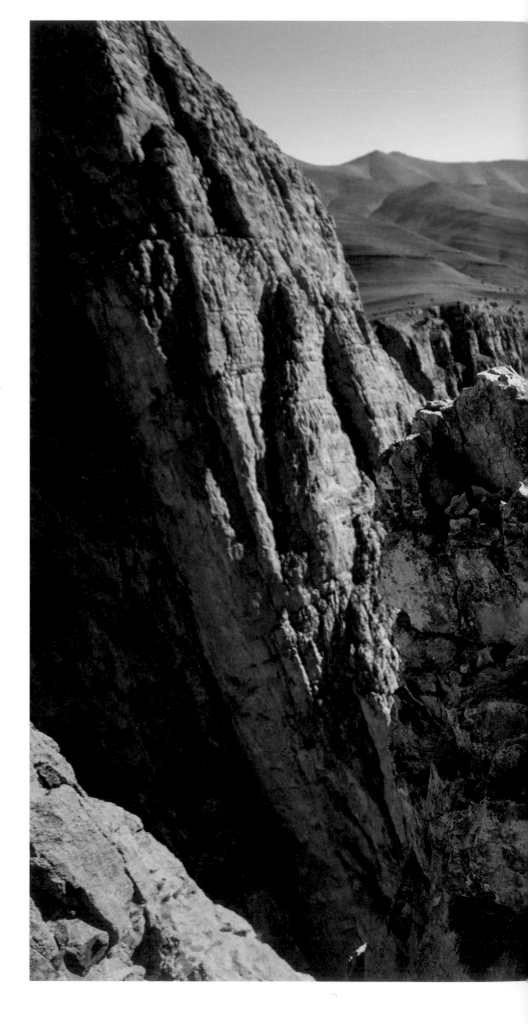

**RIGHT** To train endurance and technical face climbing before the Yosemite climbing season, Alex Honnold recruited Tommy Caldwell to join him in Taghia, Morocco. Alex and Tommy take a break midway through their linkup of the three biggest formations in Taghia Gorge. They eventually climbed over seventy-five pitches of hard technical climbing in a twenty-four-hour push. It was easily the biggest one-day linkup of climbing ever done in Taghia.

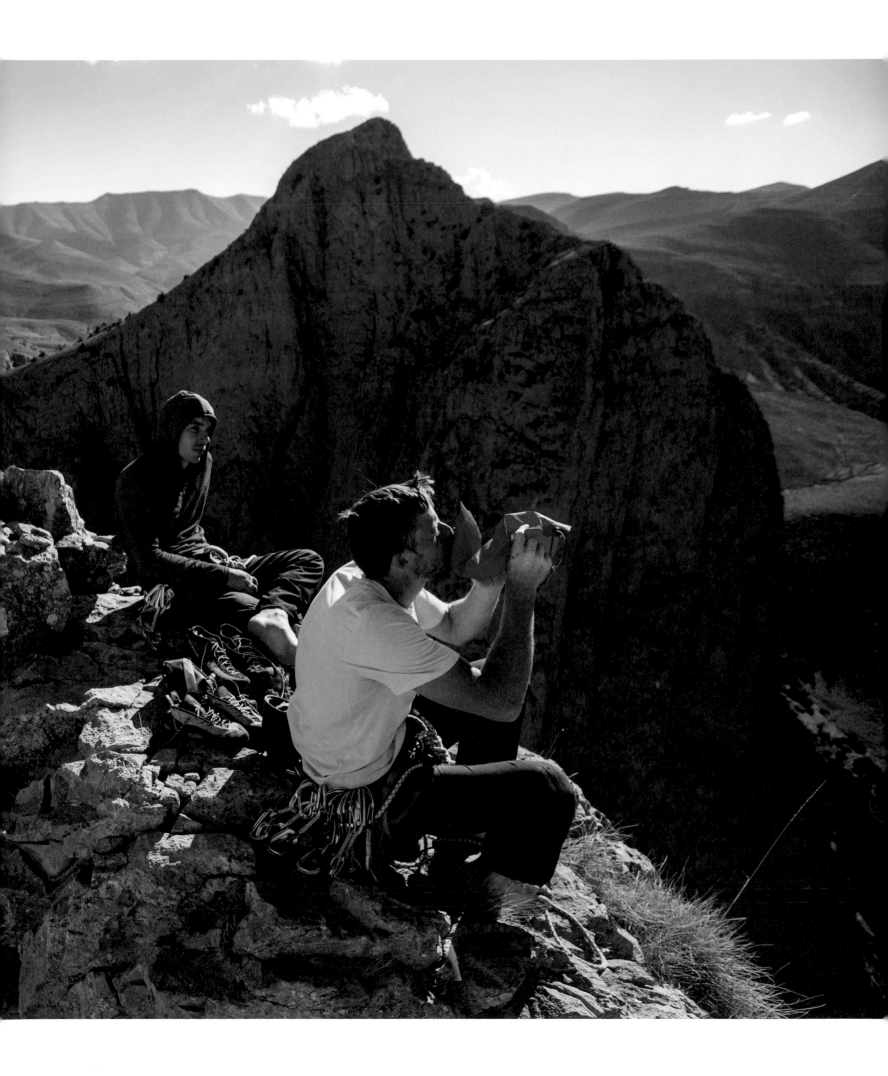

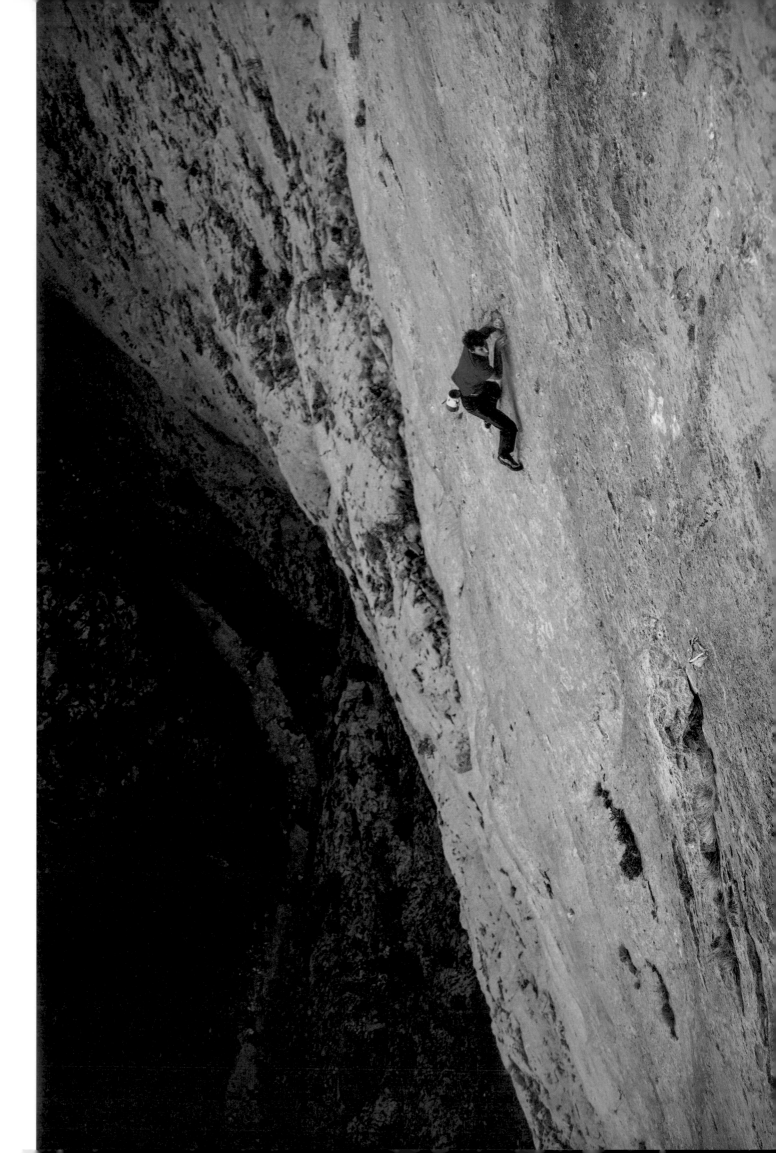

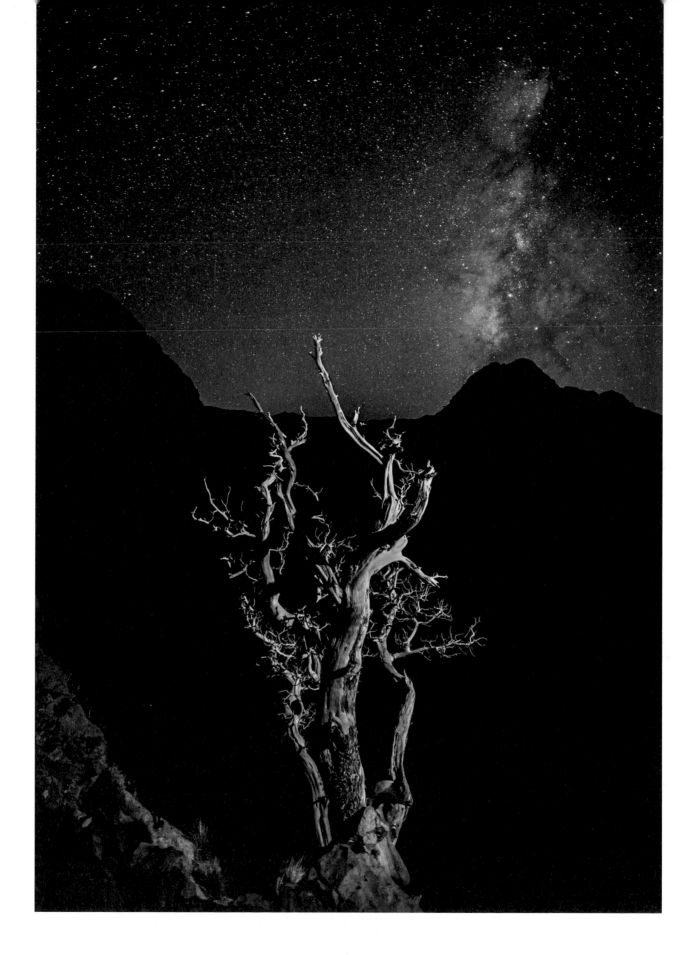

**OPPOSITE** Alex Honnold wanted to do a big "warm-up" free solo before arriving in Yosemite. At the end of his trip to Morocco, Alex free-soloed the two-thousand-foot Les Rivières Pourpres Route (5.12c) in Taghia.

**ABOVE** Juniper tree. Taghia, Morocco.

266

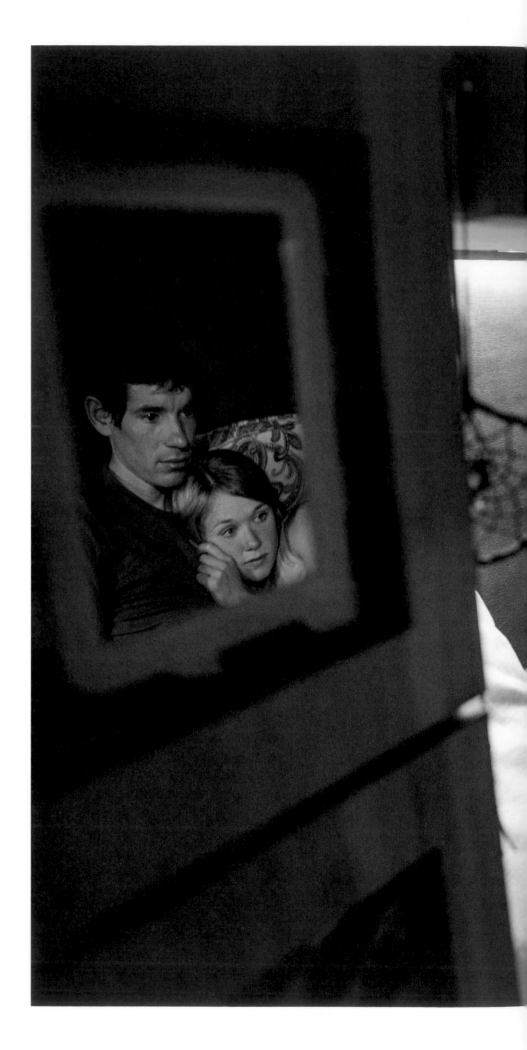

**RIGHT** Alex Honnold and Sanni McCandless watching a movie on a rest day in his Dodge van. Yosemite National Park, California.

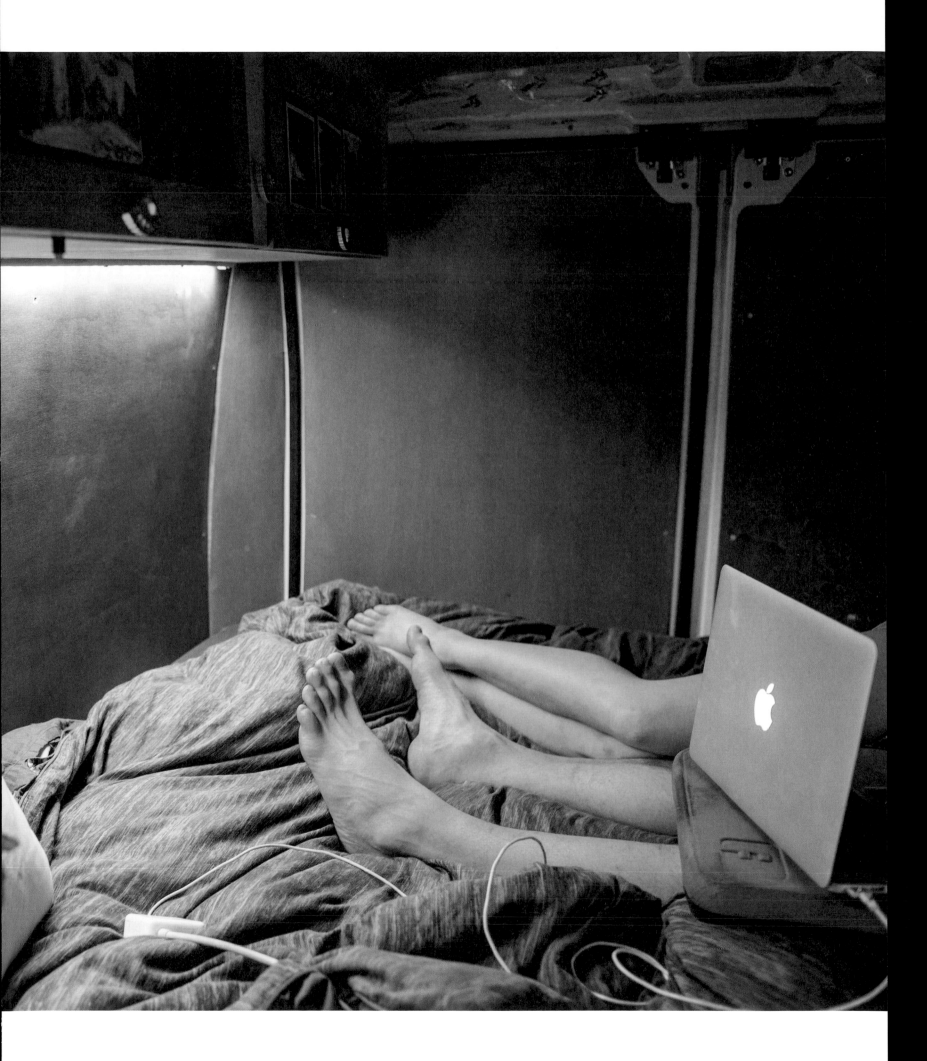

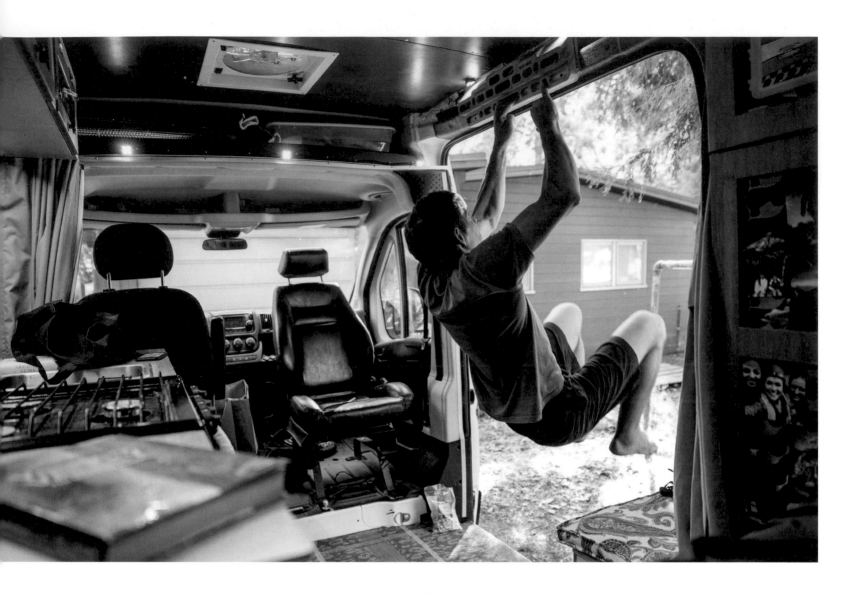

**ABOVE** Alex Honnold hangboarding in his van. Training finger strength was one of many aspects of Alex's preparation for free-soloing El Capitan.

**OPPOSITE** Alex emerging from his van two days before he free-soloed El Capitan. He often spent hours lying in his van, visualizing the moves on the climb.

**FOLLOWING** Alex hiking to the top of El Cap. Alex routinely hiked to the top of El Cap so he could rappel in from the top to practice moves on the upper pitches of Freerider.

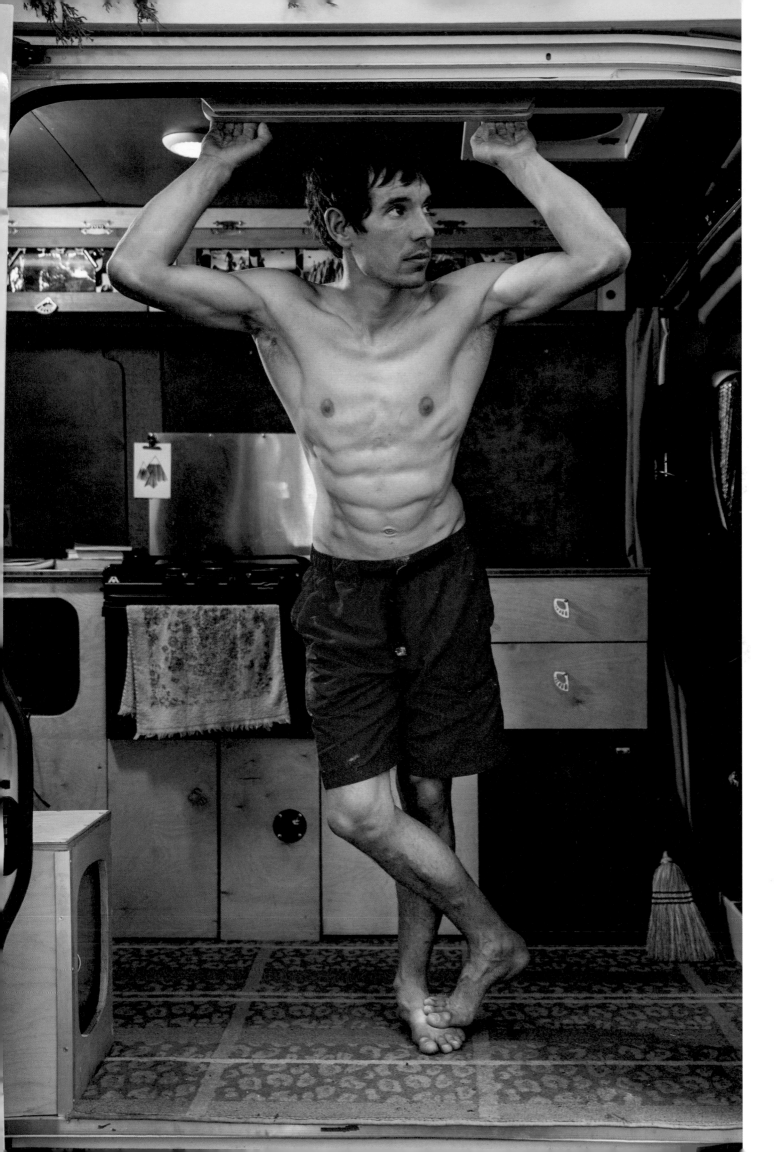

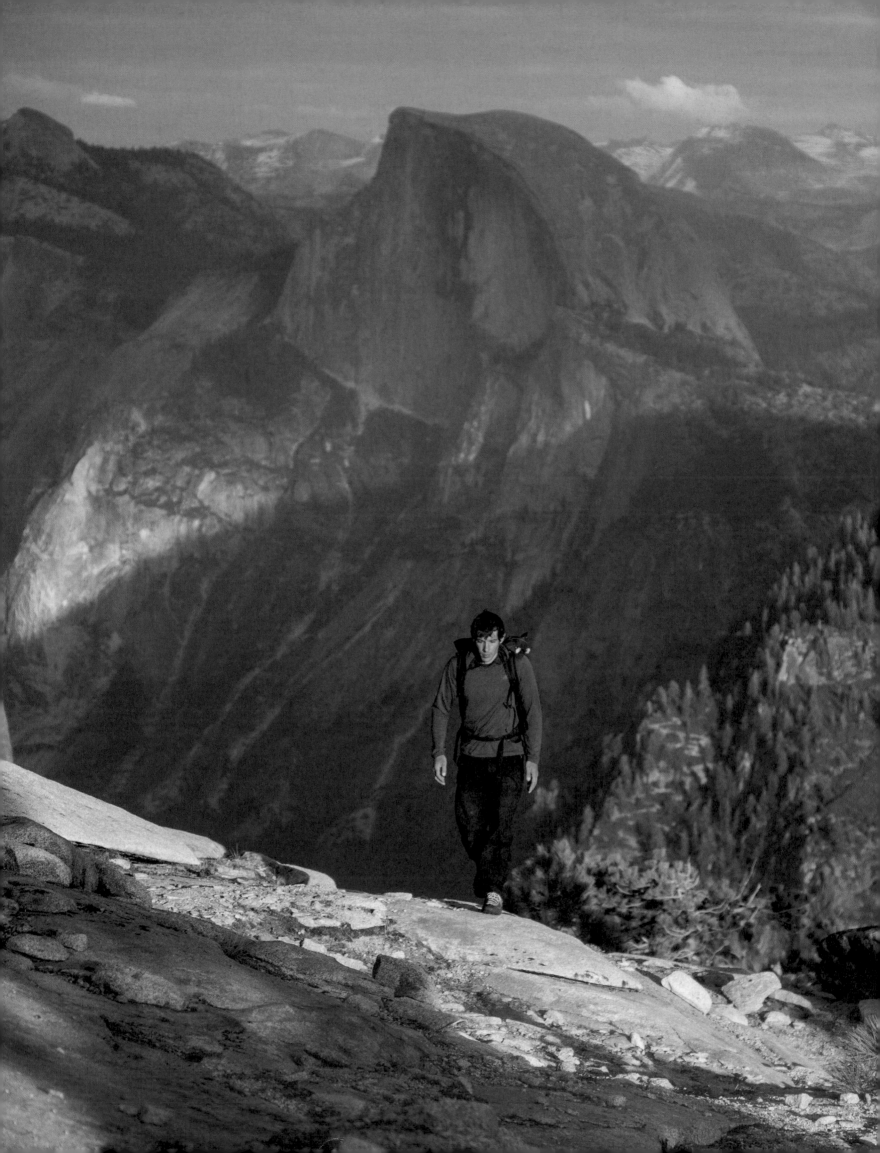

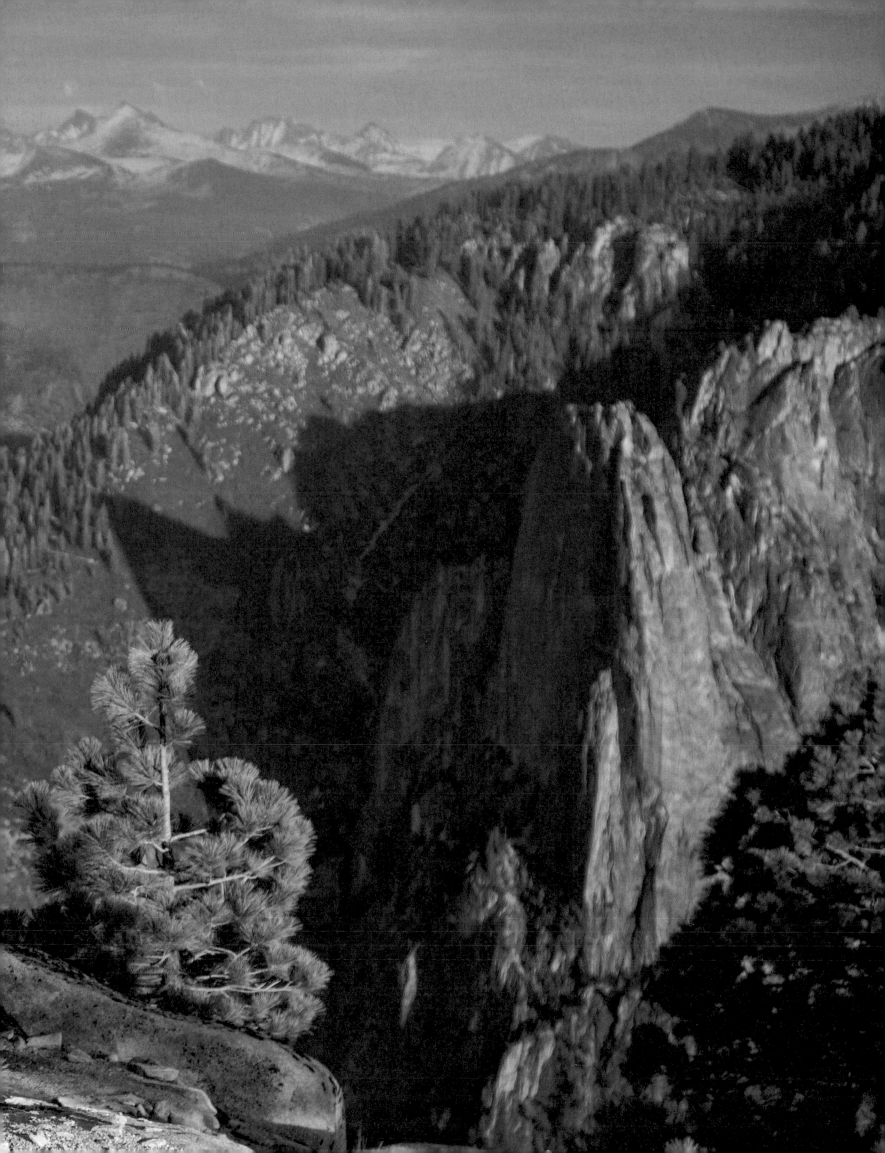

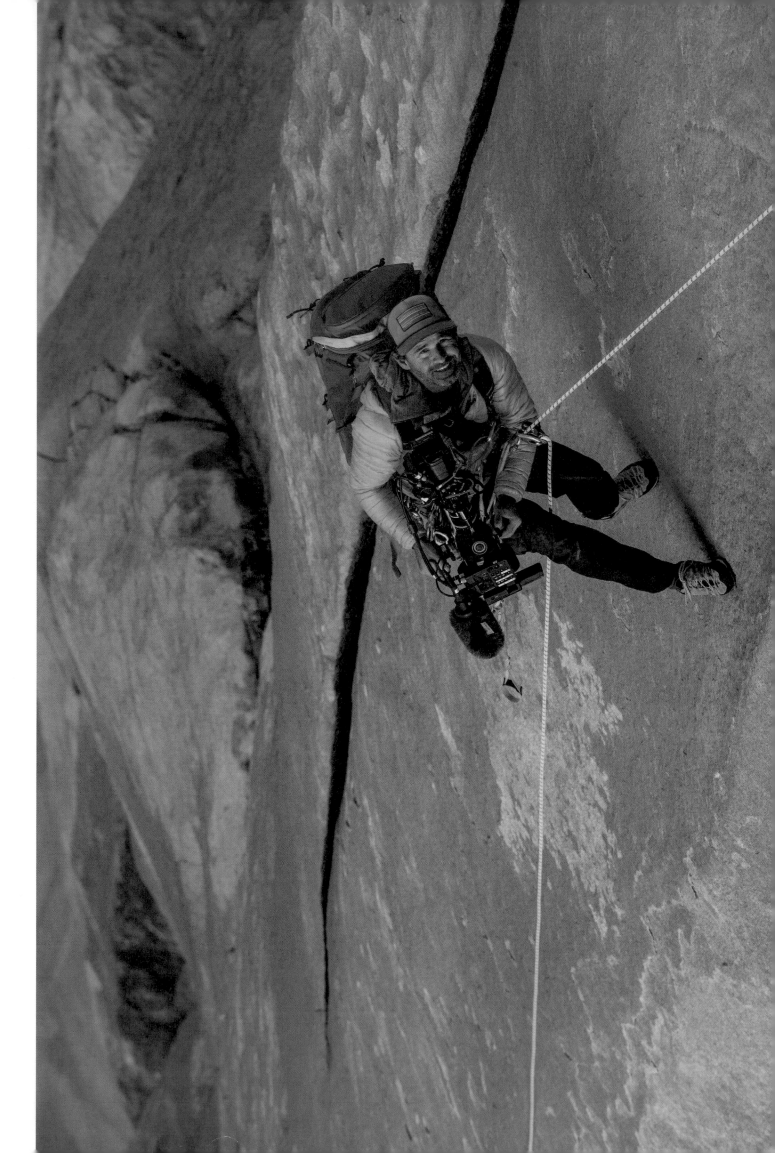

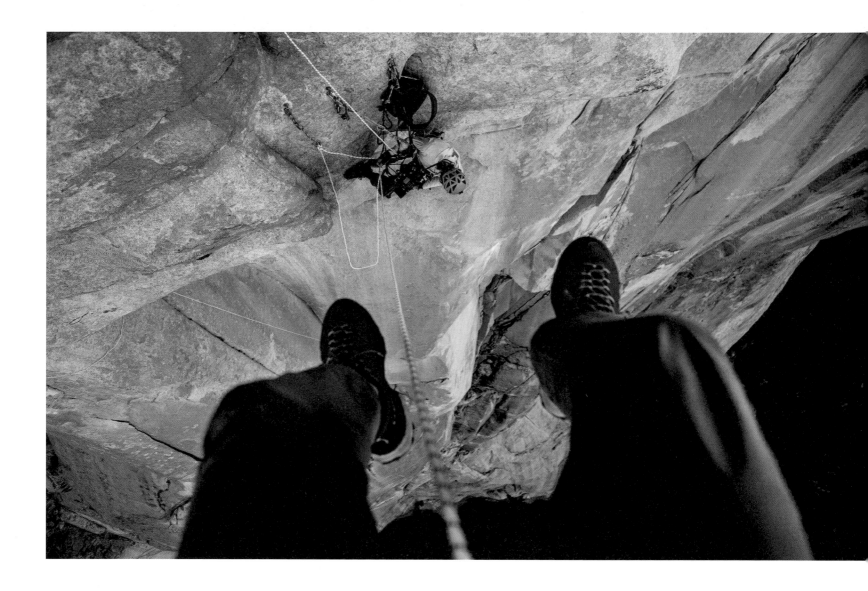

**OPPOSITE**  Mikey Schaefer preparing to film on El Capitan. Mikey is a world-class climber and high-angle cinematographer. His official title on *Free Solo* was the high-angle DP (director of photography), but he managed most of the rigging on all our shoots and acted as a therapist for the production crew.

**ABOVE**  Hanging out above the Great Roof on El Cap with climber and high-angle cinematographer Cheyne Lempe. We spent several seasons rigging and dangling in space several thousand feet off the deck while filming *Free Solo*.

**FOLLOWING**  Cheyne and Josh Huckaby on top of El Cap organizing thousands of feet of rigging rope during the filming of *Free Solo*.

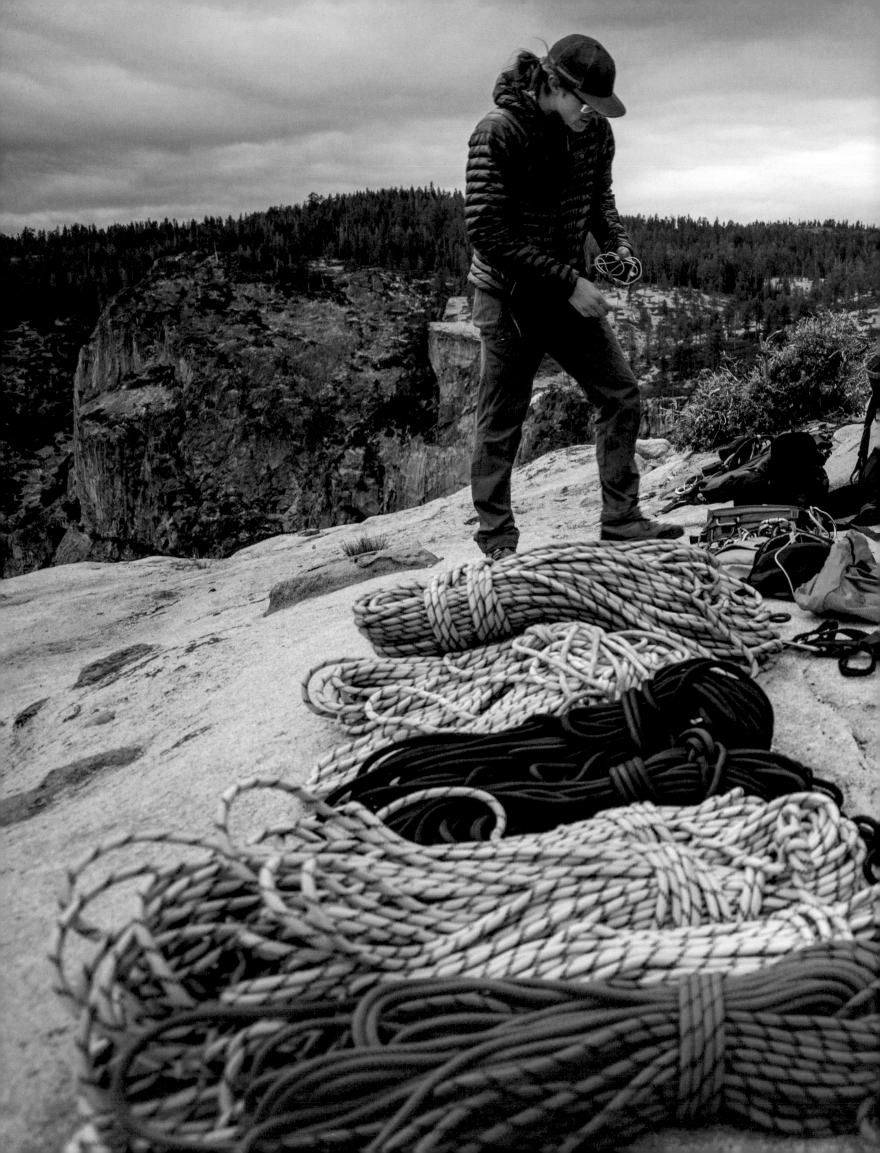

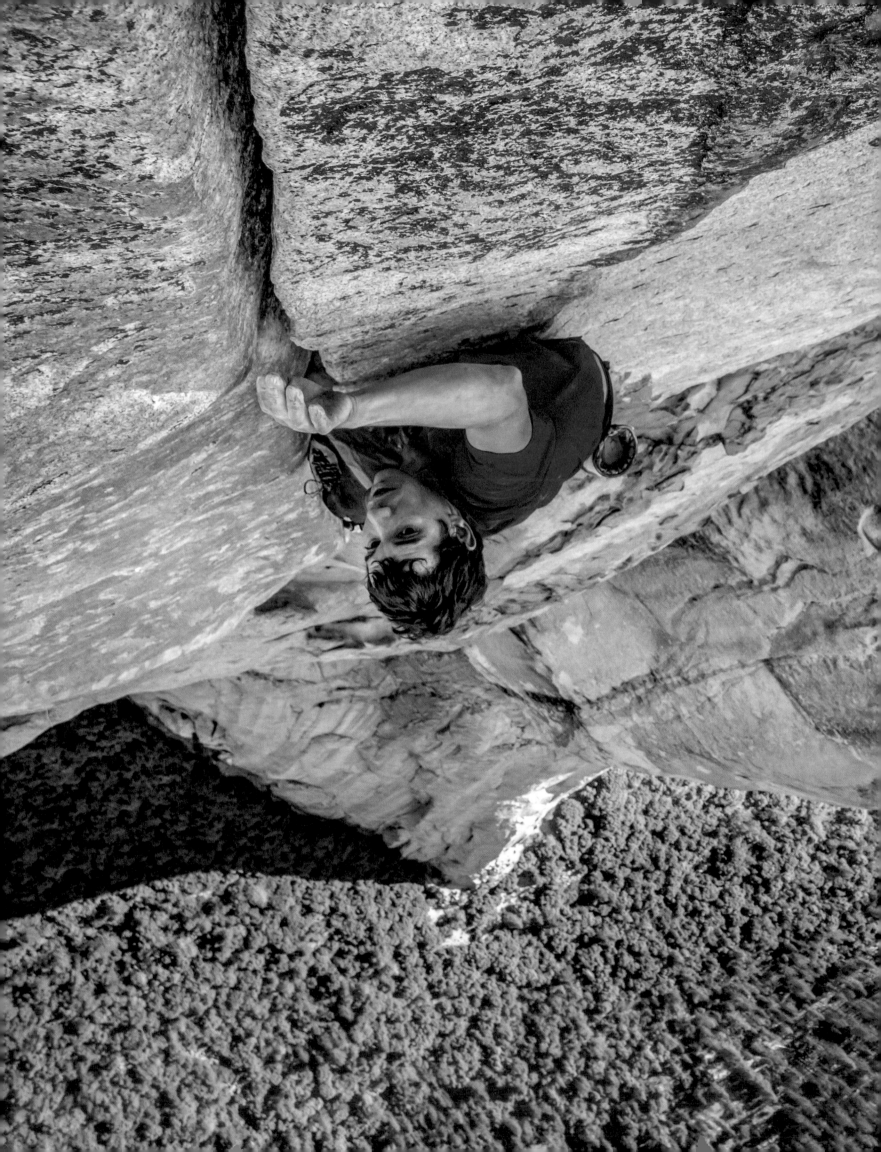

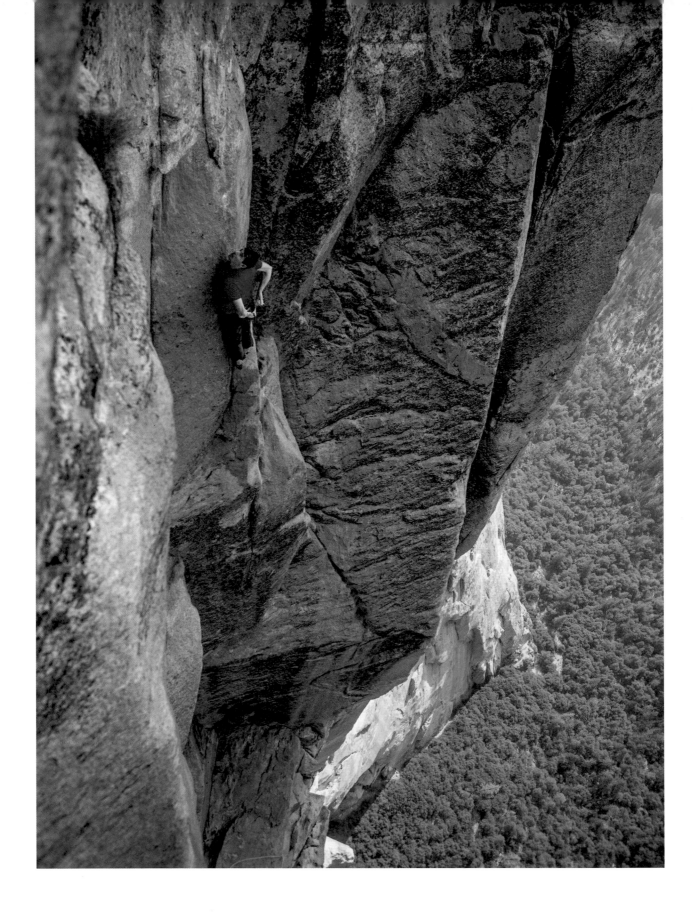

**OPPOSITE**  Alex Honnold climbing one of the upper pitches near the top of Freerider. At this particular moment, I was trying to stay ahead of Alex and out of his way while jugging the line above. He was climbing fast. I didn't have time to pull up the camera and look through the viewfinder to take a shot. I just aimed the camera that was hanging off my harness and pressed the shutter button. It ended up being the cover of *National Geographic* magazine.

**ABOVE**  Alex chalking up below the Boulder Problem crux of Freerider, two thousand feet up El Capitan without a rope.

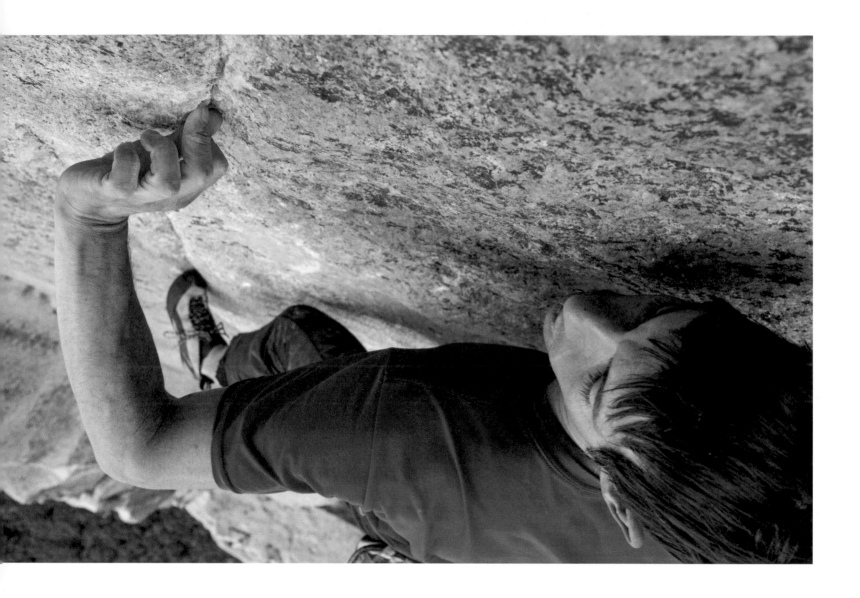

**ABOVE** Alex Honnold presses into the "thundercling" in the Boulder Problem crux of Freerider. In the sequence of moves through the Boulder Problem, Alex needed to move his fingers on his left hand out of the way to match the hold with his right thumb. There would be a moment when only the pressure from half a thumb pad pressing him down on two terrible sloping footholds would keep him attached to the wall. Alex considered this move the most tenuous on the route.

**OPPOSITE** Alex free-soloing the Enduro Corner (5.12b) on Freerider.

**FOLLOWING** June 2017. Alex free-solos El Capitan in three hours and fifty-six minutes.

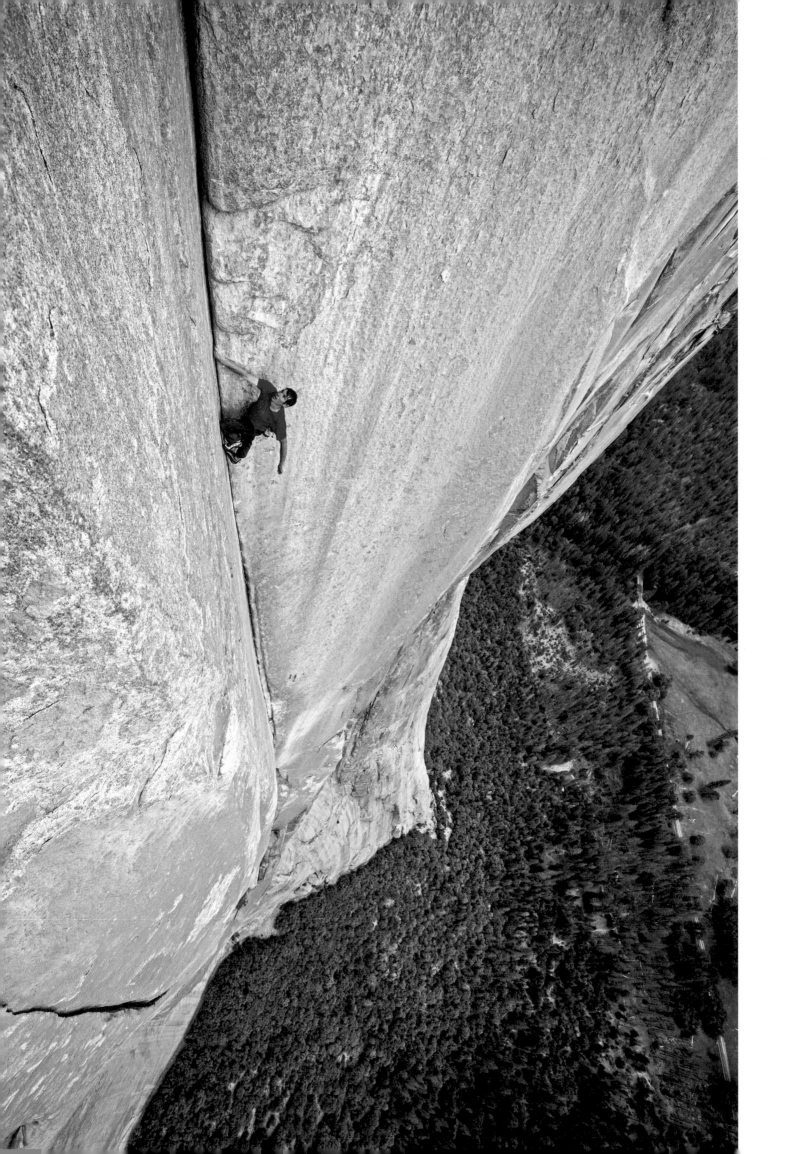

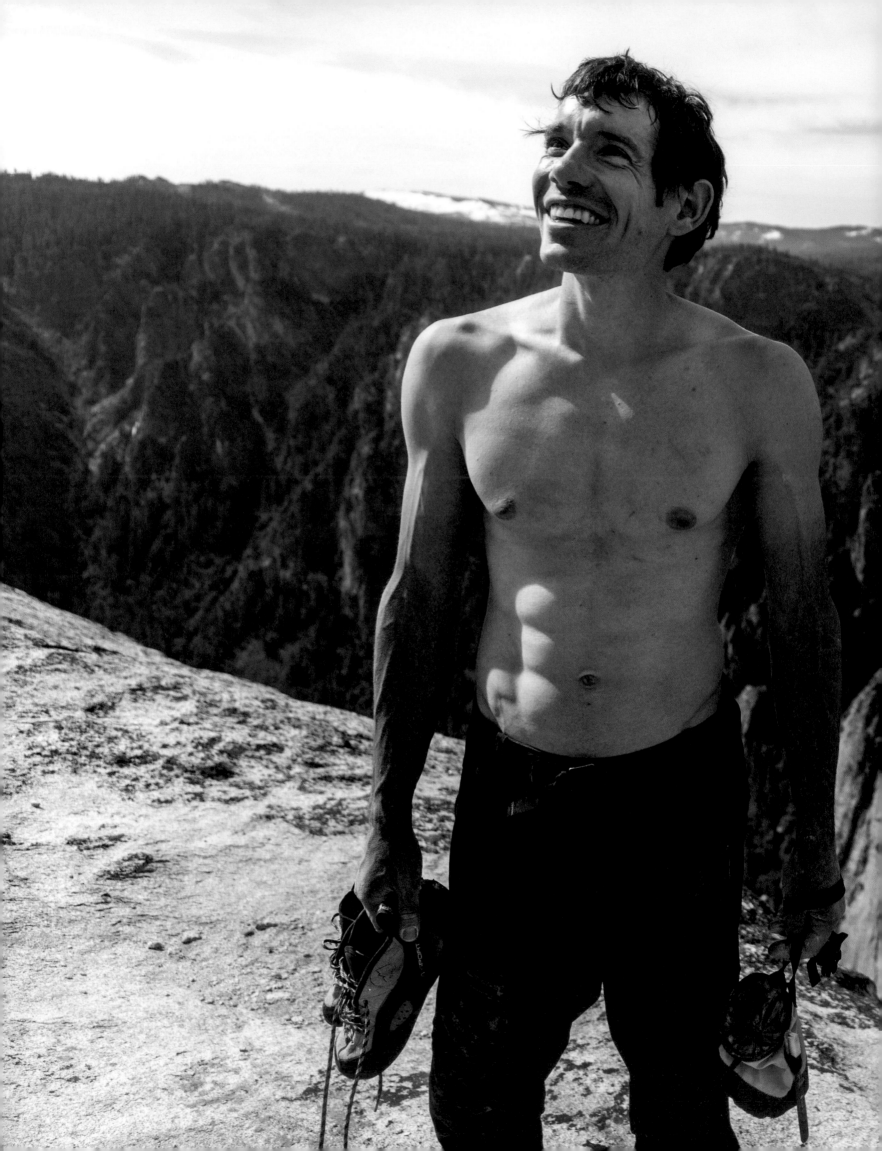

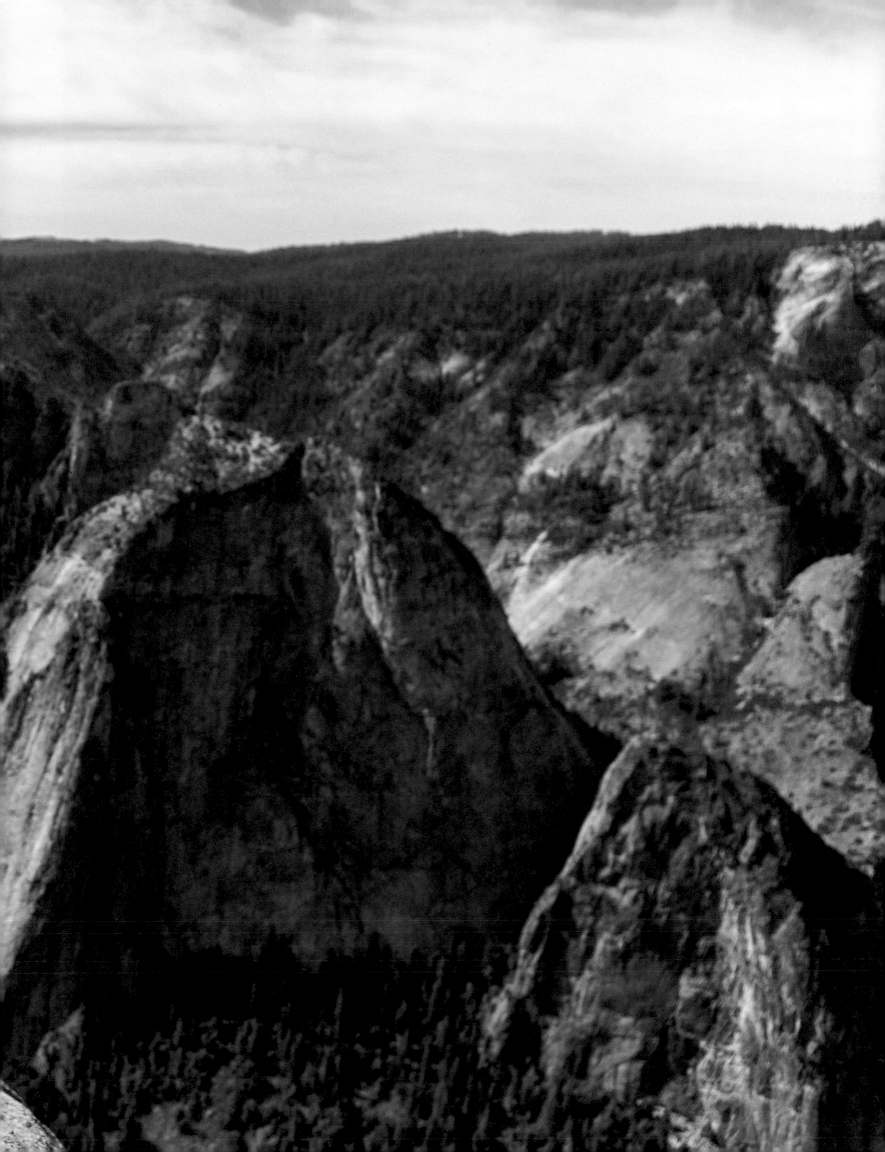

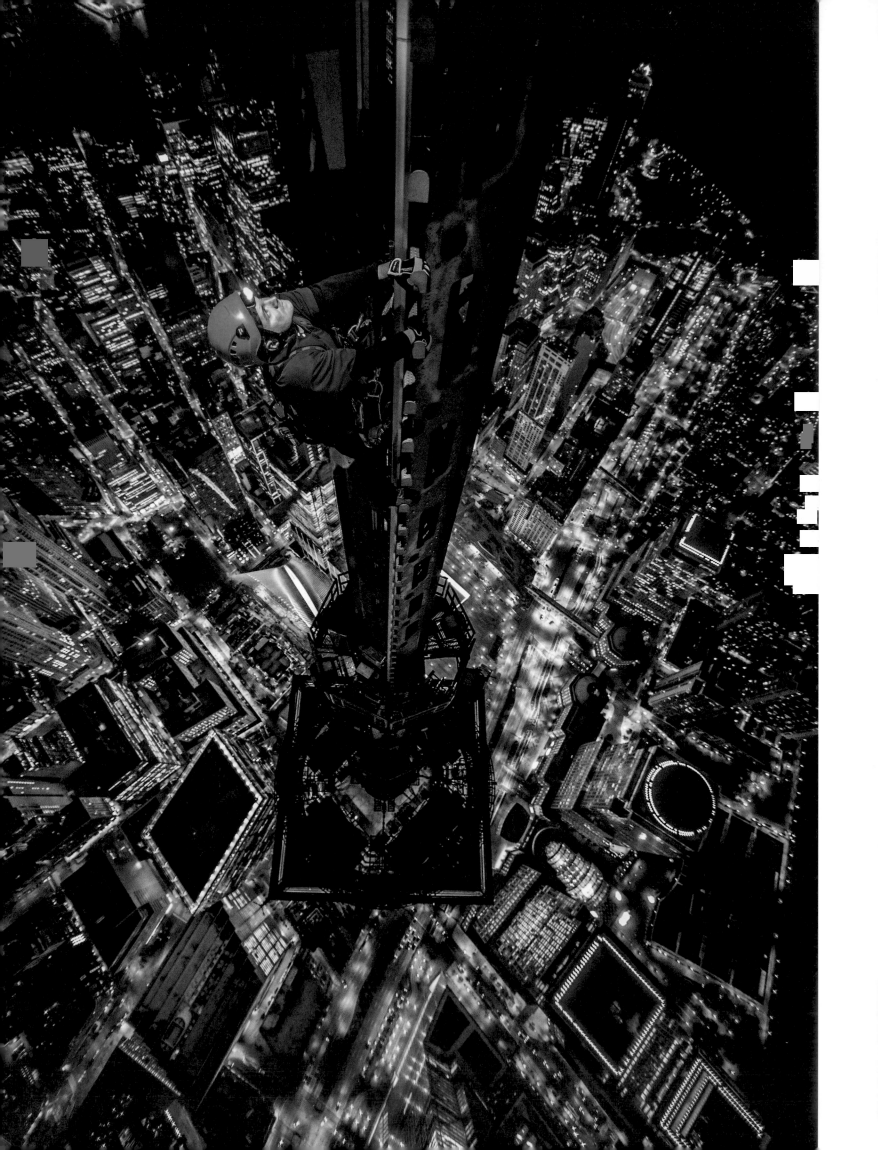

## ONE WORLD TRADE CENTER

Taking an elevator to go climbing might seem like cheating. But this wasn't a normal climb. Exiting ninety-four floors up, on the roof of One World Trade Center, I gazed at the last four hundred feet to the top of the spire. How hard could it be?

This assignment in 2016, my first for the *New York Times Magazine*, came to me from legendary photo editor Kathy Ryan. I remember walking down the hall to her office, gazing at the iconic images from the photographers she had mentored over her career. "Jimmy, let's take what you do and apply it to an urban setting," she said. "Any ideas?"

The Manhattan skyline had always reminded me of an urban mountain range, with One World Trade Center the apex. "How about a shot from the top of the World Trade Center?" I proposed. "I thought you'd say that," said Kathy, smiling. I could already see the image—a night shot of someone scaling the spire just below me, the city lights sprawled out underneath. I explained my vision to Kathy. "Well, let's see if we can make that happen," she said. I was thrilled and nervous.

During a safety briefing the day before, I'd been directed to finish by sunset, since they couldn't turn on the spire's massive floodlights until I was down. The lights are so intense, I wouldn't be able to see to navigate the descent, creating a major safety hazard.

It was 5 p.m. by the time I'd passed through security and prepped all my gear on the roof. Accompanying me would be Jamison Walsh, one of two Americans certified to climb the spire for annual inspections. We had two hours to get the shot and get down. "So, I hear you're some sort of professional climber?" said one of the security guards, arms crossed. "I don't care who you are so long as you're fast enough to get down before dark." I thought to myself, "Oh yeah? Watch this . . ."

So, it began: the race against the clock, a thousand feet over the city. Starting up the ladder, I discovered there was a deck every twenty feet, with a small, square opening I had to squeeze through. This meant holding on to the ladder with one hand while I used the other to pull off my 50lb pack and jam it through ahead of me. After a hundred feet, I was breathing hard, cursing, and sweating profusely.

By the time we'd climbed near the top, the sun was on the horizon. Clambering to the crow's nest, I took a moment to appreciate the absurdity of the location. Then I got to work, spreading out all the strobes, clamping them to different spots on the guardrail. As the sun set, the radio crackled, "How's it going up there? You should be heading down now." Ignoring it, I tested the strobes for the final shot. Nothing. I checked all the settings. No luck. The radio waves from the massive antennae were interfering with my remote triggering system. Nothing worked. It was now well past sunset and getting dark.

Someone on the radio yelled, "You need to come down NOW!" I turned it off. "Sorry, I'm making art," I muttered as I jammed a headlamp on my head and screwed my camera to the end of a ten-foot monopod. Hooking my heels under a rail welded into the tower, I extended the monopod as far as I could, my body levered out horizontally over Manhattan. With the camera in time-lapse mode, firing in one-second intervals, I shot blindly, my arms aching as I held the monopod still for the slow shutter speed. Simultaneously I waved my head back and forth, using my headlamp to paint Jamison with light. He appeared terrified. I'm sure I looked like a maniac. After every click of the camera, I shifted the angle of the camera in tiny increments. I could only guess at what I was shooting. After a minute or so, it was time to go down. I'd done everything I could.

Back at the *Times*'s offices, we scrolled through the images. There was one tack-sharp shot with Jamison perfectly positioned and perfectly lit. I stared at it for a moment, smiled, and left. It would become my first cover for the *New York Times Magazine*.

As I looked through the window of my cab, I could see the top of the World Trade Center. I felt the similar sense of awe and satisfaction I'd felt after other big climbs. The spire was lit beautifully in the night sky, but tonight, just a little later than normal.

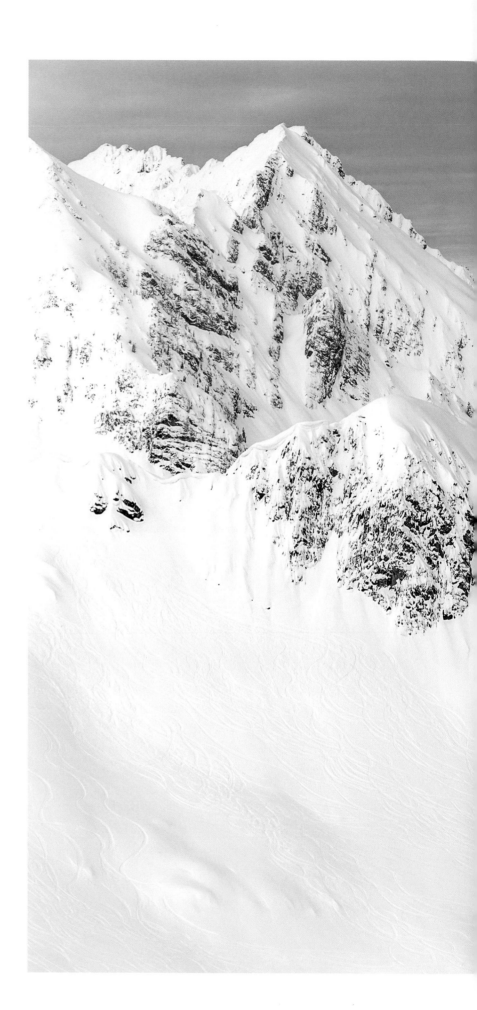

## SCOT SCHMIDT

The first poster I ever owned as a kid was a shot of Scot
Schmidt. I watched all his films and even modeled my
ski turn after his. Scot has one of the most distinctive
and beautiful turns on the planet. We're now friends, and
I consider it an honor every chance I get to ski with him.
Here Scot drops into the steeps at Island Lake Lodge,
British Columbia.

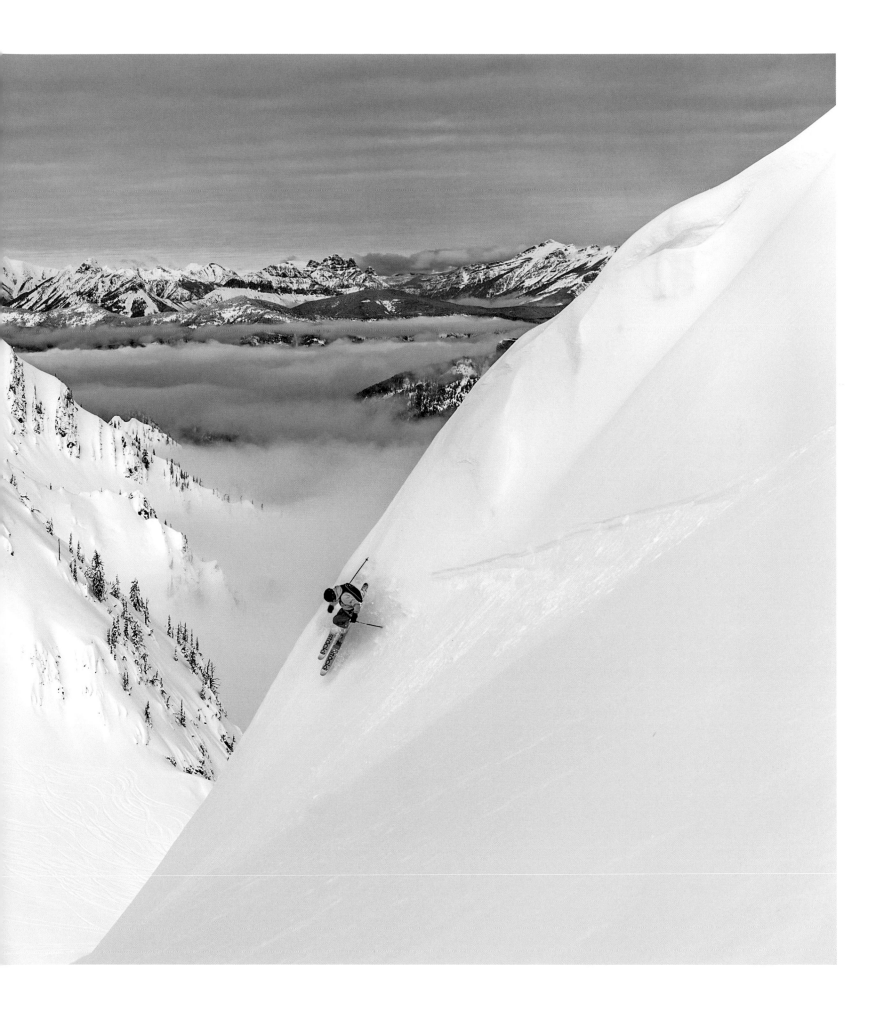

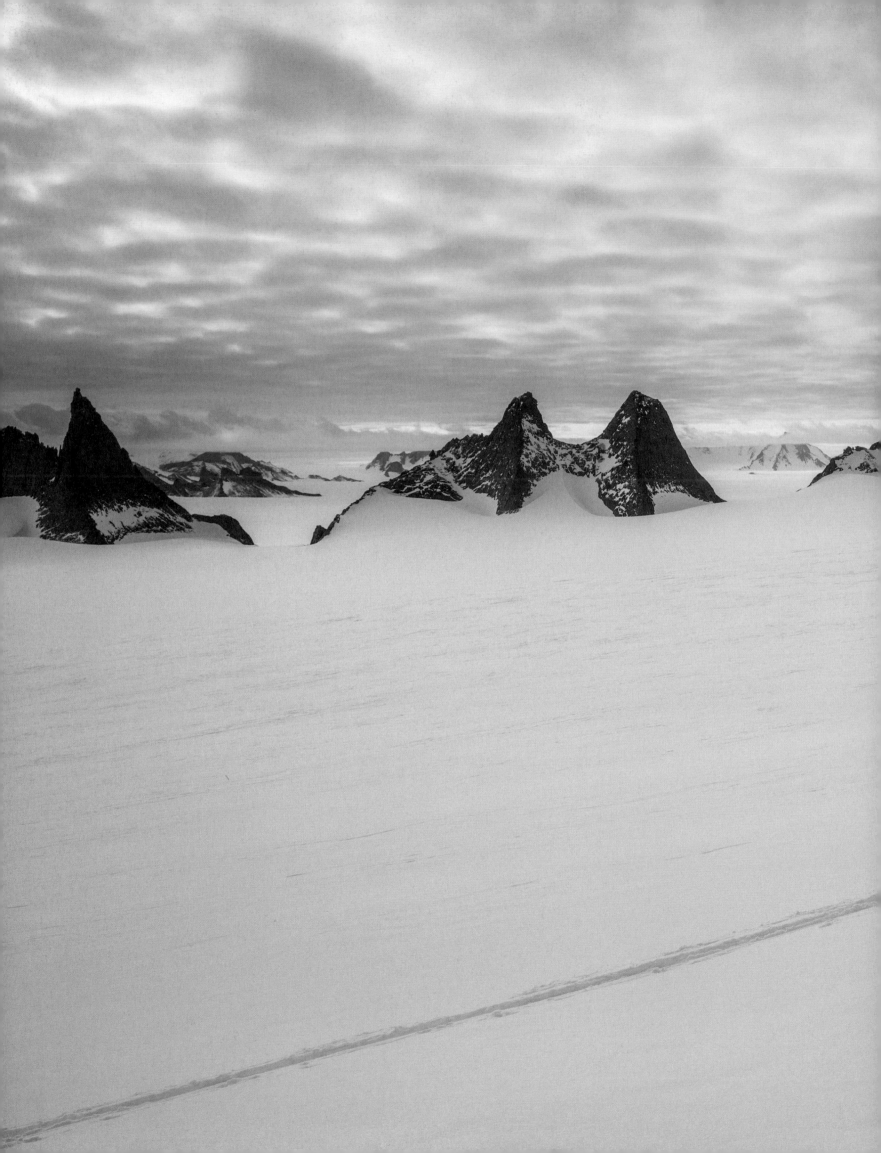

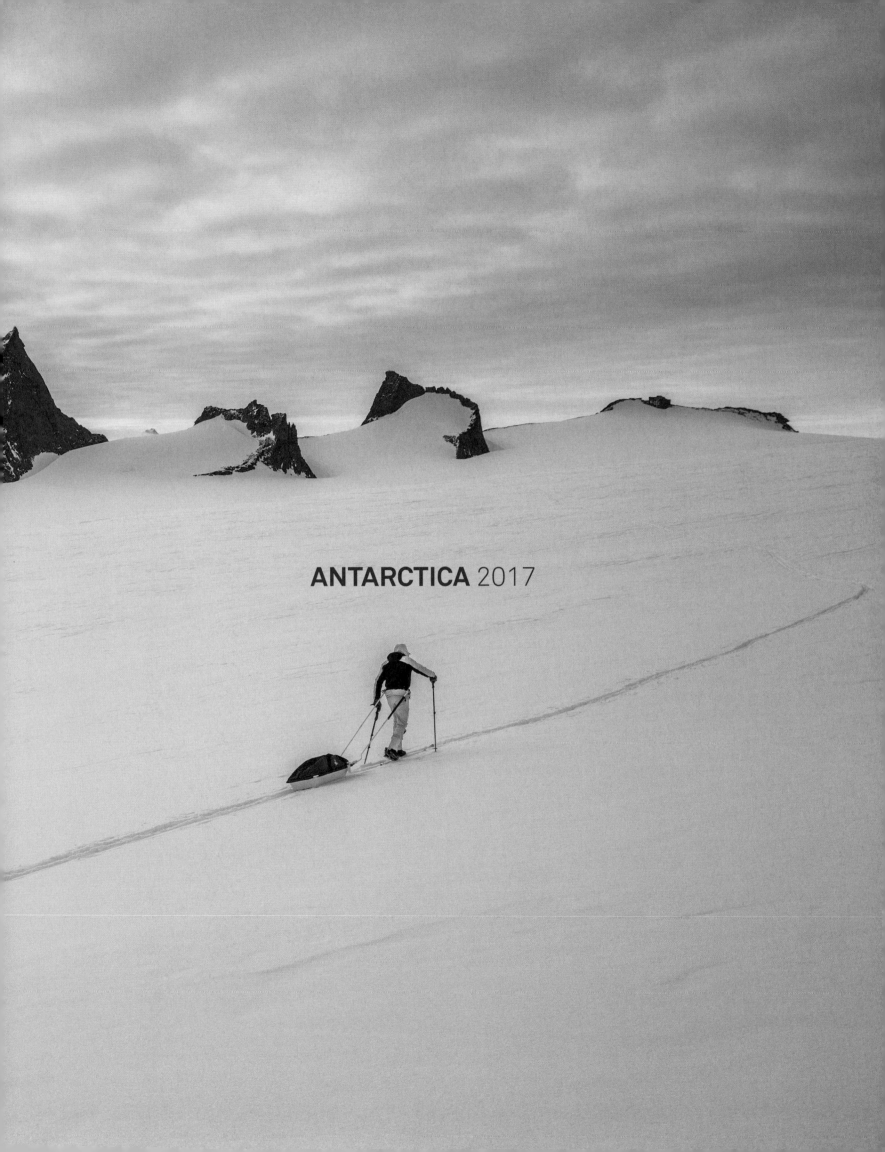

ANTARCTICA 2017

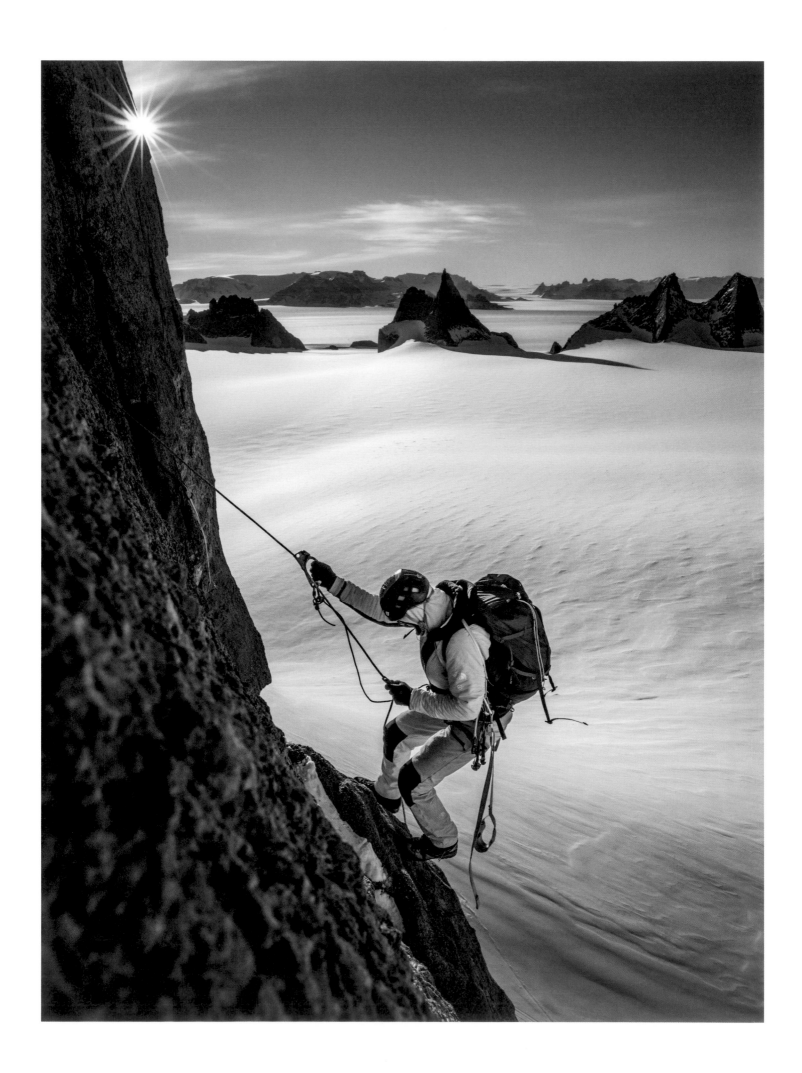

At -30°F, snow squealed under our crampons, and our eyes threatened to freeze shut if we blinked too slowly.

A mist of microscopic ice crystals drifted over us, around us, beneath us. It was one of the coldest days on one of the coldest climbs I'd ever experienced.

Swapping leads across the wind-sculpted ridge, Conrad Anker and I inched our way toward the upper headwall of a four-thousand-foot rock spire called Ulvetanna (Norwegian for "the wolf's fang"). It stands dominant over its peers in the range, which curves across the white Antarctic plain and resembles a half-buried jawbone with dark incisors.

To get here, we'd spent six days groveling in Michelin Man-sized layers of clothing, up two thousand feet of off-width cracks and brutal squeeze chimneys. The razor-sharp conglomerate shredded our down jackets; this wasn't rock-star climbing—just blue-collar grinding.

The reward was a five-star high camp perched on the crest of an elegant arête. Below us was nothing but crystalline Antarctic sky, the cleanest air on Earth, and views of the dreamscape that is Queen Maud Land. Inside the tent, down feathers from our torn jackets spewed into the air whenever we moved, making it look like we were sitting in a snow globe.

Although Conrad and I were the only climbers on Ulvetanna, comrades Alex Honnold, Cedar Wright, Savannah Cummings, Anna Pfaff, and Pablo Durana were not far away, scaling every other formation in the range while we labored up this single objective.

We were warned by the Norwegians who first explored this area that things down here were bigger than they first appeared, and everything would take longer than we might think. Turns out they were right on both counts. We spent more time shoveling snow off the wall to expose handholds and footholds than actually climbing.

After a day of fixing our two ropes from our high camp, we embarked on a summit push up the final fifteen-hundred-foot headwall. As Conrad stoically put it, "We may be old, but we sure are slow." We had to stop often to manage the bitter cold, swinging our hands and feet to increase circulation and get warm again. Sixteen hours later, we were just below the top. It was 2 a.m., the coldest part of the day, when the sun is barely above the horizon. A strong wind raked the summit. The temperature was -50°F. Conrad and I both sensed, without discussing it, that we were teetering on the edge.

After almost two decades of expeditions, our partnership had evolved to a point where we often didn't need to speak to communicate. We laugh without having to tell the joke, and difficult decisions are made without debate or drama. Such is a good partnership.

I stomped around for a while trying to warm up. Then, knowing I would never be here again, I led across a thin ridge of shifting rock plates that took us to the summit. I unfurled a kata scarf for my father, who had recently died. Conrad took some of Alex Lowe's ashes and released them to the wind in sight of Rakekniven, a stunning peak they'd climbed together in 1997, two years before Alex's death.

Up there on top of Ulvetanna, the realm beyond felt near.

**PREVIOUS** Conrad Anker hauling gear to base camp in Queen Maud Land.

**OPPOSITE** Conrad ascending fixed lines on our new route on Ulvetanna. We spent five days leading and fixing lines on the lower wall before launching onto the upper two-thousand-foot wall of climbing.

290

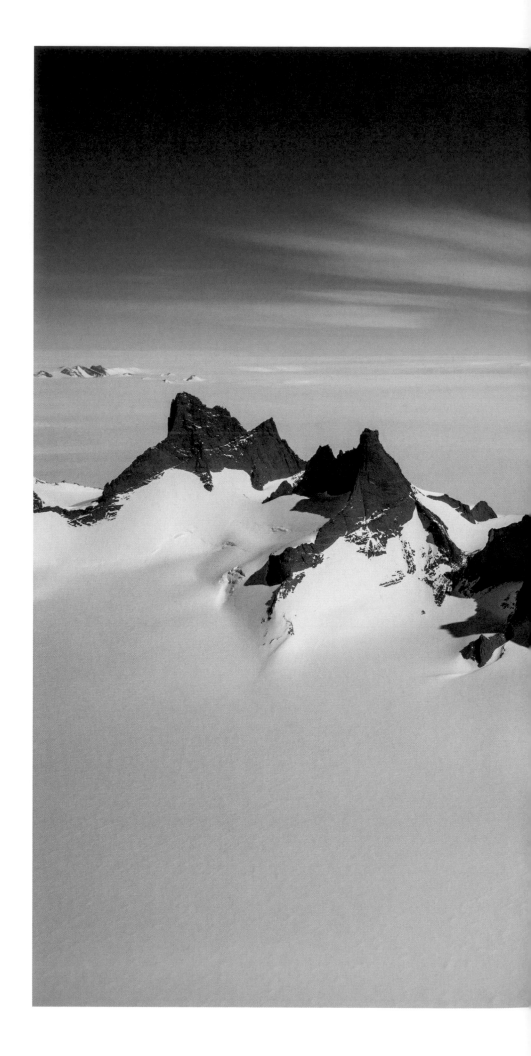

**RIGHT** Aerial view of the Fenriskjeften Range. Standing over four thousand feet, Ulvetanna is the tallest peak in the photo.

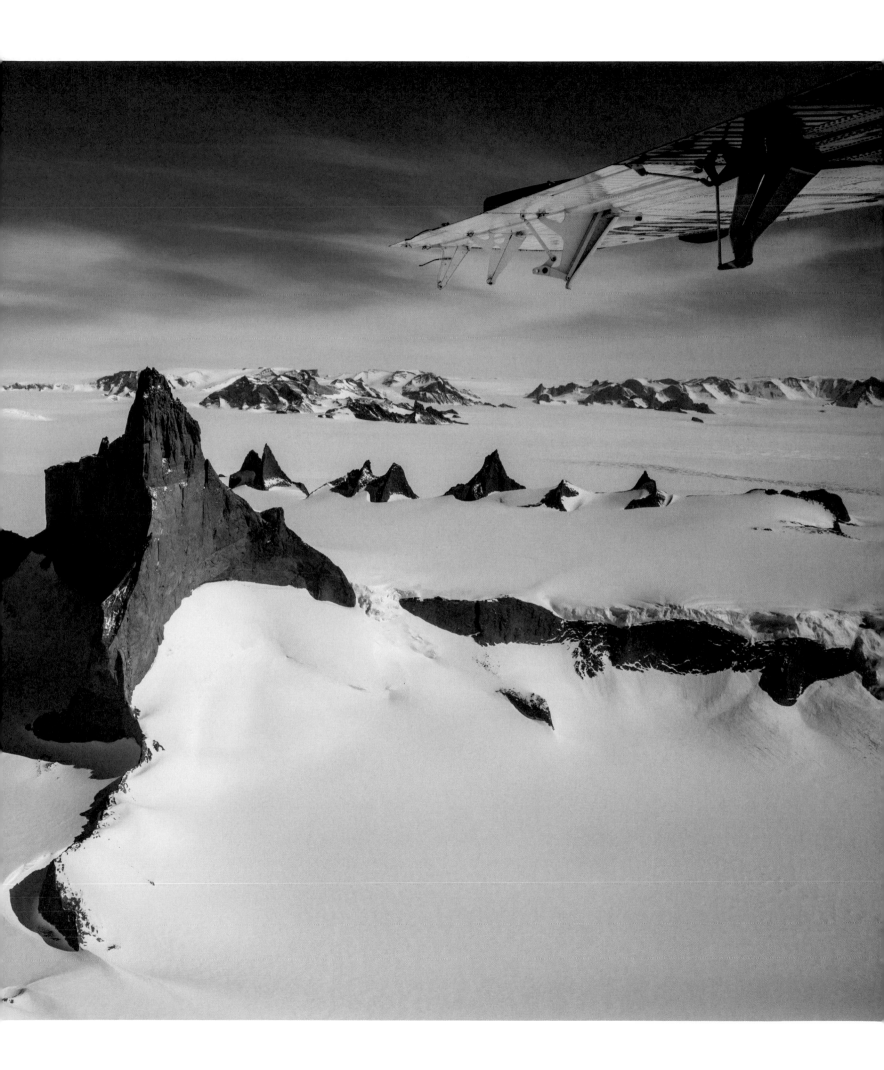

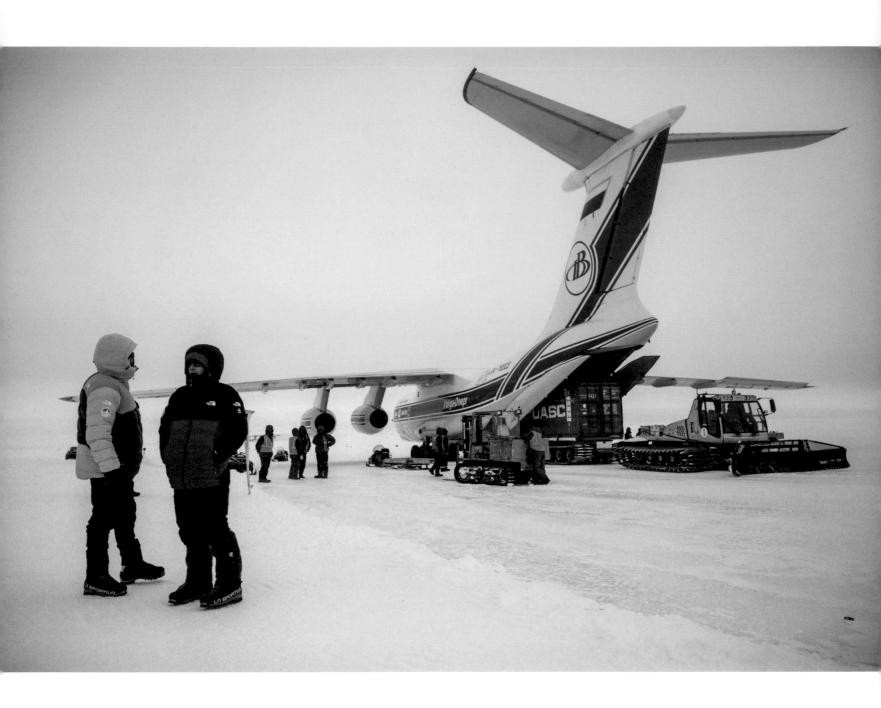

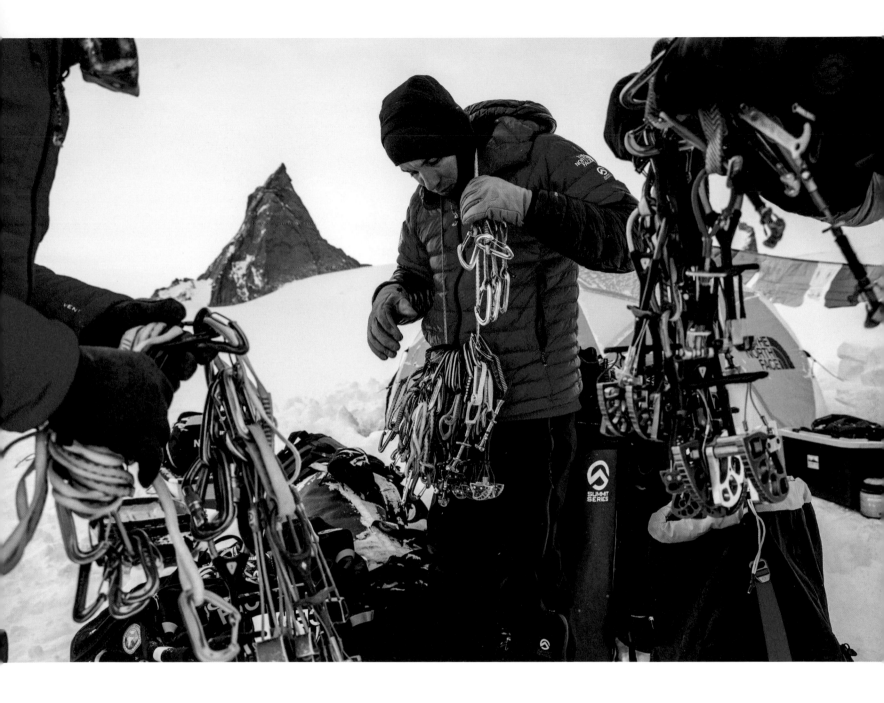

**OPPOSITE** Conrad Anker and Alex Honnold arrive at the Novo Russian base in Antarctica via the Russian Ilyushin 76 jet.

**ABOVE** Savannah Cummins, Alex Honnold, and Anna Pfaff organize gear and rack up for their first climbs in Queen Maud Land.

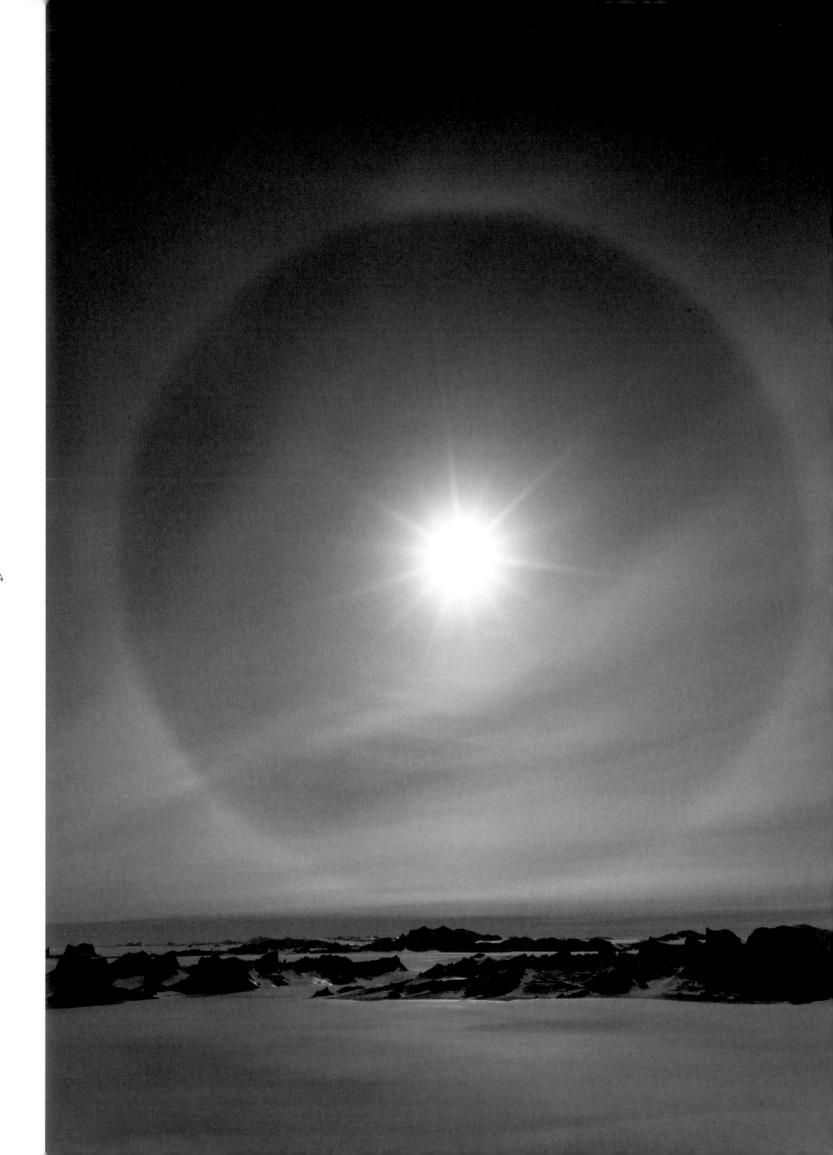

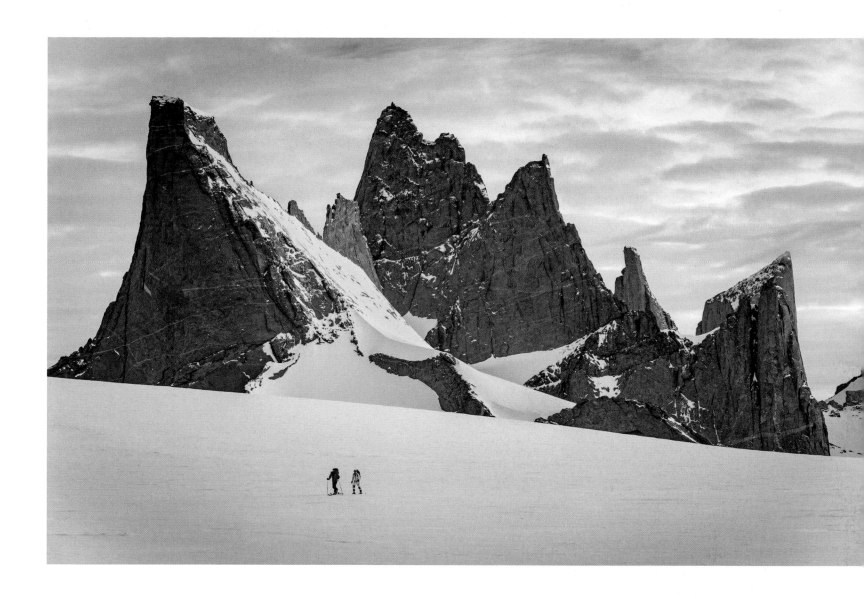

**OPPOSITE** Antarctic sun dog. The view from our high camp on Ulvetanna.

**ABOVE** Cedar Wright and Alex Honnold ski touring back to base camp at the end of a long day. The pair focused on climbing all the various formations in the Fenriskjeften, aka the Wolf's Jaw, while Conrad Anker and I focused on a new route on Ulvetanna, aka the Wolf's Fang. As a team, we climbed all the formations in the Jaw by the end of the expedition.

**ABOVE** Base camp life in the dome tent. We each had individual tents for sleeping and shared the dome tent for meals and downtime. There is an art to building the perfect base camp dome setup.

**OPPOSITE** Cedar Wright shows off his "expedition manicure"—the result of a lot of sharp rock, bitter cold, and miles of climbing.

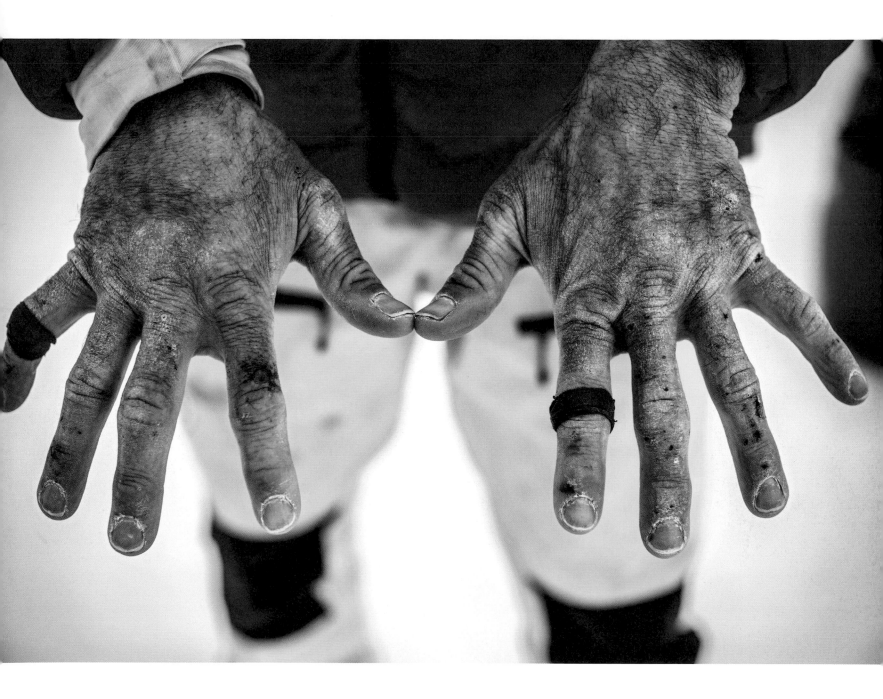

298

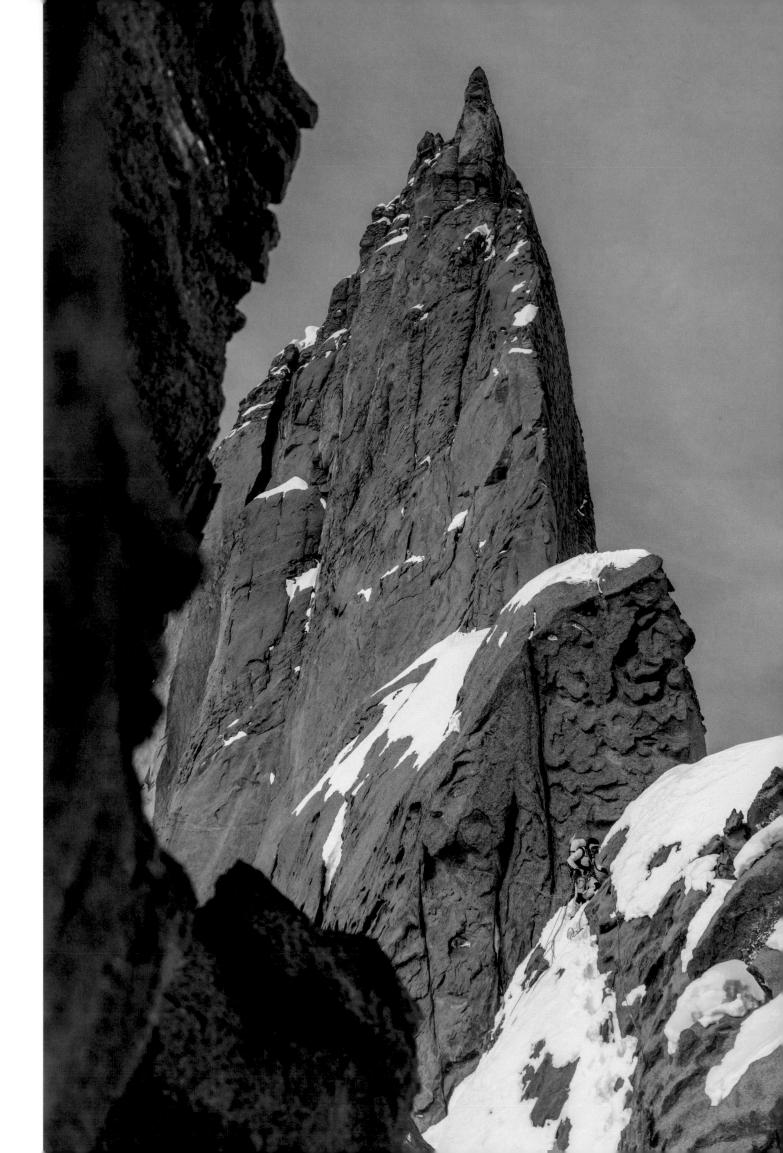

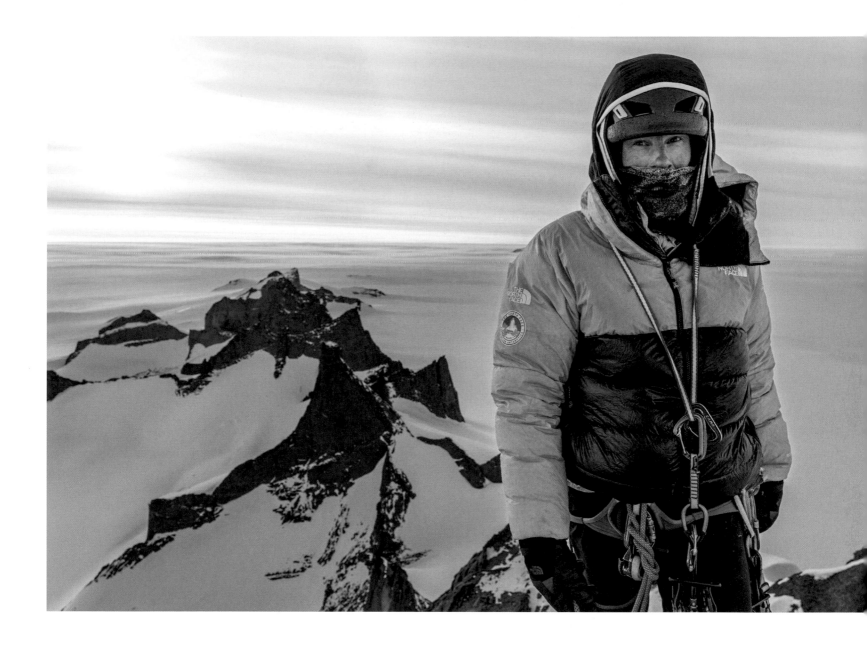

**OPPOSITE** Conrad Anker traversing the convoluted and committing ridgeline toward the fifteen-hundred-foot upper headwall of Ulvetanna.

**ABOVE** Conrad on the summit of Ulvetanna. After eight days of climbing, we summitted Ulvetanna at 2 a.m. in −50°F temperatures.

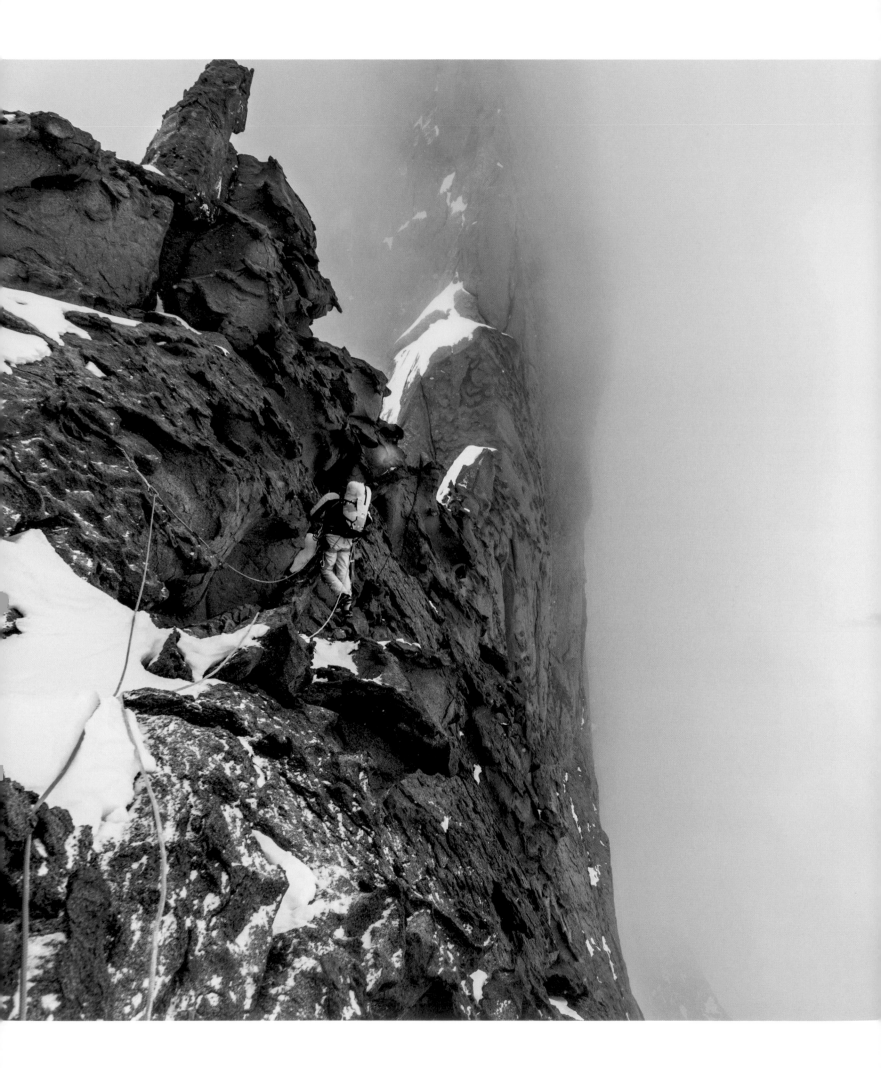

**LEFT** An ice mist drifted over us during our fifth day of climbing. When you lose the sun in Antarctica, temperatures plummet. At −30°F, everything feels more consequential. With a 2,500-foot void looming to our right, Conrad Anker leads across the wind-sculpted ridge, slowly making his way toward the upper headwall.

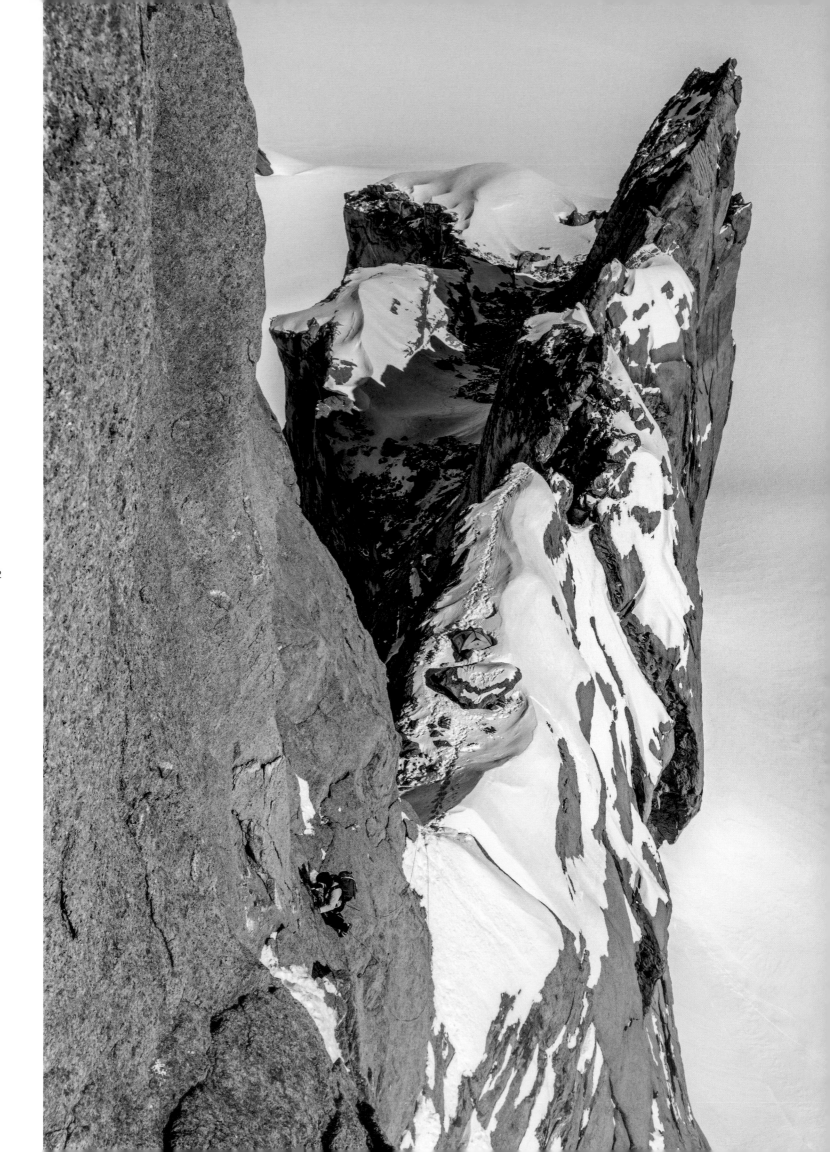

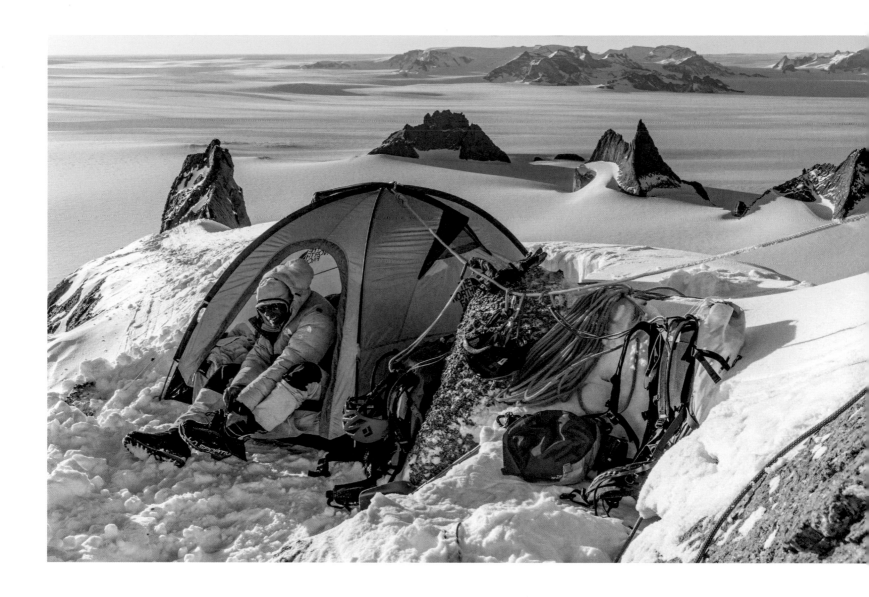

**OPPOSITE** Conrad Anker following the first pitch of the upper headwall of Ulvetanna. The ridge traverse and our high camp can be seen below.

**ABOVE** Conrad is perpetually in motion. It is a rare moment when he is sitting and I am not. Conrad finally sits down after twelve hours of climbing and building camp.

**FOLLOWING** Twenty-four hours of light provided endless days. Conrad traversing toward our high camp on another endless day in Antarctica.

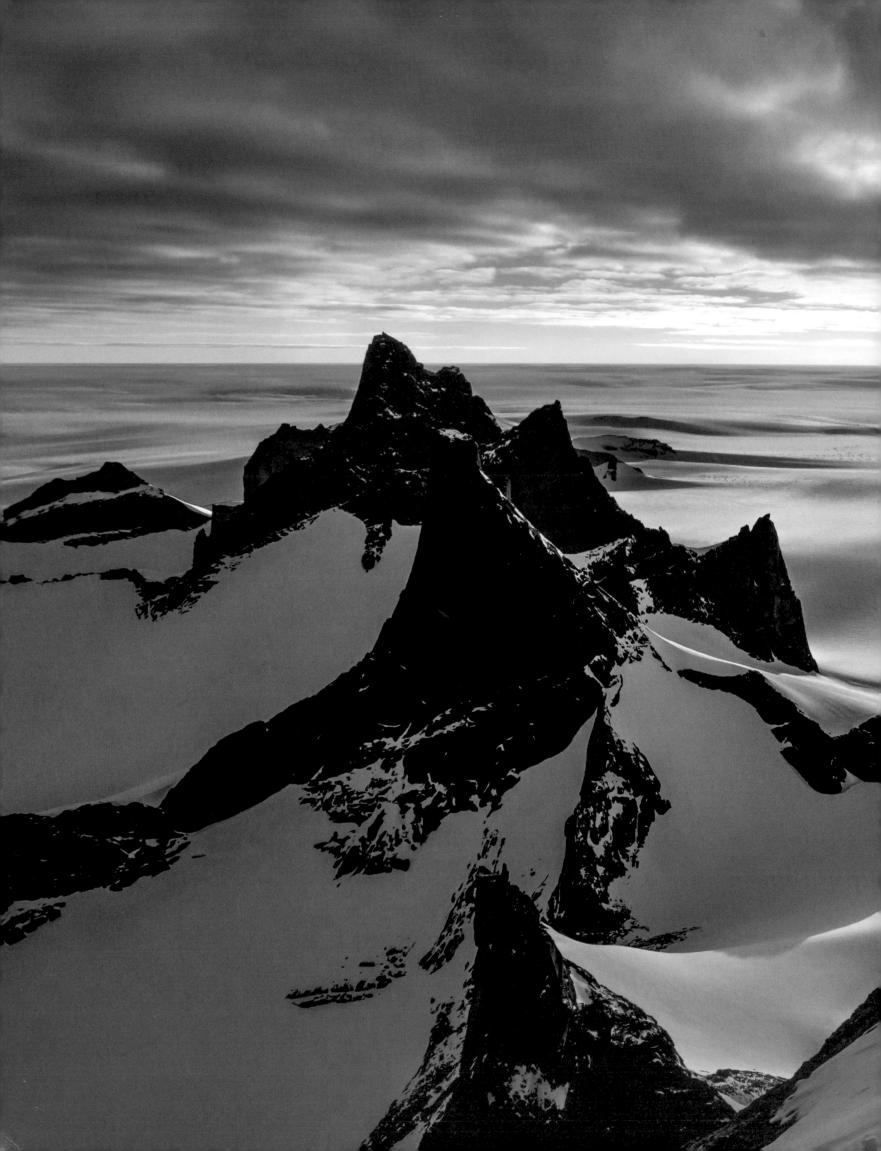

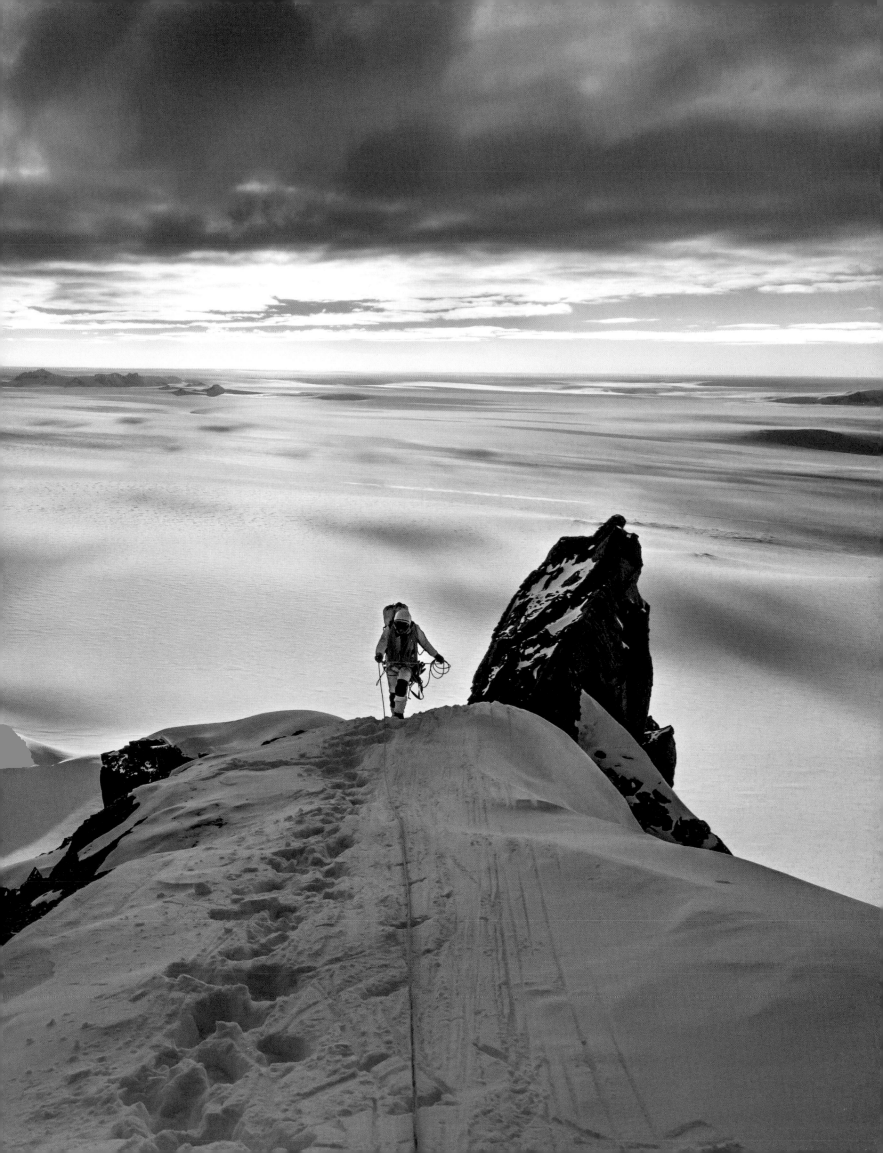

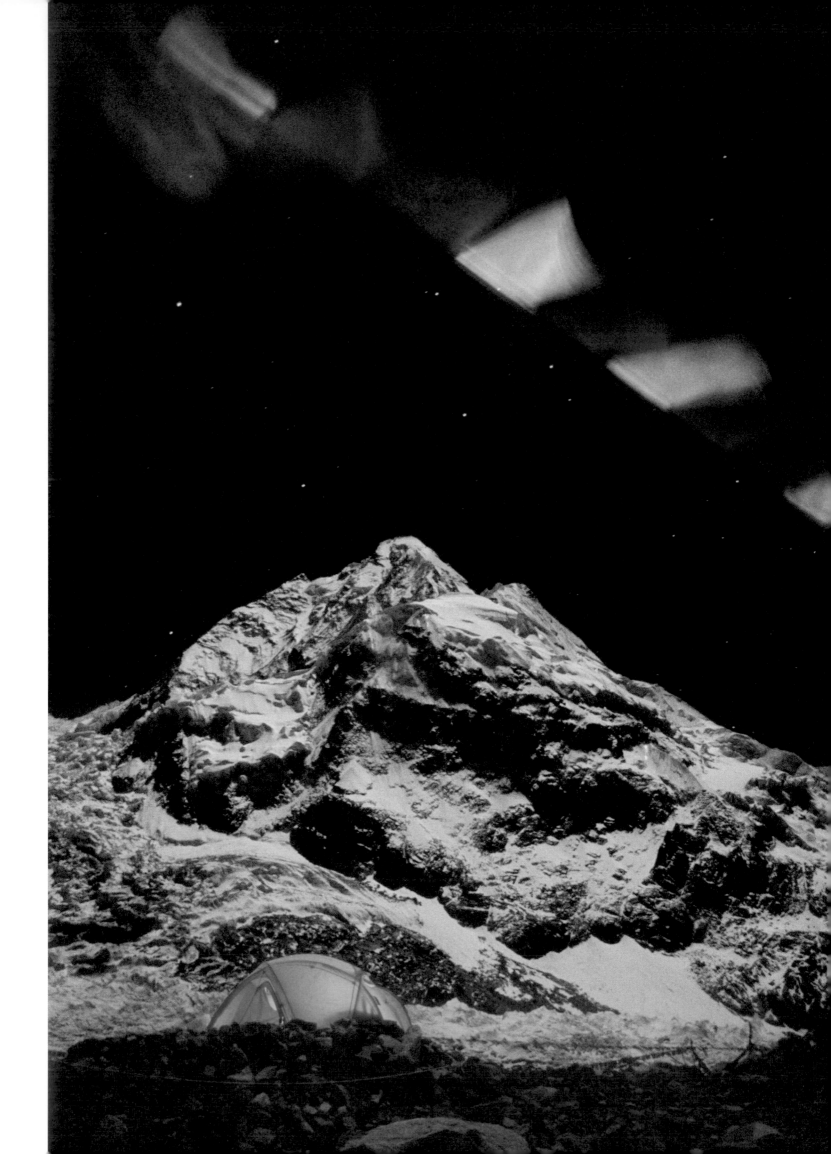

# Acknowledgments

This book owes its existence to many.

To Mom and Dad, thank you for your unconditional love and for shaping me into who I am today.

Thank you to my sister, Grace, who has taken care of me for as long as I can remember and encouraged me to forge my own path.

I am indebted to my dear friends and mentors—Conrad Anker and Jennifer Lowe-Anker, Rick and Jennifer Ridgeway, Yvon and Malinda Chouinard, Doug and Kris Tompkins, David Breashears, Galen Rowell, and Jon Krakauer—for sharing their wisdom and showing me the way.

Thank you to my editor, Matt Inman, my designer, Kelly Booth, and my agent, Alex Kane, for their patience and guidance at each stage of creating this book.

Thank you to Jon Krakauer, Marshall Heyman, and David Gonzales for the help with the writing. There is a reason I am a photographer and not a writer.

There are countless climbers, skiers, snowboarders, alpinists, and mountaineers who have inspired me to do what I do, especially Peter Croft, Dean Potter, Steph Davis, Timmy O'Neill, Alex Honnold, Tommy Caldwell, Jeremy Jones, Travis Rice, Scot Schmidt, and my teammates on The North Face Athlete Team. You've all influenced me more than you know.

I am especially thankful to my photographer peers at *National Geographic*, whose excellence I am endlessly aspiring to; to Sadie Quarrier, my photo editor at *National Geographic*, for all of her insight and editing over the years; to Rebecca Martin who believed in me from the beginning and to The North Face and Steve Rendle for supporting me over the last twenty years.

To my friends who have always been there for me through thick and thin, I am forever grateful to all of you. Special thanks to Jimmy Hartman, Brady Robinson, Rob and Kit DesLauriers, Doug Workman, Dave Barnett, Eric Henderson, Matt Wilson, Dave Cronin, Mikey Schaefer, Dirk Collins, Peter McBride, and Chris Figenshau.

Finally, thank you to my amazing wife, Chai, for sharing your brilliance with me and for being such an incredible mother; and to my children, James and Marina, for bringing a light and joy to my life I never knew was possible.

307

# About the Author

Jimmy Chin is an Academy Award-winning filmmaker, and *National Geographic* photographer. For over twenty years, he has collaborated with the greatest adventure athletes and explorers in the world.

As a professional athlete and photographer focused on documenting cutting-edge expeditions, he has climbed and skied Mount Everest from the summit and made the coveted first ascent of the Shark's Fin on Mount Meru, among other firsts. He has photographed on all seven continents, and his images have graced the covers of numerous publications, including *National Geographic* and the *New York Times Magazine*. Chin's work has also been featured in the *New Yorker*, *Vanity Fair*, *Outside* magazine, and *Men's Journal*. His photography accolades include being awarded the National Geographic Photographer's Photographer Award by his peers in 2020.

As a filmmaker, Chin co-produces and co-directs with his wife, Chai Vasarhelyi. Their film *Meru* won the Audience Award at the Sundance Film Festival in 2015 and was shortlisted for the 2016 Academy Award for Best Documentary Feature. Their documentary *Free Solo* won the Academy Award for Best Documentary Feature in 2019, a BAFTA, and seven Primetime Emmy awards. Jimmy splits his time between Jackson Hole, Wyoming, and New York City with Chai; their daughter, Marina; and son, James.

**RIGHT** Jugging on the Pacific Ocean Wall. El Capitan, Yosemite National Park, 2007. Photo by Dave Hahn.

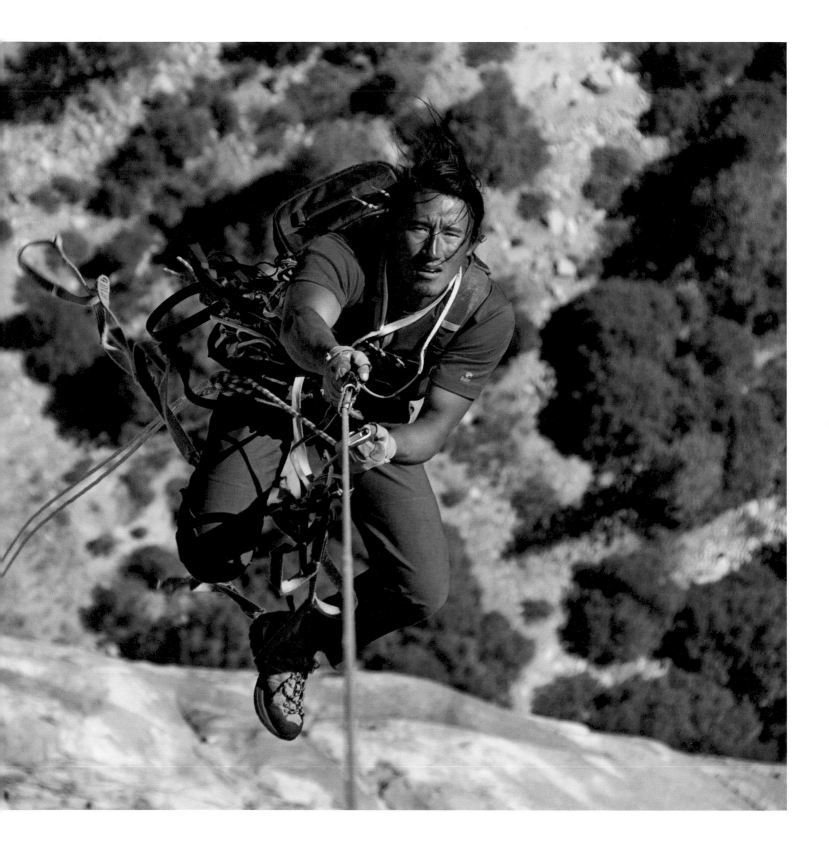

Published in the United States by Ten Speed Press, an imprint of Random House, a division of Penguin Random House LLC, New York.

www.tenspeed.com

Ten Speed Press and the Ten Speed Press colophon are registered trademarks of Penguin Random House LLC.

Pages 2–3: map elements courtesy of Shutterstock.

Library of Congress Cataloging-in-Publication Data is on file with the publisher.

Hardcover ISBN: 978-1-9848-5950-1
eBook ISBN: 978-1-9848-5951-8

Printed in Italy

Editor: Matt Inman
Production editor: Kimmy Tejasindhu
Designer/Art director: Kelly Booth
Production designers: Mari Gill, Tamara White, and Lauren Rosenberg
Typefaces: Lineto's Akkurat by Laurenz Brunner and MCKL's Shift by Jeremy Mickel
Production manager: Serena Sigona
Prepress color manager: Jane Chinn
Copyeditor: Janet Silver Ghent | Proofreader: Chris Jerome
Publicist: Jana Branson | Marketer: Daniel Wikey

10 9 8 7 6 5 4 3 2 1

First Edition

**FRONT COVER** Kami Sherpa and Mingma Sherpa carrying loads toward Camp 2 through the Western Cwm on Mount Everest.

**BACK COVER** Jimmy Chin shooting on El Capitan during the filming of *Free Solo*. Photo by Cheyne Lempe.

BORNEO BIG WALL

SHANGRI-LA EXPEDITION

YOSEMITE 2010

CHAD 2010

SKIING DENALI

MERU 2011

OMAN